ALL KINDS OF EVERYTHING

DANA ROSEMARY SCALLON
with KEN MURRAY

Gill & Macmillan

Published by Gill & Macmillan Ltd
Hume Avenue, Park West, Dublin 12
with associated companies throughout the world
www.gillmacmillan.ie

© Dana Rosemary Scallon 2008
First published in hard cover 2007
978 07171 4528 7
Index compiled by Rachel Pierce at Verba Editing House
Type design by Make Communication
Typesetting and print origination by Carrigboy Typesetting Services
Printed in Great Britain by MPG Books Ltd, Bodmin, Cornwall

This book is typeset in Minion 12pt/14.5pt

The paper used in this book comes from the wood pulp
of managed forests. For every tree felled, at least one tree
is planted, thereby renewing natural resources.

A CIP catalogue record is available for this book
from the British Library.

5 4 3 2 1

I dedicate this book to the memory of my late father Robert and to my mother Sheila Brown; thank you for your love and strength and the inspiration you have been throughout my life.

CONTENTS

ACKNOWLEDGMENTS

I have many people to thank for their support in the writing of this autobiography. Let me begin with Ken Murray, for the many hours he spent listening and transcribing. A special mention also to Sue for the ever-flowing tea and sustenance. My brother John for his vision and for sourcing an excellent publisher. Thanks to Michael Gill, Emma Farrell, Liz Raleigh and all at Gill & Macmillan for their expertise and guidance.

Without my husband Damien's safe keeping of letters, hand-written notes, diaries and newspaper articles, as well as his constant encouragement, I really couldn't have completed this book. My mother was a tireless and accurate source of information regarding our early family years and long-standing friends like Robert Hilliam provided relevant details of the musical phase of my life.

The political chapters demanded meticulous detail and research, and I'm forever indebted to those who helped me in this painstaking work, in particular: Dr Catherine Vierling, Brian Simpson MEP, Anthony Coughlan, Elizabeth Bruton, Professor Eamon O'Dwyer, Colm Scallon, Rich Maggi and John Brown. I am eternally grateful for your invaluable help. A big thank you also goes to friends like Mattie Smith, Tom Savage and Terry Prone for their sound advice and guidance. Of course there would have been no political chapters to write had it not been for the many supporters who worked so hard and so selflessly in the various campaigns throughout my political career. I will never forget you.

Lastly, a sincere thank you to all my friends, members of the Brown and Scallon clans, my husband Damien and our children Grace, Ruth, John James and Robert for your understanding, generosity and unfailing support.

Chapter 1 ᧞

DERRY
DAYS

There was always music in the Brown family. John Brown, my paternal grandfather, who passed away before I was born, played the bass drum and euphonium in our local St Columb's Brass and Reed Band in Derry. It was only natural therefore that his eldest son, Robert, my father, followed in his footsteps. I still have a faded photograph of that little six-year-old boy, proud as punch in his band uniform, sitting cross-legged at the feet of Granda.

Like most young people of his generation, Dad left school at the age of fourteen. He trained as a barber and by the time he was in his late teens, his brother Johnny and himself had established a flourishing business together in Rossville Street in an area that would later become known as the Bogside. My eldest brother, Robert Jr, and my sister Eileen were to follow in Dad's footsteps, so as you can imagine, no one was allowed to leave our house with a hair out of place.

My father was also a very accomplished musician. He graduated from clashing a pair of cymbals, almost as big as himself, at the age of six, to being chosen as the solo cornet player for the 1932 Eucharistic Congress in Dublin, when he was just twelve years old.

As he matured, his fine trumpet skills earned him a place in a number of well-known dance bands in Derry, founded by respected musical families such as the McIntyres, the McCaffertys and later the Quigleys.

However, by the time he was in his thirties, Dad had formed his own band, 'The Imperial All Stars'. It was quite normal for us to wave goodbye to him when he'd set off in the afternoon, to play at a 'gig', knowing that he probably wouldn't return until sunrise the next day.

He loved to tell us of the time his band drove from Derry to Cork and back, a return journey of almost six hundred miles, for just one solitary pound per man, and he did *all* the driving. It was hard-earned money and how those musicians stuck it out I'll never know.

At that time, a man could earn around six to eight pounds sterling a week for a normal nine-to-five job—if he could get a job! There was so little work available for men in Derry that most had to emigrate to find employment, as my father had to do a number of times throughout our young lives. But during those periods when he was able to find work at home, he would supplement his income playing in dance bands at night. From the 1950s on, Derry was awash with dance bands. They were known locally as 'pick up' bands because if a regular player dropped out for any reason, the band would just pick up one of the many other available musicians in the town.

Not surprisingly, it was music that brought my parents together, when a young Susan Sheerin—for some reason known to one and all as Sheila—fell in love with the handsome young trumpeter she heard playing at a dance in Dunree Fort, in Co. Donegal. She tells me that he sounded better than the famous trumpeter Eddie Calvert and was the best-looking man in Derry. Well, he certainly must have been something special because they were engaged one week later, married within a year and went on to spend almost fifty years of married life together.

Their wedding took place in St Eugene's Cathedral in Derry. In those days the wedding reception was held in your home and Mum's was a tiny 'two-up, two-down' terraced house, so-called because there were two small rooms on each floor. Her parents had raised thirteen children in this little house in Union Street, where Granny Sheerin would scrub the footpath clean outside her front door. Neighbours depended on one another to get through those difficult days of the late 1930s and 1940s and on the day of Mum and Dad's wedding, they all pitched in to help.

Mum's father, Bernard Sheerin, hailed from Burt in Co. Donegal and her mother, Ellen Hasson, from Park, Co. Derry. Granda Sheerin was a master butcher and a flute player and, with other members of his family, played in the local flute band. Granny Ellen Sheerin was a strong, practical woman and a real lady. She inherited a fine singing voice from her Scottish mother, Susan, who I'm told never lost her Scottish brogue, despite living in Derry for most of her life.

I also had Scottish roots on my father's side of the family. Dad's family was a mix of Northern Ireland Catholic and Scottish Presbyterian. All his life he remained very close to the Jamesons, his Glasgow cousins. They were members of the Orange Order. Every July his cousin Jack, who was closest to Dad in age, would travel to Derry to march in the parades commemorating the victory of King William III, Prince of Orange, over the Catholic King James, back in the 1690s.

Jack would stay with my father's family in their terraced Georgian house in Pump Street, right in the centre of Derry city and opposite the Convent of Mercy. Under strict instructions from Granda Brown, young Jack would leave the house with his ceremonial sash and bowler hat carefully concealed in his overcoat, with the threat that if he put them on before he rounded the corner out of sight of the convent, he would have no head to put his hat on next time! Well, thankfully, cousin Jack kept his head and was to prove himself a good friend to me in later years.

My parents raised us in the Catholic tradition, but there was always openness and tolerance in our home and we were taught to respect other people's beliefs. I never remember my parents making a distinction between 'Us' and 'Them', our Protestant neighbours, and memories of my young life in Derry are devoid of any awareness of the tensions that would later tear our community apart.

After their marriage, Mum and Dad's first 'home' was one good-sized room in the Brown house in Pump Street, but soon the arrival of Robert Jr and my eldest sister Eileen necessitated a move to a roomier dwelling back in Union Street.

Derry was famous for its shirt factories and my mother, like thousands of other women, followed the call of the early-morning factory horn to begin her long day's work in Tilly and Henderson's, or Hogg and Mitchell's, two of the local shirt and pyjama factories. She began her working life at the age of fourteen and she says she was happy and at home amongst the endless rows of young women seated at their whirling, clacking sewing machines. They loved to sing all the popular hit songs at the top of their voices in those days before radios blared out over workroom floors.

Mum had a great love for music and despite the fact that her parents could afford to send her to only a few piano lessons, she had the ability

to pick out any tune and was good enough to be hired as pianist in her new husband's dance band. No day was complete in our house without hearing her tinkling on the ivories. Throughout our childhood, Mum was the driving force behind her children. She went that bit extra to ensure that we had every opportunity to achieve our ambitions, and of course she made sure that we all took music lessons. Dad passed on his musical knowledge and expertise not only to us, his children, but free of charge to any young person who had the desire to learn. This included the local orphanage Brass Band, hundreds of individual young people and lastly his grandchildren, several of whom are really fine musicians.

Times were hard in Derry in the mid-1940s and even though Dad was working two jobs, as a musician and as a barber, it was difficult to make an adequate living, with two young children, Robert and Eileen, and a third on the way. Like many before and after him, he was forced to head to England, leaving his young family behind him in Union Street. After a stint working at the docks in Southampton, Dad managed to get a job on the railway at King's Cross Station in London and was eventually able to send for his family to join him. But before they could travel, their newborn daughter Grace died tragically after reacting negatively to penicillin.

The move to London was a new start for Mum. She found that amid the bomb-damaged buildings and piles of rubble, people were struggling to carry on a normal way of life, and she overcame her own loss and pain by throwing herself into the job of finding a home for her family. Within a short space of time she was proudly holding the keys to a rented bomb-damaged house in Islington, not far from King's Cross.

My parents always spoke with great fondness of their years and experiences in London. Like the day Mum and Dad moved into 89 Frederica Street with hardly a stick of furniture or even a kettle to make a cup of tea. An unexpected knock at the front door announced the arrival of neighbours who, with little or nothing themselves, had nonetheless brought a pot of tea and a home-made cake to welcome the young Irish family to their new home.

Another vivid memory often shared was the amazing celebration that took place on Victory in Europe Day, when my parents along with hundreds of thousands of deliriously happy people flocked onto the

streets of London and jostled and danced their way to Buckingham Palace to mark the end of the Second World War. That evening, when all had returned home footsore and exhausted, the party continued in Frederica Street until dawn, with neighbours sitting out on their front doorsteps singing and Dad serenading them on the trumpet with popular tunes of the day. According to Mum, this scene was often repeated on other long balmy summer evenings.

Another celebration took place in Frederica Street after my arrival. I was the fifth child born to the Brown clan, following on from my older sister Susan. John arrived a few years after me and finally Gerald, the youngest, was delivered into the world in Derry, shortly after our return there in the mid-1950s.

My memories of our terraced Georgian house in Islington are surprisingly vivid. Big wrought-iron railings guarded the front of the tall, narrow four-storey building. The basement kitchen was approached by a couple of stone steps leading down from the long, narrow entrance hall and, as a toddler, I loved to sit on those steps watching the adults come and go, while my mother, working in the kitchen, kept a watchful eye.

Our house always seemed to be bustling with people; members of my mother's and my father's families stayed with us at various times till they could find a place of their own. Then there were the young Irish men Dad found at the railway station. They would have arrived in London with no money and nowhere to go, so he would bring them home and give them somewhere to stay until they sorted them-selves out.

I shared a bed with my sisters Eileen and Susan until I was about twelve, sandwiched in the middle. Eileen being the eldest lay on the outside, with Susan 'squashed up against the wall', as she frequently informed us. Eileen naturally assumed authority in any disputes, but Susan, an independent spirit, would have none of it. On the nights when my determined sisters traded elbows across the bed, I would simply slide down under the sheets and stick my head out the other end, leaving them to wonder where I'd disappeared to when peace finally descended.

Away from the difficulties of duelling sisters, my best friend in London was a little girl I knew simply as Loopy Loo. She lived across

the street and we spent endless hours in her attic playing with a doll's house. But as my childhood friendship with Loopy Loo continued to strengthen, health problems were developing within our family. It became clear at an early stage that John, just like Susan, had bronchial problems that weren't being helped by the choking smog that floated in abundance over London in the winter months. The doctor advised my parents that the purer air of Derry would be a better environment for their condition and so the decision was made to move back home.

It was hard for Mum and Dad to leave London. They'd made some good friends there and a number of Mum's brothers and sisters had moved there to live, so for her it was like being separated from her family for a second time. She particularly missed taking us on long walks down Caledonia Road, or to the famous Angel Market on a Sunday morning. She never lost her love of exploring Sunday markets and it was something we would share each summer when we'd return to England on holiday.

We moved back to my Granny Sheerin's house in Union Street and, although it was only a temporary arrangement while we looked for a new home, I'm sure it can't have been easy with so many noisy children about the place. I always seemed to get on well with Granny. It was very easy to be comfortable with her and she had lovely necklaces and hats that she didn't seem to mind me borrowing.

Within a couple of years, my family had moved to a larger house in a smart new housing estate overlooking the city, called the Creggan. This house overlooked a public field where the children would gather to play and community events would take place. There was a very strong sense of community in the Creggan. Most families had moved there from the older houses in the city centre and they knew each other well. My mother could tell me a person's family history three generations back. There was a majority of Catholic families in the Creggan, but also a fair number of Protestant families and I don't remember there being any difference made between us.

There were particular occasions when the whole community celebrated together, like Bonfire Night every 15 August. Throughout that day we would watch as an enormous bonfire was built in the middle of the field and then, as evening drew in, neighbours from the surrounding streets would gather around the big roaring fire. Everyone

came: mothers with babies balanced on their hips; grannies comfortably seated on their own kitchen chairs; children with faces crimson from the heat of the fire, running and jumping with excitement while their parents stood guard around the flames.

By now my sister Susan and I were enrolled in St Eugene's Primary School down in the town. This meant a bus ride, or a very long walk for us each day. We preferred to walk if the weather was good, because we could use the bus fare we'd save to buy sweets in the shop opposite the school. Walking into that shop was like walking into paradise. The shelves behind the counter were lined with big glass jars of sumptuous, multicoloured sweets, but our choice never varied—four Walkers' toffees for me and a quarter ounce of Dolly Mixtures for Susan.

As I worked my way through primary school, it seemed that an ever-increasing circle of musicians centred itself in our house. At one stage, there were so many musicians practising in our home, the only place I could find a seat was on the stairs. My father's dance band was playing away in the front room, my brother Robert's group was in the kitchen, while my sister Eileen's band was forced to practise in an upstairs bedroom. They were all playing different styles of music in different keys and tempos and I just sat there on the stairs in the middle of this amazing cacophony of sound!

Lily Kerr, who lived just round the corner from us, was my best friend. She had beautiful auburn hair and she also had a super new bike! Oh, how I wanted a bike like that, but we couldn't afford one and there was no way I was going to ride the big black bike that belonged to my older brother. It had a crossbar, not like Lily's elegant lady's bike. It seemed an insurmountable problem until my father came up with an ingenious plan; he simply painted the black bike *pink* and persuaded me that it was now a lady's bike. Many's the time I fell off that darned bike as I tried to manoeuvre it around the oval of grass at the end of our street. With one leg under the crossbar, positioned at a delicate right angle to the rest of my body, I clung onto the handlebars while pedalling for dear life like some kind of circus balancing act! But I was determined, and despite my collection of cuts and bruises, I persevered till I could ride like the best of them.

When we tired of 'world tours' on our bikes, we would tie a rope around the lamp post at the end of the road and swing around it for

hours at a time. Many years later, just after I was elected to the European Parliament, I was walking around Dublin's Merrion Square one Sunday morning, admiring the work of artists on display, when I was stopped in my tracks by a painting of two young girls swinging on ropes round a lamp post. I bought it immediately and hung it in my office in Brussels so that it would always remind me of my childhood and where I'd come from!

At the age of six, I began piano, violin and ballet lessons, generously paid for by my great-aunt, Mary Hasson, to help out my parents. At that time it was unusual for young Catholic girls to learn ballet; they normally preferred traditional Irish dancing. I loved both, and so, for a short time, I attended Irish dancing and ballet classes, but I was eventually forced to choose between the two because of the conflict in styles of movement and stance.

And so it was that on every Saturday morning I'd happily make my way by bus or on foot to Miss Kathleen Watson's Ballet Studio at the top of Clarendon Street. It was quite a long way from the Creggan, but that was never a deterrent for me. There was always a sense of anticipation as I'd knock on the green-painted front door and wait for Miss Watson's sister Margaret to open it. Her greeting was always the same: 'Hello, Miss Brown. Run upstairs now and get changed quickly!'

Some of my happiest memories are of the exhilarating, exhausting hours spent in that bright, sparse studio which occupied almost the entire first floor of the elegant Georgian house. I loved ballet and by the time I was twelve I had decided that I wanted to be a ballet teacher. I attended classes on Tuesday evenings and all day Saturday, as I worked my way through my grade exams with Miss Watson. At the age of fourteen I was accepted into the Bush Davis ballet school in England. I attended the school as a full-time student for a six-month trial period, and though it was a wonderful experience, my parents rightly felt that I was too young to live away from home.

My ballet training taught me a discipline and work ethic that has been very valuable throughout my life. I found it particularly helpful in my show-business career. When working with television directors giving camera moves, choreographers with dance steps, or producers with stage positions, Miss Watson's instructions were always engraved in my mind: 'Stand absolutely still and do not move a muscle when I'm

telling you what to do. How will you remember if you don't concentrate?!'

Quite recently I found myself in Clarendon Street for the first time in a very long while and I made my way back to Miss Watson's front door. The house is converted into offices now and in need of some tender loving care. The door is painted dark blue, but on closer inspection it was somehow reassuring and surprisingly touching to see the original green paint peeping through the scratches. I literally pressed my nose against the inner glass door so that I could make out the entrance hall and the familiar staircase that brought me running up to the changing room and the dance studio beyond. Number 73 Clarendon Street will always be Miss Kathleen Watson's Ballet Studio to me.

There were also excellent music and singing teachers in Derry, like James McCafferty, one of the best accompanists I've ever sung with, and Mrs Edward Henry O'Doherty, an elderly lady who'd make you stand close beside her piano at the Feis, so that she could whisper the Irish words to you in case you'd forget them. And then there was Mrs Cafolla, my first music teacher, and David Fulton, my piano teacher, and many, many others.

Like most of the young people I knew, I took part each year in various Feiseanna. Our city had two—the Derry Feis, which was a celebration of Irish culture, with competitions in Irish dancing, singing and music, and the Londonderry Feis, where we competed in ballet, classical music and song. Competition was always fierce between the rival schools of music and dance, some of whom travelled great distances to compete. My mother gave us all sound advice when we were young. She told us simply to do our best and that if we won, we should never get big-headed. 'If you win, keep your feet on the ground,' she would say, 'because there'll always be someone not as good as you, but if you lose, don't get upset, because there'll always be somebody better than you.'

The most exciting time of the Derry Feis was the 'All Winners Concert' on the Saturday night. The Guildhall, with its magnificent stained-glass windows, would be packed, and as each winner performed, the audience would cheer and stamp their feet. It was a wonderful night whether or not you were a winner. In one particular Derry Feis I competed in the under-eleven girls' solo, representing my

school, St Eugene's. There were 120 competitors taking part, with all 120 of us singing the same set piece in Irish. I presumed I hadn't a chance of winning, because other singers were re-called to perform a second time and I wasn't one of them, so by the time the results were announced I wasn't even present in the hall—I was busy running around and playing with other girls. As it turned out, the judges said that they had made up their mind that I was the winner when they first heard me sing and so they didn't need to re-call me. Someone grabbed me by the arm and practically dragged me the length of the corridor into the competition hall to receive my gold medal! I was flabbergasted at the result. Not only had I won, to the delight of my family, but the next day when I went into class, Miss Butcher, our singing teacher, threw me a little white paper bag filled with Walkers' toffees, my favourites!

Talent competitions were also very popular in Derry and were generally held in St Columb's Hall which was a hive of musical and cultural activity for the whole community. It was the home of St Columb's Brass Band, and in future years of the Derry Players, a fine amateur drama group. Regular concerts, plays, pantomimes and of course talent competitions were all held in 'the hall'.

My life revolved around music and dance and it was the same for most of the people I knew. I was never bored as a young person. There was always something creative to do. I was learning piano, violin, ballet, and if that wasn't enough, I was also in the choir, as well as performing in various events and loving every minute of it. No doubt that's why my school teachers began to comment that I had too many irons in the fire and that I was devoting more time to music than to my studies. The Sisters in St Eugene's were particularly worried about my fast-approaching 11-plus exam and, as things turned out, they were right: I failed my 11-plus by half a point.

The result was a blow to me, because I really wanted to go to Thornhill College, a grammar school for girls, just outside the town. All my friends were going there. However, I knew that if you failed the 11-plus you could go there only as a fee-paying student and that seemed to me to be an impossible financial hurdle for our family. There was also an entrance exam that had to be passed and my parents said that if I did well in that exam, they would do everything possible to send me to the school. When I passed without any problem, Mum and Dad scraped

the money together and made it possible for me to go to Thornhill. It was a dream come true, but I also felt a sense of guilt at the financial strain I knew it must put them under.

Keeping a balance between school work and music was never easy. I continued my music and dance studies and also sang with my sisters in the charity concerts Dad organised, which meant that the Browns were getting plenty of work singing and dancing in hospitals, homes and halls around the area. It also allowed us to broaden our repertoire of songs, because we could sing the hits of the day at these shows.

Our 'act' was slowly gaining popularity in and around Derry when we had something of an unexpected setback: Eileen decided to go to Birmingham in England to study hairdressing. Then, with only Susan and me left, we were dealt another blow: Susan decided to walk away from Derry's bustling showbiz scene and enter a convent! Her decision caused a certain amount of tension in the house and it was particularly bittersweet for Mum. It was very much an honour to have a family member enter the religious life. But, as far as Mum was concerned, at fifteen years of age, Susan was too young for such a vocation. However, Susan pursued her ambition, and with Mum eventually capitulating, she entered Bloomfield Convent in Mullingar, as a novice. Although she never took her vows, she learned to develop her talents there and she left Bloomfield a well-educated, accomplished pianist.

Back home in Derry, Susan and I took up our singing again and at a charity concert in St Patrick's Hall in the Waterside area of Derry, we met up with a young instrumental group headed up by brothers Ronnie and Freddie McClelland. They were looking for lead singers and we were looking for a good band, so pretty soon we were a team, making a name for ourselves on the local concert scene. Susan and I also continued to sing as a duo, securing a summer season in the Palladium Theatre in Portrush.

However, Susan had itchy feet again and by 1964 she was heading to England to train as a nurse. We had been writing our own songs for some time and my mother's sister, Aunt Rosaleen, who lived in London, wanted us to meet the husband of her best friend—a music arranger called Frank Barber. We travelled to London to sing for him and he liked our singing *and* our songs, so in turn, he introduced us to his friend Les Perrin, a writer for the *New Musical Express* (NME) magazine.

Les subsequently became press agent for the Rolling Stones, and my own press agent, immediately after I won the Eurovision Song Contest.

We must have made a good impression, because over the coming weeks the two men set up a recording session for us in London and then took us along to Decca Records, where we were offered a recording contract. It all seemed to be happening for us, but as the exciting lure of a full-time life in showbiz beckoned, Susan, at the age of eighteen, fell in love with a young US airforce man stationed near her hospital in Braintree, Essex. Suddenly the dream of jetting around the world, selling millions of records to millions of adoring fans had little appeal for my sister. She had found the love of her life and made up her mind in a very short space of time that she wanted to marry him and settle in the US.

The thought of Susan emigrating to America was very upsetting for Mum and Dad. They knew little about her husband-to-be and were apprehensive about her living so far away from the support of her family and friends. In the 1960s the USA was the other side of the world, a place where people went with little hope of ever returning. However, Susan and Ron eventually married and have remained so for over forty years now.

In the 1960s we didn't have a telephone but we did have a black-and-white television and it was on that little set I watched my first Eurovision Song Contest. The winner was a young Italian girl called Gigliola Cinquetti singing 'Non ho l'età'. With her hair tied back in a ponytail she looked young enough to be around my own age and I was mesmerised. As I watched her receive her award to tumultuous applause, little did I think that within a few short years I would be standing in her place.

SCHOOL AND
BEYOND

Thornhill College is an imposing grey-stone Victorian house about four miles outside the city of Derry, overlooking the River Foyle. The former private residence was established as a convent school by the Sisters of Mercy in 1932 and by the time I went there in the early 1960s the main school buildings, housed in the former stable block, had been extended by adding new classrooms, built in the beautiful grounds. Luckily much of the garden was still intact, with its magnificent rhododendron bushes and peaceful lawns rolling down almost to the river bank.

It was a long journey to the school from our house, so on my first day Dad drove my friend Margaret McKeever and me out to Thornhill. Walking through the school gates, wearing our new navy-blue uniform, was an unparalleled moment of happiness for both of us. However, our first day turned out to be as challenging as it was exciting. I was heartbroken to discover that I was separated from most of my friends from St Eugene's as we ended up in different classes. By the time lunch break came around it was a great relief to see their familiar faces again. When the final bell rang at four o'clock we were happy but exhausted and ready for home. Margaret and I crammed our books into our new schoolbags and staggered to the bus, only to discover that the Creggan bus had already left. There was nothing for it but to walk—the full, agonising three-and-a-half miles. By the time we eventually reached home we were practically on our knees with exhaustion and hunger.

I soon settled into life at Thornhill and became part of a group of friends who stayed together not only through our school days but through our adult lives as well. I was determined to study as hard as I

possibly could, especially as there was a limited number of scholarships awarded at the end of the first year, and I felt that if I could earn one, it would relieve my parents of the burden of paying for a further two years' tuition. My hard work paid off because at the end of the year I got the highest average of the first-year students. However, the elusive scholarship was not to be. It appeared that a list of names had been drawn up of pupils suitable for the scholarship awards; a line was then drawn and those named above it received a scholarship. My name was below the line.

With my confidence somewhat bruised, I picked myself up and soldiered on toward my Junior exam. I vividly remember the morning my results came out. My mother woke me to tell me that I'd passed. I felt a tremendous sense of relief as though a weight had been lifted from my shoulders. Of course alongside my school exams I still had Royal College of Music exams to sit, as well as my ballet exams.

Attending an all-girls school had its advantages. For one thing, you didn't have to worry about how you looked in the mornings. However, as we all had a healthy interest in boys, the return journey home was a different matter entirely. When the bus reached the city centre we would meet up with the boys from St Columb's or Foyle College and it was imperative that you look your best. Within no time at all we had become experts in fixing hair and applying make-up on a wobbly school bus, as it negotiated the twisty, bumpy roads on the outskirts of the city. It was such a delicate procedure, particularly with your cake-mascara and eyeliner being applied with a fine brush, that any unexpected bump or pothole could ruin the painstaking transformation from ugly sister to potential Cinderella. This training stood me in good stead, and as I began travelling regularly by car to sing in folk clubs in Dublin and elsewhere, I found I had no problem applying my stage make-up en route.

On the showbiz front, the Beatles had emerged as the biggest thing since Elvis. Boys wanted to be them and the girls wanted to date them! It seemed that Beatlemania engrossed everybody around me, and in my class it was obligatory to be in love with at least one of this famous group. The trouble was, I was a dedicated fan of the Shadows and more recently of Cliff Richard, but not wanting to look out of place with the rest of the girls, I decided that if I was going to be interested in any of

them it would have to be Paul McCartney, because he had the nicest eyes. I ended up being just as hooked as everyone else on the music of the Beatles, and even today, listening to it transports me back to my friend Evelyn McCafferty's sitting room where we would all gather and spend the evening listening to John, Paul, George and Ringo.

At weekends my friends and I would change into black stretch trousers, black polo-neck sweaters and white Aran cardigans—a kind of 'Beatles meets Makem and Clancy' look. With half a crown as pocket money we were rich! The new highlight of the week was to buy a big bag of vinegar-sodden chips, which cost only one shilling, on a Friday evening, and then climb over the railings into the nearby children's park close by the Cathedral. We'd sit on the swings and roundabouts with our supply of piping-hot chips and munch away till the last morsel was gone from the bottom of the bag; then it was off to Evelyn's house.

By now my circle of friends included Maura McAteer and her brothers Seán, Hugh and Fergus, as well as their cousin Pauline. Maura's dad Eddie McAteer was the most prominent Catholic politician in Northern Ireland at that time and led the Nationalist Party at Stormont. I spent many enjoyable hours with this family who, like their father, had a wonderful, dry sense of humour. Then there were my friends Bláthnaid and Evelyn McCafferty, Sheila Doherty, Santina Fiorentini and Martin Cowley who would later become a highly respected journalist with the Press Association. I was also very close to my cousins Philip Sheerin and the Gallaghers—Aileen, Anne and Seamus.

In all, there were about twelve of us in our little gang of friends and it was great to have the security that friendship gave us. When we were about fourteen or fifteen years old, we decided to play truant, or 'dob' school as it was known in Derry. Mrs Gallagher was going to be away for the day, so the plan was to head there, pockets bulging with potatoes for chips and tins of peas for lunch. Bláthnaid schemed up the idea of the girls meeting at her house first, after her mum had left for work, so that we could change out of our uniforms and then make our way to Gallaghers'!

Trying to look as innocent as possible, we all set off for school as normal that morning and were soon crowding into the narrow front hallway of Bláthnaid's house. Giggling and laughing, we wobbled on

one leg trying to stay upright while we removed our school stockings. Suddenly to our horror we heard Bláthnaid's mother making her way down the stairs. Just our luck that of all days she was late going to work! We almost fell over each other as we panicked to get out the front door. As we raced frantically down Francis Street in various stages of undress, I had one stocking on and the other flying like a flag from my hand. We barely stopped till we had arrived puffing and panting at the Gallaghers' house.

When we eventually got our breath back, we took to 'dobbing' like fish to water. Excited as children on Christmas Eve, we spent most of the morning peeling potatoes as we sang rousing choruses of the latest Beatles hits. By mid-day we had enough bowls of hand-carved chips to feed the Russian Army and soon the frying pan was hopping as we dished out mountains of chips and peas.

The more we cooked, the more of a commotion we made, and as the smell of chips and vinegar became overpowering, we made the mistake of opening the steamed-up windows to let in some fresh air. The noise, combined with the smoke from the chip pan that streamed out of the window, alerted an anxious neighbour that something was amiss in the otherwise peaceful Gallagher house. When the inevitable knock came to the front door pandemonium broke out as we took off in all directions looking for somewhere to hide. I ended up in the coalhouse with about three others. Aileen earned a career in the diplomatic service that day when she convinced the concerned neighbour that she was simply cooking a spot of lunch for her brother and sister who were both sick in bed, and we crawled out from our hiding places to enjoy the rest of the day.

Around this time I started dating Ronnie, the young guitar player in the group Susan and I were singing with. Had my parents known about this budding romance, the likelihood is that it would have ended as quickly as it began. It did fizzle out after a couple of years, but nevertheless Ronnie and I have remained friends. My first 'official' date was with Seán, the brother of a friend of mine. He was tall, dark and handsome, with a great sense of humour, always an important quality for me. As it turned out, his sense of humour served us both in good stead, as the first Christmas present he received from me was aftershave—unfortunately he had a beard at the time!

By the mid-1960s folk evenings were all the rage and we had regular get-togethers at one of our houses, when people brought their guitars and sang along to the songs of Joan Baez and Bob Dylan, as well as traditional Irish folk ballads. The Civil Rights movement in America had spawned a number of folk anthems like 'Blowing in the Wind'. This became my party piece, but though we sang the songs, we rarely discussed the circumstances that had inspired them and we certainly didn't think that within a very short space of time we too would be singing them as we marched over the bridge in our own town, seeking the same civil rights the black people of America were now struggling for. We were certainly aware that problems did exist in our own town. 'One man, One vote' didn't apply in Northern Ireland and the gerrymandering of votes was a common practice so that in Derry city, as elsewhere in the North, the voice of the Catholic majority was never reflected in the elected city council.

For me, though, at the time, life was basically good. I had great friends and our expanding social scene saw us meeting more and more young men of our own age. A great attraction was going to a céilí where we'd take the floor in traditional Irish set-dances. Most of us hadn't a clue about the right steps and formation, but that was all part of the fun as we tried to keep up with the best of them. The most precarious point of the proceedings was when you had to 'swizz'; gripping on to your partner's waist you'd twirl faster and faster on the spot, hoping neither of you would let go, or you'd end up twirling across the floor and crashing into a pillar or wall, which was regularly the case!

The local ballrooms where everyone flocked to see Ireland's colourful showbands of the 1960s included The Embassy in the centre of the city and the appropriately named Borderland across the border in Muff, eight miles or so outside Derry. The latter was where we headed on one particular night and I felt on top of the world. All my friends were there and we danced the night away, feeling that our moment had finally arrived; we were grown up at last. Towards the end of the evening, the young man I was dancing with asked if he could 'leave me home'. I had to ask my sister Eileen of course and she, being the protective older sister and my chaperone for the evening, made it clear that this particular boy would not be getting a late-night guided tour of the back roads around the Creggan. Discretion being the better

part of valour, I returned to him and explained delicately what he didn't want to hear, before dancing out the last set of songs with him.

When the music ended we exchanged our goodbyes and, as the crowds poured out into the crisp Donegal air, I looked around in search of Eileen, but she was nowhere to be seen. I waited patiently but when there was still no sign of her I thought, somewhat indignantly, that she must have gone home with someone herself, so I took a seat in the bus that was soon to depart for home. The rattling bus with its fogged-up windows eventually took off minus one passenger and trundled its way towards Derry as I reflected on a wonderful evening and the complexity of older sisters. I expected Eileen to be waiting for me at the house, but when I eventually stepped through the front door, I was greeted by two unhappy parents anxiously enquiring where my older sister was and why she had left me to return home alone.

A detailed explanation was duly given and Eileen was branded as being totally unreliable. However, as the hours slipped by, my parents' anxiety turned to anger and as it approached four o'clock in the morning with still no sign of Eileen, *I* was now to blame for having left the ballroom without my sister! Dad, fearing that something serious had happened, was just about to get into his car and drive the route to the ballroom, when Eileen, having trudged the eight long miles from Muff, burst through the door like an army tank on full assault! Let's just say there are hardly enough words in the dictionary to describe accurately the number and level of insults she fired at me, and I was put under house arrest for the foreseeable future.

During my third year in Thornhill, I was given the lead part in the school musical, *Love from Judy*. It was a great success and I enjoyed every minute of it but it meant a great deal of additional work for me. Our music teacher Sister Imelda helped me more than anyone else during that time. We'd met during my first year when she'd reported me to the headmistress for talking in the chapel and I'd written her off as a bad-tempered old nun. But after that disastrous first meeting I got to know her better as she taught me music off and on throughout my time in school. I had thought her severe but I soon discovered the very caring and beautiful personality inside that little lady. I felt a great sense of loss when she died in March 1983. When I last visited her she was very frail; having suffered a stroke she could barely speak or move, yet

she still looked radiant and I told her so. 'You don't expect me to believe that,' she answered softly, and when I insisted her smile grew into her familiar mischievous grin and she said, 'All right then, beautiful except for my feet.'

Fr Edward Daly, later to become Bishop of Derry, was a real man of the people and shared their love of music. He organised many of the events in St Columb's Hall, one of the most popular being the annual talent competition which my friend Roma Cafolla and I entered when we were about fifteen. We were to compete in the speciality section with a dance routine called 'The Bisto Kids'. As luck would have it, just before the competition date Roma took ill. It was very disappointing for both of us and I made my way to Fr Daly to tell him the bad news and get our £1 entry fee back. He was aware that I was one of the musical Browns and so, after commiserating with me over my disappointment, he suggested that I enter the Folk section and accompany myself on the guitar. I explained that apart from the Feis I had never sung lead vocals on stage, only harmony with my sisters, and I'd sung folk songs only for my friends. That was all he needed to hear and I left him that day as a solo competitor in the Folk section.

On the night of the competition there was standing room only in the hall and, despite the fact that I already had a great deal of stage experience performing in the Feis and elsewhere, I felt almost paralysed with nerves as I took my place at the microphone, gripping on to my guitar for dear life. I closed my eyes tightly and tried to imagine that I was singing 'Blowing in the Wind' and 'Goodbye Angelina' with my friends. I didn't open my eyes again till I was finished singing. Somehow I managed to finish in second place, much to my surprise!

Fr Daly was delighted and encouraged me to keep up my folk singing, and so within a few months I entered another local talent competition in the Embassy Ballroom on Strand Road. Though I had been practising, my nerves hadn't improved much and I again sang with my eyes tightly shut. This time I took first place. The prize, sponsored by a local teacher named Tony Johnston, was the possibility of sending a tape recording of my singing to a Dublin record company. Tony was the Headmaster of Mullaghbuoy Primary School, just outside Derry, and in his spare time he promoted promising young singers, one of them

being a Derry girl named Majella Brady who was making quite a name for herself as a pop singer. We had a long chat and he offered to take me under his wing. Very soon I was accompanying Majella on the piano. This in itself was good experience for me as piano was my main instrument and I felt I was better at it than at singing and playing the guitar. The only problem was that my O-level exams were creeping up on me and I was determined to pass them.

A satisfactory compromise was reached with my parents, when Tony agreed to coach me on the academic side, as well as helping me with my singing career. He was a very good teacher and, true to his word, he ensured that I devoted sufficient time to my books. His children, who were around my age, were also taking exams, so being in their home was conducive to study and I found that I really enjoyed it. After a prolonged period of 'nose to the grindstone', I eventually emerged exhausted but happy, with seven O levels.

Alongside my studies I gradually recorded a tape of songs, written by both Tony and myself, which was sent to Michael Geoghegan, head of Rex Records in Dublin. Michael ran an Irish distribution company for the London-based Decca Records, but he wanted to promote the many talented Irish artists who found it almost impossible to get a recording deal, so he set up a small record company called Rex Records and went in search of artists. He liked my tape and within a short time I was sitting across the desk from him in his Dublin office, as he offered me a recording contract. It was an incredible moment, for having missed the opportunity of a recording deal with my sister Susan, I really didn't think I'd get a second chance. Michael proceeded to tell me in no uncertain terms that I had to believe that each record I released would be a number one! I listened intently to what he had to say and, though I nodded in agreement, I felt that in all probability it would never be the case for me.

Michael wanted me to record under a different name from Rosemary Brown. He felt that my own name was too long and that a shorter one would make a greater impact in publicity. I asked the girls in my class to choose from a few names, one of which was Dána, which means 'bold' in Irish. It was a nickname I'd picked up in my teens because of my sister Eileen who was an expert in judo and often practised her 'throws' on me. In turn, I tried out her judo tricks on my

friends in school and that's how I earned the nickname Dana, the bold or mischievous one!

My debut release as Dana on Rex Records was a catchy little song called 'Sixteen', written by Tony, with my own composition entitled 'Little Girl Blue' on the B-side. Well, it certainly didn't go to number one; in fact it didn't go anywhere, but the publicity arising from its launch helped to raise my profile and left the door open for more releases with Rex Records. I began to get some bookings in the popular folk and cabaret venues in Dublin. After school on a Friday evening, I'd travel from Derry by car, applying my make-up on the way, then, accompanying myself on guitar, I'd sing at one or two different venues like the Old Shieling, Liberty Hall, or the Green Isle Hotel, alongside well-known folk artists like the Dubliners, Emmet Spiceland, Wee Four and others. I'd do the same on the Saturday night and then head home to Derry on the Sunday to be ready for school on Monday morning. It was a great experience, but I still had difficulty getting over the terrible nerves I felt going on stage.

Throughout this period my father was working in the Arabian Gulf. His hairdressing business in the Creggan had not gone as well as he'd hoped and when he was offered a job working on an oil rig, he was glad to take it. As my fledgling career as a folk singer progressed, I'd send him newspaper cuttings, recordings and photographs and he'd write home telling me how proud he was of all I was doing. We also kept him up to date with the changes taking place in Derry. New flats were being built in Rossville Street and my grandmother was going to move into one of them, just across the way from her old Union Street home. The area, with its narrow streets of little 'two-up, two-down' houses, with outside toilets and no bathrooms, was going to be re-developed. In a town centre that had seen so little new building over the years, it was unusual and exciting to see the towering structure slowly rising amid the high cranes and gantries. The flats were much admired when they were first built and in the evening when the lights were switched on in the various rooms, it looked like a giant Christmas tree in the middle of the town. We moved from the Creggan in 1967, following Granny into the flats.

Moving to the Rossville Street flats was like returning home for us. Granny and her son Jim lived just a few doors away and most of the

other residents had been raised together in the surrounding area, so there were no strangers in the flats. Dad returned from his job in the Arabian Gulf because there was the opportunity to open a hairdressing business with my sister Eileen and eldest brother Robert in the parade of shops on the ground floor of the flats. Dad and Robert ran the barber shop at the front of the premises, while Eileen opened a ladies' hairdressing salon at the rear, where I earned pocket money washing the customers' hair on Saturday mornings.

We had a three-bedroom flat with a sitting room, small kitchen and bathroom. The front door was on the fifth floor but you had to descend a flight of stairs before you entered the flat itself. The sitting room and kitchen looked out over Rossville Street and the Lecky Road as it wound past the old gas works and disappeared into the distance. The city walls were to the left on which stood Walker's Pillar, a towering monument in memory of the late Governor Walker. The bedrooms looked out over the back courtyard of the flats, with an uninterrupted view of the clock tower of the Guildhall. Not everyone had a beautiful neo-gothic alarm clock like we had! Eileen and I shared the middle bedroom, flanked by John and Gerald in the smaller bedroom to our right and Mum and Dad to our left. It was real progress!

My singing career was progressing too. Alongside singing at weekends and holidays, I was invited to appear on a few more television programmes like *Teatime with Tommy*, an Ulster Television programme, and the *Late Late Show* with Gay Byrne on RTÉ. Then in 1968 I was crowned Queen of Cabaret at Clontarf Castle. I wore the only long dress I possessed—a red floral creation I'd worn to my school formal. A tiara was placed on my head by Red Collier, the Meath and All-Ireland footballer, and I was then whisked off in a white, open-topped Rolls Royce to be piped along O'Connell Street by the Fintan Lalor Pipe Band, while I waved happily to the passers-by.

Later that year RTÉ announced that the upcoming 1969 National Song Contest would be open to semi-professional and amateur singers from around the country. Michael Geoghegan's secretary Phil Mitton felt it was an opportunity I should not miss, so my name was put forward for a place in the auditions. Ireland had first entered the Eurovision Song Contest in 1965 with Butch Moore singing 'Walkin' the Streets in the Rain', followed annually by Dickie Rock, Seán Dunphy

and Pat McGeegan, our 1968 entrant whose son Barry McGuigan was to become the World Featherweight Boxing champion in 1985.

The auditions were to be held in Wynn's Hotel in Dublin. I was nervous as usual but I was chosen as one of the contestants who would take part in the 1969 National Song Contest which was to be broadcast early in the new year. I don't remember what I sang at that audition; in fact my only really vivid memory of that day is of meeting Tom McGrath, head of Light Entertainment in RTÉ. He was very laid back and spoke with a kind of a drawl, while he sucked on a pipe that was forever balanced at the corner of his mouth. He was friendly and helped me feel relaxed as I sang for him, but I never dreamt the incredible influence he would be on the course of my life.

Something else was to happen in 1968 that was to change the course of all of our lives in Northern Ireland. My parents and grandparents had been raised in a city where poor housing and high unemployment were the norm for both sides of our mainly working-class community. But in Derry, as in other towns where nationalists were in the majority, the gerrymandering of electoral boundaries, with overcrowding of Catholics into a small number of electoral wards, and the absence of 'one man, one vote', ensured that the unionist minority maintained a position of seemingly irreversible power.

There was also an East/West divide, with unionist power vested in Belfast, and although Derry was economically on its knees, the blows kept coming; among other things the new University of Ulster was granted to the smaller predominantly unionist town of Coleraine, even though Magee University College in Derry could have easily been upgraded to full university status. The downgrading of the rail links and the Derry docks ensured further isolation of the city and was another nail in the coffin as far as employment was concerned. Yet there was never the same segregation of Protestant and Catholic in Derry as there was in parts of Belfast. We were a close-knit community and, as was the case with almost every Catholic I knew, I had good friends, boyfriends, and family who were Protestant. My family wasn't 'politically active'. We were raised to be respectful of everyone's individual beliefs or political persuasion.

But there was urgent need for reform and by the mid-1960s, when the call for civil rights was reverberating around the world, triggered by

the Black American struggle, the political status quo was about to be challenged for the first time on the streets of my town.

On 24 August, Austin Currie MP had organised the North's first civil rights march and it had passed off peacefully. A second such march was planned to take place in Derry on 5 October. It was organised by the Derry Housing Action Committee (DHAC), established in the spring of 1968 to protest publicly against the city's poor standard of housing, a fact acknowledged in the Derry City Council report. The DHAC considered this problem to be a direct result of political gerrymandering and invited the Northern Ireland Civil Rights Association (NICRA), formed in 1967, to take part in what was supposed to be a peaceful demonstration calling for: 'one man, one vote' in council elections; an end to the gerrymandering of electoral boundaries; fair allocation of public housing; and a mechanism to prevent discrimination by public authorities and to deal fairly with complaints.

However, on 3 October William Craig, the Northern Ireland Minister of Home Affairs, banned the march. He had accused the civil rights movement of being a political front for the IRA and announced the ban because the Apprentice Boys had stated their intention of holding their own march along the same route and at the same time as the proposed civil rights march. As tension mounted there was debate as to whether or not the march should be cancelled because previously only loyalist marches had used the planned route. Some NICRA members and others in Derry felt that it could be inflammatory. However, in the end, the organisers decided on direct action and to go ahead as planned.

The people of Derry were not prepared for what happened. Eddie McAteer MP, father of my friend Maura, joined the organisers at the head of the march, alongside Gerry Fitt, Republican Labour MP for West Belfast, and other prominent political representatives, including three English MPs.

Martin Cowley, the first of our close group of friends to start work, was also there as an enthusiastic junior reporter of nine months. He had always wanted to be a journalist and was hired by the *Derry Journal* earlier in the year. He covered the main news stories of poor housing and ongoing high unemployment, but felt that the Duke Street march could be very important. There had been lots of public protests and

there might possibly be a stand-off, so like all dedicated journalists, he wanted to cover the story.

Martin, who later went on to work as London Editor of *The Irish Times*, for the BBC and the Reuters news agency, rarely speaks of his experiences in Duke Street. However, shortly after the event he told us that around 400 demonstrators set off along Duke Street in the Waterside, to march peacefully to the city centre, only to find their way blocked by the police. Those at the head of the march clashed with the RUC and a number of the marchers were injured. At that point, unable to proceed any further, they held an impromptu public meeting, but as they did so, more RUC officers moved into position behind them, blocking their only exit from Duke Street. One of the NICRA organisers was calling on the crowd to go home when the RUC baton-charged them from the front and the rear. There was total panic and fear among the demonstrators and no means of escape.

As was reported at the time, the RUC cleared the street with 'boots and batons' and finally with water cannons. As many as 100 marchers were treated for their injuries, among them Gerry Fitt, Austin Currie and Eddie McAteer. John Hume was hosed by water cannon and Martin Cowley, bloodied and dazed from being batoned around the head, was manhandled into a police van. Only the intervention of Labour Party activist Ivan Cooper, a Protestant, convinced the RUC officers that he was a reporter, whereupon he was taken to hospital for treatment. The only camera crew present was from RTÉ, and its coverage of the unprovoked brutality used against the marchers, including some prominent politicians, was broadcast around the world and compared to the tactics used against the civil rights demonstrators in America just a few years earlier.

As the word spread through the town, there were further clashes on the edge of the Bogside between the RUC and youths that lasted well into the night. The next day almost a thousand people were involved in clashes in or about the Bogside, and for the first time, petrol bombs were thrown in Derry.

There was a feeling of disbelief that this could be happening. Derry was a quiet, safe town; we could walk home at any hour and not feel threatened. Then suddenly overnight the building sites around our flats became battlegrounds. We watched it happening from our window.

We'd never seen anything like this and we were afraid to leave our home.

There was reaction in other parts of the country too. In Belfast, students organised a demonstration in protest against the RUC action in Duke Street; almost 3,000 people attended. On that same day, the Derry Citizens Action Committee (DCAC) was formed, with a steering committee that included, among others, Ivan Cooper, Paddy Doherty, Campbell Austin and John Hume. There were ongoing meetings and marches and sit-down protests. Then on 16 November, a re-enactment of the Duke Street march was organised by the DCAC. Once again it was banned and the world press arrived in Derry waiting for the violence to erupt, but the night before the march the Protestant and Catholic bishops of Derry opened their cathedrals so that all-night prayer vigils for peace could be held.

The following day, 15,000 people took part in the march and this time an attempt to block it at the end of Craigavon Bridge failed. My mother and I took part in this peaceful and very moving demonstration. I saw Catholic and Protestant, old and young, walk side by side, mostly in silence, and when a voice started up 'We shall overcome' 15,000 voices rang out over the waters of the River Foyle and echoed through the streets as we made our way to the Diamond in the city centre.

By the end of November, under pressure from the British Government, Prime Minister Terence O'Neill announced the abolition of the Derry Corporation and appointed a special commission to replace it. Other reforms regarding housing and local government were also announced. The concessions did little to calm the situation; they were too late and not far-reaching enough for many in the Catholic community, but went too far for many Protestants.

When Terence O'Neill made a television appeal calling for peace, in early December, we watched it in the front room of our flat and hoped more than believed that his appeal would be successful. He was strongly supported by most of the population. NICRA and the DCAC announced a moratorium on marches and in the resulting hiatus we tried to carry on with life as normal. There was school to attend and I had to prepare for the National Song Contest in the spring, but it was hard to concentrate on anything except the events that were erupting around us. Christmas

was quiet but tense and we prayed for peace and an end to 'the troubles'. Most people I talked to thought it would be all over in a matter of months but, sadly, the troubles were only just beginning.

Any hopes for a peaceful New Year were soon dashed; 1969 was to begin and end with conflict and violence. On 1 January a march set out from Belfast to Derry organised by supporters of People's Democracy (PD), a student activist group formed in Belfast. Their planned demonstration was criticised by the leaders of the Derry Citizens Action Committee (DCAC) who were observing a moratorium on marches and considered the idea too risky and provocative at such a difficult time.

However, forty people, including Eamon McCann and Bernadette Devlin, set off from Belfast that day. The group was not made up exclusively of students or Catholics; there were also some Protestant members, as well as two professors from Queen's University. There were intense protests from a group of militant loyalists, and the ever-growing numbers of marchers were attacked and harassed for the entire four-day journey, with little or no intervention from the RUC. It culminated in an ambush at Burntollet Bridge, a few miles outside Derry city, where around 300 loyalists, armed with cudgels, iron bars, bottles and stones, bombarded the marchers and pursued them into the fields and even into the River Fahan. Collusion was reported between the RUC and the attackers, most of whom were identified as off-duty B-Specials.

The account of Burntollet triggered violent clashes with the RUC well into the night in Derry. Things eventually calmed down, but at about 2 a.m. some members of the RUC vented their anger on the residents of the Bogside, shouting and breaking windows along the Lecky Road and St Columb's Wells and calling on the 'Fenians B…s' to come out and fight. Those people who came to their doors to see what was happening were beaten up or stoned. But they weren't 'Fenians' or rioters. They were just ordinary people, frightened and confused by what was happening around them.

Growing up in Derry, I was not aware of a difficult relationship between the Catholic community and the RUC men stationed in our town. The force was predominantly Protestant but there were also a few Catholic members. In fact our family was friendly with a number of policemen and they were good people—some of them were customers in my father's barber shop. But it seemed that as soon as the troubles

began, the relationship between the RUC and the people of the Bogside, in particular, was totally undermined.

There was also a history of fear and mistrust of the B Specials, a part-time police force that was exclusively loyalist and patently anti-Catholic. It was formed to protect the state and could be drafted in to supplement the RUC, but its members didn't know the people in our community and our community feared them. That night in the Bogside, the actions of the reportedly drunken RUC members, combined with the involvement of off-duty B-Specials at Burntollet earlier in the day, was seen as a confirmation that the people of the Bogside had no one to protect them but themselves.

I had been out in Tony Johnston's home the day of Burntollet, rehearsing my song for the National Song Contest. As he lived not far away, we had all walked down to Burntollet Bridge to see the march arrive. The road was closed off when we got there and, because of the delays the marchers faced, by the time they arrived we had already gone home and therefore missed the ensuing attack. When I returned to the flats the following day, my parents told me of the commotion that had taken place in the Bogside. I don't think any of them had slept that night. It was very difficult driving into our area, even taking the back roads. We were stopped at least three times at road blocks manned by residents enquiring who we were and what our business was in the Bogside. This was to become normal practice over the coming months.

From the window of our flat we watched a man painting the words 'You are now entering Free Derry' on the gable wall of a house at the bottom of St Columb's Well. Others were dragging anything that could be moved from the surrounding building sites, to erect a barricade across Rossville Street, just in front of the flats.

There was political and social pandemonium after the events of 4 January. Within the space of one month an inquiry was set up to investigate RUC action in the Bogside, which later confirmed the eyewitness accounts; there was a major split in the Unionist Party; and the Prime Minister dissolved the Stormont Parliament and called a general election, in which John Hume, Ivan Cooper and Paddy O'Hanlon stood as Independents and were elected.

In the Bogside, the hastily erected barricades came down after a week, but the tension and fear were rising daily. The political situation

in the North was the only topic of conversation. We were glued to the television for every news bulletin and I devoured every newspaper article on the situation. This wasn't just another news story; it was about my town and people I knew. My parents were afraid to let us out of the door. In fact, apart from school and the barber shop, my younger brothers were pretty much confined to the flat, unless Mum or Dad went out with them.

In the middle of these goings-on, I travelled to Dublin to take part in the National Song Contest on 2 February. Dublin felt like a world away from Derry. You could walk down the street without worrying that something terrible was going to happen. Even the air felt different and I would have been totally relaxed if it weren't for the fact that I had to sing on a major television show. Each of the contestants had been given a song chosen for us by Tom McGrath, the show's producer. My song was called 'Look Around', written by Michael Reade. Up to now I had done very limited television work, but the National Song Contest would be seen all over the country and it was very important that I performed the song well.

I had counted the days and sleepless nights to the transmission of the show and there I was, make-up and hair done, waiting to walk into the studio. The programme began with a medley of Eurovision-winning songs and we all had to stand in line and sing our allotted verse or chorus as soon as the camera reached us. I was to sing part of Luxembourg's 1965 winning song, 'Poupée de Cire, Poupée de Son', performed by France Gall. As I watched the camera slowly glide along the line toward me, I felt as though I was standing in a firing line waiting to be shot. My mind was racing. I knew that if I missed my cue I could knock everyone else out of sync—the cameraman, the orchestra conductor, the next contestant. So I stood in line with my stomach in knots and a feeling of panic that was increasing by the second.

When the camera was almost beside me I felt like making a swift bolt for the studio door, but out of the corner of my eye I noticed that Butch Moore, who was standing beside me, was nervously rubbing the side of his leg as he sang his song. It was comforting to see that someone with a lot more experience than me was also nervous, and that moment's distraction was enough to save the day. Suddenly the camera was on me and I was singing away as though I hadn't a care in

the world. As I told Butch some years later, but for him I would probably have run out of the studio that night before I'd even had the chance to sing!

Despite the nervous tension of the opening medley, I managed to sing my song, 'Look Around', without too much difficulty and then it was back to the green room where I sank into a chair feeling that a huge load had been lifted from my shoulders. As the votes began to trickle in from every corner of the country, I felt that most people around me were praying that they'd win. I, however, was praying that I would *not* win! I knew I had neither the confidence nor the experience to represent my country before millions of viewers and so, when the last batch of votes came in, I was delighted and relieved to find that 'Look Around' had finished in second place behind Muriel Day singing 'The Wages of Love'. Muriel went on to do Ireland proud by finishing seventh in the Madrid final. Coincidentally, her song was also written by Michael Reade!

When I returned home, our friends and neighbours were really supportive. It meant a lot to them that someone from the flats had sung in the National Song Contest. After all, Derry was recognised first and foremost as a very musical city and I suppose having that highlighted was a little moment of normality in all the chaos. Taking second place was more than I'd hoped for and over the coming months, between school and personal appearances, I was kept quite busy. I also did some more radio and television work. Even so, there was nothing that could distract me for long from what was happening outside our window in the Bogside.

By now the flats looked very different. Dad and Robert, along with the other owners, had boarded up the windows of the little parade of shops, and on the walls of the entrance hall beside the lifts someone had written up the directions on how to make petrol bombs, or 'Molotov Cocktails', as they were called. A new and unique use had been found for the empty glass milk bottles that were normally left outside the front door for the milkman to collect! The whole area had deteriorated too. Instead of the new homes that had been planned around the flats, there was a rubble-strewn 'no-man's land', with rows of derelict houses beyond waiting for demolition.

By April we had the first bombings in Belfast; a promise of 'one man, one vote' from Terence O'Neill, who subsequently resigned

within the week; and Bernadette Devlin at twenty-one years of age had become the youngest woman ever elected to Westminster. In her maiden speech, which was considered to be ground-breaking, Bernadette Devlin called for the abolition of Stormont and the imposition of direct rule from Westminster, because of the permanent control exerted by the Unionist Party through the use of gerrymandering.

When school broke up that summer, the Johnston family invited me to join them for a holiday in Newport in Co. Mayo. My parents allowed me to go. No doubt they thought it would do me good to get away from the situation in Derry for a while. It was such a long journey to Newport and we were all grateful to reach the little house they'd rented in the centre of the town. We were to stay there for a couple of weeks, but when I saw how small the town was I thought there wouldn't be much to do. I was mistaken. We visited the beaches, fished in Clew Bay, walked the length and breadth of stunning Achill Island and even hitchhiked to the nearby bustling market town of Westport to buy souvenirs. I just fell in love with the peaceful beauty of the west of Ireland. I particularly loved the stone walls that bordered the fields, especially when the evening sunlight hit the granite stone and they seemed to shimmer with a soft silvery light.

On our return to Derry it was clear that the conflict between the RUC and the youth, in particular, was steadily increasing. Then in July we had our first fatality. Samuel Devenney was a taxi driver in his early forties, who lived with his family around the corner in William Street. He died from injuries received when he was batoned by police who had mistakenly broken into his house while chasing stone-throwing youths. It was a real tragedy; he was well known and liked, and his death had a profound effect on the town.

Stone throwing and baton charges were almost routine and generally unpredictable. You could easily get caught up or even injured in a riot, going about your daily life, on the way to the shops, or on your way home from school, as happened to some of my friends. There was around 20 per cent unemployment in the city and the anger and frustration of the unemployed youth were palpable and increasingly difficult to control. No doubt among the ranks of the RUC there were also decent men whose nerves were stretched to the limit. These were

very dark days and, to make matters worse, the 'marching season' was about to begin.

The Apprentice Boys' march was held annually on 12 August and as the date approached there was a tangible sense of foreboding. There had been reports circulating in early August of a sectarian attack on the Catholic Unity Flats in Belfast, involving RUC and Orange men, and there was high anxiety that the same thing could happen in the Bogside.

The march was routed through the city centre, but also passed by the edge of the Bogside, so in order to avoid confrontation, the Derry Citizens Defence Association (DCDA), met with senior representatives of the Apprentice Boys Association on 10 August, to ask that the march be cancelled or rerouted. When this request was refused, the DCDA made an assurance that stewards would be present to help contain the inevitable numbers who would protest the fact that the Apprentice Boys were allowed to march without restriction, while civil rights marches were banned. That evening they also made preparations to set up protective barricades at every entrance into the Bogside, and women and children were evacuated to safer locations from streets that were considered vulnerable in the event of a hostile attack.

On the morning of the twelfth, you could see the marchers on the city walls overlooking the Bogside and, as was traditional, pennies were thrown to the Catholic community below—a derogatory action that was normal practice; but these were not normal days. The march continued without incident through the town centre, but at the bottom of William Street the police had set up crush barriers to keep opposing sides apart. There were many thousands of people in the town that day: those taking part in or watching the parade; a counter demonstration of mostly younger people; shoppers going about their usual business; and a hoard of international journalists and television crews waiting for violence to erupt—they would not be disappointed.

The DCDA had found it difficult to gather a sufficient number of stewards to marshal the demonstrators, because there was resentment in the Catholic community that they were in effect doing the job of the RUC. Those stewards who were present, including local men, priests and politicians, found it impossible to keep the crowd and the rapidly deteriorating situation under control. The initial name-calling quickly escalated into action and a hail of stones soon rained down on police

and stewards alike. The marchers, however, safely out of reach of the missiles, returned the heckling, but continued with their marching.

The media reported that the police showed restraint and did not retaliate, but they also speculated on whether the considerable presence of the world press had been a major influence on this response. The police, however, would maintain that they were afraid to move on the demonstrators for fear that militant Protestants would join in the charge. By early evening, with the march over, most of the participants and their supporters left for home in the buses that had transported them from all over the North. It was then, when most of the international media had also departed for the night, that the police, supported by loyalist youths, began to force the demonstrators back into the Rossville Street area. But barricades were already in place there, and stones and petrol bombs were at the ready to prevent any hostile invasion of the Bogside. From that point on, the 'Battle of the Bogside' raged for the next 48 hours, as the police tried to gain control of the area, using armoured vehicles, water cannon, and CS gas, and the mostly young demonstrators fought to keep them out, armed with stones and petrol bombs.

My mother and grandmother, who was housekeeper in the Northern Counties Hotel which overlooked Waterloo Place, were unable to make their way home safely and were forced to remain there for two days. Meanwhile, I watched the running battles that were taking place at the barricade below us in Rossville Street. Sometimes my father would venture onto the landing overlooking the courtyard and Chamberlain Street, where the fighting was just as fierce. But like most people that night, we also followed the incredible events on television.

Throughout the night and the following day the police repeatedly charged the barricade from the William Street end, thereby scattering the few hundred people manning it. As they began to dismantle and drag away the various building materials, vehicles and even, at one point, a petrol tanker used to form the makeshift barrier, the 'Bogside Defenders' would regroup and in turn charge the police, hurtling petrol bombs and stones, aided by a hail of petrol bombs from the roof of the flats. As the police were forced to retreat, the barricade was hastily reconstructed, and so it went on at regular intervals for hours on end. It was like watching a war movie from the window of our flat, so unreal were the events unfolding on the streets below.

Adding to the tension were the rumours. In the early hours of 13 August, word went out that a Protestant mob was about to burn St Eugene's Cathedral. As there had already been an attempt to burn down St Columb's Hall, this new possible threat brought older men out onto the streets. That same evening when I watched Taoiseach Jack Lynch announce on television that the Irish government could 'no longer stand by and see innocent people injured and perhaps worse', I thought, like everyone around me, that the Irish Army was going to cross the border and defend us. While this news may have brought a sense of relief to us in the Bogside, it no doubt caused great anxiety to the unionist population. But the rumour that caused the most fear was that the B Specials, who were already mobilised, were about to invade the Bogside.

Chapter 3 ∿

| EUROVISION

Over the summer of 1969 I had come to the conclusion that a full-time singing career was not for me. I had enjoyed my modest career to date, but I knew that I really wanted to be a teacher of music and English. I had been studying piano for some time with David Fulton, a former concert pianist who carried his books of Bach and Beethoven as tenderly as a mother would carry her baby. He had already chosen the piano pieces I would play for my A-level practical exams which were to take place in the spring of 1970. I remember them still: Brahms' Rhapsody in G minor and Bach's Prelude and Fugue in D minor. They were beautiful but demanding compositions and, combined with the many technical exercises I had to master, it had meant upping my piano practice to six or seven hours a day.

My A-level exams were fast approaching and I'd already made my application to St Mary's, a teacher-training college in Belfast. So, bearing in mind the time needed for my studies, I told my parents and Tony Johnston that I had decided to 'retire' from show-business and focus on my upcoming exams. There were only two in our class taking A-level music—Aileen McCarroll and myself—so for the most part we had the practice studios to ourselves. We'd store our lunchboxes inside one of the old upright pianos till we'd meet up for lunch, usually a luke-warm yogurt and some fruit.

By the time Christmas came around I was up to my ears in books. Then, out of the blue, I got a phone call from Tom McGrath in RTÉ. He told me that he had remembered me from the National Song Contest earlier in the year. He asked if I would be interested in performing in the 1970 song contest. Apparently he had found a song he thought would suit me, called 'All Kinds of Everything'.

By that time I had already completed my interview in St Mary's College, Belfast. Now my future depended on the success of my A-level results. I didn't want anything to get in the way of my plans, so I thanked him for remembering me, before explaining that I was preparing for my A levels and that even if I wanted to take part in the contest, I would need to think about his proposal and discuss it with my parents and teachers.

My practical exams were scheduled just weeks after the date of the contest so I talked things through in much detail with my parents, teachers and Tony Johnston. Having weighed up everything, I decided I would do it, because it would be a wonderful experience and a similar opportunity would never come my way again After my A levels, I'd be off to St Mary's College to study for a career in teaching, so this song contest would be my swansong.

I went to Dublin after Christmas 1969 to meet with the songwriters, Jackie Smith and Derry Lindsay. Derry and Jackie worked as compositors in a Dublin newspaper and were delighted to have their song chosen for the contest. We were a perfect team; they were amateur songwriters and I was an amateur singer. However, we were up against some of Ireland's most accomplished writers and performers. All the contestants and writers met for a group photograph for the RTÉ *Guide* and there was great excitement all round. Jackie and Derry were gung-ho for a win, but I took the approach that it was simply a matter of showing up on the night, singing the song to the best of my ability, wishing the winners well and returning to Derry to put showbiz behind me once and for all. With all the pre-publicity that went along with the contest my studying took a bit of a battering. I appeared on the *Late Late Show*, on various radio programmes and in numerous publications. This was my last throw of the showbiz dice and I was prepared to go with the flow and enjoy the buzz while it lasted.

The day of the contest itself was hectic with rehearsal, costume and make-up calls. The make-up girls wanted to do something special with my long straight hair, so they patiently fixed it in a complex style of plaits piled on top of my head, which led Tom McGrath to remark after the dress rehearsal, 'What have they done to your hair, Rosy Mary? Your head looks like a sputnik!' There were panic stations in the make-up room and because we were so close to the transmission of the show,

there was no choice but to brush out the plaits and leave my hair flowing down over my shoulders. I rarely wore my hair like that and as I moved my head, long wavy strands kept falling over my face. The day was saved, however, when one of the RTÉ girls clipped my hair back out of my eyes with a simple white plastic clasp she'd found in a drawer. So it was that my signature look was born; out of total panic and the good fortune of finding a plastic hair clasp!

As the show got under way, I found that I was much less nervous than at my knee-knocking performance the previous year. I had decided to sing my song seated on a stool, because the opening lyrics, 'Snowdrops and daffodils, Butterflies and bees', had suggested that I could be sitting in the countryside looking at the beauty of nature all around me. I had a few butterflies in my stomach too, but I felt it went quite well.

The other competitors included major stars of the day, such as Maxi, Dick and Twink, Tony Kenny, Anna McGoldrick and John McNally, and before we knew it, the time had come to decide on the winner. A handful of jury members sat in secluded rooms in various hotels in each of the twenty-six counties and, when called upon by the presenter, each respective chairperson declared the votes per song in ascending order. As the votes rolled in, the strong contenders were separated from the weak and, before long, 'All Kinds of Everything' had emerged as the most popular song of the night. I had won! I couldn't believe it! Mum and Granny were with me in the studio and they too couldn't believe what had just happened! Between hugs, kisses, flashing cameras and enough bouquets of flowers to start my own botanical gardens, the reality of representing Ireland in the Eurovision Song Contest was about to sink in.

Back in Derry's Bogside, on the fifth floor of the Rossville Street flats, the rest of my family was over the moon. In a brief telephone conversation my father told me that neighbours were knocking on our door continuously and that everyone in the flats was thrilled. I suppose my win gave them something to cheer about in the middle of all the sectarian and political madness that had descended around us. For someone in the Bogside to be given such an opportunity was an unexpected boost for the whole area. I returned home as quickly as possible, weighed down with four or five large bouquets of flowers.

We could rarely afford to buy *bunches* of flowers, never mind bouquets.

The Eurovision Song Contest was scheduled for 21 March in Amsterdam and the days and weeks leading up to it were frenetic. Alongside my school work, my time was eaten up with endless rounds of photographic sessions and interviews, as well as a very exciting trip to London to work with one of Derry's great musical sons, Phil Coulter, who by now was a Eurovision song-writing guru, having co-written the highly successful 'Puppet on a String' for Sandie Shaw and 'Congratulations' for Cliff Richard. Phil had secured the publishing rights for 'All Kinds of Everything' and felt it needed a fresh arrangement, which we recorded in a studio in Bond Street with some of London's top session musicians present.

The experience was amazing and the state-of-the art studio was the most impressive I had ever been in up to then. At the end of the day, with little time to spare to get to the airport, Phil and I stood on Oxford Street trying to flag down one of those famous black taxi cabs. I waved my right arm ever more frantically as the minutes passed, but they continued to whiz by us as though we were invisible. Eventually, Phil had to run and get his Alfa Romeo sports car and drive me to the airport like a Formula One competitor! Needless to say I made the flight and was back in school the next morning.

As the date of the contest approached I also had to decide what kind of outfit I was going to wear on the big night. I wanted it to be distinctly Irish, but also contemporary, and when a young Irish designer called Maura O'Driscoll sent some of her designs for consideration, I knew that her ideas were exactly what I was looking for. Maura designed the dress I eventually wore in Amsterdam. It was a short-sleeved, A-line shift dress, very popular at the time, but the traditional white bawneen fabric, with distinctive Celtic embroidery, worked by nuns in the west of Ireland, gave it a unique Irish look.

With everything prepared, I was looking forward to going to Amsterdam, but I nearly didn't make it. About two weeks before my departure date, I had to travel to Dublin for meetings in RTÉ. Tony Johnston accompanied me, with his wife Eithne at the wheel. It was early morning and we took a bend outside Slane, Co. Meath, where the overnight frost hadn't yet thawed. Suddenly the car skidded across the

road towards the oncoming traffic and then rolled over and over, landing on its roof in the ditch. A passing motorist acted as a Good Samaritan, helping us out of the car and driving us to RTÉ where, 90 minutes or so late, I did a number of interviews and had a wardrobe fitting. Proving that 'the show must go on', car crash or not, later that evening I sang at an event in Co. Kildare just south of Dublin. God was clearly on our side that morning; we'd had a very lucky escape and when the shock wore off, all we had to show were a few bruises.

Mum and Granny decided to come with me to Amsterdam to give me moral support. I knew it really stretched their finances to travel to the Netherlands, but I was so glad they'd be with me. In all there were about thirty people in the Irish team. Tony Johnston and his wife Eithne were there, and John Daly, a friend from Dublin, who was to act as Tony's assistant during the week. Then there was the RTÉ crew, as well as a good number of reporters and photographers. I remember clearly the morning we left Dublin Airport; we were waved off by two cleaning ladies and a porter. It could not have been more low-key.

All the contestants were in the same hotel in Amsterdam and I was looking forward to meeting them, especially Mary Hopkins, the beautiful Welsh singer representing the UK. I was a big fan of Mary's and when we met I found her to be a very genuine, friendly person, and not only did we get on well, but our mums chatted like long-lost sisters.

I attended a couple of rehearsals before the big day but as Ireland wasn't considered in the running, the European media weren't interested in me, so apart from the various receptions throughout the week and a few interviews and photographs for the Irish media, I was pretty much left alone. The UK had an enormous team of people compared to ours and one of them was Bill Cotton, Head of Light Entertainment at the BBC, who would later go on to be Chairman of the Board of Governors there. His father was a famous band leader and our family had listened to his radio programme, *The Billy Cotton Band Show*, every Sunday. I met Bill at one of the many receptions thrown throughout the week and he unexpectedly said in his polite English accent, 'You're a lovely girl and I think you're in with a good chance of winning this competition.' His comment totally threw me as I could never take a compliment. Without even a 'thank you', I replied by

saying, 'I bet you say that to all the girls!' He looked at me stunned for a second before throwing back his head and laughing heartily.

Despite Bill Cotton's remark, it didn't sink in that there really was a growing interest in my song, so I continued to be relaxed and was able to enjoy the build-up to the show. There were other European performers I was not familiar with, like Katja Ebstein, from Germany, and Julio Iglesias, representing Spain. The latter was already a big star in his own country and he looked it. He dressed impeccably, was tall, dark and handsome, and had an entourage of excited Spaniards who fluttered around him like butterflies. They were clearly eager to win as they spent most of their time putting 'Vote for Spain' stickers on everything and everyone!

Unknown to me, away from the rehearsals and receptions, tension was mounting within the Irish camp. I wasn't aware of it at the time but it seems that Tony Johnston was building a barrier around me. Jackie Smith and Derry Lindsay were beginning to find that they couldn't get access to me, while my mum and granny were having difficulty getting tickets to attend the receptions and rehearsals with me. They didn't tell me because they didn't want to upset me, so I just thought that there weren't enough invitations issued, but I felt awful leaving them behind in the hotel; if they couldn't go to the receptions and all that went with the build-up to the contest, there was really no point in their being there.

On reflection, perhaps Tony was afraid that if I *were* to win, someone might steal me from his grasp, so he was keeping everyone away from me, including my mum and granny. It seemed word was leaking out that there was a problem and an Irish journalist, the late Jim Dunne, turned out to be a good friend to me in Amsterdam and remained so until he died. He informed me of what was going on. Apparently Tony was taking care of the invitations for the people in our party and the Irish team was very unhappy that my mother and granny didn't even have tickets to the contest itself, so they made sure that my family was able to attend the event. When I found out what had been going on I couldn't believe it and I understood why my mother would be so upset. I was able to speak openly with Jim without fearing that I would read my comments in the newspaper the next day. As it was, what had happened cast a cloud over the whole

proceedings and was just the beginning of the problems between Tony and my family.

Suddenly it was Saturday, 21 March 1970. Showtime had finally arrived at the RAI Congrescentrum auditorium in Hilversum. We had two full rehearsals on the day of transmission, during which I heard the other songs for the first time. I had studiously avoided the other artists' rehearsal times, because I knew that I would only make comparisons with my performance and make myself feel more nervous. There was also hair and make-up to be done, as well as making sure that my costume was perfect. It was the last day of my Eurovision adventure. I would be returning to Dublin the next day and back to school in Derry on the Monday. I remember feeling a pang of guilt that I hadn't opened one book to study! At the same time, I wanted to enjoy the whole experience and make the most of it while it lasted.

During the final dress rehearsal I sat in the stairwell at the back of the stage and played 'I Spy' to keep myself occupied. As I did so, Julio Iglesias was striding up and down the corridor practising his scales, as if he was warming up to perform in an opera. He was wearing a long black cloak and each time he turned sharply at the end of the corridor, the cloak would swirl in the air, reminding me of a matador.

The clock slowly rolled up to transmission time, the overture started and the fifteenth Eurovision Song Contest began. The presenters, Wim Jacobs and Willie Dobbe, opened the programme and appropriately the first contestants were Patricia and Hearts of Soul for the Netherlands, singing a song called 'Waterman'. Once that song began, there was no going back. The artists waited their turn in a room at the back of the stage area. There was just a long table at which we all sat and a single television screen that we all watched, but the feeling of camaraderie in that room was fantastic. As each performer got up to go out and sing, we would all wish him or her well and after each performance applause and cheers would break out as a gesture of solidarity.

I was the last competitor to sing and I was determined not to dwell on the fact that any minute now I would be on stage. It was inconceivable to try and imagine the millions who were tuned in. The largest audience I'd ever sung to was around 400 or so in Derry's Guildhall. It was somewhat heart stopping when the floor manager came and asked me to follow him to the side of the stage. I remember

standing there and scolding myself as I waited for my announcement. 'Do not screw this up,' I told myself. 'You have only three minutes out there!'

Katja Ebstein of Germany finished singing her song, 'Wunder gibt es immer wieder', I said a little prayer and then it was my cue to walk on stage. I chose my steps carefully; the sloped walkway looked and felt smooth and slippery and I'd had nightmares of falling on my bottom, but so far so good. I approached the metal cylinder I'd been given instead of a normal stool. It had no footrest to help me get up on it, but before I knew it, I was seated and positioned perfectly before the microphone. The music began and the tempo was spot on, now all I had to do was sing for three minutes. I looked straight into the camera, knowing that I was looking straight into the eyes of at least 200 million people, and began to sing, 'Snowdrops and Daffodils ...'. My three minutes were like three seconds, and the audience broke into applause as I searched the smiling faces unsuccessfully for my mother and grandmother.

My sense of relief was indescribable. Thank God I had got through it and I had done the best I could. I really didn't mind what happened now. The casting of the votes was secondary to me. I just wanted to lock each remaining moment in my memory, and what an incredible experience to remember at the end of my singing career! The voting began but I was watching the other performers sitting around me at the table, cheering as one or other received votes. Then at some point in the middle of the voting, we were asked to move to a television screen at the side of the stage. During this migration, Ireland received a very big vote, but unaware of this I continued to store my memories. Mary Hopkins was standing beside me with her arm across my shoulder. It was unreal. She looked so elegant with her beautiful blond hair and her long, black, sequined dress. I was sure she would be the winner and I was happy for her. Caught up in this magical moment, I wasn't even looking at the television when suddenly Mary turned to me and exclaimed, 'Congratulations!' and I saw that Ireland had received a huge vote from Belgium, putting me in the lead.

The next second the floor manager grabbed my hand and started pulling me towards the stage, telling me to follow him, that I'd won. I leaned all my weight against him, protesting that I couldn't have won as the voting wasn't over. The resulting tug of war ended only when Mary

Hopkins intervened: 'Yes, you have won. Congratulations! You'd better get on stage.' I didn't know what to say or do and as I followed him like a lamb to the side of the stage, all kinds of thoughts were racing through my mind: how happy my mother would be; how much this would mean to the people at home in Ireland; I could see the face of my father watching this in the flats. I was in deep shock and I must have looked it, because the floor manager asked if I would like a drink of water, which I promptly swallowed the wrong way. I began spluttering and coughing, but that helped focus my mind on the fact that I would soon have to sing my song again, so I tried to compose myself. Ireland had won its first Eurovision Song Contest and I was the singer of the song, as unreal as it sounded. I was going to go back on stage to receive the coveted award and I was determined to sing my song without breaking down.

I heard my name announced and made my way on to the stage, where I was greeted by a battery of flash bulbs as hundreds of photographers jostled for position at the front of the auditorium. I had never seen so many cameras in one place at one time. Lennie Kurr, the Dutch winner from the previous year, hugged me and presented me with my award, a bronze Eurovision medallion in a blue velvet box. Young girls rushed forward to place huge baskets of flowers around me and the heady perfume of freesias filled the air as the orchestra struck up the opening bars of my song. As I sang it again it was impossible to concentrate on my well-rehearsed camera moves. Beyond the wall of flashing light bulbs, it looked to me as if the entire audience was making its way to the front of the stage.

As I finished singing my last note, Jackie Smith and Derry Lindsay bounded onto the stage, lifting me in the air and hugging me till I could barely breathe. Suddenly I was surrounded by an excited, milling crowd of media and well-wishers, all trying to speak to me at once. My mother had managed to make her way to the stage and the crowd parted to let her through. She was in tears as we hugged. We were both carried along by the crowd to the back-stage area and as we swept past a rather stunned-looking Tom McGrath, he called out in his usual droll manner, 'How dare you win this! We can't afford it!'

Somehow, in all the pandemonium, I managed to call my father at home and he told me of the wild celebrations going on in the Rossville Street flats; by all accounts, the neighbours had practically broken into

our home and carried him shoulder-high along the landing, singing 'All Kinds of Everything' and 'For he's a jolly good fellow!'

To finish off this incredible evening, the Eurovision representatives and their respective entourages were invited to a celebration dinner in our hotel and the Irish table was the focus of attention. It seemed that everyone was genuinely delighted for us and, amidst the eating and drinking, laughing and singing, a steady flow of people filed by with their congratulations and good wishes. There was also a steady stream of journalists and photographers and although I was absolutely starving by the time we sat down to eat, every time I attempted to put a fork full of food into my mouth, there was a question to answer or a photograph to be taken.

Media interest was intense not only because I was an unknown amateur singer, but also because I was from the Bogside flats, a place featured at the top of international news coverage over the previous months. Eventually, despite the fact that I really wanted to stay and share in the celebrations, Tony Johnston felt it was necessary to set up a suite in the hotel where journalists could meet with me. As they each wanted their own exclusive story, they formed a queue in the corridor outside the suite, entering by one door for their interview and leaving by another, allowing the next journalist to take their turn immediately. I felt as though I was in a glorified confession box: as they took their seat, I poured out my story over and over again every fifteen minutes or so until the early hours of the morning. I thought of the enterprising young journalist who had earlier beaten his colleagues to the chase; he had to leave before the transmission of the show and so had recorded interviews with all of the contestants. No doubt he was curled up in his bed, while his peers climbed over each other in a panic to get quotes from me! It was exhausting, but the interviews had to be done; the journalists needed to file their copy and justify their presence there and I had to take full advantage of the media opportunity.

In the meantime, as telegrams of congratulations began to flow in from all over the place, there was commercial consternation going on at the celebration dinner. The predicament stemmed from the fact that I was signed to Rex Records, the Irish distribution arm of London-based Decca Records. Through the years Michael Geoghegan of Rex had pushed hard to get a record deal in London for any Irish artist he felt was promising, but the powers-that-be at Decca had never shown

much interest. Now all of a sudden, Dana from Ireland had won the Eurovision Song Contest and Decca executives like Dick Rowe, who had famously turned down the Beatles, realised they needed to get the recording out on the Decca label immediately, while it was the hottest tune in Europe. The problem was they didn't have the master tape in London. Furthermore, they had no rights to the master tape because I was signed to Rex Records, not Decca, and to make matters worse, my contract with Rex Records was about to run out.

As events unfolded, 'All Kinds of Everything' had to be released on Rex Records and for the first time ever, Decca Records was outsold by its distribution company. It was a costly lesson for Decca and in the future they and other major labels in London would not be so dismissive of Irish talent. In one sense I believe that my win helped to change the status quo for Irish artists at the time, and when Dublin rock band Thin Lizzy was signed up by Decca two years later, the door was opened wider for others to follow in the coming years.

My last energy cell ran out of power at around 5 a.m., when the thought of a good night's sleep seemed more precious than winning the Eurovision itself. For the majority of the Irish team, however, the celebrations were in full swing and the wild Irish party carried on elsewhere in the hotel without me. I had no idea at all of what lay ahead. I hadn't time to think about what this win would mean for my teaching career. Maybe I might have to put my A levels back a year and return to study in about six months' time when the madness had settled. But for the moment I barely had the energy to crawl into bed.

The excitement and media attention continued the following day but the greatest surprise of all was a specially chartered Aer Lingus plane with 'Operation Dana' emblazoned on the side, waiting for us at Schipol Airport. During the flight we enjoyed a special lunch with dishes named after my home town, as we dined on 'Foyle Salmon', 'Derry Potatoes', 'Thornhill Gateaux' and so on. When the doors of the plane opened in Dublin, I stepped out to be greeted by thousands upon thousands of cheering, waving people. They were everywhere; on the roof of the terminal building, at the open windows and even on the tarmac. It was a sight I'll never forget.

After an official state welcome and refuelling of the plane we took off for Ballykelly military airport just outside Derry city. This short flight was another landmark, because it was the first time a passenger

flight from the Republic had ever landed on Northern Ireland soil! Waiting for me on the tarmac was a small group of mostly family members and close friends. The Nazareth House Céilí Band played as I was officially welcomed and congratulated by Brian Morton, Chairman of the Derry City Commission, and John Hume MP. Then, after another performance of 'All Kinds', I was driven in the Chairman's black limousine to the city centre, where a civic reception was planned in the Guildhall.

The entire route was lined with cheering, happy people—an unexpected but welcome sight in such difficult days for the North. As we eventually approached the Guildhall Square from along Foyle Street, the car ground to a halt as it became increasingly difficult to cut a path through the thousands of people waiting. We were totally surrounded and those people pressed against the car by the sheer weight of the crowd began to panic and scramble onto the roof for safety. We couldn't open the doors of the car, but even if we'd been able to, it would have been impossible to get out and walk. It was actually a frightening experience, not only because we felt trapped in the car, but also because it was obvious that someone could get seriously hurt in the crush.

When we finally managed to open the passenger door partially, I was lifted out and onto the shoulders of two British Army soldiers and then passed along from shoulder to shoulder towards the Guildhall. It was a surreal experience bobbing up and down over the heads of the people as they called my name or touched my hand while I edged closer and closer to the Guildhall steps where the reception committee was waiting. It was a tremendous relief to step on to solid ground, and as I looked out over the sea of faces, many of them in tears, an enormous cheer went up. I had made it and fortunately no one had been hurt!

Sister Imelda, my music teacher, and Miss Watson, my ballet teacher, were waiting there beaming with joy. They both walked with me as I was led up the imposing stairway to the main hall where the reception would take place. It was very different from the countless times I'd walked up those stairs in the past. I was now a guest of honour, but I still felt like an insignificant schoolgirl on my way to compete in the Feis. The magnificent hall was filled with guests—various dignitaries, including Drs Farren and Peacock, the Catholic and Protestant Bishops of Derry, friends and family, and a number of hopeful showbiz

representatives like Mr and Mrs Solomon, powerful and formidable theatrical agents who looked after artists like the Bachelors, one of Ireland's most successful singing trios who had enjoyed great chart success in the UK.

After the customary speeches, I met with each person individually and by the time the event came to a close at around 11 p.m., I was more than ready to sit down at home, kick off my shoes and just relax with my family around me. However, the crowd outside in the square had not dispersed and they would not leave until they'd seen me once more, so I was helped out onto a small balcony from which I called out my thanks and once again sang 'All Kinds of Everything'.

No doubt my civic reception must have caused anxiety for the authorities. With public gatherings of that size there was the danger that violence would flare up. Thankfully that didn't happen and I believe it was because this huge crowd of people, from both sides of our community, was united in celebrating the fact that *their* city was being recognised for something good and positive, something that was far more natural to them than the street battles that had become synonymous with our town.

When I eventually made it back home it was after midnight. I was just exhausted and ready for bed, but outside in the courtyard around 20,000 people were chanting my name and calling for me to sing that song again! I could barely speak, never mind sing, as I drooped over the railing of the fifth-floor landing surrounded by media. I think they could see how very tired I was and so the crowd gathered in the courtyard ended up serenading me. As I thankfully laid my head on the pillow that night, I could still hear the song being sung along the landing outside and it lulled me to sleep.

In the days that followed I was shadowed by a number of European TV crews who were so keen to cover my every move that they even slept on the cold cement landing outside our front door. Two days after my return to Derry, they followed my family and me to Dublin, where we were invited to meet with the President, Éamon de Valera. When we arrived at Áras an Uachtaráin, the President's official residence in Phoenix Park, I was delighted to see that Derry Lindsay and Jackie Smith, the writers of the winning song, had also been invited. I knew that they had been upset by what they felt was their deliberate exclusion from the media

spotlight following the win in Amsterdam. As a musician, I had the utmost respect for them; they were the composers and without their creative work there would have been no Irish win, so it was important to me that they received the respect and recognition they deserved.

Back in Derry, with my every move monitored, I was trying to think about my future in the middle of everything that was going on. Just weeks earlier I had thought that singing in the Eurovision would be my last showbiz fling before sitting my A levels and moving on to train as a teacher. Now my plans and my world had been turned upside down. I could not escape from the media attention. They followed me everywhere. In fact there were TV crews regularly filming at Thornhill College even when I wasn't there. I quickly realised that if I did go back to school, the media circus would be worse and it would be a serious distraction for the other students facing into exams. So, although I really wanted to sit my A levels, in the circumstances it just didn't seem that it would be possible, for the moment. I decided that I would just have to return to study when all this hullabaloo was over.

There was also the problem of the tension between Tony Johnston and my parents. Stories had appeared in the press about what had happened in Amsterdam and although I was desperately trying to keep a lid on the whole thing, the questions kept coming from the media. I was a very private person and I found it embarrassing to have my life publicly examined and discussed, but most of all, I didn't want to hurt my parents or Tony and I increasingly felt that I was being forced to choose between them.

Looking back, I can appreciate the pressures that were also on Tony. Like me, he was dealing with being unexpectedly catapulted into the limelight. But I also believe he feared I would be stolen away from under his wing by a big-time manager in London. Nothing could have been further from *my* mind, however. I had already made it clear that I was planning to pursue a career as a teacher, not as a performer, and I hadn't done any real work as a singer since the end of the previous summer. People in the business were already predicting that I would be another of Eurovision's one-hit wonders and I believed that that was the most likely outcome. But for now the world was lining up outside my door and I hoped we could all make the most of this extraordinary opportunity while it lasted.

Chapter 4 ∿

A CAREER
IS BORN

With 'All Kinds of Everything' dominating the charts, knocking Simon and Garfunkel's 'Bridge over Troubled Waters' from the number one position, several would-be managers had already beaten a path to my door. As my parents and I discussed the best way forward, we came to the conclusion that perhaps what I really needed was an agent rather than a manager, someone who had the contacts to generate work opportunities and help to manage my diary, but who would not have to be with me and making decisions for me all the time.

I was on the road a great deal at this time and I found that I was comfortable and secure with my father; he was also a good musician and understood the business, so it seemed to make sense for him to close the barber shop and travel with me as my personal manager/advisor/driver all rolled into one. Now all we had to do was find the right person to be my agent and, though I did not look forward to that daunting task, Mum and I set off for London to meet with the four or five people on Michael Geoghegan's list.

The first door bell we rang was that of Evie Taylor. She was a very experienced and successful manager who looked after Sandie Shaw, the first Eurovision winner for the UK, in 1967, with the Phil Coulter and Bill Martin composition 'Puppet on a String'. Evie and my mother hit it off the minute they met and I also liked her. She came across as very practical and straight-forward and she was willing to work with me as an agent.

Our next meeting was with a young and charming Michael Grade, nephew of Sir Lew Grade and Lord Bernard Delfont, the high kings of

the British showbiz scene in the 1960s and 1970s. The Grade family owned the best theatre circuit in the UK, as well as the Rank cinema chain, Pye records and the highly successful independent television station ATV, whose many hit series included *Crossroads*, *The Muppet Show*, *New Faces* (a popular talent show where so many stars got their first break), and *The Golden Shot* (hosted by Bob Monkhouse).

Getting in the door to meet the Grades was as important in showbiz terms as getting into the White House to meet the US President, but at the time I didn't really understand how powerful and influential this family was. Unfortunately, the meeting could not have got off to a worse start. After graciously welcoming us into his very plush office, Michael was explaining how he felt the Grade Organisation could develop and move my career forward, when suddenly my ever-protective mother asked him to promise that he wouldn't force me to wear low-cut dresses. I wished that the ground would have opened up and swallowed me.

I must have looked uncomfortable because he turned to me and asked if I could give him a smile. He then handed me a weighty brochure of the many stars the Grade organisation represented and suggested that I have a look through it. I knew the faces and had seen most of them on television, but of course to a teenager, anyone over twenty seems ancient and most of these stars looked at least twice, and in some cases, three times, my age. I was pondering this when he unexpectedly asked me what I thought of the famous artists the Grades handled, and with all the delicacy of a sledgehammer I responded, 'Do you have any modern up-to-date stars?' It was another 'Billy Cotton' moment and as the last word fell from my lips and hung in the still air, I knew that irreparable damage had been done and I could not wait to get out of his office. As Mum and I made our way to Bond Street to meet with Dick Katz of the Harold Davison Agency, I felt it would be much better if I didn't speak at all this time.

When I first saw Dick Katz I thought he looked like a caricature of the typical agent. He was about five foot four inches tall *and* round and he continually puffed away on a large Cuban cigar as he sat behind his big desk. However, over lunch in the Westbury Hotel, it was evident that he was anything but loud and flashy. He was quite an unassuming man who knew his business thoroughly. He also had a good sense of

humour and when he laughed his eyes actually twinkled, like when he told us that although he was only five foot four, on the phone, where he did all his business, he was six feet tall!

Having fled from Germany during the Second World War, narrowly escaping with his life, Dick Katz was now considered the best agent in Europe, handling artists like Dusty Springfield, Lulu, Jimi Hendrix, Julie Felix, the Three Degrees and my new-found friend from the Song Contest, Mary Hopkins. But it wasn't just his expertise as an agent that finally convinced me. Dick was also an outstanding jazz pianist and arranger who had played with the Ray Ellington Quartet on every episode of *The Goon Show*, a huge hit series on BBC Radio in the 1950s and 1960s, starring Peter Sellers, Spike Milligan and Harry Secombe. Having been raised with musicians, I immediately felt at ease with him. I knew that, having worked on stage himself, he would have an understanding of both sides of the showbiz coin.

We talked very openly about the difficulties I had come through with Tony Johnston and I told him that I wanted my father to be my personal manager. He invited us to come to his office the following morning to meet his business partner, Harold Davison. We assumed he would also want to talk about a contract. However, when we mentioned this the following day, Dick surprised us by saying that he didn't believe in signing contracts with any of his artists, because if he or the artist were not happy working together, a contract wasn't worth the paper it was written on. We went on to work successfully together for nine years and I'm so grateful that during that time I also had the opportunity to get to know Dick, his lovely wife Valerie, and their daughters, as friends.

My first major commitment in England was a week-long cabaret engagement at Batley Variety Club in Yorkshire, one of the biggest venues in Europe. Theatre-going had declined in popularity in England and there was a new audience who wanted first-class entertainment in a 'supper club' setting. I followed Louis Armstrong into Batley and, although that was a daunting challenge, I found that I really enjoyed working in that setting. It was a little similar to my experience in the Irish folk clubs, except that there was a full-size orchestra, and a show that included dancers and comedians. Bookings at other major venues followed and as my professional life took off, Dad and I were soon

travelling the length and breadth of the UK, as well as flying back and forth to Europe for TV shows, and of course home to Derry at every possible opportunity.

By the summer of 1970, Mum had found her dream home in quiet, leafy Duncreggan Road and I was about to embark on another 'first', a part in a major children's movie entitled *The Flight of the Doves*. The film was directed by Ralph Nelson who had just shocked the world with a landmark movie called *Soldier Blue*, one of the most controversial films of the time, because of its graphic violence. Not surprisingly, Ralph was hot property in Hollywood and had carte blanche for his follow-up movie, which, it turned out, was based on a children's book written by Walter Macken from Galway.

In complete contrast to his previous work, *The Flight of the Doves* had a Disney-type plot and starred Ron Moody, famous as Fagin in the film version of *Oliver*, Jack Wild, who had played opposite him as the Artful Dodger and Hollywood leading lady Dorothy McGuire, along with a long list of Irish actors and personalities that included Noel Purcell, Niall Tóibín, Des Keogh and Brendan O'Reilly. It was shot mainly in Ireland and the scenes in which I was to appear were to be filmed in and around Athlone.

I had no ambition to be an actress, but whatever hopes I had of looking the glamorous Hollywood star, they were soon dashed on the first day of filming. I was playing the part of a young Traveller called Sheila and my costume was an old cardigan that apparently had once belonged to Eamon Andrews. When Wardrobe had finished tearing off the buttons and cutting a hole in it, they proceeded to smear it with dirt. Then instead of make-up, they smudged brown marks on my face and combed glycerine through my hair to make it look dull and greasy. I looked like the proverbial bag of chaff tied in the middle! To make matters worse, large crowds had gathered to watch us filming on an open set in the monastic ruins in Clonmacnoise. I had never acted before cameras or curious onlookers before and I was really nervous, but the late Jack Wild, who became a good friend, helped put me at ease.

Filming is a slow process where you can wait around for hours for the right light or shade so that it matches exactly the previous scene you've shot. Unfortunately the weather was not good that August and

as we began filming my scenes when it was overcast and rainy, we'd have to stop if the sun came out and wait for the correct shade of 'dull' again. My brothers and sisters in the film were played by real Travellers and we got to know each other well during the long hours we'd have to kill time. Then one evening on returning to the hotel I got a taste of what it was like to be one of them.

All the cast and crew were staying at the Prince of Wales Hotel in the middle of Athlone and, because Ralph hired as many locals as possible to act as extras, there always tended to be some people hovering around the front of the hotel hoping they'd be hired, or perhaps just to get a glimpse of one of the stars. There was a small group standing about the entrance and foyer when I arrived back, still dressed in 'character', feeling exhausted and hungry, but the security men refused to let me in. The harder I tried to convince them that I really was acting in the film, the more insistent they became that I move away from the door. So, in a last desperate attempt to get to my room, I told them I was Dana and had just won the Eurovision for Ireland, but with a look of 'nice try' on their faces, they threatened to call the police if I didn't move on. I was beginning to panic. Luckily for me one of the production team arrived at the door at that moment, so I grabbed his arm, begging him to vouch for me. The embarrassed security men eventually allowed me into the hotel, much to the disbelief of those at the door.

Not long after completion of filming, I was invited to go to Los Angeles to do some promotional work. It was my first trip to America and I was very excited as my father and I travelled there with Dick Katz. From the moment we arrived it was Hollywood treatment all the way. My own personal assistant met us at the airport and escorted us by limousine to the Beverly Wilshire Hotel in Beverly Hills, a beautiful, mostly residential area with endless sunshine, tilting palm trees and magnificent mansions with manicured lawns. It had not been long since this idyllic world had been shattered by the gruesome murder of actress Sharon Tate by Charles Manson, and Hollywood was still in a state of fear. My hotel suite was luxurious and elegant, but the sight of the multiple locks on the doors un-nerved me and I barely slept for the duration of my stay.

Apart from that, it was an incredible trip, with a number of memorable highlights like visiting Disneyland to do a photo shoot. I

was allowed access to every area and it was so enjoyable, as was appearing on the *Tonight Show* with Johnny Carson and the *Merv Griffin* (TV) *Show*, with Margaret O'Brien, the famous child star, and Jack Haley, who had played the Tin Man in *The Wizard of Oz*. Also resident on that show was the Harry James Big Band, much to the delight of my father, and before long he and Dick were hanging out with the musicians, exchanging stories. But the greatest highlight for me was when I saw Doris Day in person. She came to our hotel for lunch, on her bike, dressed in a pair of cut-off cotton trousers and a T-shirt, with her blond hair pulled back in a pony tail.

Jack Wild's agent John Daly was anxious to sign me up for further film work, but much as I appreciated the offer, working in the film business didn't appeal to me. In the world of theatre, if your performance isn't to your liking on the first night, you can always decide to make changes and adjust it to your own satisfaction for future performances. In the film business, however, you stick to your script and once you've shot your scenes, you have no control whatsoever over the way it is edited and presented to the public. You also have to invest a much greater amount of time in each individual project. I felt that I'd rather have more control over the work I did and how much time I would invest in it.

When *The Flight of the Doves* was finally released it was very well received and I got good reviews, but I think Ralph Nelson's association with *Soldier Blue* worked against him on the worldwide distribution of this wonderful children's film.

By the close of 1970, I had received a gold disc for a million sales of 'All Kinds of Everything' which had spent a total of sixteen weeks in the British charts and seventeen weeks in the Irish charts. I had also learned that success can be very fleeting and should never be taken for granted. My follow-up single to 'All Kinds' was called 'I Will Follow You' and expectations for this song were good as I had enjoyed massive publicity. The demo disc, produced by Ed Welch of the Shadows, was sung by a young unknown Australian girl called Olivia Newton-John. I met with them both after the recording session and apparently Ed was trying to promote Olivia as a solo singer. Over the coming years Olivia and I got to know each other and I was so delighted that she did achieve great success throughout the world.

My new single, however, did not fare so well. In fact much to everyone's surprise, apart from in Ireland, it was a total flop. When it didn't even make the top 50 in the British charts, I resigned myself to the fact that what the newspapers were saying was true: I was another one of those Eurovision one-hit wonders who would never be heard of again.

In hindsight, I am grateful that my record flopped, because up to that point I was being carried along like a surfer on a long breaking wave. My success had come so unexpectedly and so effortlessly, it was easy to be lulled into thinking that the roller coaster would continue forever. But now, less than six months after Amsterdam, I was resigned to the fact that my career was over. I went to meet with Dick Katz to tell him how I felt but he simply said, 'Well, Dana, now it's your choice. You can go back to Derry and live a normal life or you can stay here and fight!' I was surprised and challenged by his words. They were a real turning point for me. Now my future was in my hands and I chose to stay and fight. From that moment on, we became a team, my attitude to my career changed and, supported by my parents, I set about learning my craft; meanwhile Dick began searching for a new record producer.

There was much to do and learn. For example, I'd had a lot of success in Germany singing in English, but I now began to record in German and apparently as I had no trace of an accent, everyone thought I was a fluent speaker! It was the beginning of a new kind of relationship with the German public and the record company was delighted at how well these new recordings were received.

Then at Christmas I was booked to play the part of Cinderella in my first pantomime, a touring production which opened at the Gaumont Theatre in Doncaster. I was still dressed in rags, just like my film debut, but at least I got to wear a glittering ball gown at the end of each performance. I found that I loved working in pantomime. I enjoyed being part of the company and it was always wonderful to see the children's involvement and excitement.

After a great deal of searching, Dick Katz found the man he thought would be a good record producer for me. His name was Bill Landis, a New Zealander who did a lot of work with Decca Records and came highly recommended by his close friend, American singer/songwriter

Neil Sedaka. Now all we had to do was find the right song and it came from a most unexpected source. Dick's business partner, Harold Davison, was a personal friend of Frank Sinatra and booked all his European tours, as well as looking after the British rock band The Who. His stepsons, Paul Ryan and Barry Ryan, had enjoyed some chart success in the mid-1960s but Paul was now writing songs, one of which, 'I will drink the wine', was recorded by Frank Sinatra and one of which his stepfather thought would be perfect for me! So Harold Davison called me to listen to 'Who Put the Lights Out?' It was an unusual song, but I really liked it, so Bill and I went into the studio straight away and when the record was released in February 1971, it quickly went into the top twenties in the Irish, UK and European charts.

At that time there was a very popular chart show on BBC Radio on Sunday afternoons, presented by Alan Freeman, and I remember lying in bed and hearing Alan announce that my record had gone to number 14 in Britain. The timing couldn't have been better either, because as my record entered the charts, the 1971 Eurovision Song Contest was about to take place in the Gaiety Theatre in Dublin. My win in Amsterdam obliged RTÉ to produce the show in colour, a first for the nine-year-old network! They did a brilliant job. Ireland was well represented by Angela Farrell singing 'One Day Love', but Séverine won out for Monaco with 'Un banc, un arbre, une rue'. When I walked onto the stage to present the Eurovision medal to Séverine, it was so good to know that no one would call me 'last year's one-hit wonder'!

Around this time the Harold Davison Agency merged with another huge talent house called MAM (Music and Management), together forming one of the biggest and most powerful agencies in Europe. MAM represented a number of very successful international stars such as Tom Jones, Engelbert Humperdinck and Gilbert O'Sullivan, to name but a few, and before long I was appearing at the London Palladium for a week of concerts with Tom and touring Europe with Engelbert. During this extensive tour we flew by private jet to a different country each day. It was a gruelling schedule and after a while all the airports and hotels began to look alike, so that eventually I hardly knew what country I was in. To make matters worse I got a severe dose of flu. I really needed a few days in bed but that was out of the question so the only thing to do was fight it on my feet and keep going.

When we reached Vienna I thought that a soothing trip on a gondola would do me the world of good, but when I asked the concierge in my hotel to direct me to the canals, he just stared at me blankly. I persevered, asking him where I could find the gondolas, but there was still no response forthcoming. I thought he couldn't speak English until he informed me somewhat indignantly that there were no gondolas in *Vienna*, at which point I backed away sheepishly from the front desk, hoping no one had heard me.

We were appearing that same night in the Vienna Concert Hall to a very enthusiastic capacity crowd. After my performance, my arms filled with a magnificent bouquet of long-stemmed roses, I made my way back onto the stage for a second curtain call. Unfortunately no one had told the spotlight operator and in the darkness I tripped up the steps to the platform and fell forward on my mouth and nose, obliterating my beautiful bouquet and ripping the zip out of the back of my dress. At that very moment the spotlight operator swung into action, revealing me sprawled on the stage surrounded by bent and broken roses. I lay there like a deer caught in the headlights. I'd hurt my wrists, my knees and most of all my pride. Of course as I was helped to my feet to tumultuous applause, the orchestra went to town with drum rolls, cymbal crashes and trombone slides.

I travelled back and forth to Europe a great deal. On one occasion, a number of the artists including Dusty Springfield and myself almost met our maker together. We were on a flight home from Germany after having taken part in a big television programme, when suddenly the pilot announced that there was a problem with the undercarriage and we would have to fly over the control tower at London Heathrow so that they could do a visual check. Apparently the computer had indicated that although one set of wheels was locked down for landing, the other set was not. Dusty had been very good to me on that trip; my luggage had gone missing with my make-up in it and while she let me use hers, we reminisced about the time she toured Ireland with her brothers as The Springfields and my sister Eileen had been support act at one of the venues. Dusty didn't like flying and when the pilot came back on to say that we had a serious problem and we'd be making an emergency landing, she was obviously petrified. Dick Katz had been trying to keep her as calm as possible, but Dad noticed that Dick was

now intently scribbling away on a sheet of paper. It turned out that he was writing his Last Will and Testament in the belief that if we did crash, someone would find it in his pocket.

It was a very sobering moment as we touched down, but thankfully the computer was wrong and both sets of wheels *did* lock down as we landed safely at Heathrow, with a full emergency turnout of fire engines and ambulances. When we were safely on the ground, we all had a good laugh at Dick writing his will at such a moment and even he saw the funny side of it, but poor Dusty was in bits over what had happened and her fear of flying intensified after that.

One of the most genuine and down-to-earth people I met in MAM was Gilbert O'Sullivan and although we worked together only on television programmes like *Top of the Pops*, I felt comfortable with him and that wasn't just because we were both from Ireland; he always came across as a thoughtful, considerate person. It was a shock to learn some years ago that he'd had to take one of the founders of MAM to court in order to protect his own recordings and the copyright of his songs. I'm glad he had the conviction and courage to see it through. He's a fine poet and I think his work is in a class of its own and worth defending. Many years later when I was elected to the European Parliament I became a spokesperson for the music industry in the field of copyright and I fought to protect the work of composers like Gilbert.

Chapter 5 ～

ONWARDS AND UPWARDS

As 1972 began, I was appearing in my first London pantomime, *Dick Whittington*, at the Wimbledon Theatre. It was an important landmark in my career *and* it was presented by Lord Delfont of the Grade Organisation. I was playing the part of Maid Marian, alongside comedian Norman Vaughan and *Carry On* actor Jack Douglas, and as we were playing to sold-out houses every day, Lord Delfont himself was scheduled to attend one of the performances. Unfortunately, the evening he came I was feeling very ill, as I limped my way through the first half. A doctor was called during the interval and when he discovered that I had a severe throat and ear infection with a temperature of 104 degrees, I was sent home immediately and spent the next week-and-a-half in bed.

Mum and I were staying with her brother Brendan and his wife Pearl and family, who had opened their home to us and couldn't have been more generous but my illness gave me time to think about finding a place of my own in London. Although I still thought of Derry as home, the bulk of my work was in England and Europe and it was increasingly difficult for me to get back to Derry or for my family to spend time together.

It was 30 January, one of those bright, crisp winter days, when I heard the terrible news of the shootings that had taken place outside the Rossville Street flats in Derry. I was still recuperating as we watched the incredible images on television; on the same streets I'd run along to school, I saw Fr Daly running with a blood-stained white handkerchief held high, as he led to safety a group of men carrying the wounded body of John (Jackie) Duddy, a seventeen-year-old boy who would later

die from his wounds. There were further dead and wounded lying on the pavements and rubble-strewn ground I'd looked down on from our fifth-floor windows. In all, thirteen people, six of them under eighteen, were killed and a further fourteen wounded when troops from the 1st Battalion Parachute Regiment opened fire on unarmed civil rights marchers. We were in a state of disbelief and fear; Granny and other family members were living in the flats, as well as many of our friends and, as the names of the dead were released, we found that we knew either them or their families. Like Hugh Gilmore, another seventeen-year-old who had lived on the floor below us in the flats; his mother Kitty was a life-long friend of my own mother, who described her to me as a very quiet, good woman.

As soon as we could, Mum and I returned to Derry. People were still in deep shock at what had happened. Kitty and her husband talked to us almost in a daze about how Hugh had left the flat after Sunday lunch, borrowing a jacket to keep out the cold. His mother had been worried about him going to the banned march but he wanted to be there and anyway he'd just be down on the street below and there'd be other young people there. She later looked down from the window of her flat and saw the feet and legs of one of the dead, not realising it was her son Hugh.

The march had been organised as a protest against internment, introduced five months earlier in August of 1971 by Northern Ireland Prime Minister Brian Faulkner. Because of outdated information many innocent men were interned, with reports of severe beatings, and held indefinitely without trial. The 'security measures', used almost exclusively against the Catholic community, resulted in a violent backlash, galvanised support for the IRA and led to the Bloody Sunday march. According to local people we spoke with and all news reports, no one foresaw what would happen that day. In our close-knit community, most people knew each other by sight, if not by name, and there was no sense of fear as the marchers made their way from the Creggan to Free Derry Corner in the Bogside. Apparently there was singing and chanting, with the usual bantering so typical of Derry. As usual there was some stone throwing and retaliation with CS gas and water cannon, but as the marchers reached Rossville Street all hell broke loose, with people running for their lives as shots rang out through the crowd.

British Prime Minister John Major, writing to John Hume later, stated: 'The Government made clear in 1974 that those who were killed on "Bloody Sunday" should be regarded as innocent of any allegation that they were shot whilst handling firearms or explosives. I hope that the families of those who died will accept that assurance'.

Reginald Maudling, the British Home Secretary, later said that internment was 'by almost universal consent an unmitigated disaster which has left an indelible mark on the history of Northern Ireland'. An indelible mark was also left on the hearts and minds of the people of Derry and elsewhere who on Bloody Sunday witnessed one of the very tragic days in the history of the troubles, and there were more to come.

On returning to London, Mum and I, as already agreed, set about looking for somewhere to live and, after an extensive search, I found exactly what I was looking for. As people tried to recover from the horror of Bloody Sunday in Derry and watched the political repercussions unfold, it was emotionally difficult to get over what had happened in the Bogside that day. There was a deeper wedge driven between the army and the people, yet like other Catholic families in Northern Ireland, we were to have a much-loved first cousin serving in the British Army there, with another in the RUC, and so we prayed for the safety of *all* of our family as life and the troubles went on.

Later in the year, I had the good fortune of meeting Dorothy Squires who, among other things, had discovered and married actor Roger Moore of *James Bond* fame. Dorothy was a very famous singer in the 1960s and as well as recording a number of hit records, she was acknowledged as an outstanding live performer. In the early 1970s she made a stunning comeback when she hired the London Palladium and played to capacity audiences and standing ovations at every performance.

The evening we met I was singing at a new club in Wales and Dorothy was a special guest in the audience. However, to my great disappointment, it was a disastrous performance. Everything that could go wrong did go wrong; the new sound system was appalling, the audience was disinterested and I felt I was just 'dying' on stage. Nevertheless, when Dorothy walked into my dressing room, she sat down, looked me straight in the eye and gave a piece of advice that has helped me throughout my career. She told me never to resent the bad

venues and the hard audiences because ultimately these were experiences that would make me a star. I've shared Dorothy's good advice with many young artists starting out on their careers and I've learned that the same principle applies in life. It's the hard experiences that teach us and shape our character and make us better people.

Throughout this period, although I was kept busy with cabaret engagements across the UK and appeared on a number of television shows, like *Meanwhile on BBC 2*, hosted by Kenneth Williams, a very gifted comic and star of the *Carry On* films, the elusive hit record I was searching for continued to evade me. RTÉ meanwhile offered me a six-part TV series and I was delighted to do it, so it was arranged that I would fly to Dublin at the beginning of August for a planning meeting—or so I thought!

As we landed in Dublin that morning I was chatting to the lady in the seat beside me and I remarked to her that there must be someone important on the flight, because there was a film crew waiting on the tarmac. We were looking around trying to see who this VIP could be, when the air hostess made her way to where we were sitting and asked me if I would mind remaining in my seat, as the TV crew was there to meet me! I was taken aback because I had intended to go straight to the hotel to get changed and ready for my meeting. I was in jeans, had no make-up on and my hair was a mess. As I made my way down the aircraft steps with my sunglasses on, smiling self-consciously into the camera, I noticed a vintage Rolls Royce, draped with two very glamorous models in 1920s flapper dresses, parked at the side of the aircraft. A terrible sense of trepidation descended on me and it was confirmed when the series producer informed me that the RTÉ film crew was not there to film me arriving for a planning meeting; it was there to film the actual *launch* of the theme for the series.

To my astonishment he told me that the theme had already been decided and would be revealed on the six o'clock news that evening. Without discussing it with me or my management, RTÉ had already decided that the series would be set in high society of the 1920s and 1930s. The guests were already chosen and the music, costumes and dance routines would be from that era. I was speechless. I couldn't believe the way the entire idea had been foisted on me and there was nothing I could do about it. The press were also there waiting to take

photographs of me with Fran O'Toole, the main guest, so I had to go into the VIP suite, put on my make-up and come back out smiling joyfully to announce to the cameras how delighted I was to be in Dublin to launch my new series, before posing in the vintage car with Fran and the girls!

I had no say in the programme idea whatsoever and whether it was the unexpected sight of me dressed in 1920s fashion, the music of the period, the format, or the lack of rehearsal time, the end result was that the critics savaged it and the viewers hated it. It did me no favours with the Irish public and it took me a long time to recover professionally from the negative impact the series made. However, there were some positives: I got to work with Des Keogh, Angela Vale and the Jim Doherty Band. And Fran, who fronted the Miami Showband, was a real pal.

In mid-1972 I got a call from an old friend of mine, Fr Thomas O'Neill, a Cistercian monk who was concerned about the growing division between Catholic and Protestant children in the North. He came up with the idea of raising money in order to take children from Catholic and Protestant areas on holiday together. He hoped that if these children got to know each other outside their own war-torn environment they just might be able to form positive, lasting friendships that would help bring peace to their communities. All he needed was the funding and he wanted to know if I would do a benefit concert to help him to raise the money.

I thought it was a wonderful idea and I told him that I'd be delighted to help him in any way I could. I'd lost count of how many benefit concerts I had done since I'd first stepped on stage as a child and I felt very happy to do it, but little did I realise that because of this particular concert, my life was about to take yet another significant turn.

The venue chosen for the event was the Ardmore Hotel in Newry, which was owned by the Scallon family—Damien, his brother Gerald and sister Josie. I had met Damien briefly two years previously at a reception in the Ardmore, after a street in nearby Hilltown was named 'Dana Place' in my honour. The Scallon family made an unforgettable impact on me that day. I was in the middle of a very hectic Irish tour and at the luncheon with local councillors, when I stood up to thank everybody present, I suddenly felt weak and almost collapsed. All I can remember is the strong arm of Damien's sister, Josie, gripping my waist

and practically carrying me out of the dining room, not halting till she had me sitting on a very comfortable bed. Josie, who was the eldest girl in a family of fifteen, was quite firm in what she said: 'You're exhausted, wee girl. Get into bed now and have a good sleep.' I did as she said without protest and slept soundly for two hours, with security on the door to ensure that I was undisturbed.

So two years later when I arrived at Dublin Airport from London with my dad, I was met by Damien who was driving a bright yellow sports car. On the way to Newry, Damien asked me if I'd like to drive and, never one to knock an opportunity, I said 'yes'. Somewhere between Dublin and Newry, I foolishly overtook a long stream of traffic on a hill. Nobody would let me in and I had to drive over the brow on the wrong side of the white line! My father was sitting in the back gripping the seat for dear life and we all took sharp intakes of breath, fearing we were about to make our journeys into the next life! Somehow we got over the hill safely, much to the disbelief of the motorists behind us and indeed ourselves. Yet Damien, who sat in the passenger seat, never blinked an eye or uttered one word, good, bad or indifferent. It was a scary experience! Thinking I was going to get a verbal roasting from him, I was quite surprised when a minute or so later he broke the tension in the car by asking me if I enjoyed driving and if I'd like to continue in the driver's seat all the way to Newry. But I let him take over the wheel as soon as possible and it was really from there that our friendship slowly developed.

Following the concert, I was unable to return to London due to extraordinary fog at Dublin Airport, which meant staying an extra two days at the Ardmore Hotel. It allowed time for me to get to know Damien better. When it came to parting, our friendship had developed somewhat and we agreed to keep in touch. My career was forging ahead, and making the most of my new life in showbiz was at that stage my number one priority. Nevertheless I sensed that the friendship with Damien was strengthening when he would turn up out of the blue in places like London. One time, for example, I was at home there when he phoned up and asked if I'd like to go for dinner. I thought he was in Ireland but in fact he was at Heathrow Airport. On another occasion I was in Dublin and found that he was staying in the same hotel. The more I got to know Damien, the more comfortable I felt in his company.

As our friendship grew, I worked steadily on the showbiz front with stars like Val Doonican, Harry Secombe and Engelbert Humperdinck, each of whom had a BBC TV series. It was a joy to work with them. Val, a fellow Irish person, was a huge star with a very laid-back style. Nonetheless he was the ultimate professional in his work. I had often seen him on television and it was a thrill to be working with him. Val's a fine painter too and Damien and I still have the beautiful watercolour he gave us before we went to live in America.

Another favourite of mine was the late Sir Harry Secombe. He was a very friendly, unassuming man, despite his remarkable career as a comic and a fine tenor, starring in stage musicals and films like *Oliver*. I had the pleasure of working with him on many occasions, and, in the middle of rehearsals, or even when the cameras were rolling, he'd suddenly morph into Neddie Seagoon, the character he had made famous on *The Goon Show* on BBC Radio, letting out that distinctive chuckle that would make everyone collapse in laughter with him.

My career was given a useful lift when I won the Best Performance Award in the Yugoslavian Song Festival. In addition to that I appeared on *They Sold a Million* which was the winning BBC entry for the 1973 Knokke Festival in Belgium.

I also appeared on a TV series with American star Jack Jones and it turned out to be quite a difficult experience. The show was recorded as 'live' in front of an audience. I was singing a duet with him that we had painstakingly rehearsed over and over earlier in the day, to our satisfaction. On the night, when the moment to perform came around, we started into the song and everything went fine. Then in the middle of it, he took off into a different melody and timing. It sounded like a completely different song!

All of a sudden I'm on stage, bewildered and trying to hold on to my melody! He knew exactly what he was doing; he was deliberately testing me in front of the audience. It was nerve-racking, but thankfully I never lost a note or a beat and at the end of the song as we took our applause, he turned to me and said with a sarcastic smile, 'Well done.' That little trick certainly lowered my estimation of him, but I remembered Dorothy Squires' words of wisdom when she said that the shows you find most difficult are the ones that bring out the best in you.

The BBC had the pick of the biggest names in British showbiz and I was asked to take the part of Maid Marian in its 1973 TV Christmas panto *Robin Hood* which was produced by Peter Whitmore. Granted, I didn't have a lot to say, but to be on the bill was an honour all on its own. In those days the panto broadcast would be seen by close on 20 million viewers.

As 1974 got under way, more television offers started to come in and after a four-week tour of Canada with the London Palladium Show which featured big names such as Rod Hull and Emu, Frankie Vaughan and Billy Dainty, Peter Whitmore at the BBC approached me with a view to doing a television series. Peter was one of the top names in entertainment at the time in the BBC, having produced *The Terry and June Show* and *The Dave Allen Show*. The series was to be called *A Day with Dana* and would involve me travelling to different destinations around the UK where I would be filmed doing a concert or a cabaret show. Along the way, either in a small town or rural location, I would sing some songs and do a humorous sketch with some well-known comedian I would 'accidentally' bump into.

As Dick Katz and I sat down with Peter Whitmore to discuss plans, the format of the series at the outset sounded like great fun. However, there was one slight problem: I would have to drive from location to location, but I had yet to pass my driving test! In fact, having survived my 'close shave' on the hill outside Newry, I hadn't driven since. When Peter got over his surprise he said in no uncertain terms, 'Well, you'll have to learn because we can't do the series unless you can drive.' By this stage the commencement of filming was just weeks away, so I enrolled for lessons immediately.

Unfortunately the controls of the driving instructor's car were the opposite way around to those in my father's Volvo estate, so I constantly found myself switching on the wipers instead of the indicators when it came to turning corners. To complicate matters I had to take my test in Acton which had probably one of the worst traffic systems in London. If that wasn't bad enough, the local council was digging up the roads at the time. To cut a long story short, I failed the test with one week to go before filming commenced! What was I going to do? After much deliberation we decided that I'd drive without a full licence and they'd make sure that I did it legally.

Picture the scene then on our opening day of filming. The BBC soundman, Brian, who was a small guy, had to curl up on the floor of the passenger side, while I drove over and back across Chelsea Bridge at least a dozen times, singing 'live' to taped backing music in the madness of London traffic, having just failed my driving test! Brian, meanwhile, curled up like a tense hedgehog, was praying like a monk that I wouldn't hit anybody and more to the point that nobody would hit me! He'd say to me, 'Don't worry, don't worry, you have a qualified driver here beside you.' To which I'd respond, 'You're a fat lot of use to me. You're sitting on the floor.' Such was the erratic nature of my driving, whenever I would be asked to stop the car at a particular spot so that I would be in line with the camera, the crew would take six steps backwards! They were clearly well aware of my incompetence as a driver but thankfully I improved over the weeks.

Overall the series was great fun and I really enjoyed working with comedians like Terry Scott and Don McLean of *Crackerjack* fame. Don, who became a close friend, is a qualified pilot and many years later he got me out of a difficult spot when I had to go to Bristol for a radio recording before returning to Bournemouth on the south coast where I was in summer season. When I told the radio producers that I wouldn't be able to get there and return in time by road, they said, 'Don't worry, Don McLean is doing the programme as well. He's a pilot and he'll fly you. It'll only take you twenty minutes.' 'Great', I thought. 'That'll save me a long journey through winding traffic-filled roads.'

Don and his wife picked me up and we flew to Bristol, did the recording and started out to fly back to Torquay. Somewhere along the way, Don mistakenly flew over an RAF base in which firing practice was under way. Suddenly an urgent call came over our headsets for us to identify ourselves! Before the military had the opportunity to shoot us out of the sky, Don assured them of who we were and that we were *not* hostile. When he persuaded them that we really were lost, he then proceeded to make the officials at the other end laugh and somehow it did the trick. Naturally I never let him forget that interesting episode!

Around this time Dick Katz felt that I should move on from Decca Records. The music scene was changing; new labels were being established and well-known names were being pushed aside as glam rock,

bell bottoms and hot pants took over. Not surprisingly, Dick thought that a change would do me no harm and I agreed with him.

We went to see Dick Leahy who had just started a new recording label called GTO Records. Dick had had phenomenal success in the previous three years with Bell Records and scored massive hits with artists like the Glitter Band, David Cassidy, Showaddywaddy, Tony Orlando and Dawn, the Bay City Rollers and my friend Barry Blue. Dick Leahy had an extraordinary gift for spotting a hit song and he was rarely wrong. He later went on to discover Wham, featuring a youthful George Michael, and is his music publisher to this day.

Dick really believed in me and got producer Geoff Stevens to come up with a song called 'Please tell him that I said Hello'. We recorded it, released it and waited and waited! For the first three months it had virtually no sales. The radio stations didn't want to know but somehow Dick kept pushing it, fully convinced that it was a hit. Normally after three months, a record company gives up; if a single isn't selling by then, it's time to move on to the next release. But not Dick Leahy. He kept saying, 'It's a hit, I'm telling you, it's a hit.'

Then suddenly the song just took off and was getting airplay and TV broadcasts all over the world. Remember, just to get into the UK charts, you had to sell hundreds of thousands of copies. Before I knew it, the song was number eight in the British charts, three years on from my last hit. It was also racing up the charts in Germany where I had recorded a version in German. Once again, just like the weeks and months after winning Eurovision, the demands on me went crazy: TV appearances and tours with two or three countries in one day, and magazines, radio and newspapers all queuing up to talk to me. It was like an action replay, only this time I could really enjoy it.

To add to my busy schedule, Canadian film producer Jim Swackhammer was making a documentary about my life, entitled *Who is Rosemary Brown?* He was fascinated by the fact that I had grown up in the war-torn Bogside and become an overnight star through Eurovision. We filmed aspects of everyday life in Derry, at Thornhill College, and in Dublin on St Patrick's Day. The documentary contains some priceless archive footage of life in the North in the mid-1970s and Jim told me that it was very well received in Canada and the United States when it was broadcast the following year.

A follow-up single. 'Are you Still Mad at Me?' was a radio hit, meaning it received lots of airplay but didn't sell well enough to make it a top-ten hit. However, I was still on a roll following the success of 'Please tell him that I said Hello'.

Early in 1975, the Browns opted to have another bash at Eurovision when John and Gerry's song, 'We Can Fly', reached the national finals, and, as far as I know, we made history the following year when John, Gerald and I became the first family to have *three* entries accepted for the Irish National Song Contest in the *same year*. The Swarbrigg brothers were worthy winners in 1975 with their song, 'That's What Friends are For', and my brother John managed to go on and win the Castlebar International Song Festival with his song, 'You Are My Destiny'.

The weather was beautiful that summer and I was in Southport for summer season with Les Dawson. Les was a firm favourite of all my family and he and Dad got on particularly well. I loved working as part of a company and over the summer months the cast went out for meals together or on bowling competitions or to the pictures, and it made the season all the more enjoyable. Then, on 1 August, a news flash came over the radio while I was having breakfast. I didn't catch all the details, just a reference to a fatal shooting near Newry. When my brother Robert rang shortly afterwards to confirm what I thought I had just heard, I couldn't believe my ears.

The previous night, the Miami Showband and its lead singer, Fran O'Toole, the talented young singer I'd got to know on my RTÉ TV series three years previously, had finished a gig in Banbridge, Co. Down, loaded up their van and headed back towards Dublin. As they approached Newry, they were stopped by what they assumed was a routine Army checkpoint. However, the checkpoint was bogus; it was manned by loyalist paramilitaries. The members of the band were ordered out of the van at gunpoint and lined up against a fence. A bomb was placed in the vehicle with the intention of detonating it later to make it look as if the band was transporting bombs. But the bomb went off prematurely, killing two of the paramilitaries instantly.

The members of the band made a run for it but Brian McCoy, Tony Geraghty and Fran O'Toole were shot dead. Des McAlea and Stephen Travers, a family friend, were also sprayed with bullets but somehow miraculously survived.

The entire country was stunned at what had happened. Showbands were non-political and they had been given safe passage up to now. Fran, with his boyish good looks, was such a vibrant individual, full of energy, and with an infectious grin. He was newly married with his whole life before him, his career was flying, and he was without doubt one of the most popular artists on the Irish showbiz scene at the time. It was so hard to understand why this should have happened to him and his friends.

As the country grieved at the loss of these popular entertainers, their killings took 'the troubles' into a previously untouched area. At that time there was very little to do socially in the North and an evening out, to hear a band play in a dance hall, was one of only a handful of normal activities that could be enjoyed. Other showbands and artists cancelled engagements and most refused to accept future work in the North.

I couldn't get my head around this awful tragedy that had happened just up the road from Damien's Ardmore Hotel. I cried for most of the day before eventually composing myself to do two shows in Southport later that evening. Les and the rest of the cast were shocked at the news and we were all fully aware that what had happened to the 'Miami' could so easily have happened to any of us going about our work. I was honoured to sing recently at the thirtieth anniversary service commemorating the Miami members and celebrating their lives. It was very moving to hear Stephen Travers speak so genuinely of his forgiveness of those who carried out this act.

At the end of the summer season I flew to Germany for a month to record with Hansa Records, who had first discovered Donna Summer. Dick Leahy rang me one day during a session and told me that the great song writer Roger Greenaway was flying into Berlin the next day and that he wanted to see me. Roger had co-written huge hits for the Drifters such as 'Kissing in the Back Row' and 'There Goes My First Love'. His catalogue of hits, written with Barry Mason and Roger Cook throughout the 1960s and 1970s, was nothing short of phenomenal. A year later he would write a huge-selling worldwide hit for David Dundas, called 'Jeans On'.

According to Dick, Roger had written a song specifically with me in mind and felt it was going to be a big Christmas hit. Dick had heard the song, liked it and felt I should record it. Roger's arrival was clearly important in Dick Leahy's eyes as we were in the middle of recording

other material and I was in the process of learning my German grammar and vocabulary. Roger duly arrived and played the demonstration tape. I listened, liked what I heard, and recorded the song called 'It's Gonna Be a Cold, Cold Christmas'. It was something like four weeks to Christmas and so it was rushed out—by record release standards—at the last minute, but it sold in truck loads and made it to number three in the charts. At one stage it was selling 50,000 units a day. Dick Leahy maintained that if we had had a couple of weeks longer on the run-in to Christmas, it would have gone to number one. As it happened 'Bohemian Rhapsody' by Queen hit the top spot at Christmas 1975 but despite not making the top spot, I'm glad to say that after all these years, 'It's Gonna Be a Cold, Cold Christmas' is still one of the most played songs on radio throughout the world during the month of December.

GTO Records was going from strength to strength with artists like Fox and Donna Summer enjoying global success. Billy Ocean and Heatwave were about to be catapulted into the big time, my records were selling throughout Europe and South America, and there were plans to launch my record career in the US and Japan.

As 1975 came to an end, emotionally and professionally I was at my happiest. The year finished with a top-three Christmas hit, 'Cold Cold Christmas', and a top-ten placing with 'Please tell him that I said Hello'. I won the *New Musical Express* (NME) Award for the best female singer in Britain, which was considered quite an achievement as NME tended to be slanted towards rock music acts. And I also won one of the most important entertainment accolades, the *TV Times* Award for best female singer on television.

I looked forward to 1976 with enthusiasm. There were so many exciting plans ahead and it seemed as if nothing could go drastically wrong, or could it?

Chapter 6 ∿

DARK DAYS AND
BRIGHT ONES

1976 got off to a great start when the pantomime I was appearing in at Oxford was declared to be the biggest money spinner of its kind in England. My new single and album were ready for release and with television appearances, live work, and an invitation to sing in a new American TV special, I had a busy time ahead. The only cloud on the horizon was a niggling concern I had about my voice. Over the previous three years I'd had recurring difficulties and my specialist, Alfred Alexander, had diagnosed a weakness on one of my vocal cords that would flare up sporadically, leaving me unable to sing.

The previous September he had suggested cauterising the vocal cord and allowing it time to heal itself, so after the operation I had taken a three-week break, then gone back to work and had had little trouble since. The fear of a recurrence, however, was always in the back of my mind and I was trying to make sure I rested my voice as much as possible. So after the Oxford panto I headed to Derry for a relaxing break at my grandmother's house.

During my stay with Granny, Damien drove up from Newry to see me. We'd grown much closer, but I still knew I wasn't ready for marriage. We'd talked openly about this and he did not pressurise me in any way. Damien had barely arrived when a phone call came through telling him to return home immediately as there had been another bombing at the hotel. I travelled with him to Newry and, when we arrived, his sister Josie was standing in the badly damaged reception area of the hotel, looking very shaken. I held out my arms to her and as

she stepped towards me the ceiling above where she'd been standing came crashing to the floor, missing her by a split second.

Initially when bombs were planted in the hotel they would be hidden on the premises, but in more recent times the republican paramilitaries simply arrived at the front door and carried the bomb inside, forcing the owners and staff to lie face down on the floor while the bomb was planted and an escape made. No one could attempt to move or leave the building for a specified amount of time, after which they would have to run for their lives. If the bomb didn't explode immediately, Damien had the responsibility of searching the premises with the bomb-disposal experts, to find where the device or devices were located, aware that at any second they could go off.

Yet through all of the difficulty and stress, Damien had found a deep sense of peace. His brother Gerald had introduced him to a Belfast café owner named Frank Forte, who explained that a new movement was bringing Catholics and Protestants together to pray for peace, even in the most volatile areas of the city. That evening he took them to a house in Ballymurphy, a very troubled area, where there were so many gathered that people were even sitting on the stairs. Although Damien wasn't initially attracted to the Charismatic Renewal movement, he had gradually become more involved and had found it a very positive and life-changing experience.

I was aware of how much pressure Damien was under on a daily basis and I certainly didn't want to undermine the peace he was so obviously experiencing, but personally I had no desire to be involved in any way with the movement. Meanwhile I had a new single to promote and, although 'Never Gonna Fall in Love Again' made it only to number 31 in the UK charts, it did manage to get a lot of exposure on radio and TV. Dick Leahy had already found the song he'd been searching for to begin breaking into the US market. It was called 'Fairytale', written by Paul Greedus who would go on to write 'A Little Peace' for Nicole, the winning German entry in the 1982 Eurovision Song Contest. 'Fairytale' had a dance feel to it and it was a very different style for me, so Dick felt that I should work with a new producer who was making quite a name for himself. It turned out to be my old friend Barry Blue.

When we went into the studio, Barry wanted an unusual instrument sound on the track and so he chose an electric violin—not what you'd

expect to hear on a disco track but it worked perfectly. We were all very excited about the new song which was to be released in September, so alongside my existing work there were cover photos to be taken and a promotional tour to plan. This was such a busy period that I was consistently working seven nights a week and most of the days as well. Then in early September, just a few weeks before the record release date, our family suffered a terrible blow when Dad had a major heart attack.

We were enjoying a welcome evening at home in London and Dad had just gone upstairs when we heard what sounded like a heavy thud. My mother knew instantly that something serious had happened to Dad and as my brother Gerry and I ran upstairs to help him, Mum was calling the ambulance. I travelled with him in the ambulance to the hospital and it was a nightmare journey. At the hospital he was rushed into intensive care and as my family gathered through the night, we kept vigil outside the door of the ward and prayed that he would make it through. Thank God, he did.

A couple of weeks later I began promoting 'Fairytale'. I didn't anticipate any problems, but when I opened my mouth to sing in rehearsals I couldn't get my voice to work properly. I knew immediately that the old irritating problem with my vocal cords had come back to haunt me. My specialist saw me as soon as I arrived back in London and when he examined my vocal cords he told me that there was now a growth where he had cauterised the weak spot on my left vocal cord and that he would have to operate immediately to remove and examine it. It didn't dawn on me at the time that the growth could be malignant. I thought it was just a nodule, a growth on the vocal cord that plagues many singers. I was bothered about having to cancel my engagements in Ireland in two days' time, but most of all I didn't want to worry my parents about anything at all.

Mr Alexander suggested that I go home and speak with my family about what he had advised and then be admitted to St Vincent's Clinic in Paddington, so that he could operate first thing the next day. I did not understand the significance of what he had explained to me, but my parents were both very worried. That night my father informed the Irish promoter that I wouldn't be able to do the tour. From there, word of my operation spread like wildfire, so that by the time I was

recovering from the operation the following day, the story was already in newspapers throughout Ireland and Britain.

When I first saw the papers I was appalled at sensational headlines such as 'Dana May Never Sing Again', 'Surgeon Battles for Dana's Voice', 'Dana: Loaded Dice' and so on. I was sure they weren't true but when Dr Alexander came to see me he explained the reason for the headlines, and that was the first time I understood that it could have been a cancerous growth. He also explained that to remove all of the tumour he had had to remove a part of the vocal cord and, as he said, 'The dice is loaded against any singer who loses vocal tissue.' The good news was that I didn't have cancer, but he explained that it would take at least three weeks of complete silence before he could tell me if the operation was successful.

The reaction from the public, friends and colleagues like Cliff Richard, Barry Gibb, Harry Secombe and others was truly amazing. There were so many flowers arriving from well-wishers that they filled every chair and table top in my room, the entire room next door and the corridor outside. For three weeks I carried on all my conversations and interviews by writing down what I had to say in a notebook. The press followed my progress closely and the good wishes continued to pour in.

When the three weeks of silence were up, Mr Alexander's verdict was that he was pleased at how the vocal cords were healing and that he felt I would be able to sing again but I had to take things very gently. At first I was allowed only to whisper for a few minutes each day. As my voice strengthened I was allowed to begin to talk, again just for a few minutes at first and then for longer. Even though I could speak only in stops and starts, I was able to go to Japan to promote the Japanese version of 'Cold, Cold Christmas' as it was the practice to mime on TV programmes there.

By the time I returned from Japan, 'Fairytale' was on its way to number 13 in the UK charts and topping the hit parades in other countries as far away as Guatemala where it went to number one. However, my voice wasn't back to normal strength and I still couldn't sing live on TV shows or on stage. As a result, I had to keep refusing new engagements and also cancelling work that I had been booked to do prior to the operation. In early December I had to pull out of the lead role in the Christmas pantomime in Manchester Opera House.

Thankfully David Winter, head of Religious Broadcasting at BBC Radio, had asked me to record a thirteen-week music series called *I Believe in Music*. I wasn't sure if I could even manage that, but as it involved only speaking he convinced me that I should go ahead with it, and slowly but surely my confidence increased as I recorded the radio series.

By the New Year, 'Fairytale' was still high in the British charts and my confidence was well improved. Dick Leahy had found another song for me that he felt would break the US charts. It was written by Tony Macaulay, a brilliant song writer with a long list of hits that included titles like 'Build Me Up, Buttercup' for the Foundations, 'Love Grows Where my Rosemary Goes' for Edison Lighthouse and the Drifters, and 'You're More Than a Number in My Little Red Book'. Tony had just written and produced a massive worldwide hit record called 'Don't Give up on Us, Baby' for David Soul, star of the hit TV detective series *Starsky and Hutch*, and he had contacted Dick Leahy to say that he had written a song for me. The song was called 'Put Some Words Together' and he wanted to record it with me in Los Angeles where he was working on an album with David Soul. I was more than a little nervous at the thought of going into the studio, but Tony assured me that we would take things very gently, so off I headed for Los Angeles.

The recording session was held in A&M Studios, just off Sunset Boulevard in Hollywood, where we met one of the studio owners, the legendary trumpet player and the 'A' in the company name—Herb Alpert. The musicians on my session were outstanding and we even had Elvis Presley's lead guitarist playing on the tracks. It was interesting to me that the musicians preferred to work without written music; they just played the songs together till they came up with various ideas for musical riffs or phrases. There was no time pressure; they just played till they felt they'd got it right.

I really enjoyed this stage of the recording, but when it came to putting down my vocal, it was pure agony. Normally it would have presented no problem at all, but a combination of tension and the weakness of my vocal cords meant that I was struggling to sing notes as my voice continually wandered off like a kite on a stormy day.

Tony Macaulay did wonders with my very flawed recording, but on my return to England my voice went from bad to worse. I was taking part in a TV special with Bruce Forsyth. It was a very big affair, with stars

like Nanette Newman and Lesley-Anne Down also taking part, and it should have been a real pleasure, but my doctor diagnosed that I had had a relapse and would have to go back to the beginning of the healing process.

It was such a frustrating time. Career possibilities were waiting to be taken and offers of songs were coming in from a number of top writers. Barry Gibb of the Bee Gees was one of those who wrote to me during those months. Although the Gibb brothers had gone through a difficult period themselves around that time, they were in the process of writing some excellent material. Barry told me that they had a number of songs they felt were ideal for me and asked if I'd be interested in recording some of them. Who in their right mind would turn down a Bee Gees' song? I *had* to and there was absolutely nothing I could do about it.

The public and promoters wouldn't have been aware of the difficulty I was in as I was constantly in the media and still appearing on television shows, though always miming. I was keeping up this happy, successful front but I was beginning to feel that I was climbing a never-ending mountain range. Every time I moved forward a little and felt that my voice was getting stronger, I would slip back and end up at square one again.

I thought it was inevitable that the record company and I would soon come to a parting of the ways; however, Dick Leahy showed great faith in my recovery. He never applied pressure for results and I'll never forget his kindness and his patience.

Around this time I came home one afternoon to find on the kitchen table a newspaper article announcing that I'd had to cancel yet another singing engagement. I had tried to keep up a good front for my family but I suddenly felt hopeless and for the first time I experienced a feeling of despair. My father was ill, my family depended on me and I wasn't able to work. I was alone in the house and at that moment I felt totally alone in the world, because there didn't seem to be anyone who could help me. I hit rock bottom that afternoon and, after sitting for what must have been hours at the kitchen table, I remember looking up and saying, 'If there's anyone there you've got to do something. I can't do any more'.

There was no flash of light, but immediately a thought crossed my mind that I should ask my throat specialist for the name of a singing

teacher. It seemed such an obvious thing to do, I wondered why it had taken me so long to think of it and I immediately telephoned my doctor. He gave me the name of Madame Florence Norberg. I explained my problem to her, adding that I was just a pop singer, and she replied in a very firm tone, 'Never say you're "just a pop singer". You are a singer regardless of what you sing.'

Florence Norberg was a classically trained singing teacher, who taught what is known as the Viennese method of singing and included Dame Kiri Te Kanawa as one of her students. But she was much more than a singing teacher to me. She became my therapist, counsellor and friend. She was a very strict teacher, but also very loving. When she would ask me to sing a note and two notes would appear, I would panic because I had no control over my voice, but when she'd see the look of fear on my face, she'd tell me firmly, 'Don't listen to your voice. Listen to me!' or 'Give me your mind and I'll give you your voice!' It was a mental and physical battle and I'd leave my lessons mentally and physically drained, feeling as though I'd been beaten around a ring by a heavyweight boxer. Other times I'd go to her and she'd begin by putting her arms around me and just let me talk, or cry out my feelings.

It was a long, gradual and fiercely difficult journey with Madame Norberg, but it was exactly what I needed and she was truly an answer to the prayer I had blurted out at my kitchen table. First she had to get my trust, and then she could begin to get my damaged vocal cord to work. She used to say, 'A natural voice is lovely in the bathroom, but a disaster on the stage!' I was a trained classical pianist, but I had never studied singing, so I also had to learn how to protect my vocal cords. The first step was to learn how to breathe properly. The next was to learn how to speak so that I didn't tire out the cords; that meant projecting my voice to a higher pitch, which was my natural singing range. Then came the singing. It was a revelation to me and before long I was able to sing certain songs, which was a major confidence boost. However, it was to take the best part of five years before I could go back singing a long run of concerts in the way I had been used to, prior to my operation.

My next big step was the challenge of singing in public, for even though my voice was improving, the fear of singing in front of an audience, and breaking down, was overpowering. Kevin Shergold, who

helped run the Arts Centre Group (ACG), offered to organise a small concert for me in his local church hall. It was a private affair for family and invited guests only, most of whom were members of the ACG, and fully aware of my problem. I rehearsed an hour-and-a-half act with my choreographer and Madame Norberg and although I was very scared to begin with, I made it through without too many hitches. It was the most wonderful feeling to stand there at the end of my performance and know that I could sing before an audience again.

In December of 1977, I sang live on stage in front of a capacity audience at Caesar's Palace in Luton and went on to play to full houses for the week. A number of TV appearances followed and slowly the word began to go out that the girl really was back!

At the beginning of 1978 Thames Television offered me a one-hour special with full orchestra, a troupe of dancers and my choice of guests. I chose songs that were suited to my vocal range and I really enjoyed rehearsing my dance routines, choreographed by Nigel Lythgoe, an outstanding choreographer and friend I'd known for many years. He went on to produce many hit TV shows in the UK and the US, including *American Idol* and *So You Think You Can Dance*.

I was also offered a nine-week BBC television series with Rolf Harris, to be screened live on prime-time Saturday evenings throughout April and May. Then there were a new single and album to record, for release in early 1979. It was a happy and exciting time and as my voice and my career made their way back to normal, I felt it was time to take stock of where I was going in my life, in particular my relationship with Damien. What had begun as a friendship had developed into a long-distance romance, where for some periods it was three or four months before we'd see each other because of my career and Damien's commitments with the hotel.

My voice problems had allowed me time for reflection. I was in my mid-twenties and I knew that it was time to make some serious decisions. I really enjoyed Damien's company and deep down I knew that if I had wanted to be married, he had all the qualities I would want in a husband, but I also knew that I wasn't ready for marriage and I felt that it wasn't fair on either of us to keep our relationship going. I had a career to catch up on and it was clear to me that we had different priorities. I was also increasingly uncomfortable with

Damien's involvement in the Charismatic Renewal movement. I had attended a couple of prayer meetings at his invitation, but I felt ill at ease there, like a fish out of water. I was still struggling at times with my own belief in God and it didn't help me to be surrounded by people who obviously had no difficulty with that particular deliberation, although I later found a real sense of peace and happiness and a deepening of my own spiritual life through this movement.

After a lot of soul searching, I decided I should be honest with Damien and end our relationship once and for all, so I flew over from London and arranged to meet him in Derry. He suggested that we drive to Donegal town for dinner, and there I told him of the emotional dilemma I was in. 'I'm not ready for marriage and it's not fair on you to carry on our relationship,' I said, as an invisible weight lifted off my shoulders. To my great relief, Damien was remarkably understanding. He told me that he fully understood and said that we both needed to get on with our own lives. He then suggested that we enjoy our dinner and make the most of our evening together. I felt such a sense of relief and I think he did too.

Our conversation swung round to the topic of Irish dances and dance halls. I had missed out on that era, but Damien described how, traditionally, men would stand on one side of the hall eyeing the women who were lined up against the wall on the other side of the hall. Then as soon as the band began to play a new set, there'd be a stampede across the floor to 'tap' the woman of your dreams for the next dance. I was appalled. 'That sounds like a cattle market!' I said with total disgust. He was thoroughly enjoying my incredulous reaction and he suggested that as it was Saturday night, we should go to a local dance so that I could see for myself.

The nearest dance that night was in the Butt Hall in Ballybofey, a small town about twenty miles away and I agreed somewhat reluctantly to go. I suppose I was curious and I knew without doubt that it would be my last chance to experience this phenomenon. Despite having my hair in a pony tail and wearing very little make-up, I feared that I might be spotted and that the tabloids would have a field day if it got out that I was seen at a dance with Damien. But I needn't have worried. No one seemed to recognise me and it would certainly have been the last place people would have expected to see me.

It was exactly as Damien had described. The girls were lined up along the wall to the left side of the hall and the men were lined up waiting with bated breath for the right moment to charge! I'd never seen anything like it! Having proved his point, Damien suggested that I stand along the wall with the girls and he'd come and ask me to dance, so that I could fully appreciate this unique experience. Although I absolutely refused, he persevered. 'Go on,' he said. 'You'll never do this again in your life.' And like a fool, I fell for his powers of persuasion for a second time that night.

Having gingerly made my way to join the line-up along the wall, I nervously waited for Damien to rush over, which he did, but to my horror he asked another girl to dance! As I looked on in disbelief, a young man emerged from the tidal wave of testosterone, tapped me on the shoulder and said, 'Could I have the next dance?' It turned out that my dancing partner was on his way home from a wedding, which explained why he had a flower in his lapel and smelled like a brewery. Dying the proverbial death, I was whisked around the dance floor, as he came out word-for-word with every line Damien had forecast. I desperately searched for answers as I lied through my teeth, telling him I was a trainee teacher who lived about forty miles away in a town that didn't exist and I was with ten of my friends! It was all I could do to protect my dignity.

Every so often I'd look for Damien and see him glide by with the glamorous blonde, grinning at my predicament! When I got over my shock and indignation, I had to admit to myself that it was funny and as I looked at Damien it struck me in an instant that no other man I knew could make me laugh like this. I remember thinking that there was no one else I would rather be with at that moment than Damien and it was there and then I realised I was truly in love with him.

The Butt Hall in Ballybofey is not a place widely known for love stories but for me it marked another major turning point in my life. I'm not sure which of us was most surprised by the turn of events that night, but our relationship fundamentally changed. We spent more time together over the coming months than we had in the previous year and, by Easter, Damien and I had decided that we wanted to get married.

I had a very full work diary and so did Damien, as after the most recent bombing of the hotel he had begun a training course in a Dublin

centre for drug and alcohol rehabilitation, a place where he was to work as a counsellor for the first year of our marriage. All things considered, we couldn't find a suitable wedding date until October. We agreed that we wouldn't make our engagement public until July and so the media, which had been speculating about us for some time, were left puzzled by rumours of our impending marriage and the fact that I didn't have an engagement ring! I simply didn't want one; our personal commitment to be married was all that mattered to me and I felt it was a complete waste of money.

Damien, on the other hand, was in something of a quandary about this, as he feared it might look as if he was too mean to buy me one! However, at our July press conference, when the male members of the media were told that I just didn't see the necessity of having an engagement ring, there were amusing questions from the floor along the lines of 'How the hell did you get away with that, Damien? Have you any tips for us?' and so on. Damien was very relieved they dealt with it in such good spirits and we all had a good laugh about it.

As the year progressed and we made preparations for our wedding, our lives were nothing short of hectic. Damien was busy working between the Ardmore Hotel and his course in Dublin, and I was equally busy in London recording my long-awaited album, to be called *The Girl is Back*.

After the success of 'Fairytale', Barry Blue was asked to produce the new album and it was one of the most demanding but rewarding studio sessions I'd done to date. He had just finished working on an album entitled *Central Heating* for the brilliant new US/UK soul band called Heatwave, who'd recently topped the charts on both sides of the Atlantic with a dance single called 'Boogie Nights'. The band featured a quiet, unassuming musical genius called Rod Temperton. I'd got to know the guys in Heatwave pretty well as they too were on the GTO label and, as it happened, we were working in the same studio complex that summer. So every so often they would pop in to see how our recording was progressing, and we would do likewise with them.

One day when Barry and I were working on the backing vocals of the proposed first single release from the album, called 'Something's Cookin' in the Kitchen', Rod Temperton called in to say hello. The song had a very unusual arrangement and we felt it needed more backing

vocals than your usual 'oohs and aahs', so Barry asked Rod to listen to the track and let us know if he had any thoughts. Rod sat down, listened to the track a couple of times and, before leaving, he took out a cigarette packet and jotted down some notes on it. About a week or so later, Barry and I had already finished with the track when Rod put his head round the door again and said, 'I've been thinking about that song you played for me. Have a listen to this and see what you think.' He had completely re-written the backing vocals throughout the song, and the harmonies he had created were incredible. They were also very difficult to sing, with discords and counter melodies and an extraordinary vocal range, so Rod worked with me until I had completed recording the new vocal parts.

I cannot find enough words to sum up the brilliant creativity of Rod Temperton. It's only when you read the long list of hit songs he's written for so many famous artists that you get a glimpse of his extraordinary talent. Among others they include 'Off the Wall' and 'Rock With You' for Michael Jackson; 'Give Me the Night' and 'Love Times Love' for George Benson; 'Sweet Freedom' for Michael McDonald; 'Love is in Control' for Donna Summer; and 'The Dude' for Quincy Jones. And if that wasn't enough, Rod also penned the song 'Thriller', the title track of Michael Jackson's 1983 album which went on to sell over 60 million copies worldwide—to date the biggest selling music album of all time. Rod always remained an unassuming, generous and thoughtful person, as was confirmed to me when we worked together again some years later.

Meanwhile, back in the studio the last recording session for the album *The Girl is Back* was finished at 7 a.m. one mid-September morning, after which I flew back to Derry to wrap up the final preparations for the wedding. As it happened, our wedding day, 5 October 1978, fell on the tenth anniversary of the first civil rights march in Derry. Because of the significance of the anniversary there were fears expressed in the media that there could be a flare-up of violence. There were also suggestions that we had deliberately chosen that day, but it just happened to be the date that best tied in with our honeymoon flight schedule. As the day approached, I was anxious that there would be no problems in the town, an anxiety shared by the many guests who were travelling from overseas to be with us.

The night before our wedding, as we left St Eugene's Cathedral after our rehearsal, one of our wedding party asked if we'd thought about erecting barriers outside the church the following morning, just in case a crowd turned up. Damien and I dismissed the idea; we didn't anticipate a crowd and even so, we were getting married on a Thursday morning, a normal working and school day, so we didn't think there'd be many people about.

However, when I arrived at St Eugene's Cathedral there was a crowd of about 3,000 people gathered in the grounds. We had to stop the car about ten yards from the church porch and it took my uncles Mixey and Jim almost fifteen minutes to get Dad and me out of the car and into the church itself. Inside, the church was packed like never before. The pews were completely full, with standing room only in the aisles, and women and children sitting along the altar steps. The Cathedral looked magnificent, the choir sang to perfection and the wedding ceremony was beautiful as Damien's brother, Fr Kevin Scallon CM, married us in the presence of Bishops Neil Farren and Edward Daly.

As the Cathedral was 'in the round', Fr Kevin had suggested that we make our wedding vows on the altar beside him, which meant that we were able to look down at the congregation, and I began to notice that each time I glanced out, it seemed as though the seats occupied by our invited guests were gradually beginning to empty! I didn't know if I was imagining it, or if something was wrong and no one could tell us. It turned out that my uncles had worked out a plan to avoid any possible chaos when the time would come for us to leave the church. The already large crowd outside had swollen even further, so like a 'bush telegraph' the word was passed to all able-bodied men to make their way outside in order to form a human chain that would keep back the crowd and allow us to get into the car and out of the church grounds in safety.

When we eventually exited the church doors we were greeted by a massive throng of people and media representatives. They were everywhere, hanging on to the railings, on walls, on tops of cars, and there in the middle of it all was the extraordinary sight of my uncles dressed in morning suits, linked arm-in-arm with other family members and wedding guests, desperately struggling to keep the crowd from closing in and crushing us. After some photographs for the press

we eventually made it into the back of the wedding car and it slowly inched its way down the drive.

As we were driven towards the Everglades Hotel on the other side of the River Foyle, I was really surprised to see that along the entire route the streets were lined with cheering, happy people. I later learned that many factories and schools had closed for the half day to allow people to come out and celebrate our wedding with us. It was such a wonderful sight, especially as the international press gathered in the city had anticipated a very different reaction on the streets that day, and in subsequent news reports the celebrations on the streets were depicted as a 'symbol of new hope'.

By the time our guests made it to the hotel for the reception, the men were like a band of brothers sharing tales of their brave escapades with the huge crowd outside the church. It was six o'clock that night before we sat down to a fabulous meal. With everyone wined and dined and the speeches over, the music and dancing began. There were so many musicians at the wedding that we didn't even need a band. Our friends and family just got up on stage and played and sang throughout the night, my sisters and I joining in at one point with some of our old party pieces! There was such a relaxed, happy atmosphere that any earlier fears on the part of our visiting guests about the situation in Derry were quickly overcome. Some of them stayed on in the city for much longer than they had intended. In fact the festivities went on for four days! Even those who had to leave earlier took the party spirit with them; I'm told that Nigel Lythgoe insisted on dancing up and down the aisle of the plane singing 'California, Here I Come'.

Damien and I had to catch an early-morning flight to London the following day. From there we flew to Barbados and stayed at the fabulous Sandy Lane Hotel for a couple of nights, where we were delighted to meet and have dinner with Bob Monkhouse and his wife. Then it was on to the tiny island of Grenada where we stayed at the Spice Island Inn. Our villa sat on the edge of a white sandy beach, surrounded by crystal-clear blue water and palm trees. There was no radio, television or newspaper in the hotel, just glorious food and friendly, helpful staff. After the hectic schedule of the previous year and the build-up to the wedding, our honeymoon was bliss: total relaxation in an earthly paradise.

Of course no matter where you go, you'll always meet someone from home, and in our second week we met some Irish nuns and priests who were working on the island. They told us of a young priest, Fr Seán McGrath, who had a parish up in the mountains and apparently came from a village just a few miles away from Damien's home in Irvinestown. We spent a lovely afternoon with him, during which the children in his school sang and danced for us and we all tucked into a delicious dessert of fresh guavas and home-made mango ice cream. At the end of our three weeks on the paradise island, we were ready to head back to our new home in Rostrevor, where we planned to spend our first Christmas together.

My father and mother on
their wedding day.

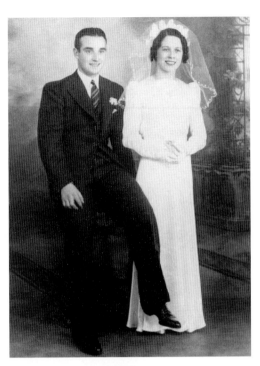

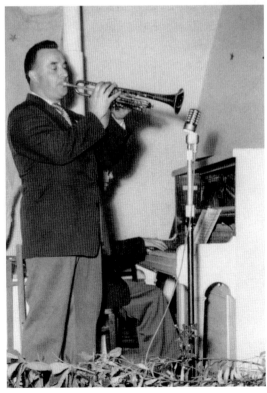

Dad on the trumpet.

In Dad's arms in London, with Robert and Eileen.

On holiday in Burtonport with my parents, Gerald and John.

At Portadown Feis in 1963
with Hilary Lemon.
(*Belfast Telegraph*)

Our ballet class at Derry Feis with the Mayor and the Countess of Rosse.
(*Londonderry Sentinel*)

The sheet music for 'All Kinds of Everything', released after the Eurovision.

Showing the Eurovision medal to President de Valera with song writers
Jackie Smith and Derry Lindsay.

In the Derry Guildhall with Miss Watson and friends. (*Londonderry Sentinel*)

A great team in 1974 and one that's still working together today; John on left, and Gerry.

(*Michael Dunlea*)

With Val Doonican in
1972, with Cliff Richard
at the Royal Albert Hall
and with Harry Secombe.
(*Willie Carson*)

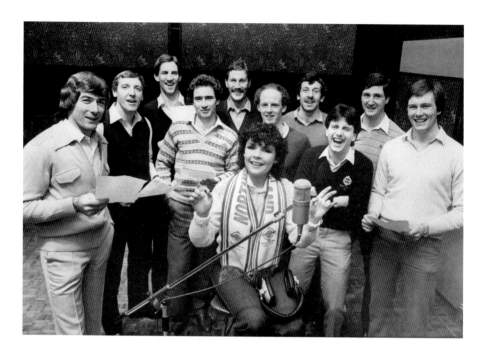

Football crazy! With the great 1982 Northern Ireland World Cup team (above) (*Belfast Telegraph*) and Kevin Keegan (below) (*BBC*).

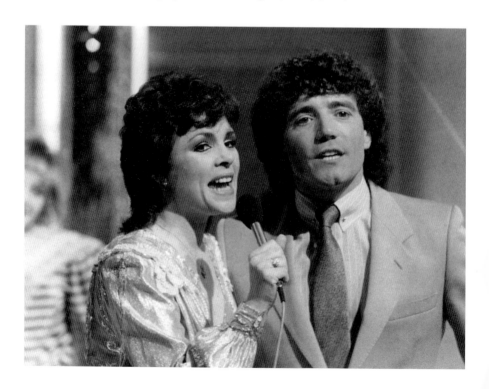

Chapter 7 ✍

FAMILY MATTERS

Damien and I shared our first Christmas together with members of both our families in the Georgian house Damien had bought a year earlier. It was near the picturesque village of Rostrevor, surrounded by the Mountains of Mourne. Set in eight secluded acres of gardens, it was a beautiful place to live and though the house had been neglected for some time, over the coming years we gradually restored it to its original condition.

Our new neighbours made us very welcome and we soon settled into the community. The Ardmore Hotel was up and running again after the previous bombing, so Damien would set off for work each day, just a short twenty-minute drive away in Newry, while I faced the challenge of running my own home. I was a very inexperienced cook and I found it daunting trying to expand my limited menu of scrambled eggs and bacon, vegetable soup and sherry trifle, especially as Damien could make a meal out of just about anything. I made up for my lack of culinary skills, however, by making sure that we had liberal helpings of apple pie, smothered in cream, for dessert each night. Unfortunately the only thing that expanded was our waistlines!

But there were other more important challenges I had to face. I knew that in order for me to adjust to married life, I needed to have time with Damien and I told my record company and agent that I wanted to cut back completely on live work, so that I wouldn't have to be away on the road for weeks on end. Having taken such a long time to commit to marriage, I wanted to do everything I could to ensure our relationship would succeed and so it took precedence over everything else in my life. There were certainly challenges in adjusting to married life. For one thing, I suppose I'd been an independent career woman for

so long and the demands of my career meant that people and events had to fit into *my* schedule. Now I had to share my life and my decisions with another person.

I found that insecurities buried deep inside me began to surface. One of those fears and inadequacies, embedded from childhood, was that I had always had a very poor self-image; in fact I felt I was ugly. As I'd grown up I'd learned to deal with it, but I hated anyone to see me without make-up and I would never leave the house without putting it on. I also had an inferiority complex, not an unusual trait in people of my generation and, as normally happens, I'd buried my childhood anxieties and their origins so deep I'd almost forgotten they were there.

But allowing someone into my life at the very intimate level that marriage demands seemed to stir up what lay hidden inside, and although I knew that Damien loved me, I gradually began to feel very insecure. I became over-sensitive to what he said or did and I would often feel fearful, angry and guilty about how I was acting, all at the one time. The worst thing was that initially I found it impossible to talk to him about how I was feeling, no doubt because I couldn't understand it myself.

However, Damien was very open and he suggested that each day we set time aside to talk. Uncovering the root of my childhood anxieties was a surprisingly painful exercise, but as Damien would say, 'The truth will set you free, but first it will make you miserable!' As I came to understand myself better, I also came to know Damien on a deeper level. It didn't mean that we hadn't disagreements to deal with, but it was a new beginning for me and for us.

Although I wasn't doing live work, I did have media promotion for my new single, 'Something's Cooking in the Kitchen', which had been chosen as the first release from my album *The Girl is Back*, so I was kept busy from March onward, appearing on UK television shows like *Top of the Pops, Swapshop, Pebble Mill at One* and in Ireland on the *Late Late Show* and *Live Mike*. I could travel to the studios and back in a day or two, so thankfully it meant that I didn't have to be away from home for long. The record company had planned a big marketing campaign for the single, using some new ideas from America. We filmed a video, a very innovative idea for the time, sent out floppy discs of the track to all the dealers and put up larger than life-size posters throughout main cities in the UK, the London underground and British Rail stations.

The first time I saw one of the posters I just wanted to hide. I felt embarrassed looking at myself staring down from the wall of the underground station.

While the single had a lot of media exposure and entered the UK charts at number 41, the sales could have been better. I think, looking back, it was a very different style of song for me and my audience, and while I enjoyed performing it on television, I still didn't have the vocal confidence to sing it live. In the US the album had received a really good review in *Billboard*, known as the 'bible' of the American pop world, and in Europe the single was doing really well. Damien was able to accompany me on a very enjoyable, if hectic, European media tour.

When we returned, I was surprised to learn that I had been voted the Top Female Vocalist in the National Club Acts Awards for 1978/79. David Jacobs presented the award and, having watched his hit TV show, *Juke Box Jury*, as a child, I could hardly believe I was receiving my award from him—a beautiful bronze sculpture of a harlequin.

I was also asked by the BBC to present my own children's TV show in the autumn, called *Good Morning Sunday*. The series was filmed in studio with children from different primary schools taking part each week. I also travelled around the country visiting primary-school children in various cities, asking them their feelings on themes such as fear, love, faith, anger, forgiveness, and so on. Each theme would be amplified through songs I would sing in the studio with my brothers Gerald and John, who were special guests on the series and wrote the music and songs for it.

All in all, everything was going along well until June of 1979 when the Ardmore Hotel was blown up yet again by massive bombs planted by the Provisional IRA. Damien and I were at home in Rostrevor when the alarm call came through and by the time we reached the hotel, thankfully, guests, staff and family had been evacuated to safety with only thirty minutes' warning. There was apprehension and fear in people's eyes as we stood huddled together on the roadway waiting for the inevitable to happen. Then suddenly the first bomb shattered the silence and the vibration shook the ground we were standing on. There were involuntary screams and some of the older women were in tears, knowing instinctively that this was the end of the hotel and of their future livelihood. We had to wait for the other bombs to explode, four

in total, before we were eventually allowed to make our way apprehensively to the bottom of the hotel driveway. We could see the thick pall of billowing smoke and the flames licking the once-clear blue sky of that beautiful summer day.

Townspeople had begun to gather as word spread that the Ardmore, the last big hotel in Newry, had been bombed once again. The building was ablaze and we stood on the driveway with our arms round each other, watching the inferno that was to rage for two days. It was a devastating sight. Within a matter of hours the whole front of the premises was gutted and by that night the Ardmore Hotel was a burnt-out shell, the roof having collapsed down through the building, taking all four storeys in its path.

Five other hotels had been bombed that same day, one of them just outside our village of Rostrevor, and the North was in turmoil yet again. On the third morning we were allowed closer to the hotel and though the embers were still smouldering, we were able to peer through the smoke and dust to make out the extent of the damage. The façade had collapsed, leaving only one main support wall standing. Firemen were still dousing the embers and the fire chief was discussing whether it would be safer to have the support wall demolished, when a voice shouted out for everyone to look up at the remains of the fireplace of Gerald Scallon's first-floor apartment. There, balanced half on and half off the burnt mantel, was a bust of Christ that Gerald had placed there three years earlier. It had survived the flames and the force of the upper floors and roof crashing through the room to the basement below, taking all before it.

The statue of Christ had remained untouched in its place and many people were moved to tears by the significance to them of this incredible sight. Despite protests from his colleagues and many of us present, one of the firemen insisted that he be taken up on an extending ladder through the ruins, so that he could lift the statue down before the support wall collapsed. We held our breath and some prayed out loud as the fireman was lifted up through the shattered building, and we cheered when he lifted the statue high in the air, as he was brought back down to safety.

There was quite a crowd around the hotel. Members of staff, many of whom had worked for the Scallon family for over twenty years, stood

shoulder to shoulder with local people who had been regular patrons of the hotel. Some of them had been married or had celebrated other special family events there. The loss of the Ardmore impacted heavily on the community, for as well as being a place of work or leisure, the hotel was also a focal centre for the major artistic and cultural events in the town. Now all of that was gone.

As the hotel had been painstakingly rebuilt after the four previous bombings, it was very sad to realise that this was the end of the road for the Ardmore. Damien felt a huge sense of responsibility towards the staff. They really were like a family who'd supported each other each time a disaster had occurred. Thank God, in all the years of the troubles, no one had ever been injured in the Ardmore, but there was no sign of a peaceful future and Damien and his family felt that they could not go through the long and difficult process of re-building, just to see their work blown to smithereens again. It was the end of an era.

The year that had started off so well was in tatters six months later, and after we had spoken with a number of close friends, Damien was advised to get away from the place for a while and try to lift his mind. He decided to train as a group therapist in the Rutland Centre in Dublin, a rehabilitation centre for drug addicts and alcoholics that had been founded by a very gifted priest, Fr Raphael Short CP. When Damien was accepted we planned to move to Dublin within a couple of months, into a three-bedroomed semi-detached house in Drumcondra.

In the middle of July, as we were preparing for our move, I got a telephone call from Stuart Morris, head of light entertainment in the BBC. I had known Stuart as a TV producer since Eurovision, having worked with him on a number of shows. He asked if I had any plans for that Friday and when I replied that I didn't he said, 'Good. I want you to take the place of Dionne Warwick in a TV special that night.' I was stunned! I didn't feel confident enough about my voice and anyway how could we prepare a TV special in 48 hours?

But Stuart is a man who doesn't take no for an answer. It was nerve-racking but it was also a very exciting experience. I flew to London the next morning to decide on the songs I would sing. Having done that, I ran round the shops searching for some new outfits while the music arrangers worked flat-out writing scores for the full orchestra that would back me on the show. Then while my outfits were being altered,

I went straight into rehearsals. Everyone pulled together in what was a real emergency for the BBC and although the audience were expecting to see Dionne, they were just wonderful to me and it was an unforgettable night.

It was hard to think of leaving our new home in Rostrevor even on a temporary basis. We were only beginning to settle in and there was so much we wanted to do in the house. But then Damien had another narrow escape, missing a huge bomb blast near Warrenpoint by only seconds, and I began to feel that the sooner we moved to Dublin the safer it would be for him and for us.

During this period in Dublin I suffered a personal blow when my agent and friend Dick Katz passed away. Over the coming years, I worked with a number of other managers who, though very successful, could never replace the special relationship I had with Dick and his family.

Preparations were now under way in Dublin for the visit of Pope John Paul II to Ireland at the end of September and there was widespread hope that any call he might make to end the campaign of violence in the North would be heeded. Hopes were also high that the Pope would be able to visit the North but, in the interests of security, it was decided that Drogheda would be the nearest he could travel to the border.

As things turned out, I was in Manchester filming my children's series when the papal visit took place, but Damien made his way to the Phoenix Park in Dublin along with members of his family and a million other people. When I returned to Dublin we went to the Phoenix Park together to try and catch some of the atmosphere of that wonderful day. There were hundreds of people there who obviously had the same idea. A few days later as we drove by the site of the papal mass in Drogheda on our way to Newry, Damien mentioned the Pope's motto, 'Totus Tuus', which means 'Totally Yours' and how different he felt we would be as individuals and as a society if we lived by that motto ourselves. He suggested that we try to write a song based on it and by the time we reached home it was almost completed.

I thought our song would be heard only by family and close friends, but Damien felt I should record it and so I spoke to Dick Leahy. Dick liked the song and while GTO as a pop label wasn't the vehicle for it, he

fact he talked like him and even looked like him. Having made his mark in the world of folk music, Joe had gained a lot of respect in the business for the way he had recently guided singer Mary O'Hara from obscurity to global fame. When I told him about my decision to go to the NRB he was very negative about the idea, warning me that it was a big event and that I would be mad to go there without a proper invitation from the organisers. On top of that I'd be a fool to think they'd be interested in an Irish Catholic singing about the Pope's motto, because the Christian market in the US was controlled by Southern Baptists.

According to Joe, the only record company he'd recommend was one called Word Records, but it was founded and owned by Southern Baptists, so in his opinion I was wasting my time. I could see the sense in what he was saying. I knew nothing about the US Christian market but, nevertheless, I still felt I should go, so John and I flew over to join Sam in Washington.

When we arrived at the conference I understood what Joe meant when he said it was a 'big event'. There were nearly 10,000 people attending, with only major US Christian artists performing at it, and it was opened by the President of the United States, Jimmy Carter. I felt it would be better if the ground just opened up; then I wouldn't have to face Joe when I returned home. As we had only a few records with us, the first thing we had to do was get some cassette copies made and then we just walked around meeting friends of Sam, one of whom was a renowned classical organist called Diane Bish to whom we gave a copy of the tape.

There wasn't much interest shown in my recording, but as the word got out that an Irish Catholic singer and her brother had travelled all the way from Ireland, with just one recording and without having arranged to meet with anyone, we became objects of interest—if not suspicion.

Some time later I was in London recording a television programme when I was contacted by Kurt Kaiser. He explained that he was the Vice-President of Word Records, that he had been given a copy of my tape by Diane Bish, and that he liked it very much and hoped that perhaps we could work together. Kurt, who came from Waco, Texas, was very charming and very understated even though, as I discovered,

suggested that we record it ourselves and approach CBS, with whom GTO was merging, to see if they were interested in distributing it in Ireland. Within a week I was in Windmill Lane Recording Studios in Dublin. I wanted the arrangement to be authentically Irish and I was delighted that some excellent traditional musicians like Donal Lunny and Davy Spillane played on the track, along with backing vocals from a choir of young people who had sung at the Pope's Youth Mass in Galway. Rush-released by CBS Distribution on 12 December, 'Totus Tuus' went straight to the top of the Irish charts, sold almost 60,000 units and within four weeks Mike Murphy was presenting me with a silver disc on his RTÉ television show.

The public reaction to the song was quite unexpected and Damien had the last laugh at his siblings who'd told him as a child that he didn't have a note in his head! However, my releasing a song about the Pope had obviously left a number of media people in Dublin bewildered. During press interviews I was asked why exactly I had recorded the song and was I not worried about the effect on my career. It was becoming clear to me that in the minds of some, recording 'Totus Tuus' was seen as a major turning point in my career, even though I had performed and recorded religious songs throughout previous years.

In early January 1980 I got a telephone call from Sam Sherrard, a Protestant lay minister originally from Northern Ireland whom I had met when I toured Canada with the London Palladium Show. Sam had heard 'Totus Tuus' when he visited his relatives at Christmas and as he would be attending the National Religious Broadcasters (NRB) conference in Washington DC at the end of the month, he suggested that I come to it and bring a few copies of the record so that he could let some people hear it. I had never heard of the NRB and I wasn't at all keen on going. I had more than enough work to do and as Damien wouldn't be able to go with me—and it was always his ambition to go to the US—I didn't want to go there without him. My brother John was visiting us at the time and he offered to travel over with me, adopting the attitude of nothing ventured, nothing gained. After much consideration I felt that maybe I should go, much to the vexation of my new manager, Joe Lustig.

Joe was a dynamic, straight-talking ball of energy from Brooklyn, New York. He was a close friend of producer and actor Mel Brooks; in

he was a celebrated pianist and composer and had worked with just about everyone on the US music scene. He was aware that we were Catholic but that didn't seem to make any difference to him and when he discovered that we were booked to go to Florida on holidays in a few days' time, he asked if we would be willing to fly to Waco, Texas, courtesy of Word Records, and stay at his home. During our stay they hosted a dinner for us attended by other senior executives of Word Records, including the founder and president of the company, Jarrell McCracken.

As the relaxed and enjoyable evening wore on, there were requests for me to sing, so Kurt sat down at the piano and played the intro to 'Danny Boy', which went down a treat. When the applause had died down, Kurt asked me to sing a little of 'Totus Tuus' for Jarrell McCracken and when I'd finished Jarrell said, 'That will be the first song you record for Word Records.' And so it was.

Signing the Word Records contract was surreal. Eight months previously I had had no intentions whatsoever of drifting into Christian recording, as I was content working on my marriage and slowing down my pop-music career to my own pace. Now here I was signed to a Southern Baptist record label in Texas!

On our return from America I began working on my first album for Word which was simply entitled *Totally Yours*. I was also adjusting to— and rejoicing in—the first months of pregnancy. I was reluctant for anyone outside the family to know that I was expecting a baby, as I was understandably anxious, having had a threatened miscarriage at eight weeks. It was during this traumatic experience that I wrote a song to my unborn child, entitled 'Little Baby'.

Luckily, my build was so slight that nobody could see I was expecting for the first six months; however, as time passed, my carefully monitored pregnancy began to be noticed. The final TV show I was to take part in before the birth was a TV special for Ulster Television in October at the Royal Opera House in Belfast. Celebrating the twenty-first anniversary of the network, it was an all-star line-up including the Chieftains, Makem and Clancy, Mary O'Hara, Roy Walker and many others; it was hosted by Gloria Hunniford. With my baby due in a couple of months' time, I had a beautiful silk georgette floor-length dress designed by Sue Le Cash, a very gifted lady who did my stage and

TV outfits. It was very flowing, in a beautiful shade of green, and from the front at least I thought it disguised my ever-increasing and much-loved bump. But the following day the newspapers carried a 'side on' picture of me with the caption, 'What a Swell Party!'

Our first baby, Grace, was born in the Rotunda Hospital, Dublin, at six o'clock on the morning of 18 January 1981. Damien was a great support to me all through the long, difficult labour, which culminated in an emergency caesarean operation when the baby became distressed. Holding her in my arms for the first time was an amazing experience; there was a sense of awe that this perfect little person had been living within me just hours before, and from a short time after her birth both Damien and I felt as though she had always been with us. However, with the combination of lack of sleep and post-operative shock, I found myself struggling with feelings of post-natal depression. But there was an immediate problem to be dealt with: the media were clamouring for interviews and photographs.

My press agent, Clifford Elson, felt that the best way to handle this was to bring in just one photographer, who could then pass the pictures on to newsrooms in Ireland and Britain. Clifford felt it would be less stressful on me and the baby. However, the Irish media were furious. As they saw it, my London agent was trying to control what photographs they would be given. There were some angry meetings between Clifford and the photographers, and unfortunately such a backlash was created that the Irish media boycotted the pictures. I was deeply uncomfortable about this situation, as over the years I had got to know most of the Irish photographers and journalists personally. Clifford, to his credit, put his hands up and blamed himself for the furious row that had ensued, but in truth he had just been trying to protect me.

We wanted a big family christening, so when Grace was about three weeks old we headed north to our home in Rostrevor. Grace was named after my grandmother Brown and my sister who had died as an infant.

At the beginning of the year my agent had called to say that I had been offered a twenty-week summer season in Torquay. As Damien had completed his course at the Rutland Centre in Dublin we discussed what we should do as a family. We felt that a new phase was beginning in my music career and that as things were still very tense in the North of Ireland, perhaps Damien should work more with me on the

show-business side, so that we could be together. However, we both agreed that Grace should not take second place to our work. It made sense to us then that if I were going to continue with my singing career, it would be best to do so while our baby was young enough to travel with us. Nevertheless it had been almost five years since I had undertaken such a prolonged period of live work, and even though Madame Norberg had assured me that I was well able for it vocally, the closer I got to the beginning of the season, the more nervous I became.

It was a very busy period for us; we had to move back to our home in Rostrevor where, alongside the sleepless nights with Grace, I had to work on my new album for Word Records, which thankfully was recorded in Dublin. By that stage I was very tired and Damien suggested we take a couple of days away in the west of Ireland to recuperate. It was a life-saver, and an impromptu visit on our way back home provided the inspiration for a song that proved to be very important to us.

Damien suggested that we visit Knock in Co. Mayo. I wasn't particularly keen to go, as I wanted to return to Rostrevor as quickly as possible. However, as it was just a short detour, we decided to attend the 9 a.m. mass and take a little walk around the shrine. I found it a very peaceful and relaxing place, and as we were leaving we met the young curate at the gate. He spoke to us about our song 'Totus Tuus' and asked if we could write a song like it for Knock. I declined immediately but I told him that if they did find a song they liked, we would help to make sure that they got it recorded. With that, we got into our car and headed for home, but on the journey to Co. Down, a song basically just wrote itself and we called it 'Lady of Knock', also known as 'Golden Rose'.

As I was scheduled to record some new pop tracks in London on my way to Torquay, I recorded 'Lady of Knock' at the end of the session and we sent a copy of it to the curate. We didn't intend to promote the recording in any way; we didn't want people to think that we were simply churning out a new Christian song because of the success of 'Totus Tuus'. Shortly after this, Monsignor James Horan, the parish priest of Knock, wrote to us asking if we wanted to enter the song in the competition he was holding to find a new theme song for the shrine, but we declined the offer. Damien and I were happy just to supply the song to the shop at the shrine when and if they needed it.

I never did a radio or press interview about the record and we never spent a penny promoting it, so you can imagine our surprise some years later when, on a holiday in Florida, we met an Irish-American gentleman by the name of McNamara. He was from Boston and he informed us that he listened to Irish music each day as he drove to and from work, adding that his favourite Irish song was 'Our Lady of Knock'. It turned out that our composition was the most popular song on Irish radio stations up and down the east and west coasts of America and that it had been recorded by almost every prominent Irish artist in the US.

As the opening night of my summer season in Torquay approached I was a nervous wreck. If I sang for even a couple of minutes, I would get pains in my neck and up into my head and at times I felt as though I couldn't take in air. Damien suggested that I see a local doctor, and Dr Jack Coughlan came highly recommended. His surgery, which resembled a ransacked library, was the front room of his Victorian home and though Dr Coughlan, who hailed from Cork, was welcoming and full of chat, he had the air and appearance of an absent-minded professor. Almost as soon as I began to describe my symptoms, he sprang up from his desk and rummaged his way along a shelf heaving with medical volumes. Having found the one he wanted, he flicked through a couple of pages and triumphantly slammed his index finger on a paragraph, announcing, 'Yes, this is your problem.'

Dr Coughlan then placed the weighty volume on my lap with a flourish and I read an exact description of all my aches and pains. There was nothing wrong with my voice, he told me; my problem was anxiety, pure and simple, and as he rightly said, there were no pills he could give me for that. He then called his wife in to say hello and asked her to put on the kettle and make us a pot of Irish tea. For the next hour we sat round the kitchen table and talked and talked. Jack and Pauline became our close and trusted friends and, as well as keeping an eye on me through a difficult period, they took great care of Grace and also our other children when we returned to Torquay some years later.

Once the opening night was over, the twenty-week season went by without a hitch and played to packed houses. After a much-appreciated holiday, Damien and I went straight back into the routine of TV shows and live performances, and my work with Word Records also

necessitated a number of trips to America to promote my newly released album.

Dick Katz and subsequent agents had expressed concern that my religious recordings might impact negatively on my pop career, but it seemed that though there were some negative comments in the pop press, as far as the public was concerned, far from impacting negatively, my career strengthened and I found that I was able to continue concentrating on my pop career in Europe, while promoting my Christian work in the US. Over the next few years Kurt and I toured together throughout most of the United States, taking part in all of the major Christian radio and television shows, as well as doing some live concert work.

Kurt was a personal friend of many Christian artists and leaders and because of his recommendation and my involvement with Word Records, I was invited in the mid-1980s to sing at two major rallies with the Reverend Billy Graham; one of these was held in Boston College in the US and the other in Wembley Stadium in the UK. Billy Graham was a major evangelical force within the US and throughout the world, so hundreds of thousands of people attended both events. I was curious and even somewhat sceptical about the kind of man he would be. As a performer myself, I am aware of how it was possible to manipulate an audience, but he spoke with simplicity and sincerity and I would say that he was a humble and good man. He encouraged me to share the fact that I was a Catholic, even though this did result in some serious complaints from those evangelicals who had a problem with Catholic teaching. It was reassuring that he didn't give in to this pressure and that in his rallies he encouraged people to go back to whatever church they belonged to and become better Christians and members of that church.

Word Records, however, had to be careful with its mainly Evangelical distributors and retail outlets, so I could not record anything that could be interpreted as being overtly Catholic. I could understand the dilemma but gradually Damien and I felt that I needed the freedom to record whatever I felt led to do, and although I was to move on from Word Records in the mid-1980s, I continued to work and share a friendship with Kurt Kaisser and others I met during my time there.

Having learned the pitfalls and restrictions involved with being contracted to a record label, Damien, my brother John and I had set up our own company in early 1980, which we called Lite Productions. This not only gave me greater freedom in the choice of music I recorded, it also allowed us to decide on the record company we would like it released on, as we had done with Word Records. It meant that I was able to record both Christian and commercial material, some of which we wrote, and through this period I enjoyed some chart success in England and Europe.

It was exciting to be able to delve into various types of music. One of the most unusual and enjoyable experiences for me was when my brothers, John and Gerry, and I co-wrote the theme song for the Northern Ireland soccer team, which had just achieved the unthinkable by qualifying for the 1982 World Cup finals in Spain. The song was called 'Yer Man' and was inspired by the Belfast logo—a cartoon drawing of a little man wearing a flat cap, with a cigarette hanging out of the corner of his mouth. The team loved the song, so we went into the studio with the squad and recorded it alongside soccer greats such as Pat Jennings, Gerry Armstrong, a young Norman Whiteside and Martin O'Neill. We had some laughs trying to get these guys to sing, and though it was not their area of expertise they did a great job belting out the immortal lyrics:

When yer man gets the ball,
Northern Ireland has it all,
Oh! we'll have a go and the goals will flow
When *yer man* gets the ball …

I was in summer season in Blackpool's Opera House with comedy duo Little and Large when the World Cup took place, and Damien and I were glued to the television for every match. Unfortunately, the quarter final qualifying match against Spain conflicted with our Friday-night performance. Of course everyone assumed that Spain would win, but at the finale of our show Eddie Large announced that *my* Northern Ireland team had beaten Spain, and the 3,000 people present in the hall erupted into cheers and applause, as Eddie and Syd lifted me shoulder high.

Our second daughter, Ruth, was born the following 18 August 1983 in Daisy Hill Hospital, Newry. I wanted a natural birth and I was so worried that I might end up having another caesarean, but thankfully Ruth made her own determined way into the world in the early hours of the morning. She was dark-haired in contrast to Grace who was blonde, and the first time I held her in my arms I thought she looked like a beautiful little Jewish child with her tiny dark curls pressed onto her head, and so we called her Ruth. We were so delighted with her as we did battle with the nappies all over again, and we had a few lovely months in Rostrevor before moving to London in November to prepare for the West End opening of my pantomime, *Snow White and the Seven Dwarfs*.

The previous year the writers of the show, Dennis and Basil Critchley, had approached me to do a pantomime in the north of England. The *Snow White* book, written by their father for Ruby Murray, had not been staged for over thirty years and although the theatre was not keen on the production, preferring a more popular panto like *Aladdin*, the choice was up to me and I immediately opted for *Snow White*. It was to prove a good choice; the show was a phenomenal success and was moved to the Phoenix Theatre in London's West End the following year, where all of Noël Coward's plays had been staged.

It was such a thrill to be in the West End; there really is a sense of being part of a theatrical community, and it was quite magical especially as I was using Noël Coward's dressing room. I used to imagine him making up in front of the same mirror. Again the run was very successful. In fact one particular weekend we had the biggest box-office returns for the whole of the West End. I was to go on to star in this wonderful production, which continued to break box-office records, for the next fourteen years.

During my pregnancy with Ruth, Damien and I discussed the best way to deal with two children on the road with us. We didn't want them to be pushed from pillar to post and as a great deal of our work was in the UK, we felt that we needed a base in London so that they would be close to us. It would also mean that they would be able to get to know their grandparents, my mum and dad, who would be near at hand for those times when we couldn't take the children with us to Europe or the US. So we began looking for an apartment and found one on the borders of St John's Wood and Maida Vale.

We also agreed that if we were to plan a summer season and a panto each year, we would have two substantial blocks of time when we could all be together in one place. After much searching and prayer, we found a wonderful nanny in Sue Sheard. She was a PE teacher by profession, having taught in a girls' private school in North Yorkshire, but she had also worked as an auxiliary geriatric nurse in Leeds, as well as doing some general nursing in London, so I knew that when I couldn't be with Ruth and Grace they would be in safe hands. Sue is still with us today and is an irreplaceable part of our family.

With two shows each day and a new baby at home, I seemed to be continually exhausted, but when this tiredness increased even after the pantomime had finished, I decided to visit the doctor and see if he could give me anything to boost my energy levels. Well, he couldn't do much to boost my energy, but he certainly got to the root of my tiredness: I was pregnant for the third time! Initially a sense of panic set in and I wondered how I was going to cope. I'm sure my agent groaned when he heard the news but I was able to go ahead with my summer season in Great Yarmouth, alongside comedians Tom O'Connor and 'Les Dennis and Dustin Gee'. Bella Emberg, a lovely actress and comedienne who played 'Blunder Woman' on Russ Abbott's ITV series, was also on the bill. She was a very 'big lady'; however, by the end of the season it was difficult to tell us apart!

The year was complete for me when John James Robert was born in Westminster Hospital, London, on 5 November 1984. As he was delivered, we could hear the fireworks, celebrating Guy Fawkes Night, that had been set off just across the river at the Houses of Parliament, so our lovely baby had quite a dramatic welcome into the world! John James was a very calm little baby and the five weeks at home with him after his birth were a real oasis for me; then it was back into panto rehearsals for Wolverhampton. It was a traumatic wrench to have to go back to work so soon, and for that panto season my dressing room resembled a nursery! The other members of the cast played their part too in keeping Grace occupied while the babies slept; she even got to join in the children's chorus!

Over the next few years our work pattern remained virtually the same; summer season, pantomime, with concerts, television and recording in Europe and the US in between. It was a very busy and,

thankfully, successful time. The main challenge was ensuring that I wasn't away from the children for any length of time, because it made me feel very down and also guilty that I couldn't be there for them. This was to become an ever-increasing challenge as the years passed.

The one major blot on our happiness was my father's deteriorating health. Since his first heart attack in 1976, he had developed many health complications and eventually after two further coronaries and open-heart surgery, he was diagnosed with gangrene, which eventually necessitated the amputation of both his legs. It was a terrible blow for him but, determined not to give into the depression that naturally follows such a loss, he kept as active and involved in things as he could. He was a bit of a radio buff and he found that through the night when he couldn't sleep, it was a great comfort to listen to a small local radio station broadcasting from Co. Donegal. He soon got to know the people working there as he regularly called in to chat and make requests for friends and family.

One of the disc jockeys asked him if I would be willing to present a Country Music Award on behalf of the station, to a young up-and-coming country singer from Donegal. Of course I agreed, so Mum, Dad and I went to Buncrana where I handed over a statuette to a young man called Daniel O'Donnell. After the show I had the opportunity to speak with Daniel and his family. His mother Julia told me how hard it was for him to get on television in Ireland, and as I was about to record a new music series for RTÉ, I invited Daniel to be one of my guests; it was his first-ever appearance on television and he was great.

During the summer of 1987 I was appearing at the North Pier Theatre in Blackpool and it was there that I first met Bobby Ball and his wife Yvonne. Cannon and Ball were the top comedy duo in the country, with a highly successful TV series and a feature film in the cinemas. I felt very cautious of Bobby because he had a reputation for being very fiery and unpredictable and, in the showbiz fraternity, stories of the difficult relationship between him and his stage partner, Tommy Cannon, were legendary. So when Damien and I were told by a friend that Bobby had become a Christian and that he and his wife wanted to meet with us during the summer, my first reaction was very negative because I found it hard to believe that he could have changed so much.

We met up at a rock and roll event Bobby ran each year for charity, and I was completely taken aback at how humble and gentle he was. He told us he'd done a lot of things in his life that he regretted but that he'd had a real conversion in his life and it had completely changed him as a person. Everyone he know thought it was an act; even his partner Tommy couldn't accept the change in him and wouldn't talk to him about it.

He asked if we could meet up each week because he and Yvonne needed friends they could talk to and pray with. It was a real lesson for me not to judge people. Bobby and Yvonne are two of the best and kindest people we've had the pleasure of knowing, and I'm so glad for Bobby that over a period of seven years or so, 'Rock-on Tommy' had a similar conversion in his life and they are closer now as friends and working partners than they have ever been.

It was also in that summer of 1987 that Archbishop Philip Hannan of New Orleans heard our song 'Totus Tuus' and invited me to lead the young people of Louisiana in singing it for Pope John Paul II when he came to the famous Superdome during his American visit. So, on 13 September, accompanied by my mother, my 93-year-old granny and other family members, I had the great honour of leading 98,000 young people in the New Orleans Superdome, as we sang 'Totus Tuus' for the Pope. When the song was finished, the Pope made his way over to our stage, followed by security guards who could barely keep up with him, and personally thanked Damien and me for the song. It was a very special moment.

On our return from the US, Damien and I moved our family back to our home in Rostrevor, Co. Down. It was a balmy Indian Summer that September and I took the children blackberry picking in the garden. Just to look out at the stunning Mountains of Mourne was a gift and, despite the ongoing troubles, it was good to be home.

Two months later a terrible bombing took place in Enniskillen in which eleven people were killed. It was a turning point for many people, and Damien and I became actively involved in the work of a peace organisation called 'Co-Operation North', a cross-border group working to bring Catholics and Protestants together. My brother Gerry was a good friend of Patrick Grant, the brother of reggae singer Eddie, and he had just recorded one of his songs entitled 'Harmony'. Gerry

and I had spoken about the work of Co-Operation North, and he felt that the sentiment of the song was perfect for the young people of Northern Ireland. Its chorus said:

Silent souls are praying for Peace and Unity,
We can live together in Harmony.

Damien and I met with leaders of the organisation and suggested that Gerry and I record the song with a choir of young people and use the proceeds from the sale of the records to support the peace work of Co-Operation North. We released the record on the Fanfare label owned by Simon Cowell, now famous throughout the world for his hit TV shows *American Idol* and *The X Factor*.

I had met with young people who had survived both the Enniskillen and other bombings and so I asked them if they would be willing to speak out on behalf of all the young people of the North. It was not easy for them to step forward but they did so with great courage. I then met with Minister for Education Dr Brian Mawhinney to explain what we wanted to do and to ask if he would help us gather a thousand Catholic and Protestant schoolchildren at the Peace Wall in Belfast, a 20-foot high brick wall that divides the Catholic and Protestant areas of the Falls and the Shankill. He immediately agreed and organised for the children to be bussed there and back from their schools.

Our filming day began with Gerry and myself and our brave little choir at the Giant's Causeway. We then made our way in to the Peace Wall in the heart of Belfast, where a thousand children from both sides of the community were waiting to sing 'Harmony'. Two of our top soccer players, Pat Jennings and the late Derek Dougan, one Catholic and the other Protestant, had also agreed to be part of the video and, as the song rang out through the narrow war-torn streets, people ventured out to see what was happening.

We had been given special permission to open the gate in the Peace Wall. It had not been opened for many years because of the conflict and as the children began to stream through it, singing and laughing and waving their arms at the cameras, little by little men and women who had been standing by watching began to join with them, walking

through the gateway from one side of the divide to the other. It was a very moving experience to be there.

When the record and video were released we were asked to bring the choir over to London where 'Harmony' was performed on stage with Phil Collins as part of a TV special. Phil and everyone else on the show were so moved by those incredible young people and I know they made a lasting impression on anyone who had the honour to meet them. One of the Co-Operation North leaders, Tommy Fegan, asked that night if Gerry and I would be willing to travel to Russia and Estonia the following summer to sing 'Harmony' in a rock festival for peace that would be broadcast all over Eastern Europe. We immediately agreed. However, I had no idea how challenging that trip would prove to be.

I travelled to Liverpool in early December for panto rehearsals while Damien stayed in Rostrevor with the children till Grace's school broke up for Christmas holidays. At the end of one of my rehearsal days I began to feel really ill, with an excruciating pain in my lower stomach. An ambulance was called and I had to be taken out of the hotel in a wheelchair with a blanket over my head, as we were days away from opening and I didn't want word to leak out that I was ill. I must have looked like a criminal but I was past caring. My symptoms apparently indicated a kidney stone, but the doctors couldn't explore the true cause of the pain because they discovered that I was pregnant!

It was the best Christmas present ever to know that we would have another child and I didn't anticipate any difficulties as my last two pregnancies had been so straightforward. However, one night close to Christmas, I came off stage to get changed for the finale and discovered that I was haemorrhaging badly. There was nothing I could do but rush back on stage for the walk down, while the company manager called for an ambulance to take me to the hospital. Thankfully, my baby was safe and although I was uneasy in case anything else went wrong, throughout the rest of my pregnancy I was healthy and happy.

I took things as gently as possible throughout the spring, but there were a number of important commitments I had to fulfil, one of them being our trip to the Soviet Union in early June. When I had accepted the invitation to go there, I had not anticipated being seven months pregnant and so it was with some trepidation that I took off on the Aeroflot flight from Shannon to Moscow with Damien, my brothers

John and Gerald, and representatives of Co-Operation North. We made some interesting discoveries on that flight. Firstly, the dog we heard barking was not in the hold of the plane as we'd assumed, but on the lap of the lady sitting in front of us. Secondly, the man sitting across the aisle was feeding capfuls of whiskey to a duck in a cardboard box at his feet!

When we arrived at our hotel in Moscow there was no food or drink available, but thankfully we met some Aer Rianta staff, based there to run the duty-free shop in Moscow, and we all piled into their rooms to share their store of tea bags, biscuits and whatever else was available.

Moscow was quite a culture shock for all of us. I found the people pleasant but guarded, and in our hotel, tourists stayed on separate floors from Soviet citizens, so that outside the lift on each level, a security lady sat at a desk noting every entry and exit and checking that you had the correct room key for that floor. When we wanted to eat in the hotel restaurant or coffee bar we were issued with a ticket allowing us to order our food, but even so, you could get only whatever the kitchen had in stock and on different mornings there was no milk or no butter for breakfast; and despite the fact that the hotel restaurant had a very comprehensive menu there was only chicken available.

Our guide took us on a tour of the city and it was memorable actually to stand in Red Square looking up at Lenin's Mausoleum and the multicoloured domes and spires of St Basil's Cathedral, but what struck me most during our few days there was the lifeless expression in people's eyes. The first public elections since 1917 had been held that year and people were beginning to speak publicly about the dire conditions they were living in. We were taken to the local 'black market' shop and groups of men stood on the street outside asking tourists to give them US dollars for their worthless local currency. Our guide told us not to speak with them and some became quite threatening. There was a definite air of frustration and I couldn't blame them for the anger they must have felt as we walked by them into a shop they could not enter, with dollars in our pockets that could buy any number of items they could never hope to own.

I was quite relieved to leave Moscow on the overnight train that was to take us to Tallinn, the capital of Estonia. It was a journey I will never forget. We were travelling in the first-class compartment, but the train

could be best described as a 'bone shaker' as it bounced and rattled its way through the long hours of the night. There was no tea trolley available, so if you didn't have food and drink supplies with you, you were in trouble. To pass the hours, Damien and I discussed possible Russian names for our baby, as I was convinced I'd be jolted into labour before the journey was over!

Arriving in Tallinn was like stepping into a different world. Materially, the Estonians were just as poor as the Russians but they had kept their culture and language alive and so their eyes were alive too. They also seemed to be more optimistic about the future. I was not surprised to learn that the first significant political challenge to the power of the Soviet Union came from Estonian leaders, when they successfully contested, on ecological grounds, the dumping of Russian waste in their country.

But Estonia won its independence through what is known as the Singing Revolution which was going on while we were there. Night after night, the people would gather to sing their national songs and hymns and listen to rock music, and though I didn't realise it at the time, we performed at what was one of the climactic moments of the peaceful revolution when we sang to the almost 300,000-strong crowd attending the open-air rock concert. There were people as far as the eye could see and they stood holding hands, joining in so enthusiastically with our song 'Harmony'. We felt an immediate affinity with the Estonian people we met and I have never forgotten that very special time there.

When it came to our homeward journey we had to wait on the tarmac, for a long time in a line of people, waiting to board our Aeroflot plane for London. Armed guards with guns at the ready were patrolling the area, watching everyone and everything. All of a sudden two guards approached our party and motioned to us to follow them. There was no explanation given so we had no idea what was going on, but when we were led to a small private jet we began to wonder where they were going to take us.

We sank into the plush leather seats and waited to see if other passengers were going to join us, but no one did. We were almost afraid to speak so there was much whispering and nervous laughter as we tried to figure out what all of this could mean. Suddenly two air

hostesses came on board, the door was closed and the engines started up. Even as our plane took off, we still had no clue as to what was going on, but as one of our party remarked, if we were being banished to Siberia at least we were going there in comfort!

Before long we were served chicken dinner, glasses of wine, coffee and dessert and by the time we were two hours into the flight most people didn't care where we were heading to; it was party time, with everybody on board singing and laughing to their hearts' content! We eventually landed back in Ireland and to this day we have no idea who arranged that mysterious but fantastic flight!

It was during a short summer season with Les Dawson in the south of England that I heard of my father's death in July 1989. It's hard to describe my feelings as I travelled home. My father had been my constant companion and we were very close. Over the fourteen years of his ill health, my family and I had stood so often outside intensive-care wards, not knowing if he would live or die and able only to pray that God's will would be done, because he was suffering so much.

I have never known a braver person than my father; through his most difficult times we never heard him complain. He was an inspiration to us and to many others.

St Columb's Brass Band and the Pennyburn Choir played and sang at his funeral mass and it was a fitting goodbye for such a fine musician. After his funeral I flew back to England to be with Damien and the children. Les and the cast were very supportive and there was no pressure on me to re-join the show, but I felt that my father of all people would have expected me to fulfil my obligation there. Three weeks later, our fourth child was born in Newry, and we named him Robert in memory of my late father. He was well named: he loves music!

As 1990 got under way, I completed a concert tour in England that had been booked for some time and by the time it ended I could hardly wait for the family holiday we'd planned that Easter in Florida. Packed and ready for our holiday, we travelled to the US via London as Damien and I had just one more very enjoyable event to attend before flying off to the Sunshine State: we had been invited to attend our friend Gloria Hunniford's birthday party.

Gloria throws the best parties ever and this one was held in a fairytale castle in Kent. There were many friends there, including Cliff

Richard, Kenny Everett, choreographer and TV producer Jeff Thacker, comedian Jim Davidson and a host of other well-known celebrities. The setting was magnificent and over a beautiful candlelit dinner we had a wonderful time catching up with friends we hadn't seen in a while and hearing the latest showbiz news. The next day we set off for Florida, blissfully unaware that our lives were about to undergo the biggest upheaval we had ever experienced.

AMERICA CALLS

While I was soaking up the Florida sunshine and enjoying a much-needed break with the children, I got an unexpected invitation to fly to Birmingham, Alabama, for a guest appearance on the tenth anniversary show of the Eternal Word Television Network (EWTN).

EWTN was established by a feisty Italian-American nun called Mother Angelica. She had been raised in poverty in the town of Canton, Ohio, living with her mother in a rat-infested apartment after her father had deserted them. She entered a convent in her home town but when she experienced a miraculous healing after being crippled in an accident, she vowed that she would set up a convent in the south, and so she did, on what was basically a piece of waste ground on the ouskirts of Birmingham. She was undeterred by the fact that the area was less than one per cent Catholic, and that shots had been fired through the convent windows where she and the other handful of sisters sold roasted peanuts to support themselves.

Mother Angelica was a natural communicator, with a real sense of humour, and so she began writing prayer leaflets which became so popular with both Catholics and Evangelicals that she was eventually asked if she would record her teachings on the local TV. However, when the channel broadcast a controversial film that she considered sacrilegious, she felt she could no longer contribute to the station's programming.

Being the spirited woman that she was, she headed back to the convent where builders were constructing a garage and immediately instructed

them to make the building longer and wider as she was going to build her own television studio! Her enclosed convent didn't possess a television or radio set and she did not have the knowledge or finances needed to run a television station, but that didn't stop her from opening the Eternal Word Television Network, now the largest religious media network in the world.

Damien and I first got to know Mother Angelica in 1983, through an Irish nun called Sister Briege McKenna who became internationally famous for her gift of healing. Sister Briege had suggested that I should be invited to sing on one of the EWTN programmes.

During the Tenth Anniversary programme, I saw Mother Angelica 'in action' for the first time. She was clearly a deeply spiritual woman, but also very down-to-earth, with a wonderful sense of humour. After the show there was a small reception, and we had the opportunity to speak for a few minutes that night and again the following morning before I left for my flight back to the family in Florida. Mother Angelica told me that thousands of people were visiting the Network's studios week in, week out, but as the convent was a shrine to the Blessed Sacrament, she really wanted people to experience being on a *pilgrimage*, not just a visit to a TV station. She explained that for some time she had been looking for someone to set up a pilgrimage programme for her and also to be part of building a retreat centre. Out of the blue she asked if Damien would be interested in taking on the task as she felt he would be the kind of person she was looking for.

Damien was as taken aback as I had been. One thing we were in total agreement on was that we definitely did *not* want to live in America; however as we discussed the suggestion, going through all the pros and cons of such a move, the more the benefits became apparent; a move to Birmingham, Alabama, would allow us to be an ordinary family in a new country. I could ease up on my busy career and be more at home with the children, while Damien worked on setting up the pilgrimage programme and retreat centre. Damien and I flew back up to Alabama and had a long, detailed discussion with Mother Angelica, after which the proposal certainly seemed more attractive, though we were not ready to commit just yet.

The week before we returned home from Florida I had been asked to sing at a Rosary Rally held in Palm Beach that was organised by an Irish priest named Fr Patrick Peyton. I wanted to meet him because I knew it

would mean a lot to my mother. Since we were young children she had told us about going to a packed Wembley Stadium in London just after the war, to see a 'living' Rosary presented by this world-famous Irish priest. The event made a big impression on her, and as we grew up she would frequently quote Fr Peyton's motto, 'The family that prays together stays togther'.

The night before the event in Palm Beach I was invited to a private dinner party with this now very elderly gentleman. He spoke in a gentle, humble way, about his upbringing in Co. Mayo, and he captivated all of us who were present. Suddenly he focused his attention on me, explaining that throughout the past forty years he had searched unsuccessfully for a theme song for his Family Rosary Campaign and he asked me if I could write one. I was taken aback and replied that I didn't think I could. However, as I was speaking to him a melody had come into my head and by the time the weekend was out, a song was beginning to take shape that intermingled with the prayers and meditation of the Rosary.

With the help of some members of the choir and other speakers at the event, I made a very rough tape of how I felt the Rosary and song should be recorded. When Fr Peyton heard it, he told me that it was exactly what he had been searching for. Working with Fr Peyton and members of his family was a privilege I will not forget. Sadly before our recording was released, Fr Peyton's health deteriorated and so, with his agreement, we asked Fr Kevin Scallon to write his own meditations and teachings and to take Fr Peyton's place. This recording of 'The Rosary' has become popular all over the world and at the last audit had sold over a million copies.

My choreographer, Jeff Thacker, and myself were working hard at this time on a new stage show for a summer season in Blackpool where I was scheduled to work for eighteen weeks with comedian Freddie Starr. Freddie was notorious for his unpredictable antics, like the time he poured a bucket of water over one of the performers in his show while she was singing on stage. I'm glad to say he was well behaved with me and also thoughtful in his own way. An example of this was the night I was preparing to go on stage and he called into my dressing room to say hello. Every theatre dressing room has a Tannoy speaker relaying the show, so that the artist knows when the time for his or her performance is approaching. But the particular speaker in the ceiling

over my dressing table was blaring out at full blast, because the volume control wasn't working properly. Freddie asked why I liked the Tannoy so loud and when I explained the problem, he immediately replied, 'Don't worry, I'll soon fix that,' and climbing up on a chair, he ripped the speaker, wires and all, clean out of the ceiling! What could I say except 'Thanks!'

Sadly that summer I lost a wonderful friend and confidante when my grandmother, Nellie Sheerin, died. She was a tremendous influence on my life and I still miss her wisdom and strength.

By the end of the Blackpool summer season, although we still had many reservations about moving to Birmingham, Damien and I had decided to put our home on the market. My narrow-minded image of Alabama was one of cotton fields, dirt tracks and pick-up trucks, not to mention its violent anti-civil rights history. Also it was very hard to think of leaving our home and family for a place where we knew only a handful of people and had no family support system. To make matters worse, Sue, our nanny, was not keen to move, as she had by now developed a fond attachment to Rostrevor and the friends she'd made there. However, she offered to go over to Alabama to help us to settle in, and then perhaps return to live in Co. Down.

Yet, despite all these drawbacks, Damien and I still had a nagging feeling that we were meant to move there. The property market in Northern Ireland was slow due to the troubles and though there was some interest, it seemed that the work involved in looking after a 200-year-old house with its expansive eight acres of gardens was proving a deterrent. We had set a deadline of 17 March 1991 to sell our home and, with extraordinary timing, the sale was agreed three days before that date. Five months later, we were living in Alabama!

Birmingham, Alabama, was not at all as I had imagined it to be; the city is situated in the foothills of the Appalachian Mountains, and EWTN, on its outskirts, was in an area reminiscent of Co. Wicklow, with narrow roads winding through rocky, wooded areas. With a population of around one million, the city itself is a little smaller than Dublin, but with an excellent network of roads that made it quite easy to drive around. Birmingham was once famous for its steel production, with more than 30,000 men employed in the local mill, but computerisation had now reduced the workforce to just 3,000. After this major blow, the city was

in the process of re-inventing itself as one of the foremost centres for medical research and development in the United States.

I was genuinely surprised at how beautiful and scenic the residential areas were around Birmingham, and no matter how closely we looked there wasn't a dirt track or cotton field in sight! One real test for Damien and myself was finding the right school for our children. We decided to ask Mother Angelica's advice and she immediately recommended St Rose Academy in the city centre, which was run by Dominican Sisters from Nashville, Tennessee. It was co-ed, so all our children would be able to attend the one school up to the age of fourteen years. There was a very vibrant and happy atmosphere in St Rose Academy and our concerns about an American school environment, with reports of drugs and guns, quickly evaporated.

Our day began at around 5.30 a.m., as Damien left for work by 6.30 and the children had to be in school, a half-hour drive away, for eight o'clock. What a scramble that was! We weren't used to early nights. At home in Ireland our normal bedtime was between 1 and 2 a.m., so at first we scoffed at the 'wimps' who turned their lights out by ten. Nonetheless, within a couple of weeks we could barely stay up to ten o'clock ourselves and that really was a lifestyle change! On Saturday mornings we piled everyone in the van and headed off to the children's sports games: volleyball, basketball, soccer and softball, with each game held in a different school in a different part of town. All the parents attended the games and we soon got to know each other as we precariously manoeuvred our way across the bleachers or stood on cold mornings on the sidelines of the soccer pitch, sharing flasks of hot chocolate and cheering on our little athletes!

Early in the spring of 1992, Chris Harrington, Vice-President and head of production at EWTN, asked Damien if I would be interested in doing a series. The studio was just down the road from where we lived, and as I could record during the day and be home when the children got out of school, I felt there was no problem in my accepting Chris's invitation. The next step was to decide the kind of a series I should do. As it was a teaching network, most of the programming on EWTN was speech driven and ideally Chris wanted me to do a music series. I wasn't keen on this idea, as I really wanted to do an interview format, focusing on women. The network accepted this proposal, but Damien

encouraged me to think again as they already had so many talk shows. What he said made sense so when I returned from Manchester, England, after the panto season, Damien and I began working on a music series called *Say Yes* which was based on a song we had written.

The series featured interviews with musicians and singers of various denominations from throughout the US and Ireland. The interviewees shared their music and what had led them into Christian music ministry. Many of them had started out in successful commercial careers, like Phil Keagy, an outstanding guitarist, referred to by his friend Jimi Hendrix as the best guitarist in the world! The Christian music scene was a whole new world to me and I found it exciting to work with such fine musicians. The series was broadcast by satellite on TV and radio throughout the world. In the US alone, EWTN went into an estimated 50 million homes, but we received correspondence from around the globe.

As the popularity of the series grew, so too did the requests to appear in cities throughout the US, but the last thing I wanted to do was start travelling more than I had to. Towards the end of 1992, all the family was looking forward to panto in Belfast, though it was ironic that during all the years we had lived in Rostrevor I had never been asked to do pantomime in Ireland. Now after moving halfway across the world, I was invited to appear in Belfast and we ended up renting a house in Warrenpoint.

It was about this time that Damien, John, my sister Susan and I formed Heartbeat Records Inc., the purpose of which was to reach the very extensive but specialised religious market in the US, with the music I had recorded.

America was beginning preparations for the 1993 World Youth Day, which would be attended by Pope John Paul II. Without telling me, my sister sent a tape of some of my recordings to the organisers, hoping they would invite me to sing at one of the youth events. Included on the tape was a song I had written called 'We are One Body' and despite the fact that I declined the invitation to enter it in the competition set up to fund a theme tune for the US World Youth Day, my song was chosen as the theme song for the event anyway.

Almost a million young people travelled from all over the world to be present in Denver, and there was such intense media interest in the

run-up to the event, I was invited to appear on all the major US TV networks, including ABC's *Good Morning America, The Today Show* on NBC and CBS *This Morning*. The whole family went to Denver with me that August and in the Mile High Stadium I led 280,000 young people in singing 'We are One Body' for Pope John Paul II. There was an incredible reaction and as I was led to the back of the podium to meet the Pope immediately after my performance, the cheers of the young people were deafening. When I got within a couple of feet of Pope John Paul, I literally couldn't move and so he put his arms out to me and the next second my head was on his shoulder and he kissed the top of my head as he thanked me for my song. It was a very emotional moment: I felt totally secure and loved, as though it was my own father embracing me, and so many people who were there in the stadium or watching on television later told me that they shared that moment with me.

The year 1995 was the twenty-fifth anniversary of my Eurovision win and in late 1994 RTÉ and the BBC began work on a documentary about my life, to mark the event. The programme was filmed in the US, UK and Ireland and it was wonderful to work with Bill Hughes, a very gifted director and producer. Bill and his crew travelled over to Birmingham and filmed every move I made, including my involvement in the famous Jerry Lewis Coast-to-Coast Telethon, which was presented by Hollywood actor John Goodman and Tony Orlando of 'Tie a Yellow Ribbon Round the Old Oak Tree' fame. I sang with Tony and the late great soul singer Lou Rawls, and also had the pleasure of meeting John Forsyth, star of the hit TV series *Dynasty*, who shared our table. It was a very ritzy affair, but also very relaxed and friendly.

Bill filmed us going about our daily lives, collecting the children from school, attending dance and basketball practice and having a meal together. We said our grace before meals, which was no big deal in our house, but it seemed to mean a great deal to many of the viewers who watched the programme later.

As the Eurovision anniversary date drew near I was very honoured to receive the Paul Harris Humanitarian Award for my charity and peace work, presented by Rotary international, especially as this award, by the Irish branch, had been presented in the past only to Mother Teresa of Calcutta and Derry's own John Hume. Added to this, Derry City Council made a special presentation in recognition of the twenty-five years I had

represented my city throughout the world and it meant a great deal to receive this recognition in my own home town.

Another highlight of that special year was when John Cardinal O'Connor, Archbishop of New York, invited me to sing 'We are One Body' at an open-air mass held on 7 October in Central Park. Attended by 250,000 people, it marked the visit to the city of Pope John Paul II. Prior to the mass a huge open-air concert took place, featuring some of the biggest names in showbiz including Natalie Cole, Peabo Bryson, Jon Secada and Roberta Flack. Another name on the list of performers was Plácido Domingo, and he and I were the soloists at the mass that followed on from the concert. He's a true gentleman; Damien and I struck up an instant friendship with him and we've kept in touch ever since.

I was watching the clock as we made our way back to JFK Airport that evening after the event, because I had promised Daniel O'Donnell's sister Kathleen that I would be the surprise guest in Kincasslagh, Donegal, the following night, at the annual Belle of the Ball Festival. We knew for sure that Daniel would never guess I'd be the special guest, as my performance at the New York mass was featured on the RTÉ TV nine o'clock news. It was certainly a challenge getting there, but with a Concorde flight to London, another flight to Belfast and a car journey to Donegal, I made it with time to spare. When the moment came for my entrance into the tense, packed marquee, Daniel was duly blindfolded. I walked on stage and when he saw me his jaw dropped in disbelief. He was really delighted and grateful for the effort it had taken to be there on the night, but I must say that the look on his face made the effort worth while.

The next day Daniel took us on a tour of the Rosses and in almost every village we drove through, the local people turned out to greet us and lit bonfires, a traditional greeting in Donegal and the west. On my subsequent concert tour throughout Ireland I received the same warm welcome. The documentary had been transmitted by this time and people seemed delighted to catch up on what I was doing in America. Many of them spoke so openly to me of the personal struggles they were having in everyday life, how they felt the values they had been raised with were being eroded, and their concern about the changes that were taking place in modern Ireland, in particular the increase in

crime, the lack of investment and employment in their rural areas and the feeling that political leaders in Dublin were either not listening to them or, if they were, didn't seem to care!

These were ordinary people in small villages and towns who felt they had little or no influence on political decisions that affected their lives, and were feeling more and more isolated. I was learning that although there was a perception that with its much publicised and rapidly growing economy everything in Ireland was fine, these people regarded the so-called 'Celtic Tiger' as nothing more than a myth, it seemed. Everyone we met had a story to tell about the rising cost of living and the dwindling farming and fishing communities.

I returned to Alabama and back into the routine of my life there, but what I had heard bothered me and, though I didn't realise it at the time, it was to affect the course of my life within the next few years.

By 1997, we were settled into life in Alabama and were happy there. In June of that year, we had just returned from a motoring holiday in Ireland. We'd had a lovely time but again there was an undercurrent of unease. A new phenomenon of suicide amongst young men was on the increase and Ireland was still in a state of shock after the murder the previous year of well-known journalist Veronica Guerin, by drug criminals.

As I sorted through the stack of mail waiting for us on our return from Ireland, I came across an envelope with a Dublin postmark on it. It was from a Gerry O'Mahony. He was writing on behalf of the Christian Community Centre which believed that the principal duty of the Irish President was to act as guardian of the Irish Constitution enshrined in the Christian ethic and for the common good. As President Mary Robinson had just announced her early resignation in order to take up a post at the United Nations, Mr O'Mahony said that my name had been discussed among others and he wished to put me forward for nomination to run in the upcoming Presidential election.

Being in the public eye I have received all kinds of letters with various requests through the years and I try to deal with them respectfully. However, I had no idea who Mr O'Mahony was or who he represented. And his proposal seemed incredible so I threw the letter in the bin without showing it to Damien. A week or so later another letter arrived from the same gentleman, repeating his request, but this time

asking if I would meet with a delegation of four or five interested people, either in Dublin or in Alabama, to discuss his proposal in more detail.

I spoke to Damien so that we could decide how best to put a stop to this correspondence. Of course Damien saw the funny side of it as he knew I had no interest in politics, whereas he had an avid interest in the political world. It turned out that Damien's brother Colm knew Gerry O'Mahony who, it seemed, had been involved in various Christian movements through the years. Colm agreed to pass on the message that I was totally disinterested in the proposal and, as far as we were concerned, the matter was now closed.

Soon, however, unsolicited letters and faxes began to arrive urging me to consider running for the Presidency. They were from people unknown to me personally who wrote of their concern at the changes they saw taking place in Ireland and particularly of their fear of the eroding of the constitutional protection of family and life. They clearly wanted someone to speak on their behalf, but though I could identify with their concerns, I did not feel I could be their spokesperson and I did not respond to their letters.

When Damien and I arrived home one evening, we discovered a message on the answering machine telling us that a newspaper in the UK, called *The Catholic Times*, had a front-page report that I was considering running in the Irish Presidential election. Apparently Mr O'Mahony had issued a press release or given an interview, in which he had said that a delegation would soon be meeting with me in my home in Alabama.

I was taken aback, angry and embarrassed that, without any consultation, I was front-page news in a story that could only make me a laughing stock. I told Damien that Gerry O'Mahony must be made to retract the article and apologise immediately. Damien tried to calm the situation, assuring me that the story would die down and be forgotten about in no time, and of course he was right.

Nevertheless, I was surprised at how upset I felt. While I was extremely annoyed at Gerry O'Mahony's behaviour, I had sympathy for those people who felt helpless at the eroding of their Constitution, especially as successive governments were using public funds to promote the result they desired in referendum campaigns. This had

caused controversy in the funding of the Yes vote in the referendum campaign for Irish membership of the European Union and also in the recent divorce referendum, where the Supreme Court ruled in favour of Patricia McKenna MEP, when she took legal proceedings against the Government for unfair allocation of public funding to promote the Government's Yes position.

I also thought of the many people who had spoken to me about their deep concern at the changes taking place in Ireland where, despite the many positive things that were happening, there was a spiralling growth in violent crime, a lack of regard for life and a deep-rooted alcohol and drug culture. Many parents had told me that they were afraid to let their children out of their homes and they were frustrated that there wasn't enough being done to remedy the situation. It seemed that, despite the ever-strengthening economy, there were the accounts of neglect and lack of investment in inner-city areas and in the western region of the country where the elderly and the sick were feeling increasingly abandoned and voiceless.

I knew that Presidential elections afforded a broader debate than the local issues that were the focus of Dáil elections, so the people of Ireland now had the opportunity to stop and examine where we were going as a society and also to learn from the experiences of other countries. Living in America, I had seen firsthand the growing acknowledgement of how vital it was to foster stable family units for the good of children and their parents, but also for the good of society on so many levels. The Irish Constitution already recognised this and if the Constitution were to be changed in any way it was the right of the Irish people to have the final say on what those changes would be.

Having thought through these and other points, I came to the conclusion that there was a lot that needed to be said on behalf of those people who felt they had no one to speak for them. Although I knew I had a public platform from which I would be heard, I realised that raising my head above the parapet would mean stepping into the firing line and being ridiculed. Nonetheless, I saw that I had an opportunity to speak the truth as I saw it, and I shouldn't be afraid to do that, whatever the cost.

We agreed not to give any response to Gerry O'Mahony, or the media. Instead we would take more time to think about the situation. I

knew instinctively that if I *were* to seek a nomination, I could not align myself with any group, or individual. I had to be able to stand on my own, in order to be free to say whatever I felt I had to say. We knew we needed advice if we were going to proceed. However, we didn't know who to ask for guidance. Neither Damien nor I, nor any one in our immediate family circle, had been directly involved in politics, and while we had acquaintances who were in the political system, they already had allegiances to various parties. Anyway we didn't want to approach anyone in Ireland at this time as we didn't want to fuel the story in case I decided I could not proceed. We knew that finding an advisor would be the deciding factor in whether or not I would be able to seek nomination.

My brother John called us the next day having heard of the newspaper article, and offered to help with any campaign if I decided I was going to run. On reading the Irish Constitution I saw that any Irish citizen over the age of thirty-five was eligible to seek nomination to run in a Presidential election, with no specific qualifications or past experience required. However, since the inception of the state, nominations had been granted only to candidates put forward or agreed by the main political parties. Nomination required the support of twenty members of the houses of the Oireachtas, either TDs or senators. Alternatively, the support of four county councils was needed.

A question kept nagging me: what if the people didn't want the choice of nominees put forward by the political parties? What would happen if they were given the choice of voting for an Independent candidate from outside the political arena? In the past when there was all-party agreement on a particular candidate, or when a candidate was unchallenged, no public ballot was held. This had happened in six out of the twelve possible Presidential elections since 1939. Personally, I believed that there should *always* be a public ballot, thereby ensuring that the constitutional and democratic right of the people to elect their President 'by direct vote' (Article 12.2.1) would be protected and a healthy debate on the state of the nation could take place every seven years.

As I didn't issue a press statement disclaiming the article in *The Catholic Times*, other stories began to appear in the UK and Irish media,

most of which dismissed the notion of me running as typical of the 'silly season'. By now there was an ever-growing demand for interviews, in particular from English and Scottish papers such as *The Times* and *The Scotsman*, but there was little point in doing interviews, because we still hadn't found the advisor we so badly needed, and all I could say was, 'Yes, I've been asked to run but no, I don't know if I'm going to.'

I was committed to personal appearances in the New England area and Damien and I went to Providence, Rhode Island, where we met up with Ray and Eileen Castagna, good friends whom we'd known for some time. Ray was a straight-talking Italian and he had had some experience in politics as Mayor of his town for a number of terms. I decided to tell him what was going on in our lives as he drove us to the concert venue. He was clearly surprised and he gave me some sound and accurate advice in his distinctive accent: 'You know, politics is a dirty business; you gonna need thick skin, 'cos they can destroy you if they want you outta the way.'

He added that a friend of his was coming to the concert that evening. Mattie Smith had just retired after almost thirty years' political experience as Rhode Island Supreme Court administrator and clerk, so Ray suggested that he would talk to Mattie and ask his advice.

Mattie Smith was a friendly, courteous man with an air of confidence about him. He spoke in a quick-fire manner but it was obvious that he weighed his words very carefully before giving an opinion. He was clearly politically astute and he had a deep love for Ireland, regularly visiting his relatives there, so he had a comprehensive grasp of the political situation.

I explained our story so far and he pointed out all the potential pitfalls. I felt he might be the advisor we were searching for. Before we parted company, he offered to help me in any way he could, should I decide to go forward for nomination, and he also offered to fly down to Birmingham if we needed him. In the meantime, he recommended that I read a book called *You are the Message*, a lay person's guide to communicating what you believe. In a nutshell, you have to believe in what you are saying and convey it simply and naturally in a relaxed, conversational manner. In other words, be sincere and be yourself, but also make sure that you are fully conversant with the points you are trying to get across.

Back at home in Birmingham, faxes were arriving from my London agent with requests for interviews from more newspapers as well as the BBC. Then Gerry O'Mahony threw a spanner in the works when, unknown to me, he did an interview with Myles Dungan on RTÉ, once again promoting my nomination. At the same time he was releasing regular statements to the press, with the heading 'Dana for President'. I then learned the hard way that the term 'ex-directory' is a complete fallacy, as the media from Ireland, England and the US were ringing the house every other minute. The pressure was on and I knew I must make a decision sooner rather than later.

Damien and I kept in touch daily with Mattie Smith and also with my brother John in England. True to his word, Mattie arranged to fly down from Rhode Island and spend a few days with us. In the meantime, Damien and I spent endless telephone conversations speaking to some family members and close friends, trying to get feedback from those who were sensitive to the situation on the ground in Ireland. Most of them were very fearful for us and recommended that I should not run, as the media would most likely be hostile and there was a danger that my reputation could be destroyed. I was also asked if it was worth putting ourselves and our children through so much distress, when it could all be for nothing and I could even end up harming the cause of the very people I was trying to speak for.

Mattie arrived with a suitcase full of books dealing with the Irish political system, past and present. We discussed the issues I wanted to deal with and how best to present them. During Mattie's stay with us, the *Sunday World* carried a front-page story endorsing my candidacy. The metaphorical dam had now burst wide open.

It was getting harder and harder to keep things from the children, so Damien and I decided to tell our eldest three. To our surprise they thought it was 'cool!' and they appeared to be very open to the idea of my seeking a nomination. Grace even joked that if I did win the Presidency, she wouldn't have to double up with Ruth when visitors came to stay at Áras an Uachtaráin!

My mother unexpectedly rang me one evening and in her deadpan way she asked, 'Is it true what I've read in the papers? Are you thinking of running for the Irish Presidency?' In an instant I felt as though I was fourteen years of age! In the same deadpan tone she uttered two

powerful sentences: 'Don't ever be afraid to stand up for what you believe in. Whatever you decide, I'll be here for you!'

By this time I knew that I was ready to declare publicly my intention of seeking nomination as a candidate for the Presidency of Ireland. My brother John had suggested that I ask Lindsey Holmes to co-ordinate the interview requests that were multiplying daily. We had already worked with Lindsey for more than two years and she was, and is, superb in her job as a public relations professional. Lindsey also looked after the Irish PR for U2 and was highly respected in the Irish media scene. Although she had just given birth to her first baby a few months earlier and U2 were preparing to bring their 'Pop' World Tour to Dublin in just six weeks' time, she agreed to act as my PR person in what was a totally new field for both of us! Lindsey advised me that my first interview should be on the radio programme *Morning Ireland*, which was and remains one of the most influential public affairs programmes in the country.

As I prepared to go on national radio for my first political interview, I felt as though I was standing on the edge of an abyss and I knew well, from almost thirty years of media experience, that once I stepped over the edge, there was no going back!

Chapter 9 ～

RUNNING FOR
PRESIDENT

It was arranged that the *Morning Ireland* team would ring me late at night, Alabama time, so that they could record and edit the interview for broadcast later that morning in Ireland. As I waited for the call, I continually asked myself if there could be a more unlikely candidate stepping into the political arena. I had long ago become disillusioned with politics, with its broken promises and smoke and mirror truths. I knew that what happened over the next ten minutes could determine my future. Would I be seen as a laughing stock or would I be a credible candidate seeking a Presidential nomination? A bad start could bury my prospects and I knew I had to convince the public, as well as the political correspondents and opinion writers, that I was a serious contender.

I had written down my thoughts on the questions Mattie assured me I'd be asked. My notes were carefully placed across the desk in front of me, and I was concerned that I might be asked some obscure political question to which I wouldn't have the answer. Though Damien sat across the desk from me, willing me to be calm and confident, and Mattie lounged in his chair looking relaxed, I felt totally alone and quite petrified. The piercing ring of the telephone made us all jump and my stomach twisted into knots as Damien picked up the receiver. He asked who I would be speaking with and, giving me the name, handed me the phone, whispering, 'You'll be fine.'

In what seemed like an instant, the interview was over. I was asked practically every question Mattie had predicted. I thought the interviewer spoke to me in a manner that was a delicate mix of interest

and amusement. No doubt she was as incredulous as I was about the possibility of my becoming a serious Presidential candidate! Immediately afterwards there was an interview with the BBC in London. It was like an action replay of the first, though this time I felt the interviewer was patronising me. I found it humiliating, but as things turned out, it was nothing compared to what I was to face in the coming weeks.

Next morning, the reaction to the RTÉ interview was very mixed. Those who felt it was right for me to run gave messages of congratulations and encouragement. Those who felt I should not run, wanted to know what game we were playing and regarded my intention to run as a bad joke.

Upholding the constitutional right of any citizen to contest the Presidency was as important to me as actually running in the election itself. I felt that if you didn't uphold and protect citizens' rights, they could easily be denied altogether, as we had seen happen in the North. When we went to live in Alabama I took my children to the Civil Rights Museum in Birmingham, a city where division and suffering went hand in hand. I found it very emotional looking at the photographs of the marchers, the Bloody Sunday tragedy and the burnt-out buildings, as we listened to voices from the past, singing 'We Shall Overcome!' It was a mirror image of what had happened in my home town. The only difference was the colour of our skin. It reinforced to me how hard-won was the right to have a say in determining your own destiny and I felt that this precious and fragile entitlement should not be taken for granted.

After the *Morning Ireland* programme, the media were clamouring for interviews and it was clear that I would have to go to Ireland at the earliest possible moment. There was a long list of journalists who had requested interviews, and Lindsey and John felt that I should meet them on a first-call, first-serve basis. Before leaving Birmingham, however, I agreed to do an interview for Press Association Television (PA-TV), which is syndicated to thirty-nine countries, on condition that PA agree to offer it to RTÉ for first transmission.

That interview was my first political television grilling and it certainly was in-depth. As the interview progressed over the course of an hour, I became more confident. The interviewer was challenging,

but he was fair, even though I sensed we had little in common politically. I explained that I was asking for the democratic right to run in the Presidential election, that my platform was based entirely on the articles contained in the Irish Constitution and that the Irish Constitution could be amended only with the agreement of the Irish people by public ballot.

In his final question, the interviewer asked if I was imposing Catholic values on an Irish people who had perhaps drifted away from the Church. My answer just poured out. I told him that I had the right to say what I believed and that, in doing so, I was not imposing my beliefs on anyone. The right to speak and be heard must be guaranteed and protected, regardless of religious belief or absence of belief. The principles I upheld of protecting and supporting the family, and respect for life, didn't belong to any particular church, society, or era; they were universal principles that were relevant and timeless and must be upheld. For the first time in the interview he smiled and said, 'That's the most important thing you've said.'

My first major political interview was over and as it had been so delving and detailed, it helped me to crystallise my thoughts and put into words what I was thinking. By now, newspaper articles were being faxed through to me daily and, almost without exception, they were good for my humility, like the one Grace read before I could stop her! All I could do was watch her face as she read it and frowned. It was a particularly scathing article by Fintan O'Toole of *The Irish Times* that subsequently produced a flood of criticism (from the public and some fellow journalists) on the grounds that it was intolerant and virulently anti-Catholic. When she had finished reading it, without saying anything, she put the article back on my desk and I told her not to worry about what the writer had said. She gave me a reassuring look and said, 'I'm not worried. It's only words.' Again I was struck by the wisdom of my children and I thought, 'She's right. It's only words and they won't change who I am or what I believe.' I didn't feel anger at what was written, more a sense of bewilderment that I could have provoked such a reaction from someone who didn't know me. I assumed therefore that a nerve had been touched that had nothing directly to do with me.

Mattie's view of the negative media reaction at this stage was that it revealed an underlying fear of my candidature. He also believed that

the grip the main political parties had on the office of President would be challenged. This view was endorsed by political commentator James Downey, who wrote in his *Irish Independent* column that my appearance on the Presidential scene had served to remind the political parties that they were in a fairly serious pickle! He added that my attempted entry into the field should make politicians think for a change and that the political hold on the Presidency was safe only as long as the parties kept control of the Oireachtas and local government! He did not, however, think that I would break that grip, as I was an Independent and didn't have the 'machine' behind me that the established parties possessed.

Over the following days I decided that I should get my thoughts on paper in the form of a letter outlining my objectives in the campaign. This so-called 'letter to the Irish people' effectively became my manifesto and the basis of my nomination request to the local county councils. I let Damien see it first and then sent it to Mattie and John to see what they had to say. Mattie in turn shared it with his close friend, Paul O'Malley, a professor of Irish History in Rhode Island. 'Uncle Paul', as everyone called him, continued to be an essential point of reference for any future research needs.

When I returned to Ireland no other candidate had formally declared their intention to run. There was growing speculation that John Hume was going to put his hat in the ring and if he did, I felt that the contest would be over even before it began, especially as David Andrews, the Fianna Fáil Minister for Defence, had urged all-party support for him if he decided to run. I certainly did not want to go against John Hume, so I decided to write to him, saying that if he intended to run, I would not.

During the flight home to Ireland I read the Irish Constitution from beginning to end and underlined any key points that caught my attention. By the time I had finished, there were red lines on almost every page. I was particularly interested in Article 12, which dealt with the procedures that had to be followed in order to secure a nomination. If I didn't get the support of twenty members of the houses of the Oireachtas (which seemed likely), my only other option was to appeal to the county councils. But no one had ever succeeded in taking this route before and to my knowledge it had never been fully tested. I'd be

setting a precedent if I succeeded and I had no doubt it would be an unpopular precedent as far as the main political parties were concerned! The county councils' constitutional right to nominate a Presidential candidate was one of their last remaining powers and I hoped the councillors would have the courage to use it.

The only journalist waiting for me at Dublin Airport was Paddy Clancy. I had known Paddy for years and I always thought of him as the original 'cheeky chappie' of the *Irish Sun*. But he was a very experienced and professional journalist; hence he was the only one to find out exactly when I was going to arrive in Dublin. So my first political interview on Irish soil was conducted beside the lift in the car park at the airport! I felt comfortable talking to Paddy; he knew me well enough to discount the extraordinary labels that were being attached to me. With the interview over, Damien and I sped off to Jury's Hotel in Ballsbridge. We were back in Ireland and the challenge to secure a nomination for the Presidential election was about to get under way. When I arrived in Dublin after Eurovision in 1970, I had been greeted as a national hero. I wondered if this time I would be regarded as a national clown.

The Towers in Jury's Hotel, Ballsbridge, was both our home and our headquarters over the coming months. My team consisted of Damien, his brother Colm, John, Mattie Smith, Lindsey Holmes and her assistant, Deirdre Crookes. There was great suspicion expressed in the media as to where I was coming from. I had been referred to as a 'right-wing extremist', 'a joke', and even 'an Ayatollah'! So the first thing I felt I had to do was meet the press and let them decide about me after we'd met in person.

Over the following three days, interviews were lined up one after the other. As I was speaking to a succession of TV, radio, newspaper and magazine reporters, I decided to tape each interview on my personal cassette player so that I could listen back to it and refine my answers for the future; it would also ensure that I was accurately quoted. It was interesting to see the reaction of some of the reporters who looked quite taken aback that I wanted to record our conversation. I also kept a copy of the Irish Constitution close at hand as it was the basis of my campaign; if any questions arose I could point out there and then what I was referring to. A couple of the interviewers assumed it was a bible!

At the end of one of those long days I was interviewed for RTÉ radio by Myles Dungan who had interviewed Gerry O'Mahony a week or so earlier. From the moment the interview began, I felt more at ease with Myles than with some of the others. I felt he treated me as a normal person, rather than a curiosity. The same was true with Joe Jackson. We'd first met two years earlier when he interviewed me for *Hot Press*, a rock magazine that wouldn't be part of my natural fan base! Joe had asked some very probing and tough questions but he ensured that the interview was published verbatim with no editorial changes, just as he had said it would be. Joe did the first in-depth feature interview of the Presidential campaign, simply because he had put his request in ahead of everybody else. When the interview was published, however, there was uproar as to why Joe should have been granted the interview ahead of his colleagues, and Lindsey found herself under serious pressure!

That August weekend, as the stories appeared in the press, the headline of the *Sunday Tribune* editorial stated, 'Never underestimate your enemy.' It went on to say that 'only the foolish and complacent' would think that my aspirations for the Presidency were a national joke; that the newspaper needed to know who was backing me and whose candidate I was, as the 'masterminds of the right' seemed to be managing my campaign. Apparently the writer felt that anyone who had heard me speak would realise that what I had to say regarding the Constitution and pro-life issues was the product of much coaching and practice. Furthermore, that the progressive Ireland that Mary Robinson represented would be quickly submerged if she were replaced by the 'orthodox Catholicism Dana represents'.

It was strange to read that editorial. It revealed a paranoid fear of 'liberal' Ireland losing ground. This fear had led to a totally distorted picture of who I was and what I stood for. Ironically, though it implied that I was the 'mouthpiece' of orthodox Catholicism, as far as I was concerned most of the conservative right were as puzzled about me as were liberal members of the media. I have no doubt I was regarded as a loose cannon, to be avoided if possible.

I had made a decision to try to make a clearing in the forest that would allow people of various political and religious persuasions to come forward and stand with me on issues that we shared in common.

I was not a religious bigot or extremist and I was not a one-issue candidate. The so-called 'masterminds' of my campaign were the small team made up of family and a few close friends. And though Gerry O'Mahony's letter to me had been the catalyst that had set me thinking about running, the decision to go forward was mine alone. He was a good and sincere man, but it was now clear that the press statements and interviews he continued to give were causing confusion and misinformation. It was therefore necessary for me to release a statement to the media clarifying that he did not represent me or speak on my behalf and that only my appointed representative, Lindsey Holmes, was authorised to do so.

One lighter moment during that tense period was when The Edge of U2 led a crowd of 40,000 in singing 'All Kinds of Everything', during U2's opening night in Lansdowne Road, telling them that it could be Ireland's next national anthem!

While Damien and I returned to the US to fulfil a long-standing commitment in Los Angeles, John was gathering information on the names and telephone numbers of TDs, senators and county councillors. On my return I would begin systematically calling as many of them as possible. We had already begun to draw up a list of people who might be open to supporting my bid for nomination and I had called a few of the names before leaving America, like Joe Brennan, an Independent councillor from Galway, and Susan Phillips, also an Independent, on the Dún Laoghaire-Rathdown County Council. Susan told me that she would be supporting another candidate should that person succeed in a nomination bid; however, she said that she would be willing to give me whatever advice she could. I needed to seek the support of as many people as possible, but I had made it clear that if someone belonged to a particular organisation or political group, I would accept their support only as an individual, as I would not align myself with any organisation or group.

On our return to Dublin at the beginning of September we met Susan Phillips over dinner with some of her friends. She advised me that she felt it would be extremely difficult if not impossible to get support from TDs and senators, even though I was seeking only twenty signatures out of a House of 166 members. She also felt that if we didn't get their support we would have practically no chance of gaining the

support of councillors around the country who would share the same party allegiances, and no doubt their respective party whips would ensure that no one stepped out of line.

Susan said that three of the Independents on Wicklow County Council—Mildred Fox, Jim Ruttle and herself—had agreed to support me, but because of the shortness of time there would have to be a special council meeting called to discuss my nomination request and that would need the support of five members. However, she didn't know who would make up the numbers and she was convinced that 'short of a miracle' my request would be rejected. She also abhorred the undemocratic system for nominating Presidential candidates and she felt I had started a debate that would run on and in time might even lead to constitutional change to ensure citizens' rights. Thanks to Susan's determination and courage, the 'miracle' did happen and Wicklow County Council went on to support my nomination.

Over the coming weeks John, as campaign manager, and Damien worked together in organising a plan of action while I was kept busy calling, or preferably meeting with, as many potential supporters as I could. As John was very skilled in dealing with media, he also worked closely with Lindsey, while Damien and I travelled to meet with key people. Another member of the team, Damien's brother Colm, suggested that I meet with Seán Doherty TD, a senior member of Fianna Fáil. A meeting was duly arranged in Colm's home and we spent an hour or more talking. Seán listened as I explained what had motivated me to run and, after he heard what I had to say, he said that he would draw up a list of councillors he felt might support me and he also promised to speak with the Taoiseach and ask that my nomination not be blocked. True to his word, he sent a letter with information on the councillors as he had promised.

I also requested a meeting with the recently elected Taoiseach, Bertie Ahern, and, accompanied by my brother John, I met with him in his offices in Government Buildings. He was very personable and made us feel welcome and at ease. As an Independent candidate I asked him, in the interests of democracy, not to impose a whip on Fianna Fáil councillors and he assured me that he did not wish to stand in the way of my nomination. He also informed me that as

Fianna Fáil had not yet chosen its candidate I was free to put forward my name for consideration. An unlikely scenario, I thought!

With approximately three weeks to the deadline for nominations, we badly needed sound legal advice regarding the proper procedures that we should follow. Colm was instrumental in introducing us to a young solicitor named Elizabeth Bruton, a cousin of John Bruton TD, ex-Taoiseach and the then leader of the Fine Gael Party. After we had had a long discussion with the petite, gently spoken Elizabeth and her larger-than-life husband Mattie, Elizabeth volunteered to act as my legal advisor and, should I be nominated, my election agent, saying that it would be a unique and challenging experience for her.

The first step towards nomination was to send a formal letter, based on the one I had begun writing in Alabama, to all the local authorities, laying out my basic platform and seeking their support. Then, as I needed an election agent in every constituency throughout the country, Elizabeth began tracking down men and women who would be willing to undertake the job. Names were referred by word of mouth from all quarters. We discovered that while some were 'apolitical', there were complaints from supporters in one constituency that my election agent belonged to a rival political party! But anyone was welcome in our team, as long as they came as individuals, not party representatives. Elizabeth did her work so well that in the subsequent election apparently one newspaper reported that I had more representatives at one particular count than some of the political party candidates.

It was vital to speak face-to-face with as many councillors as possible, so we had a tough and adventurous challenge on our hands as we traversed the roads of Ireland from east to west and north to south in our rented five-seater van, trying to convince the county councils to support me. There was a pioneering spirit among the team as we ventured where few had dared to tread before. Our days began at 6.30 a.m. and finished perhaps eighteen hours and many bumpy miles later, with my sisters and me balanced in the back seat of the van, mobile phones in one hand and a list of councillors' names in the other, as we called each one in turn. As they would get through to the councillor in question, they'd announce, 'Hello, this is Dana Rosemary Scallon's office calling. Will you hold for Dana, please?' and I'd try not to laugh as I surveyed my mobile 'command centre'. For the most part I didn't

know any of the men and women I was speaking to but they were generally courteous, with just the occasional person telling me in no uncertain terms what he or she thought of my attempt to buck the system.

I first met Councillor Joe Brennan in his home in Ballinasloe when Damien and I drove down to meet with him and his wife Bridie. Originally a member of Fine Gael, he had become disillusioned with the party and was subsequently elected as an Independent member of Galway County Council. A headmaster for many years, Joe was very respected and liked in his community. He had already submitted a motion to the council at its August meeting, calling for my nomination to be discussed, but it was deferred till 12 September because of procedural difficulties—the Minister for the Environment had not passed an order for the Presidential election (Presidential Act of 1937), permitting the council to vote on possible nominations. Joe Brennan maintained that this was a delaying tactic and that it was discriminatory against non-political candidates. However, he was still hopeful that I would be nominated by the Galway councillors at their 12 September meeting and he was anxious that I would travel down to Galway to address them that night.

And so, on 12 September, the day President Mary Robinson formally resigned, I duly addressed the members of Galway County Council. Joe Brennan had arranged for his friends Jim and Mary Thornton to lead us to the temporary council chamber in Merlin Park Hospital. And sure enough, as we stepped out of our car, our guides were waiting to show us the way to the meeting. Jim worked with Teagasc as an agricultural expert and Mary taught Irish at University College Galway.

Council business was suspended in order for me to present my case. It was a relaxed and good-humoured meeting. Even so, I felt quite nervous at the thought of addressing the councillors, just as I had been at a previous meeting with Clare County Council. I explained that I was not asking them to pledge their support for me as a candidate; I was asking them only to consider my nomination, so that I could have the democratic right of going before the people of the country. And although their constitutional right to nominate a Presidential candidate had never before been exercised, I hoped they would now use it. The more I talked with councillors around the country, the more it became clear to me that

there was a growing discontent because power had been stripped away at the local level, leaving councillors to take the flak for decisions made in Dublin. I also caught a sense that councillors perceived political leaders in Dublin to be out of touch with the feeling on the ground in those constituencies that were 'outside the Pale'.

Shortly after meetings with Galway, Clare, Louth and the two Limerick councils, Damien, John, my mother and I drove to Donegal for a crucial council meeting that was to be held in Lifford on 15 September. I was to address the council in the same reconstructed courtroom in which Napper Tandy, one of the leaders of the United Irishmen, had stood trial for his part in the 1798 rebellion. And this was the building in which the members of the council would now deliver their judgment on whether or not I would become the first Independent candidate ever nominated to run in an Irish Presidential election.

This was the first time that a council could legally vote on the question of my nomination. By the time I arrived, the entrance to the courthouse was already surrounded by representatives of international media. Tension was running high. The Chairman, Maureen Doohan of Fine Gael, had decided to call the special council meeting despite the reported strong opposition from some Fianna Fáil councillors. Paddy Kelly of Independent Fianna Fáil would put forward the motion to nominate me, but Fine Gael had a whip in place forbidding support for the motion, and we were waiting anxiously to see if it would be the same situation for Fianna Fáil councillors, who were deeply split on whether or not to give me the go-ahead.

My roots are in Donegal and though I was praying that this county, where I'd practically been raised, would allow me to go forward, I was not overly hopeful as I took the podium to begin my address. I was greeted by applause and when it had died down I made an impassioned plea to the eighteen members present, after which there was a flurry of activity in the chamber, with Fianna Fáil requesting an adjournment for five minutes to discuss its decision. Some Fine Gael members had made it clear they would break the whip and there were heated exchanges going on. If Fianna Fáil decided to vote against me, there was no hope. It was the longest five minutes of my life as I stood with my family preparing for the worst. Suddenly the door into the chamber

opened and former Fianna Fáil Chairman, Seán McEniff, gave me the thumbs up. For a second it didn't sink in that the impossible was happening: Donegal County Council had voted in favour of the motion and the reverberations were felt all over the country.

Outside the courtroom we had to fight our way through a virtual media scrum of television crews and reporters from Europe, America, Britain and Ireland, all wanting pictures and quotes at the same time. We had booked a flight to Cork in order to get there in time for the council meeting and I couldn't miss that flight. By the time we arrived in Cork, yet another scrum of media was waiting for us in the terminal and, with one shouting louder than the other, they informed me that while we had been in the air, Wicklow and Longford County Councils had given me their backing too; I now needed only one more council to be nominated.

You would have thought the reporters had been nominated themselves; there was so much excitement and everyone was beaming as we made our way to the council chambers where I was received by the Mayor of Cork, Councillor Dave McCarthy. He explained that although I couldn't address the chamber, I could meet and speak with individual political groupings in the council chamber. There was a sense of excitement as I made my way to my first meeting with the Fianna Fáil representatives. We stood almost huddled in a group in the middle of the room and there was some good-natured bantering as I made my plea for their support. Suddenly the double doors of the chamber burst open as photographers and reporters rushed in, shouting, 'You've done it!', 'Kerry and Tipperary North have nominated you!'

It was amazing news after all the struggle and worry; not four but five councils had supported my nomination in the one day, and history was made as these courageous county councillors exercised their right for the first time to nominate a Presidential candidate. Councillors were hugging me and shaking my hand and then a rich baritone voice started up, 'Snowdrops and daffodils ...' and the councillors and even some of the media joined in singing 'All Kinds of Everything'. It was an unbelievable moment. I had not expected to be nominated, and though I had spared no effort in fighting for the approval of the councils, I had not planned beyond the nomination period. So when my family and I

sat quietly together at the end of that incredible day, emotionally and physically exhausted, the question in all our minds was, 'What are we going to do now?'

At the outset we had used our own finances to fund day-to-day expenses, which we had kept to a minimum. Where possible as we travelled through the constituencies we would stay in people's houses to save on expenses, though we discovered that my brother Gerald had a knack of negotiating very good rates when we had to stay in hotels. And throughout the campaign, apart from my PR representatives, office and travel expenses and the promotional material I needed, the vast majority of those who worked tirelessly for me, often without any public acknowledgement, asked for no remuneration whatsoever. But as a serious contender in the election, I would now need help to cover the further expenses that would be involved, and so appeals for funding got under way with ads in various newspapers.

Slowly but surely donations began to trickle in: one pound here, five there, twenty from someone else. Every penny helped. But without my family, Damien's brothers and some close friends, it would not have been possible to achieve all that we did. And despite the conjecture that 'mysterious forces' were funding my campaign, at the end of the day it was all down to family and friends and so many of the Irish people themselves.

At the news of my nomination success, Councillor and Senator Shane Ross, who had supported my bid for a nomination in Wicklow County Council, described himself in the *Sunday Independent* as 'A Southern Prod supporting a traditional Derry Taig'. He also wrote, no doubt with great glee, 'The columnists of the politically correct organs sneered at Dana. They declared her an intellectual pygmy … we have to settle for a self-made millionairess who defied the ridicule of *The Irish Times*, who stuck to her beliefs, however unfashionable, and who unlocked the stranglehold held over the presidency by Ireland's political fixers.'

Meanwhile alarm bells were ringing in the headquarters of Fianna Fáil, Fine Gael and Labour. To everyone's surprise, I had bucked the system. But the political establishment was about to fight back, and no sooner had I cleared one hurdle than another more difficult one came into view.

With days to go to the closing date for nominations, an article appeared in the *Sunday Business Post* claiming that because of technicalities, there was potential legal difficulty with some of the nominations I had received. I now had to seek legal advice as it could mean that I would have to submit my applications again in order to be re-nominated; but as most of the councils who had backed me would not be meeting again until October, it would be too late. The article stated that in Wicklow, for example, my name was not on the Resolution circulated to the members. In Tipperary North apparently the required notice of three days had not been given in advance of the council vote, and so on. It sounded surreal to me.

Writing in the *Sunday Independent*, Conor Cruise O'Brien remarked: 'I have a pretty good nose for Fianna Fáil dirty tricks and I can smell one going on right now ... aimed at eliminating Dana from the Presidential contest ... Mary McAleese is now the Fianna Fáil candidate and ... Dana will gather quite a lot of those votes ... So it is highly desirable from a Fianna Fáil point of view at this stage to knock Dana out of the race—if that can be done in such an inconspicuous way as not to alienate the people who like Dana, of whom there are quite a few.'

Whatever or whoever was behind this heart-stopping problem, thankfully where necessary the councils in question re-affirmed their decisions in time for me to hand in my nomination papers on 30 September.

Fine Gael named MEP Mary Banotti as its candidate, while Adi Roche, founder of the Chernobyl Children's Project, represented Labour. Popular and respected, Adi was initially considered the frontrunner to follow in the footsteps of outgoing President Mary Robinson, who had sensationally won for Labour in the 1990 election. The only male candidate was former Garda Derek Nally who was following my lead in securing nomination from the councils as an Independent candidate. But all eyes were now on Fianna Fáil. It was expected that former Taoiseach Albert Reynolds would be that party's automatic choice, having served his party and country, making history in 1994 when he put his reputation on the line to deliver the long-awaited, and much-needed, IRA ceasefire. So when Professor Mary McAleese, untested politically and a northerner like myself, emerged as

the surprise choice, many in Fianna Fáil were shocked at what was regarded as the public humiliation, or as the media referred to it, the public 'shafting', of Albert Reynolds.

The first opinion poll published in the *Sunday Independent* on 21 September showed that Adi Roche was favourite to win at 38 per cent, giving her a three-point lead over Mary McAleese at 35 per cent. Mary Banotti was running at 18 per cent, while I was at only 9 per cent. Still, I had started out in the betting in August at 100/1 and by 22 October, I would be down to 8/1. My polling figures surprised me, however, because the feedback I was getting on the ground suggested I had a higher level of support.

Within hours of the publication of that poll, Adi Roche's campaign took a major nosedive when former disgruntled supporters spoke to the press and launched what could be best described as a personal vendetta against her. The impact was devastating. I liked Adi and I was sorry that because of the personal attacks coming her way she and her family were put under a great deal of additional pressure. That *Sunday Independent* opinion poll seemed to be a kiss of death for Adi's campaign, and for me the whole affair highlighted how dirty and devious politics could be. I was learning this myself, especially when top London publicist Max Clifford was quoted in the media as saying that Irish political activists had contacted him to ask if he could dig up dirt about me! Max, who had known me in UK showbiz circles throughout my career, disappointed them by saying that he had no sleaze or scandal on me at all, and that if he could vote in Ireland, he would give me his number one.

I was gradually beginning to see some small signs of a turnaround in the media's attitude to me. Damien Kiberd, writing in the *Sunday Business Post*, said, 'Dana is now being described as the 10 per cent candidate by the political sages. They would do well to be very careful when assessing her prospects. This is, after all, the woman who beat the political system comprehensively by by-passing the political elite and going directly to local government. She has also handled herself very well on radio and TV interviews in recent weeks and this could prove very important in a battle that is fought often on screen.'

His words were encouraging, especially as at this time there was still doubt over my nomination and there was a serious possibility that I

would not be accepted as a legitimate candidate. In an *Irish Times* article on 22 September, it was reported that Fianna Fáil would not 'impose a whip on those councils that have already nominated Dana' but would attempt to prevent my endorsement—or the nomination of Derek Nally—by other county councils because the party now had its own candidate in Mary McAleese. However, county councillors had tasted what it was like to flex their political muscle and within a matter of days Derek Nally had followed my route to nomination with the support of four councils. The electorate now had a choice of five candidates.

Once my nomination papers were handed in, we had to hit the ground running. With Gerald as driver, my sister Eileen as wardrobe mistress and hair stylist, and my mother as my most serious rival, we covered as many towns and villages as possible, where I would meet and greet the local people, sometimes saying my piece soap-box style without a microphone, reminiscent of the old days of Irish electioneering. On one of these occasions, as I finished addressing a crowd of about fifty people on the main street of Ardee in Co. Louth, a lady asked us if we had eaten dinner. It was about nine o'clock and we hadn't eaten anything since a hurried sandwich at lunchtime, so she told us to follow her to her house as she had a pot of stew ready on the cooker. Off we went up a country lane and, sitting in her simple farmhouse kitchen, we were served a dinner fit for a king! We got back into our car and headed off to the next town. That lovely woman's hospitality was typical of the warm reception we received all over the country. We experienced a real sense of community and there was a momentum growing in my campaign with every day that passed.

There were constant interviews with local radio stations and newspapers, and the political correspondents of the national papers would often join the candidates as we campaigned throughout the country. I have always tried to take people as I find them, but I was very wary of the Dublin media because initially they had either been hostile or treated my candidacy as a joke. Looking back, I think that all of us in the team were afraid to let the media come too close to us. Apart from anything else, we were absolute beginners in politics and we were wary of putting a foot wrong and finding it splashed all over the newspapers. Perhaps our caution gave the impression that we were trying to hide

something, but that was not the situation at all. I believe that gradually journalists began to realise that it was a genuine case of 'what you see is what you get', and by the end of the campaign we had struck up good relationships and friendships with the many true liberals we met in the Irish media.

It's hard to explain the pace and the pressure involved in campaigning. It's not just the constant travelling and meeting people, while trying to ensure that you look half presentable at every minute of the day. There's the challenge of dealing with the many questions on a wide range of topics that candidates have to be able to answer in the course of an election, never mind the debates, the newspaper columns you're asked to write and the speeches you have to give—as I was writing these myself, it sometimes meant sitting up half the night. We didn't have the resources of the political parties to be able to hire a team of advisors and writers and neither would I have wanted to. John and Lindsey were doing a wonderful job but as the pace of the campaign increased we needed more support so that we could at least catch our breath every now and again. Paul Allen's public relations company was recommended to us, so we brought him on board to design my campaign literature and help with PR.

Then one day I got a message through the office that the *Sunday Independent* journalist Jonathan Philbin-Bowman wanted to meet with me and I felt a bit uneasy. I had met Jonathan once before and it was an unforgettable confrontation. A couple of years earlier I had recorded my first album of Irish songs and the record company held a reception in Dublin to launch it. Suddenly a young man with an angelic face and a mop of curly hair appeared directly in front of me and, without introducing himself, launched into a barrage of grievances against the Catholic Church, obviously expecting a response from me on each topic.

I was verbally pinned to the wall for at least fifteen minutes. I could see the looks of sympathy I was getting from passers-by, but try as I might there was no stemming the flow of righteous indignation from this highly articulate young man. Finally I'd just had enough and I said firmly, 'I'm not here to defend the Catholic Church. I'm here to promote my album. What's your name anyway?' It was obvious he had assumed everyone knew him and with a look of surprise on his face he

replied in a more chastened manner, 'I'm Jonathan Philbin-Bowman.' At which point I thanked him for coming to the launch, suggested we talk again sometime and made my exit.

I couldn't imagine what Jonathan wanted. He hadn't asked for an interview and I just didn't have the time for a theological discussion. However, when we finally met some days later in the Jury's Towers he offered to do anything he could to help me in my campaign! I knew that I had good reason to be sceptical. He had already written a witty but withering piece in a Sunday broadsheet proclaiming, 'It is a deeply daft and silly suggestion that Dana should become president.' He could have been trying to infiltrate my team so that he could do a hatchet job from the inside, but all I can say is that I felt he was sincere. There was no resemblance to the brash young man who had hijacked my record launch and neither of us ever spoke of our previous meeting.

From that day on, Jonathan became a key backroom player on my team, and in our regular meetings he gave indispensable support and advice as we worked on press releases, speeches and communication techniques. We would have been seen as being worlds apart but we shared a belief in the principle put forward by the French philosopher Voltaire, who said, 'I may not agree with what you say but I will defend to the death your right to say it.'

Jonathan never asked a penny for his time or his expertise and as the campaign progressed everyone on my team and in my family grew to love him. He was highly intelligent and had a touch of genius with words, but he also had a great sense of fun, with a razor-sharp wit that could be devastatingly funny, especially when combined with his gift for mimicry. But most of all he was kind and thoughtful and devoted to his son Saul whom he said he loved more than anything in the world. I still expect to see him sometimes when we walk by the Shelbourne Hotel, and Dublin, his 'village', is less vibrant and colourful without him.

My first major television 'debate' was on 29 September when I took part in *Questions and Answers* on RTÉ. I was extremely nervous on the night of the broadcast and as I waited in the hospitality room for the programme to begin, a tall slim man came in and sat down. He wasn't particularly talkative. In fact the only thing I remember him saying to me was, 'Have you got your hymn sheet with you?' He turned out to be

Alan Dukes, the former leader of Fine Gael. However, I didn't immediately recognise him at the time, as I had been living out of the country for the previous six years. A Fianna Fáil minister who was to have taken part in the programme had to cry off at the last minute and was replaced by a junior minister. Pat Rabbitte, the current leader of the Labour Party, was the other panellist.

It was suggested to me afterwards that there could have been an agenda behind my invitation to be part of that particular show; I was the first and only one of the Presidential candidates invited to appear on the programme. On the other hand, in the subsequent programmes where Presidential candidates took part, there were always two candidates, a representative of a third candidate and a journalist on the panel.

On the show that night there were a few exchanges when Alan Dukes delivered what I felt were 'put-down' lines to me and I countered as best I could. Then when Pat Rabbitte made reference along the lines of 'those people who want to contribute to Irish life but aren't paying their taxes here', a comment I viewed as directed at me, I defended myself in a good-humoured manner, saying that I was an Irish citizen and had always paid my due taxes, to which there was laughter and a round of applause from the audience. Overall there was a positive response to my first debate!

A week later I was asked to appear on the radio programme *Tonight with Vincent Browne*. I had never heard the programme before and was advised that the interviewer would be tough but fair. The RTÉ radio building was almost deserted as Damien and I waited in an open-plan office area for someone to take us to the studio. A man appeared, introduced himself as Vincent Browne, and proceeded to walk down the corridor ahead of us towards the studio. There were no niceties or small talk. Damien sat in the control room, and Vincent Browne and I sat at a round table in the studio below. He suddenly looked up and asked me why people should vote for me and not for Mary McAleese. As I answered him, it dawned on me that the programme was now going out live.

Throughout the interview he continually sighed and tut-tutted when I didn't give the answer he wanted to hear and every so often, with a look of despair, he'd put his head in his hands. By the time the

advert break came, I was concerned about him, so I asked in all innocence if he would like me to get him a glass of water or something. I genuinely thought he was sick! He dismissed my offer and no doubt couldn't understand why I was being so sympathetic towards him. I was puzzled as to what was going on, but as the second half of the programme got under way, every so often he'd raise his voice and repeatedly ask in an aggressive tone, 'Will you please answer my question?' to which I'd reply, 'I am answering the question but I'm not giving you the answer that you want to hear.' He was clearly not listening to what I was saying and I began to be very weary of his behaviour as he asked the same questions over and over again, particularly on pro-life and family issues.

The next morning my brother-in-law Brendan rang to say he had never felt so angry listening to a radio programme and we were soon to learn that he was only one of many. Practically every media person in Dublin rang our office for comments before the morning was over, and all of them appeared sympathetic. The RTÉ switchboard was jammed with angry callers lodging complaints, and the following night Vincent Browne publicly apologised on air for his behaviour during my interview.

He issued a press statement and sent a letter to me stating, 'I regret causing offence to any listeners, and I regret causing any distress to Dana. I also very much regret if my manner conveyed any disrespect towards Dana.' The statement went on to say that he believed I was being deliberately evasive on a variety of issues and so he had responded in his customary manner, but he realised afterwards that the evasion was 'not deliberate' and that therefore his style was inappropriate.

When I appeared on Eamon Dunphy's *Last Word* radio programme I was prepared for a similarly aggressive grilling, but to my surprise I found him totally unbiased. At the end of the interview, I spontaneously reached across the desk to shake his hand and thank him for being so fair with me. It had been particularly tough going in the days prior to the programme and I suppose he could see that I was feeling fragile. He immediately jumped up from the desk and gave me a big hug, telling me not to worry 'about those f...ing atheists out in RTÉ!' It was just what I needed at that moment.

Two weeks before the election all the candidates were invited to appear on the *Late Late Show*. The media focus was intense as the outcome could help to sway the large number of undecided voters on polling day. There was nervous tension for all of us taking part, although Mary McAleese looked unbeatable in the polls at this stage. Damien, John and Paul Allen were there that night and we were discussing the difficult questions that might arise such as: if the Irish people voted in a referendum in favour of abortion, would I as President sign it into law? This issue had cropped up in some shape or form in almost every interview I'd done. Paul Allen advised that I deal with it cautiously and, if possible, avoid being drawn into making a clear statement on what I would do, so that it couldn't be interpreted that I would try to impose my beliefs on the electorate.

Gay Byrne went through the usual batch of questions we had heard countless times over the course of the campaign and gradually I knew he was heading in the direction of the 'pro-life' question we had anticipated. I felt that as the people of Ireland had consistently voted in public referenda to protect life at all its stages and as polls had shown that the majority of the public and elected representatives wished to maintain this position, it was mischievous to make this an issue in the Presidential election, and I said so, to warm applause from the audience. However, Gay persisted and asked us one by one if we would, as President, endorse an amendment to the Constitution, signing abortion into law. I remember listening to each candidate's reply and thinking that I could go with the flow and say what the other candidates were saying, namely, that I *would* sign it into law, or I could tell people the truth. When the question was put to me, I responded by saying that I could *not* sign it into law, because I believed it would be an unjust law.

At that moment I was convinced I had scuppered any chance of getting a good solid vote and I could just see the headlines! It was political suicide and I knew it must be difficult for Paul watching in the green room. But as far as I was concerned it was right to let the public know my position *before* they went to cast their vote. As the programme ended I made my way back to the green room and Paul assured me that I had the right to say what I felt I had to, though it was obvious from the sombre look on his face that he felt I had just shot myself in the foot; or as he had uttered within Damien's hearing, 'She's finished.'

In fact, the reaction to my statement on the *Late Late Show* was not at all what I expected. There was a huge surge in support from the public and, interestingly, from young people. As one young woman told me in RTÉ that night, she was pro-life, but she couldn't talk about it, as you were allowed to think only one way in her workplace. Similarly the media were very fair in how they reported on it; as John Donlon in the *Star* newspaper noted, I 'challenged Gaybo' and was the only one to admit I would have difficulty signing a Bill into law legalising abortion. He went on to say, 'The others didn't give clear answers on the issue.' I felt that we had come a long way from how the matter would have been dealt with in the media at the outset of my campaign and I realised that though everyone who called to congratulate me may not have shared my position, they appreciated being told the truth and they supported my right to state my position.

I knew that I wasn't going to win the election, but the opinion polls continually baffled me because I was always in single-digit figures and that contradicted the response I was getting around the country. I was concerned that as I was polling so low, people would consider me as a wasted vote and I didn't want a disastrously low vote. If that happened I would feel that I had let down the people who had trusted me to speak for them and it could appear that the issues I was highlighting were of no relevance to the people of Ireland. As the nation prepared to go to the polls, I reflected on what had been an extraordinary five months and on how there appeared to have been a significant change in the attitude of the media towards me.

Voting day finally arrived on 30 November. All my family were Irish citizens, holding Irish passports, and, as we 'lived' in Jury's Hotel, the local school in Ballsbridge was our nearest voting centre. Damien and I left the hotel early that morning to cast our votes. Next day, during the count, phone calls coming in from all over the country indicated that my vote looked substantial. My supporters were euphoric but it was too early to tell how I would do.

The declaration of the new President was to be held in St Patrick's Hall in Dublin Castle. We had to scurry to get there in time as there was traffic gridlock in the city centre! We eventually pulled up outside the Castle in a panic, children and adults tumbling out of the van, and made it to the hall, pushing our way through the heaving crowd just

before the votes were announced live on television. I was surrounded by people congratulating me on the vote I had received. It was hailed as an amazing result and completely unexpected.

Mary McAleese, representing Fianna Fáil, was elected the eighth President of Ireland with 574,424 votes. In second place, Mary Banotti, representing Fine Gael, received 372,002 votes and, as the first Independent candidate, I came in third place with an incredible 175,458. Adi Roche representing Labour came fourth with 88,423, and Independent candidate Derek Nally finished in fifth place with 59,525 votes.

When it came to the formal announcement, it was kind of hard to believe that I was actually standing on the stage in Dublin Castle, hearing my name called out. The constituency figures made fascinating reading; in Donegal South West, with 23.5 per cent of the vote, I came in second behind Mary McAleese, while in Donegal North East I also finished second with 24.7 per cent of the poll. My vote in the combined Connaught/Ulster constituencies was an impressive 17.7 per cent, and to the amazement of all, I even managed to get 12 per cent of the first-preference votes in the traditionally liberal constituency of Dún Laoghaire-Rathdown in Dublin! Nationally I had received 13.8 per cent of first-preference votes.

All of the party leaders congratulated me and were very gracious in their praise of my performance. Even fellow Derry native Nell McCafferty congratulated me in her own inimitable way: 'Well done. You f…ed the system!' There was a sense of elation for everyone in our little team; we had done it, we had truly bucked the system and turned the political establishment on its head, with just an idealist who was prepared to take risks, backed by a family of willing amateurs and a gang of genuine, dedicated, democratic people. As Jonathan Philbin-Bowman put it so eloquently: Though I was not a president, I was a precedent.

Eventually everybody drifted away from the splendour of St Patrick's Hall, and my family and I wandered through some of the side rooms in the Castle, not wanting to leave just yet. Suddenly we came across an enormous throne. This fascinated my mother. A photographer who was walking by explained that it was known as Queen Victoria's Throne, because she had been the only person allowed to sit on it. Then he

added playfully, 'You're a Queen, Mrs Brown. Quick, sit in that chair and let me take a photograph of you.' My mother was very reluctant, but he was persuasive and so she quickly sat on the enormous, green velvet throne that dwarfed her little frame. The resulting photograph was splashed across the front page of the *Examiner* the next day. It was wonderful and I'm sure Queen Victoria wouldn't have minded at all!

The adventure was over and it was time to leave Dublin and the world of Irish politics. Returning to the everyday normality of Alabama with Damien and the children was like stepping into a different world and it was a great relief to be home again, just in time for John James's thirteenth birthday, with Christmas, our favourite time of year, just seven weeks away.

But over the following months I found myself facing a dilemma. Were we to continue to remain in the US for the sake of the children who by now had reached a critical stage in their education? Or, in light of my election performance, was I to listen to the many people who saw me as a credible voice for them and were asking me to return to Ireland to represent them again?

Chapter 10 ∽

EUROPE
CHALLENGES

It was wonderful to be able to sit in my own home with my family around me after the whirlwind of the previous six months. It marked a much-needed and reassuring return to normality as we began to pick up where we had left off in July. We still had campaign expenses to clear up, and thankfully public donations continued to trickle in from Ireland. As I had received the specified quota of votes I was also eligible for a payment of IR£30,000 from the government, which meant that we were gradually able to pay off the outstanding bills for printing, telephones, electricity and other expenses.

Within days of my returning to the US, there began a constant stream of messages asking if I would run again as a candidate in the next Dáil or European elections. Some letters were from the friends we had got to know in the course of the campaign, but most were from those private individuals who had connected and formed the grassroots network that had spread throughout the country. An eclectic mix of politics, beliefs and generations, they were empowered and anxious to move forward together again. Their hope was that I would represent them in either the election for the European Parliament that would take place in the summer of 1999, or the Dáil elections soon after. However, the thought of sitting in the Dáil or moving to Brussels was not something that appealed to me.

I had been asked to address the Law Faculty of Trinity College and also to appear on the *Late Late Show*, in relation to my performance in the Presidential election, so Damien and I flew back to Dublin for a brief visit. Immediately after the election there had been some

correspondence between Paul Allen and the Taoiseach's office regarding a meeting between Bertie Ahern and myself. It was not possible to arrange it at the time as I wanted to return to America with the children as quickly as possible. But a day or so after we arrived back in Ireland, I received a call from the Taoiseach's private secretary asking if I would be available for a meeting over the following few days. Damien and John accompanied me to the Taoiseach's constituency office in Drumcondra. In a comfortable upstairs sitting room, we talked for over an hour.

Bertie Ahern made it clear that there was room for me in Fianna Fáil, that if I wanted to run for a seat in a by-election I could more or less name the constituency of my choice. He felt, however, that I might not enjoy life in the Dáil and working in politics at the local level. He then strongly suggested that I run for a seat in the European Parliament where again there was a choice of constituencies. He asked that if neither of these options appealed to me, I would consider being part of a government-appointed 'think tank' in any area that interested me. I could do so in a public or private capacity and as a member of the Fianna Fáil party or not.

He also told me that, in the final week of the election campaign, the turnaround in under-35-year-olds giving me their number one vote, in the Dublin area, was 70 per cent. He was amazed at this and felt that it was unrelated to my pro-life stance. The information confirmed what I had encountered during the campaign where I had received such encouragement and support from the young people I met, even though it had been frequently forecast in the press that only farmers over seventy years of age, living in the west, would give me their vote! And as far as my pro-life stance was concerned, I was well aware that I had been portrayed as a one-issue candidate, but I believed many people understood that although a fundamental human right such as the right to life was of central importance to me, I was also deeply concerned that other basic human rights be protected as well.

I explained to the Taoiseach that while I was looking at all options at this time, the decision to become involved in Irish politics was a difficult one with four children to consider and that there was the alternative of continuing to work in the field of entertainment and media. However, I said that if I ever did decide to join a political party it

would have to be one that would respond to the concerns of the people who had voted for me. From what I had heard on the doorstep and seen reflected in my vote, this was not the case with the major parties on a number of issues and particularly regarding the long-demanded referendum people had been calling for to clarify the Constitutional Amendment protecting the life of the unborn.

Before I left, the Taoiseach gave me his private number for future contact, leaving the door open for me to get back to him should I wish to. On reflection, I decided that running for political office was not a priority for me at that time and that, even if it were, I felt that to accept these generous offers would compromise the independence I had fought so hard to establish. Damien and I had already planned that I would return to Ireland in mid-February to thank those wonderful people who had helped me throughout the election and I felt it would also be a good opportunity to discuss any possible future involvement I might have in politics. Our whistle-stop tour was a celebration, with lots of laughter and sharing of campaign escapades.

A small article had appeared in the press after my meeting with Bertie Ahern, saying that I was considering running in the upcoming European election. My supporters were heartened that I might go forward, though not at the thought of my joining a political party. As far as they were concerned, we had already shown political leaders that they could no longer ignore the grassroots of their own parties and we could show them again if I would run for the European seat.

I went to Derry and Donegal during my visit and there was worrying news there that Fruit of the Loom, one of the northwest's largest clothing manufacturers, was in danger of closing due to losses in earnings. Through the years we had seen the devastating effect on the community of the closure of the traditional shirt and pyjama factories that my mother and grandmother had once worked in. In the northwest, an area already familiar with the effects of long-term unemployment, the almost inevitable loss of Fruit of the Loom would be a further blow to families on both sides of the border.

The people I spoke with agreed there was more investment needed in the area, particularly in roads and transport links so that new industries could be encouraged to set up. I also met with a number of farmers and fishermen who shared how difficult it was to deal with all

the new rules and regulations and paperwork that seemed to increase by the day. And they were concerned that decisions were being made and laws passed in Europe without their being aware of it until it was too late.

As we travelled home to Alabama I knew that there was a lot to consider before I could make a decision on whether I was ready to step back into the fray. For one thing, our children were settled and happy in their schools and with their friends. We were kept busy as usual ferrying them to school, music lessons and the Saturday-morning sports games. Ruth was very keen on volleyball and she was an excellent player. John James was always so 'laid back' and he got along very well at anything he undertook. Robert, at six years of age, had a whole gang of friends from around the circle that we lived on. Our eldest, Grace, wasn't really into sports but she had plenty to keep her busy. She preferred ballet, fashion and boys! She also had a lovely singing voice and was in the honours choir at her high school.

There was tremendous interest in the US in what I had achieved in Ireland and I began to receive invitations from various colleges to give talks on my experience in the election. One such invitation took me to Stonehill College in Boston where I was privileged to receive an honorary doctorate. It was a special experience for me; I had often regretted that because of Eurovision I had missed out on going to college and I thought that I would never be able to experience what it was like to wear a graduation gown and receive a degree, as I hoped each of our children would be able to do.

Throughout the rest of the year, I settled back into recording my series for EWTN, with Damien helping out on the production side as well as organising the many personal appearances I was asked to do in different parts of the country.

The correspondence kept coming from Ireland, asking me to run in the European election. There was a definite desire to get me elected but the question was, could I secure enough votes if I put myself before the electorate again, and more importantly, was it right for me to run at all? I talked to as many of my supporters as possible to get their feedback on the ground. Politically experienced people had told me after the Presidential election that because of the spread of my vote I could probably run in any of the constituencies and make a respectable

showing. However, they were at pains to stress that a Presidential vote was unique, in that people feel freer to vote for the candidate they like, rather than strictly voting for their party, and so in the European election there was no guarantee that I would maintain the high percentage of first-preference votes I had previously achieved.

I studied the workings of the European Parliament and the impact of decisions made there on Member States like Ireland, so that I would understand how the EU functioned. There was so much to learn: the breakdown of the political groups; the committees; how the voting system worked; what input people in the constituency could have; and how an Independent could best fit in so as to make a worthwhile contribution. I knew that if I did get elected I would need to be part of a powerful group within the Parliament, because I'd need that support and influence; yet as an Independent I could not be under the whip of that group.

Also if I were going to run in the European elections, I would want to represent a constituency that I felt had the most concentrated needs. There were certainly many issues in each of the constituencies, and supporters in Munster were lobbying hard for me to consider running there. But perhaps because I was from the northwest and knew the area well, Connaught/Ulster was emerging as the constituency I was most drawn to, and having walked and driven the roads and laneways of the border and western regions, knocking on so many doors, talking and listening to people, I was now very familiar with the problems west of the Shannon. Wilful neglect and lack of investment were at the root of the problem but also a studied disregard for what the people had to say.

But it would certainly be a challenge to get elected there; it was a three-seat constituency, with Fianna Fáil holding two seats and Fine Gael one, and it was considered very difficult for an Independent, especially for someone who could be regarded as a 'blow-in' like me. One of the sitting Fianna Fáil MEPs, Mark Killilea, was retiring and Noel Treacy, a junior minister based in Co. Galway, was considered a 'shoo-in' for his colleague's vacant seat.

As the months passed, I felt I needed to go over to Ireland and spend some time meeting people in the west, and not just those who supported me, so that I could listen to what they had to say. Joe Brennan in Ballinasloe had already offered to be my director of

elections. My brother John firmly believed that I should run, as did Jonathan Philbin-Bowman, and both offered their services again. It meant a lot to me that John was willing to leave his family and his business in London for a second time in order to be my campaign manager, and also that Jonathan had that belief that I could make it.

Connaught/Ulster is one of the largest constituencies in the European Union, running from the border counties of Donegal, Sligo, Leitrim, Cavan and Monaghan, down to Roscommon, and across to Galway and on to Mayo. For any candidate it was a huge and intimidating territory to cover, but for an Independent without the backing of a political party, it was a daunting undertaking. I checked with Seán Doherty to find out if he intended to run and also to ask his advice on some aspects of my 'possible' campaign, such as: should we invest in getting some private polls done, or use that money for posters instead; where would be the best location for campaign offices, and most importantly, who could we turn to for support on the ground? He assured me that he had no intention of putting his name forward and he was very generous and constructive as always with his advice. I also spoke with Seán Dublin Bay Loftus (the first genuine environmentalist in the Oireachtas) for similar campaign advice, and with Patricia McKenna, to find out what it was like for the mother of a young child to balance family and work in the European Parliament.

The more I studied the political groups in the European Parliament, the more I felt that my leaning would be towards the European People's Party (EPP). I had read all the manifestos of the various groups and though I knew it would be difficult to find the ideal one, the EPP seemed to share my position on family and on upholding the dignity of each person from conception. Also, the British Conservatives, who were members of EPP, had a special status within the group, so that although they were full members, they were still independent and not obliged to follow the whip. Remembering what had happened with my unexpected Presidential nomination, I decided that I should write to the Secretary General of the EPP, laying out my platform and requesting membership of the group should I be elected.

But before I could consider throwing my hat in the ring, the issue that would have to be addressed was the cost of undertaking such a campaign. It was not as daunting as the Presidential election. My

campaign would be regional, not national. I was no longer a complete newcomer and I had previously polled well, hopefully making it easier to secure public donations. We felt fairly confident I could at least bring in the quota of votes needed to make me eligible for a reimbursement of IR£30,000, and that would be a good start to covering most of the cost of the campaign if we kept it short and the budget tight.

On 19 March the front page of *The Irish Family* newspaper declared that I would announce my intention to run in the European election on RTÉ's *Late Late Show* the following month. It was obviously speculation, unlike the article I read on one of the inside pages which reported that the Women's Rights Committee of the European Parliament had adopted a report calling for legalisation of abortion in all Member States, despite the fact that the people of Ireland had voted to protect the rights of the unborn in their Constitution and had also secured a protocol to the recent Maastrict Treaty which stated, 'No European legislation may affect the Irish Constitution's protection of the unborn'. Six of the fifteen Irish MEPs, which included the four elected women, had voted in favour of this report, and while I felt that people had the right to their own point of view, I was surprised that Irish MEPs had voted against their own Constitution and the stated will of the majority of the Irish people. So, I wondered, were they reflecting the wishes and hopes of the constituents they were representing, or simply putting forward their own opinion?

In early May, after a short Easter break with our children in America, I returned to Ireland where I had been invited to appear on Pat Kenny's television show on 2 May. I didn't plan to announce on the show my intention to run, as I wanted to keep the campaign to three or four weeks at the most; however, the day before *Kenny Live*, to the surprise of everyone involved, the RTÉ Editorial Board banned me from appearing on the programme. Pat Kenny and his team were very annoyed and he was quoted in the *Irish Sun* as saying, 'I've had people who have declared themselves on my radio show. I have not yet had an explanation as to why this decision was made. We are all very disappointed.'

On 6 May I announced my intention to run as a candidate, on Pat Kenny's radio show and in the *Connaught Tribune* newspaper and on UTV's *Gerry Kelly Show* in Belfast, stating that I wanted to be a 'breath of fresh air' in Brussels and that my policies would respond to the real

problems that people were facing. Immediately the media flood-gates opened and we were swept down that electioneering road again. A politically assured Lindsey Holmes was back in the PR seat with John; Paul Allen recycled the artwork from the Presidential election, providing the most creative and attractive brochures and, this time, posters! Jonathan was the multi-talented 'backroom boy' and, added to Damien and John, we had teams of dedicated supporters volunteering in the newly opened election offices in most of the counties. Meanwhile the family was back in the van, hitting the—mainly pot-holed—roads running.

My base was in Galway where I rented an office in the city centre and a house for all the family in Westside, a predominantly working-class area. But as we had such a huge area to cover, Damien's brother Michael gave us the use of his holiday home in Mullaghmore, Co. Sligo.

On Monday, 10 May, I formally launched my campaign in the Great Southern Hotel, Galway, having just put the finishing touches to my speech minutes earlier. In a nutshell, I promised the voters that if I were elected I would make sure that their values, beliefs and pattern of life would not be reshaped against their will and without consultation; that I would fight to ensure that Connaught/Ulster received its fair share of EU funding so that there could be long-overdue investment in the west for the benefit of all the community; that I believed the good of families and individuals must be at the heart of every policy; and that I would be an independent voice for them in Europe, a voice that would not be intimidated or silenced. The room was jam-packed with beaming, cheering supporters and we were ready to take on all the challenges ahead.

There were eleven candidates in all: two sitting MEPs, Pat 'The Cope' Gallagher of Fianna Fáil and Joe McCartan of Fine Gael, both assured of being returned; Junior Minister Noel Treacy of Fianna Fáil, considered the automatic choice for the third 'safe' seat; Marian Harkin, Independent, schoolteacher and Chairperson of the Council for the West; Seán McManus, Sinn Féin; Ger Gibbons, Labour; Luke 'Ming the Merciless' Flanagan of 'Legalise Cannabis' fame; Fr Liam Sharkey, Independent; Paul Campbell, Natural Law Party; Paul Raymond, Independent; and myself.

We found ourselves darting all over the constituency from the most northern tip of Donegal to southern Roscommon and all places in

between as we canvassed would-be voters. But a week-and-a-half into the campaign, I had a two very special dates in Birmingham, Alabama, that I couldn't break for anything, not even a seat in the European Parliament. Grace was graduating from High School and three days later John James's confirmation was taking place. It meant missing almost a week's campaigning, but such special moments come around only once and it was very important to me and to us as a family that I could be there.

Back in Ireland once more, I had to work doubly hard to catch up on missed time if we were going to cover the entire constituency before voting day. Then one evening in early June, we stopped late in the evening to grab a much-needed meal in Donegal and I got talking to a couple of ladies at the table beside me. It turned out that they were nurses and in the course of our conversation they told me of the dreadful situation in the nursing home where they worked. They were deeply upset that financial cuts were resulting in chronic understaffing and unhygienic conditions for the elderly men and women in their care. One of the nurses told me that while on night duty, she had the impossible task of single-handedly looking after forty to fifty dependent and incontinent elderly people and that incontinence pads were being recycled.

I was appalled at what I was hearing. My own mother was eighty-one and the thought of her having to live in conditions like that was horrifying. I really felt that people needed to be told of the neglect these vulnerable people were experiencing, but the women were petrified that if I gave any details about them or the location of the nursing home they would be identified and their lives wouldn't be worth living, so I promised that I would protect their identities.

Shortly after that conversation I was interviewed on radio by Pat Kenny and I repeated the allegations made by the nurses in Donegal. A very public and bitter row ensued with the North Western Health Board as the press picked up on the story. Most people could hardly believe what they were hearing but the debate clearly struck a raw nerve with the Irish public and I'm glad that the pitiful results of healthcare cutbacks in the northwest were brought out into the open. How we treat the most vulnerable members of our society reveals how civilised we are as a people.

Like all elections, this one had the usual spats and mischief, as well as some quite amusing incidents, like when Pat Cox MEP, later President of the European Parliament, described me in the *Daily Telegraph* as a 'political tourist', adding that 'while a few singers are good for the Christmas party, the European Parliament needs more than just personalities'. I was surprised that he'd bothered to comment on me, seeing as he wasn't running in my constituency and that apparently he himself had played the 'political tourist', as he put it.

In elections I believe that each candidate must lay before the voter exactly where he or she stands on relevant issues, particularly sensitive issues. Only then can the voters decide which candidate best reflects their opinions and aspirations. While it is legitimate for candidates to challenge each others' ideas or policies, I have no time for negative campaigning; I don't believe character assassination has any place in an election campaign.

I found that the media's response to my campaign was mainly good and those who had written me off in the Presidential election were choosing their words more carefully. Declan McCormack in the *Sunday Independent* (6 June) wrote that I was well briefed on EU funding and that I spoke knowledgeably about the wilful neglect of the west and Dublin's control of the purse strings which 'clearly indicated that my research on European affairs was well founded'. But the question most journalists were asking was, would I tap into that huge vote I received in 1997 or would I be the proverbial one-hit wonder? Thankfully, the feedback I was getting on the ground was remarkably positive.

I had a particular interest in the farming and fishing communities. Firstly, they were indigenous industries and often the *only* industries in the most disadvantaged areas. As such I believed they were deserving of special protection and support. Secondly, as the saying goes, most people in Ireland are only a generation or two away from the soil, as was the case in my own family. Many of the farmers I met were quite elderly and their dilemma was brought home to me one afternoon in Virginia when I stopped to speak with a gentleman who looked to be in his eighties. I assumed he was retired and so I asked him if he used to be a farmer, to which he replied, 'I *am* a farmer. I have no one to take over the farm from me.' I was to hear this story many times over the coming weeks.

The future was uncertain for the farming community, as it was for the fishermen, and more and more farmers were being swept off the land. Those who persevered were struggling under ever-increasing red tape and bureaucracy that was making an already difficult job even harder. It was inevitable therefore that sons or daughters, who could make a better and easier living in other kinds of work, were unwilling to remain in an industry that had such a precarious future. For most of them, therefore, it meant moving out of their home area, or even the country, in order to find a job.

After a last-minute dash of canvassing from Galway to Donegal and back again, Election Day arrived on 11 June and I cast my vote in Galway. I had highlighted the issues I felt were important, we had covered most of the constituency, and my supporters and team had worked above and beyond the call of duty. However, there was no indication in the media, or apparently in the private polls taken by Fianna Fáil, that I might have the remotest chance of winning the seat. The forecast was Pat 'The Cope' Gallagher, Joe McCartan, and Noel Treacy (for the vacant seat), although there was some speculation that if there was to be a surprise in the result it would be down to Marian Harkin.

I finally made it to bed at about 3.30 a.m., exhausted but feeling I had given it my best shot and that as long as I got a halfway decent vote, I would be very happy. The following day the European votes were being sorted from the local election ballots in the leisure centre in Galway as well as other centres throughout the constituency. It wasn't necessary for me to be there, so as I was tired I stayed in bed while the others went to our election office to confirm that we would have enough people to tally the votes at the count in Bundoran the following day. I was woken from my sleep by the sound of the telephone ringing at the bottom of the stairs.

It was Enda O'Byrne, a witty and talented cameraman from Telefís na Gaeilge whom I'd got to know well in the course of the campaign. Enda told me he was in Leisureland and then stunned me by saying, 'I think you ought to come down here because it looks as though you could beat Noel Treacy.' I had to sit down on the stairs and for a minute I couldn't speak. I felt shocked and emotional and I blurted out, 'That's impossible. He's a Minister of State. And I can't come down. I'm not dressed and I don't have a car.'

Practical as ever, Enda calmed me down and told me to get ready as quickly as possible. He'd be there to pick me up in twenty minutes and we'd do a piece in Leisureland for the TV news. I just went into automatic, grabbing the nearest thing to wear and ended up putting on my make-up in Enda's car. Nothing had prepared me for this and in my heart I was convinced that despite any early hopeful signs, I couldn't possibly have enough votes to get me over the line.

As we walked in, I was aware that people were watching me closely and it was a bit unnerving. There were very few there and I seemed to be the only candidate about the place, so I was relieved when Damien and John arrived soon after I did, having heard the news from Enda. When we'd filmed my piece for Telefís na Gaeilge, in which I said that I was encouraged by the early tallies, I left immediately to prepare for our move up to Mullaghmore and the all-important count. By the following day I would know if Enda was right in his hunch that a political earthquake was about to erupt.

Mullaghmore was always a soothing place to be and for the rest of that evening Michael's house was a haven as I relaxed with the children, not wanting to hear any further news about the tallies. It was much better not to have our hopes raised, just to have them dashed again.

The all-important day arrived and the count centre in the ballroom of the Great Northern Hotel in Bundoran was bustling with election workers, political activists, supporters, family and friends. The turnout of voters had been significantly higher than in the previous election and, with the odd reminder from the returning officer Tommy Owens, conversations were hushed so as not to break the concentration of the men and women diligently counting the thousands upon thousands of ballot papers at the trestle tables that marked out a large rectangular space in the middle of the dance floor.

All eyes were drawn to them as they meticulously discarded spoiled ballots and carefully placed the valid bundles of votes on the rapidly rising stacks dedicated to the respective candidates. All day long they counted and discarded while keen-eyed tallymen calculated the votes for their hopeful candidate with a speed and accuracy garnered through years of experience. A good tallyman could estimate the result to within a few hundred votes, I was told, as I stood gazing down at the tables in the stiflingly hot, crowded room, wondering how many tallymen already knew the outcome of this nail-biting day.

This election differed from previous ones where tallies were available on a county-by-county basis, allowing an estimate of the result to be made. This time, for some reason, there were no tallies available in many areas of the counties, and in Roscommon there were none at all. Then to make it even more difficult, when the count had started in Bundoran that morning all the counties were lumped in together, with the result that no one really knew what outcome to expect. Tallymen were gathering and exchanging information every few minutes but to no avail.

When I arrived at about six o'clock that evening I was immediately surrounded by a posse of journalists and cameramen anxious to know what I thought my chances would be after the major surprise of the first count. I had polled an unbelievable 51,086 votes, placing me in the running for the third seat ahead of Noel Treacy with 47,933 and Marian Harkin with 47,372. The media were calling it the 'shock of the night' and there was disbelief in the Fianna Fáil camp. But because of proportional representation, I knew we had a long way to go and it would all be down to the transfers. Meanwhile my team was anxiously circling the tables trying to work out my chances of holding the third position. The result of the first count had been delayed by five hours to 9 p.m. and as they started distributing transfers for the second count, we knew it was going to be a long night. I was gathering transfers from everyone, even from the Sinn Féin candidate who had rejected as 'ridiculous' the suggestion that his votes were transferring heavily to me.

As the already feverish excitement of this unforeseen cliff-hanger increased with every passing minute, RTÉ ended its television coverage at ten o'clock and its radio coverage at eleven. Its Western Correspondent Jim Fahy was absolutely furious. This was *the* story of the 1999 European Elections but as far as RTÉ was concerned, the unseating of a Minister of State by an Independent candidate didn't merit extended coverage and Jim was off the air. However, TV3, INN Radio News, Today FM and the national newspapers were all in a tizzy over what was happening! And in the count centre itself, from a very confined space underneath a television platform (the closest position he could find to the action) Raidió na Gaeltachta's Conal Ó Dubhaigh continued to give a blow-by-blow account of the extraordinary happenings in Bundoran to keen listeners glued to their radios all over the island.

My mother, always good at maths, was doing her own tallying by this time. Damien was closely watching the count, as were our children, Grace, Ruth and John James. Robert, saucer-eyed, was fascinated with everything and way past his sleep time. My brother John was on the phone as usual, always thinking and planning ahead. As the night wore on, I was told of murmurs in the political camps and grumblings that I was 'only a singer'. Philomena Begley, the Queen of Country Music, called in to lend her support in the early hours and soon let her feelings be known on that subject. 'What's wrong with being a singer?' she demanded of anyone within earshot, and lucky for them no one answered her.

By the fourth count there were only five of us left in the running and the returning officer mercifully adjourned the proceedings until the morning. It was now down to the two Independents to battle it out for the final seat, and with a total of almost 100,000 votes between us, we had made the political world sit up and take notice of the people we represented. It was time for a woman to take the seat, and if it wasn't to be me, I would be happy to see Marian take it.

The next morning at the count centre events were happening faster than expected. I had not yet seen the morning papers where on the front page of the *Irish Independent*, Brian Dowling and Anita Guidera had declared, 'Dana poised to steal a seat in biggest poll shock', going on to describe it as shaping up to be the 'biggest upset of the European elections'. Still in Mullaghmore, I was encouraging the children to get dressed so that we could go for a quick walk, when suddenly the phone rang. John was on the line from the count centre and he got straight to the point: 'Get up here quick. Noel Treacy has conceded!'

As we turned into the long driveway that led up to the hotel, I could see a wall of photographers and TV cameras waiting in the distance at the hotel entrance. There was pandemonium when I stepped out of the car, with cameras, microphones and reporters closing in around me. Suddenly Damien appeared and took my hand, and we made our way into the count centre, quickly followed by our children. The atmosphere was electric and my supporters were convinced that I would get substantial transfers from Noel Treacy, but there was a sense of unreality about what was happening and I wasn't going to believe anything until I heard the final count and formal declaration of the

elected MEPs. As it turned out, my supporters were right: I did get substantial transfers and Noel was gracious in defeat, making his way over to shake my hand and wish me good luck. Then, before his transfers were announced, Marian Harkin also conceded defeat, graciously congratulating me on my win.

After a marathon 22-hour count, to the astonishment of all present, the 'no-hoper' whose career had begun in Europe, won a seat in the European Parliament! And as I was the first woman elected to represent the constituency of Connaught/Ulster, history was made again!

After six counts, the returning officer formally read out the final votes for the elected MEPs: Pat 'The Cope' Gallagher, Fianna Fáil, 98,258; Joe McCartan, Fine Gael, 75,275; Dana Rosemary Scallon, Independent, 72,855.

I was surrounded by family and friends, and as my name was called out an enormous cheer erupted and my supporters lifted me shoulder-high, throwing me up in the air with ecstatic delight.

As the euphoria and camera flashes settled, one life-long member of Fianna Fáil made his way over to me and, grabbing my hand, he whispered, 'I have been praying all night that you would win. Congratulations!' What he said meant a great deal to me and he was typical of the many good people within the established parties who gave me their support because I stood for the things that really mattered to them.

The political establishment was reeling. Éamon Ó Cuív, the Fianna Fáil director of elections, was quoted in the *Irish Independent* as saying that the election results were 'disastrous' and that the results in the west showed that people were genuinely concerned about the way society was going. He also said that he believed the abortion issue had to be put to the people in another referendum.

The headline in the *Irish Sun* was, 'She's gone and Dana-it again'. The *Irish Independent* read, 'Dana's win rocks the party bosses'. One article that particularly impressed me was written by Kevin Hegarty in *Céide* who accurately summed it all up: 'They [the people] used the ballot box, one of the few weapons the weak can use against the strong … The cynicism of Fianna Fáil and Fine Gael, the parties that control and often forget about this conservative heartland … The whole cultural, ethical, economic and ritual fabric of the west of Ireland has been

vested in its small farmer tradition. It is dying and there is little evidence that the political and economic establishment understands or cares deeply enough.'

In the meantime as the after-shocks settled, Damien and I faced into the rapid changes that had to be made in our personal circumstances. We would have to take our children out of school and away from their friends in Alabama, sell our house and once more cross the Atlantic to a new home in Ireland.

Just two weeks after my election, I was approached to act as an intermediary in the stand-off at Drumcree church just outside Portadown. The opposing sides in this problem were bitterly divided and there seemed to be no peaceful end in sight. It was indeed a sensitive situation. Harold Gracie, the District Grand Master of the Orange Order, was living in a caravan at Drumcree church, in order to highlight his objection to the ban that prevented the Orange Order from marching down Garvaghy Road. We sat at the table with a mug of tea talking for over an hour-and-a-half, after which I was taken to meet with Breandán Mac Cionnaith and others members of the Garvaghy Road Residents Association. I spent similar time with them in their community club, listening to their deep concerns.

The Orange Order considered the march as a celebration of its heritage and the residents saw it as a provocation. As always there was tragic loss of life in the resulting sectarian violence. I remember Harold Gracie saying that he felt there were hidden forces behind the scenes, manipulating the situation, and I asked him if it wouldn't be better to sit down and meet the residents face to face just as we were doing—a question I also put to the residents. Sometimes all you *can* do is listen and pray for resolution and peace!

Chapter 11 ⌒

THE MEMBER FOR
CONNAUGHT/ULSTER

As I adjusted to having the letters MEP after my name, I had a great deal to learn in a very short space of time. Klaus Weller, General Secretary of the EPP, welcomed me into the group on the terms I had requested. I would be completely independent but a full member of the biggest and therefore most powerful group in the Parliament. The next step was to get on to the committees I wanted. There were seventeen to choose from in all, dealing with everything from Environment, to Legal Affairs, to Budgets, to Women's Rights and so on, but I already knew the committees I wanted.

Within three weeks of my election, I was due in Malaga in southern Spain, for the EPP's first group meeting of the new parliamentary term. Referred to as 'Study Days', it provided an opportunity to lay out the political programme for the coming year and to discuss the position the group would take on various reports and proposals for legislation in the new Parliament. It also allowed members to welcome the newly elected MEPs and to say farewell to those departing.

My brother John, who was to become my assistant in the Parliament, travelled with me to Malaga as Damien had already taken the children back to Alabama so as to begin packing up our belongings and preparing for their permanent return to Ireland. However, Grace would not be coming with them as she had been accepted into university in Washington DC, and I was finding it hard to think about the prospect of being so far away from her.

Travelling to the Parliament through the following weeks meant that I had just four weekends in Galway to find a house to rent, locate schools for the children and look for an office. I also had to settle into my parliamentary offices in Brussels and Strasbourg, as well as attending the

Foróige Finals in Galway, a civic reception in Ballina, visiting the Fr Peyton Memorial Centre in Attymass, and attending the Connaught Final between Mayo and Galway, at which I cheered for both teams! Life was indeed hectic and I don't know what I would have done without the support of so many friends and my family through this time.

With my acceptance into the group there were now five Irish members in the EPP and at the first discussion meeting in Malaga I sat down with the Irish contingent—Joe McCartan, Mary Banotti, Avril Doyle, the straight-talking John Cushnahan, former Leader of the Alliance Party and a northerner like me, and outgoing Allan Gillis. I was welcomed and given some tips regarding what lay ahead. The travel was one of the worst aspects, I was told, with trips to Strasbourg taking up to twelve hours each way from the west of Ireland. As there were only fifteen Irish MEPs, out of the total of 626 members in the Parliament, I hoped that we could all pull together.

I put on my earphones and listened to the English translation of the discussion taking place around me in eleven different languages. For the first time in many years the EPP, a centre-right group, had surpassed the socialists to become the largest political grouping in the Parliament, with over 330 members, who included former prime ministers and presidents, and the future controversial Italian Prime Minister Silvio Berlusconi.

One evening at dinner I was invited to sit beside Hans-Gert Poettering, the President of the EPP, and now President of the European Parliament. I took the opportunity to ask him for a place on the committees I felt would best benefit my constituency. I asked for the Regional Policy and Transport Committee since there was lack of investment and poor infrastructure in the west, and, because our youth and culture are so important, I also asked for the committee dealing with Youth, Education, Culture, Media, and Sport. I took a deep breath and asked for the chairmanship of the Regional Policy Committee, not that I expected to get it, but I wanted to impress on him that I meant business and wasn't there just to make up the voting numbers! Somewhat taken aback by the boldness of my request, Hans-Gert explained that, for a chairmanship, I would need the approval of the Irish Delegation and he also suggested that I inform my colleagues of the committees I had requested.

On checking my schedule for the various meetings taking place, I spotted the time and location of the Irish Delegation meeting. There was no one in the allocated room when I went along but I happened to bump into John Cushnahan, Joe McCartan and their friend Bartho Pronk, a very experienced and long-standing member from Holland. Apparently the Delegation meeting had been cancelled but John and Joe explained that I wouldn't be allowed to attend anyway, because Fine Gael was the Irish Delegation and I wasn't in Fine Gael. To which I naturally responded that though I wasn't a party member, I was Irish and therefore should be part of the Irish Delegation.

At this point John Cushnahan called on Bartho Pronk to give his expert opinion and, obviously bemused, Bartho pronounced that he couldn't see why I should be excluded; the Italian Delegation was made up of members from various political leanings, as were other delegations. However, he assured me that if they didn't want me, he would invite me into the Dutch Delegation instead. There was no anger expressed or felt, and John and Joe left me to discuss it further with the other Fine Gael members, saying that they'd get back to me.

Delegation meetings are held prior to the monthly voting sessions and are very important because various reports are discussed in light of how they might impact on your Member State. As you could vote on up to fifty or more reports each month in Strasbourg it was impossible for an individual member to examine them all and obviously any incorrect votes on difficult or controversial issues could be very damaging for the constituency and the MEP's reputation. Although the impact of a report on Holland would not necessarily be the same as for Ireland, I appreciated Bartho's offer and as the word of this unusual dilemma spread around the group, I was also invited to join the British and German Delegations before I left Malaga for home.

The day before I left, there was still no word from my Fine Gael colleagues, so I met with Klaus Weller who had heard of the problem and he assured me that the group would support me in forming a new delegation with the only Danish member in the EPP and that I was to be given committees I had requested.

By the beginning of the following week when we met in Brussels, there'd obviously been a change of heart in Fine Gael and I received an invitation to join the Irish Delegation, which I decided to accept.

Unfortunately by this time the press had got to hear of the goings-on, and as Fine Gael thought that I was the source of the leak, our first Delegation meeting was very heated indeed. John Cushnahan, in his usual forthright manner, made it clear that he was not happy with the situation. However, when I clarified that I had never spoken of the matter with the press, it was accepted. Over the next couple of years this wasn't the only instance of heated discussions and frayed tempers in our Delegation meetings, but so it is with the 'cut and thrust' of politics. John Cushnahan and I respected each other and over the five years I spent there, we developed a good working relationship and friendship even though I was eventually expelled from the Irish Delegation two years later, in 2001, for opposing the Treaty of Nice.

I flew to Brussels on the 7.35 a.m. flight from Dublin and as I walked through the arrivals door in Brusssels Airport, drivers were waiting to ferry the arriving MEPs to the Parliament. I had pictured driving up to a stately building in a picturesque part of town surrounded by lots of greenery, but I was in for a shock. The Parliament was housed in a spectacular glass-and-steel modern building that straddled a narrow street in an area of the city that was once very run-down and was now being redeveloped. In the surrounding streets, we drove past many once-elegant art deco houses that were now dilapidated, with boarded-up windows and doorways, forlornly awaiting demolition. Opposite the Parliament was the entrance to what looked like a pretty park, but I was soon warned not to walk there unaccompanied and never at night, as a number of MEPs had already been mugged in the area.

Apart from some group meetings and an induction session for the new members, it was time to set up our offices and find our way around the extensive Parliament buildings. It felt like my first day of school. My brother John was going to work with me in Brussels until I could find another assistant there, but already there were signs that the workload in the constituency was piling up fast, and with Damien dealing with selling our home in America I would need to find someone as quickly as possible. I wanted an assistant who would be familiar with the workings of the Parliament but also able to understand the needs in my constituency. Through an outgoing Italian member, Carlo Cassini, a judge who had been chairman of the Legal Affairs committee, I was introduced to Catherine Vierling. Catherine

was multi-lingual, born in Strasbourg and well used to Parliamentary procedures, and she ended up working with me for the five years I spend shuttling between Brussels and Strasbourg.

In those early months it was just John and me covering all bases. One day when I was sitting in my office in Brussels surrounded by a mountain of correspondence and lists of people to call, the phone rang and I answered it. The gentleman on the other end of the line spoke with a very pronounced Galway accent and, a little taken aback to discover that I was not the secretary but the MEP herself, went on to explain that he was from Ahascragh, or as he announced, 'Ah Haw Scraw' just outside Ballinasloe. An hysterical exchange followed during which I was invited to open a special event in the village, because they didn't like 'that McAleese one'. Having had years of experience with practical jokes I knew instinctively that it was a hoax but it was fun to string along. As we said our goodbyes I asked, 'Now tell me who you really are,' to an outburst of laughter at the other end of the phone from the crew of the RTÉ TV show, *Don't Feed the Gondolas.*

Strasbourg, in the north-eastern region of France close to the German border, is the seat of the European Parliament and it was there that I was formally inducted as a member. We were the first MEPs to enter the spectacular glass-and-steel edifice where over the next five years we would assemble for one week out of every month, excluding August. The building had cost in the region of €400,000,000 and as we arrived, workmen were still putting the finishing touches to it. Thankfully, our welcome packs included a map to help us navigate the miles of corridors and various sections of the vast complex; by the end of that first week my map was dog-eared and I had invested in a pair of more comfortable shoes.

One intrepid Dutch MEP subsequently decided to bring his bicycle to negotiate the labyrinth of corridors, but was thankfully banned from riding it because of the new carpet. There were other teething problems too and despite the fact that Fianna Fáil Munster MEP Brian Crowley had highlighted the necessity of designing a building that would meet the needs of people with disabilities, he turned up at the opening session to find that the main voting chamber had no proper access for his wheel-chair! As a result he had to sit permanently at the rear of the Assembly rather than in the seats allocated to the members of his own group.

Almost as soon as I arrived, I met some German women from my group but I only got as far as saying I was from Ireland when they burst into a verse of 'All Kinds of Everything' in pronounced German accents. I was so taken aback as they assured me that they knew who I was and they were so glad to have me in the EPP group. I found it ironic that while some in Ireland felt my singing career was an obstacle to my credibility as a politician, it proved to be very helpful in Europe as it opened the door to getting to know many other colleagues in almost every political grouping. This was very important for me because as an Independent I wanted to be able to work with anyone who could support me in my work for my constituents, whatever their political leaning, or ideology.

Before long I realised that what I had been told was correct. In Europe, as in other parliaments, most business was agreed 'in the corridors' or over a cup of coffee, not in committees or voting chambers. It was therefore vital to get to know as many people as possible on a personal level and for them to trust you. If you needed support for an amendment or a report that affected your constituency, it was easier and better to speak to your colleague as a friend, rather than just another face among 632 others.

As I steered my way to the famous voting chamber on that first day, I heard a familiar voice calling my name, and there he was again—Paddy Clancy, journalist extraordinaire. The reporters who normally covered Parliament business were permanently based in Europe and focused solely on political matters and I knew it would take some time to get to know them. Paddy, on the other hand, was on old friend and I was delighted to see him.

He wasted no time in arranging a photograph of me in the empty hemicycle and I stood with my arms outstretched as if to say, 'I've arrived.' The hemicycle is a magnificent amphitheatre, the largest debating and voting chamber in the democratic world. Around the sweep of the curved walls are glass-fronted translation booths where teams of translators convert every spoken word into the official languages of the Parliament. The members seated at the tiered rows of desks wear headsets that with the turn of a knob allow them to listen to every word uttered in the language of their choice: Greek, German, Swedish, French, Italian, Portuguese, Spanish and so on. The written translation of every debate is also available in each language within a

day or two as are all official documents, and I often felt that every time I left my office I returned with half a forest of paper under my arm. Because there were so many members we were normally given only one to two minutes each in which to put forward our arguments in the hemicycle and then because of the time lag in translation, it was impossible to have a proper debate on sometimes crucial issues.

As Paddy and I left the hemicycle that morning we literally bumped into Nana Mouskouri, the outgoing Greek MEP and internationally famous singer, and Paddy immediately organised a photograph of us together. I knew Nana from of old and I was delighted to meet her again, and as she had represented Luxembourg at the 1963 Eurovision Song Contest, we were the only members of the exclusive 'Eurovision singer turned MEP' club. Giving me a big hug, she said, 'You'll have to wear my cloak from now on,' which I did for the next five years as a main spokesperson in the EPP for the music industry which was lobbying hard to bring about more protective legislation relating to copyright and piracy.

In Strasbourg that week I also got to meet those Irish members elected in other constituencies. There was just a small band of us and whenever possible I tried to support their work in the Parliament. We didn't always see eye to eye, however, and on a number of occasions, especially when I opposed the Treaty of Nice and the proposed European Constitution, relationships could be very strained, with a few of the Fianna Fáil and Fine Gael members and also with Proinsias De Rossa of the Socialist group, not to mention some members of my own EDP group.

Throughout my term of office, however, I always found Liam Hyland and Jim Fitzsimons of Fianna Fáil to be respectful of the positions I held and to be kind and thoughtful, which was much appreciated at those moments when I felt so isolated because of the stand I had taken on various issues that were important to me and to my constituents.

Fianna Fáil was the largest group of elected Irish members, yet they belonged to a very small political grouping called the Union for Europe of the Nations (UEN). I always felt that when Ireland joined the European Union Fianna Fáil could have found a natural home in the

EPP. I asked a German colleague one day why Fine Gael and not Fianna Fáil had been accepted as members and what was seen as the difference between them. His answer was, 'A week'. Apparently Fine Gael's letter requesting membership had arrived a week earlier than the one sent by Fianna Fáil.

In August, during the weeks the European Parliament was closed, I returned to Birmingham, Alabama, to help clear the house. It was difficult to say goodbye to the home we'd been so happy in and even though there was a sense of excitement about what lay ahead for us, there was also sadness seeing the mementos of the past eight years packed away into cardboard boxes. Our 'American Dream' was coming to an end! We said our goodbyes to the same people who had been so warm and welcoming to us on our arrival there, and before we left, Mother Angelica gave us a guided tour of the beautiful new monastery she was building about an hour out of Birmingham in the open countryside of Hansville.

It was a coincidence that when the children emigrated to America in 1991, it was on 18 August, Ruth's eighth birthday, and when we returned to Ireland it was also on 18 August, the day of her sixteenth birthday. Our next-door neighbours arrived at our front door early that morning with home-baked breakfast rolls, freshly brewed coffee and farewell gifts for the children. And at the airport more friends were waiting to see us off. It was typical of the hospitality and kindness we'd always been shown there.

My mother and sister Eileen were waiting for us in the house we had rented in the village of Oranmore, about seven miles outside Galway. And with the helping hands of friends like Angela Grealy, Freddy Kennedy and his wife Noreen, the Thorntons and the Debonnets, the house was transformed into a home.

As we slowly settled back into the Irish way of life and particularly the Irish climate, I watched each child adjust to our new surroundings. Within a few weeks, with uniforms and schoolbooks in order, the children were in their new schools and making friends as we began another chapter in our lives. Robert was young enough to settle quickly. He immediately made friends with little Seamus Walsh across the road and was thrilled that for the first time he could actually walk to his school which was at the end of our street. His life was made all the

more content by the fact that he had a wonderful headmistress, Mary Howley, who really helped him to settle in.

Ruth had always wanted to come home so she made friends easily at her school and was accepted for a place on the National Junior Volleyball Team. It wasn't so easy for John James initially. We had moved to America when he was just seven years old and he had settled into the way of life there. He missed the many friends he'd made in Birmingham and also the sports that he loved so much. Although he was a good sportsman, at fifteen years old he could never have caught up with Irish boys who had played Gaelic football from a very young age. All in all, I think he was very lonely and he would spend hours in his room playing his guitar. Then one evening an unexpected knock came to the door. It was a young boy from just down the street, Richie Murray, wanting to know if John James would come out and play football with him and his friends. Richie was a few years older than John James and he made sure that he was included in whatever was going on. As things turned out, he was a life-line for John James and for us. Since then we have struck up a friendship with the whole Murray family who are great musicians and very involved in Comhaltas Ceoltóirí Éireann, an organisation that has done so much to preserve and promote Irish music and culture.

And when we'd almost given up hope of finding a suitable constituency office, we found one on Eglinton Street, right in the middle of Galway city. For the next five years, with Damien at the helm, it was a hive of activity where we'd run the gamut of emotions from inspiration to frustration and desperation to celebration.

By September, the new Parliament was up and running and life in Brussels and Strasbourg was quickly becoming a roller coaster of meetings—with committees, groups, lobbyists and constituents. I was also a member of a specialist EPP Bioethics Group, which examined questions on ethics in various fields of research and medicine. My work in this group was later to impact on my life in a most unexpected way.

Each month I spent three weeks in Brussels and one week in Strasbourg, so throughout the year we'd have twelve voting weeks in Strasbourg and six 'mini-sessions' of voting in Brussels. There was also constituency work to be attended to and so I decided that I would spend three days per week in Brussels with five days per month in

Strasbourg (two days of which were spent travelling fourteen hours each way). That meant that on Brussels weeks I could spend a day in my Galway office and two days travelling to meetings or events in the constituency, leaving Sunday with my family. Although this didn't always work out, I tried to keep to it as much as possible, though it meant I had precious little time with my children.

Because we had to spend so much time in Brussels, most of the seasoned MEPs bought apartments there, but as Damien and I were in the process of trying to sell one home and buy another in Galway, I decided it would be better if I were to take a short rental lease on an apartment. Just as the lease was coming up for renewal I received an unexpected phone call. A friendly voice on the other end of the phone said, 'Hello, I'm Joan Richards from Kinsale and I work in the Commission. I just want you to know that I have a house here in Brussels and if you ever get lonely, or need somewhere to stay, come and see me.'

Meeting Joan was great. She lived in a beautiful area not too far away from the Parliament and so when my apartment lease expired, her house became my 'home from home' in Brussels. Her pots of freshly brewed herb tea sustained me through many a crisis and ailment and her knowledge of their healing powers continually amazed me!

One thing I quickly learned was that Brussels is a serious 'power house' where, over a two- to three-year period, almost two-thirds of national legislation begins its journey to the Member States, and once agreed in the EU Parliament it cannot be repealed nationally. Many international bodies and organisations have headquarters in the city, so it means that Brussels is brimming with lobbyists whose mission in life is to persuade EU commissioners and MEPs to tailor upcoming legislation to the needs of whatever organisation they represent. Group and committee meetings took place there, with the entire Parliament meeting only on limited voting sessions.

In Strasbourg, on the other hand, I felt as though I was part of a real European Parliament as all MEPs and Commission members convened for debates and votes throughout the week there, unlike in Brussels where we were housed in separate buildings. Also because we were in Strasbourg for only one week in the month, there were fewer lobbyists based there and so there was less access to the members. Not

surprisingly there has been no shortage of critics regarding the monthly trek to Strasbourg and the millions of euro spent on a building that lies empty three weeks of every month. Nevertheless, once there, it felt like a natural home for the Parliament, standing as it does alongside the Council of Europe and the European Court of Human Rights.

It was an unprecedented time in the EU as we were the first Parliament to sit after a showdown with the European Commission that had resulted in the entire Commission—the executive body of the European Union—resigning in March 1999. A Commission employee, Paul van Buitenen, had exposed corruption scandals involving fraud and financial irregularities at the highest levels and while by no means all commissioners were involved, according to EU rules the Parliament did not have the power to expel the individual members so it was a case of 'all or nothing' and the Commission was disbanded.

The Parliament, as the only 'elected' body in the EU, was frustrated at its lack of powers and there was an ongoing power struggle with the 'unelected' Commission, widely regarded as the EU 'government in waiting'. There was a great deal of media coverage regarding the misuse and waste of money in the EU institutions and as members we were also under the microscope.

As I got to grips with the way the wheels turned in the European institutions, my main concern was how to ensure long-term economic security for Connaught/Ulster. I had a guarantee of only five years in the Parliament and I had to make something happen as quickly as possible. One of the privileges of being in the Parliament was that I could access all reports and funding figures relating to Ireland. Clearly my constituency was not receiving from successive governments the financial support and investment it needed. The region had in fact been starved of the funding it was due and even now, though it was still identified as 'Objective One', meaning that it was recognised as a dis-advantaged region within the EU and within Ireland, I calculated that it was still receiving less than 10 per cent of the EU funds it was helping to bring into the country, the bulk of which should have been spent west of the Shannon.

Clearly something was wrong here. Did anybody in Europe check where the money was supposed to go? I decided to bring the matter to the attention of the EU Commissioner for Regional Policy, Michel

Barnier. He was a member of my group which gave me good access to him and, accompanied by the EPP spokesman in my Regional Policy/ Transport Committee, Georg Jarzembowski, I put my calculations to the Commissioner. Neither Michel Barnier, nor anyone in Ireland, when I released the information to the press, rejected the 10 per cent funding figure and it became a slogan for the neglect of the west.

The Commissioner understood that there was a problem, but as he explained, Europe was trying to move away from micro-management of national/local issues as Brussels didn't have the staff to oversee everything that happened with funding. He also made it clear, however, that he would make this concern known to the government in Dublin. I was surprised that the Commission had not previously been made aware of the severe deficit in the share of funding that was going to the west of Ireland.

Infrastructure is such a hackneyed word but without proper invest-ment in basics like road, rail and air communications, energy, information technology, education and training, it's impossible to grow and maintain employment in a region. I looked on my constituency as if it were my household and explored its basic needs to ensure that Connaught/ Ulster could become as self-sufficient as possible so that it wouldn't have to depend on hand-outs from Dublin and would be able to provide a secure livelihood for the people who lived there. It seemed to me that there were some essential elements that could make that happen.

The constituency was perfectly placed to be a 'stepping stone' into Europe, and so first on my list was the development of an international air terminal, not just for passenger trade, which was seasonal, but as a point for import and export of cargo that could be developed as a hub, say between North America and Europe. This would give the region a certain economic security and also help to attract and sustain industry in the region.

Once the airport development was under way, it would be leverage to get funding for a western rail link running north to south, servicing the airport and linking into the east/west rail links to and from Dublin. This would help open up the whole region and make funding for other infrastructure investment easier to secure.

I knew just the man to contact about airport development. During the 1997 Presidential election I had been introduced to Art McCabe, an

Irish-American from Boston. A much respected lawyer, he had power of attorney for the Massachusetts Port Authority, or 'Massport' as it was called. This world-class independent public authority developed, promoted and managed airports, a major seaport and an international air cargo service, as well as having interests in holiday cruise routes, so I felt that an operation like that would be ideal to link into Connaught/ Ulster.

Art had a deep commitment to Ireland and had been chosen as a member of the high-level forum overseeing the working group set up by the Northern Ireland Executive to develop policies and programmes for the redevelopment of the North. He had also been asked to represent the Commonwealth of Massachusetts in the opening of the first state trade office in Derry, and I believed it should have a branch in the west.

I called Art at the beginning of August 1999, explained my thoughts and invited him to Ireland, so that I could show him the possibilities in Connaught/Ulster. He accepted and we arranged his visit for September. In the meantime I sent him information on all the existing airports in the constituency: Knock, Galway, Donegal and Sligo. I then began setting up as many meetings as possible with key bodies, chambers of commerce and the management boards of those aiports that Art considered the best possible locations, explaining my intentions. I was excited about the possibilities because the airport complex could also include various community resources such as a logistics and distribution centre and hotel and conference facilities.

When Art arrived in Ireland on 10 September we began our meetings in Galway, as he could see great potential in developing the airport there, even though it would mean moving it to a new and larger site. I had been invited to address the Galway Chamber of Commerce luncheon that day, and as the heads of the airport board would be attending, Art and I met with them immediately prior to the lunch to discuss the proposed development. They asked that I not mention the proposal at the luncheon or explain Art McCabe's presence, and I did as I was asked. Subsequently the airport board passed on the proposal without further meetings with Art. I was surprised at this at the time, but I had no vested interest in the precise location of the airport, as long as the whole constituency and region benefited from it.

After meeting with the Castlebar Chamber of Commerce and Liam Scollan of the Western Development Commission, both of whom seemed to be excited about the idea, we made our way to meet with representatives of Knock Airport Board, Cathal Duffy, Chairman and Msgr Grealy, parish priest of Knock. They were key people and again seemed open, particularly Msgr Grealy. Once I had made the introductions I stepped back from the project. Art McCabe was subsequently hired to draft a long-term development plan for Knock Airport and surroundings and also to find potential investors.

In geographical terms, Knock was virtually in the centre of the constituency, in an area crying out for investment, and there was ample room for expansion. I believed that the proposed development being drawn up by Art McCabe could establish Knock Airport as one of the premier regional airports in the world and open up the development of the whole western region.

The following week, the Fruit of the Loom factory closed in Donegal with the loss of hundreds of jobs. The worst aspect of the closure was that although it had been known for some years that the industry was in decline, and funding had been given from Europe to develop alternative industry, when the inevitable closure came there was nothing there to take its place. I travelled to the factory on the day of the closure, and though the workers had refused to meet local politicians, as they gathered in the factory canteen they allowed me to join them, and I spent three hours talking with the men and women. Whole families had been employed there and they were so worried about the future. Some of them just put their head on my shoulder and cried. I met with representatives of the union, SIPTU, and the Industrial Development Association (IDA) that afternoon, who confirmed that while there were some retraining schemes in place, there was no significant replacement employment on the horizon and most of the unemployed would likely have to leave the area to find work.

One of the most difficult things for me as a politician was to see people genuinely distressed, and trying to work out how to help them in a practical way. I wasn't sure what I could do that day, but I was determined to find a way to do something.

In September 2000, Art McCabe forwarded me a copy of the draft development plan which had taken him the best part of a year to put

together. It was impressive, with a number of community and educational resources incorporated in the airport development scheme, so that as well as an air terminal and hotel/convention complex, there was also an operations and communications centre incorporating an emergency helicopter service and a logistics and distribution centre serving as a primary European hub for north American cargo transport companies.

Art was coming to Knock a month later, on 5 October, with a consortium of potential investors who wanted to establish a presence in Ireland. The members of this group were either the founders or held senior positions in highly successful international companies, and they were willing to invest a start-up figure of IR£30,000,000 to get the project up and running. Frank O'Neill, President and CEO of Vancouver Airport and YVR Airport Services, Canada, was one of this group, and his company had already developed twenty-two airports worldwide.

Art asked me to attend the meeting, which I did with the agreement of the Airport Board members. Unfortunately when we arrived in Knock, the visitors were aware of a coolness in their reception. As the meeting got under way, Art McCabe invited one of his colleagues, Frank O'Neill, to tell the board members a little about himself, but as Frank stood up to speak, he was motioned to sit down by the chairman of the board, Cathal Duffy, who bluntly informed him that they didn't need that information. It was a very embarrassing moment for Mr O'Neill and for many others of us present. As Art later wrote to me, 'I was disappointed that the group was not more warmly received by the board, as this was the first visit for most of them to Ireland.'

I was really surprised at the cool atmosphere in the meeting. I felt that if the members of the board had any problems with the proposal, it was an ideal opportunity to raise and discuss their concerns. On the other hand, if they wished to reject the plan, they could simply have thanked the delegation and told them so. Unfortunately, successful businessmen, who were ready and willing to invest a great deal of money in developing Knock Airport, left that day feeling that they had been snubbed. There was an uneasy silence as the American group got into their van and drove away, never to return again.

I continued to pursue the development of the western rail link both in Ireland and in Europe where my entire Transport Committee

publicly agreed to give its support to the development of the Rail Corridor, as it would link a peripheral region and help develop the economy of a disadvantaged area. I was particularly grateful for the support of Philip Bradbourn and Brian Simpson, chief spokesmen on Transport for the EPP and Socialist blocks, respectively. It was then down to the Irish government to proceed, which regrettably it has so far failed to do, despite constant lobbying within the region.

Around the same time as the first Knock Airport meeting and the closure of Fruit of the Loom, I received two letters in my Brussels office that concerned me greatly. They were from a women's group in Spain that represented many thousands of mothers working in the home and another in Germany representing 30,000 professional women who worked from their homes while raising their families.

Both groups explained that although there had been an EU fund of €600,000 in place for the previous nine years, they could not access it, because the sole recipient of the money was the European Women's Lobby (EWL), a group that for ideological reasons they felt could not represent them. They were lobbying MEPs to help them access some of this EU fund so that they could have a voice at the EU and international level. In particular they wanted to attend the upcoming Beijing + 5 meeting at the UN in New York, so as to highlight the concerns and needs of women working in and from the home and ensure that their work was recognised. EWL was the only non-governmental organisation (NGO) attending this conference on behalf of the women of Europe, and without funding, these other groups could not afford to go. It was quite clear therefore that alternative voices for European women were out there but there seemed to be something amiss when they couldn't access funding to enable them to speak on behalf of the many women they represented. As there was a new EU budget vote coming up in the Parliament very soon, they were lobbying members to speak on their behalf.

On further investigation I discovered that the EWL, as the sole recipient of the €600,000 fund, described itself in the budget line as the only voice for women in Europe. As this was not the case and as it was against EU law to fund a monopoly, I felt that a simple change to the wording of the budget line, acknowledging that the EWL was *one* of the voices for women in Europe and that the fund should be opened to

include other women's groups, would be common sense. It would also be fair and just.

We were some weeks away from the vote on the Budget report, so I decided that the logical thing to do was to contact the EU Women's Rights Committee within the Parliament, about putting forward the word change in an amendment. I spoke personally with the chair-woman, Mrs Theorin, and sent her copies of the letters I had received; however, I was informed that the committee had already taken a vote agreeing to support this budget line for the EWL and therefore it was too late for them to make changes.

Never one to take 'no' for an answer, I asked in my group if there were any committees that had not yet voted on this budget line and I was told that the Budget Committee itself had yet to vote. I rang a couple of Budget Committee members in the EPP and got through to Den Dover, one of the British Conservatives. When he had read all the information I gave him, he expressed surprise that this situation had been allowed to go on and said that he would be willing to put the amendment to his Committee. The Budget Committee was made up of every political grouping in the Parliament and was chaired by a member of the Socialist block. They debated the amendment and on the grounds that the EU could not support monopoly funding they voted in favour of the amendment.

What I didn't know was that the EWL had apparently been born out of the Commission and had been set up specifically to receive this line of funding, which it had done unchallenged for the previous nine years. The lobby was an umbrella organisation for 2,700 women's groups in Europe which included the National Women's Council of Ireland. If you were not part of this lobby, you could not access funding and you had no official representation at EU or international level.

You can imagine the shock when I arrived in my office in Strasbourg the week of the Budget vote to find various faxes in the machine warning members 'not to support the amendment of the anti-abortion activist Dana Rosemary Scallon who is trying to destroy the European Women's Lobby'. A campaign had clearly got under way on behalf of EWL, targeting every MEP in the Parliament and pushing the message that I was a right-wing fundamentalist trying to destroy the EWL.

There were similar press releases sent to national media in all EU Member States and in Ireland. RTÉ television news ran a story that

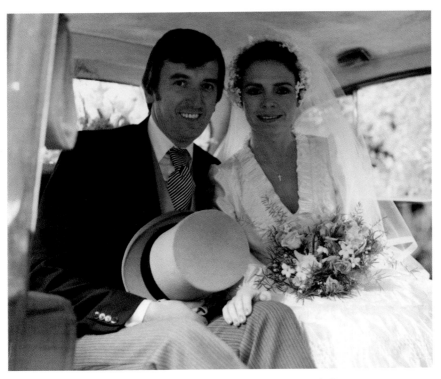

Our wedding day was as happy as it was crowded!

(Associated Newspapers b&w pic.)

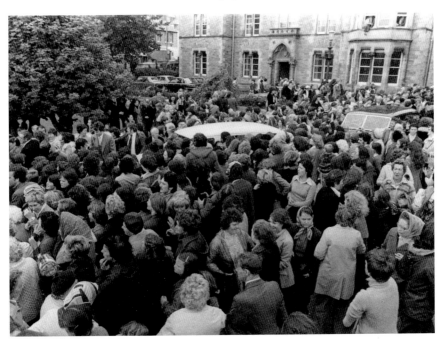

With Mum in 1974.

After Grace's birth, there were four generations of Brown women, all shown here with Damien.

Present Pope; future Pope. With John Paul II in New Orleans in 1987 and (below) with
Cardinal Ratzinger in Rome, 2004. *(John Brown)*

Stars one and all! With John Inman, Bob Hope, Des O'Connor and his wife, and Grace
Kennedy *(Doug McKenzie)* and (below) at Buckingham Palace with the Queen.

A delighted fellow Derry woman, Nell McCafferty after the Presidential Election count.
(Photocall Ireland)

Queen for a minute! Mum on the throne in Dublin Castle.

Making a point with the Taoiseach, Bertie Ahern, while canvassing in Galway in 2002. *(PA)*

Our campaign HQ in Galway. *(PA)*

Grace, John James, Robert and Ruth with the wonderful Sue who has held the family fort for so many years. *(Yann Studios)*

Relaxing together in Galway. (John Cooney/*RTÉ Guide*)

included shots of a day-care centre whose funding I was accused of jeopardising so that it might have to close down! I was even accused in the press of endangering the lives of vulnerable women in Africa! As Mark Hennessy wrote in the *Irish Examiner*, 27 October 1999: 'Dana found herself in hot water with Europe's leading liberal women's group which has accused the Euro MEP of secretly trying to starve them of funding. The European Women's Lobby adopts a generally liberal attitude towards major social issues like abortion and divorce. Deeply suspicious of Dana's motives, the President of the European Women's Lobby, Denise Fuchs, said she doubted their liberal stance on issues and Dana's efforts to deprive the Group of funding, were coincidental ... the move threatened the nine-year-old Brussels-based European Women's Lobby and its ten employees.'

What the media failed to report was that the amendment had been debated, approved and adopted by none other than the EU Budget Committee itself, based on the fact that the EU was breaking its own laws by funding a monopoly and excluding other legitimate women's groups.

The scenario in Strasbourg was unreal. I immediately asked for a debate in my group regarding reports in the media that the EPP would reverse its approval of the new budget amendment. I believe in freedom of speech and ideas but there must be a level playing pitch with all sides enjoying the same freedom. I was certainly not trying to deprive or destroy the EWL and, to make this clear, at our group meeting I proposed that as a compromise, the disputed €600,000 budget line be increased by €200,000. This additional amount would be divided between the EWL, which would receive an extra €100,000, making its total €700,000, on condition that other women's groups received the remaining €100,000. If accepted, this compromise would have been a 'win-win' situation for all sides. The EPP agreed to my proposal and appointed senior French member Jean-Louis Bourlange to negotiate, but after almost a day of discussions, M. Bourlange reported back to our group that the EWL would rather 'take less money and keep the monopoly'.

As I made my way into the voting chamber that day, there were at least three young women at every entrance door handing out leaflets calling on MEPs to 'Vote against the Scallon Amendment and protect the European Women's Lobby!' The entire scenario had created

pandemonium in the Parliament. Before the vote on the amendment, I spoke to as many MEPs as possible and I contacted all of the Irish MEPs in particular. The bulk of them, to my astonishment, either would not, or were afraid to, support the opening up of the budget line, apart from the British Conservatives and some smaller political groups who voted with me. Even the majority of the EPP group decided to support the EWL funding monopoly, including the Fine Gael members. And an EWL report stated that 'the National Women's Council of Ireland played its part along with other Irish MEPs including Proinsias De Rossa, Mary Banotti, Patricia McKenna and other pro-democracy MEPs' in defeating the motion.

The vote that day was an eye opener for me. Amendments were identified by their number, but there was confusion as the number of the amendment had been changed without notice. It was obvious that something strange was going on and a conspiracy appeared to be unfolding. Of the 632 MEPs in the Parliament, only 66 voted for the amendment and when the result was announced the members of the Women's Rights Committee in the Socialist group jumped to their feet and cheered. I couldn't believe what was going on! I was demoralised and disgusted at what had just happened; the result of the vote was a blatant example of manipulation of the truth.

Denise Fuchs's comments and the EWL campaign had clearly scared both the male and female MEPs into thinking that they would lose women's votes if they supported the amendment. The European Parliament felt a very lonely place for me that afternoon, but I was most upset that the Parliament had failed to deliver justice for those desperate women's groups in Spain, Germany and elsewhere, who had put their faith in the members and been let down.

On the shuttle bus from the Parliament to Frankfurt Airport, I sat alone. As we neared the airport, to my surprise, Íñigo Méndez de Vigo, a senior Spanish MEP in my group, leaned over to speak to me and told me that a relative of his was a member of the Spanish women's group who had contacted me looking for funding. He also said: 'I know you feel crushed, but don't despair. It takes time to change things in the Parliament. The first time you try, people will be afraid. But keep going. They will come around and eventually you will win.' His words were very timely and appreciated.

When the EWL budget line came up for discussion the following year, I again raised it in the group on the grounds that we could not support the discrimination that was going on in the way funding was being allocated for women's groups. I reminded those present that one of the core principles of the European Union was equality and we had a duty to challenge monopolies that disregarded that principle. As we left the preliminary meeting, one of the leading British Conservative MEPs, Jonathan Evans, a former British Government minister, said that he agreed with me and offered to back any initiative I put forward to diversify the funding. He and M. Bourlange, our negotiator from the previous year, supported me within the EPP group which ultimately adopted the amendment to open up the budget line and this time we achieved 200 votes out of 632 MEPs. By the third year, we were supported by a majority vote in the parliament and the monopoly on the funding was finally broken.

A number of MEPs approached me over the handling of the EWL budget and were disturbed that while there appeared to be free rein for those groups who supported a liberal agenda, there were many obstacles for those who did not. I decided to build a network of elected representatives who would keep an eye on legislation being promoted through the Parliament, especially if it touched on sensitive issues that the Parliament and Commission had no legal right to decide on, or even discuss.

I had been warned at the very beginning of my term of office that the EU had no legal competency regarding abortion, or the family; and in theory no one discussed those issues. This was particularly relevant for Ireland as our Constitution had specific articles dealing with the protection of life and the family as well as Irish sovereignty, and on these issues only the Irish people themselves could decide.

Had this principle been respected in the European Parliament and Commission, I would have found myself in a lot less bother, but unfortunately that was not the case. Like the time in June 2000, when I received a fax late in the evening from a Minister Kropiwnicki, head of a Polish delegation attending a UN meeting in New York on Bejing + 5. All of the main points of this document had been agreed at an earlier conference and were not to be changed at this UN meeting. However, Mr Kropiwnicki wrote that Maj Britt Theorin (chair of the EU delegation

and also of the Women's Rights Committee in the European Parliament) had called a meeting with him and, in front of representatives from other accession and less-developed countries, had proceeded to exert 'coercion, manipulation and unprecedented pressure' on the Polish Delegation (*his words*).

He enclosed the notes of what she had said to him: that there were 'always some countries that made problems' and the EU 'had the means to isolate those who isolate themselves'; that it made no difference that Poland was not yet a member of the EU—'since she wants to join' they had to support the EU position; that EU parliamentarians were expected 'to make progress on women's rights' and that progress meant 'acceptance of the right to abortion'; and that she believed 'Poland may not like to find herself among such countries as Iran, Sudan, Syria or Algeria.'

As an ex-Ambassador for Poland to the EU, Mr Kropiwnicki knew that neither Maj Britt Theorin nor the EU itself had the legal or moral right to force or to threaten the people of Poland in this manner. He asked me to fax him a letter as soon as possible stating that she was acting outside EU law, as he was afraid she had tried to intimidate the other countries present and they would soon have to vote on the EU proposal. I typed up a letter immediately and, armed with that and his fax, I literally ran to the group meeting-room on the other side of the building where the heads of the group were about to finish the last meeting of the evening. As they walked out of the meeting room, I simply showed as many members as possible the correspondence he had sent and asked them if they would sign the letter he had requested.

Although it was late in the day and there were few about, twenty-four MEPs, including vice-presidents of the EPP group, signed the letter and I faxed it back within the hour. The Polish delegation put copies of the letter on the desks of everyone attending the UN meeting and he later informed me that the EU position was defeated in the vote.

When the EU delegation returned to Brussels I was practically pinned against the wall by one of the women who had been in New York and accused of being a traitor to my group and to the Parliament! Mr Kropiwnicki, however, wrote that 'the reaction of the twenty-five (European) Parliamentarians in defense of the fundamental values and against the coercion, manipulation and unprecedented pressure exerted

on the Polish Delegation represents this Europe that my friends in Solidarnosc and myself have been so long dreaming of while living in the communist totalitarian oppression.' I believe this incident convinced me that it was vitally important to ensure that the EU and the representatives of such a powerful body used their power with great care and with supervision, so that the democratic rights of citizens and the sovereign rights of nations were always respected and upheld.

At home, meanwhile, the government published its National Development Plan which proposed upgrades to dual carriageways/ motorways on five radial routes out of Dublin but only vague 'improvements' for the N4, a major link road to the west/northwest. I had discovered in Brussels that a plan for a Trans European Transport Network (TENS-T) had been adopted by the EU Parliament and Council in 1996. This showed that a number of main roads in my constituency had been highlighted as important for the European road network, and that the N4, which was the main corridor from Dublin to Sligo, was of 'strategic importance' and as such should be a motorway or a high-quality road.

The N4, however, was badly in need of upgrading. When the National Development Plan failed to specify exactly what kind of 'improvements' would be made to this mostly single-lane but vitally important link road, I wrote to the Minister for Transport, Noel Dempsey, asking for details. He responded that the National Roads Authority (NRA) was responsible for the detailed programming of that work. So I then contacted the NRA. The Chief Executive of the NRA suggested that I should arrange to have 'all local MEPs, TDs and Senators' present at a meeting to discuss the details *when they were published,* and the Roads Authority would be pleased to discuss the road developments in my area. I felt that I was being set a very difficult task to gather all the elected representatives in one place, at one time, and, if we didn't have a meeting till after upgrade details were published, what would happen if the proposed upgrade wasn't adequate?

I felt that the best thing was to bring members of the European Transport Committee to Ireland to assess the state of the road and how it compared to EU standards, so we could make a report to the Parliament and the Commission. We began our fact-finding mission in Dublin, heading west to Sligo, meeting as many as possible of the county councils, county managers, chambers of commerce, elected

representatives and interested parties, including state and semi-state bodies, along the way. I made sure, too, that prominent campaigners such as Marian Harkin were also invited to meet with the EU representatives.

Some of my visitors were shocked at the state of the roads. The advisor to Karla Peijs, a Dutch MEP on the Transport Committee, had not much experience with single-lane roads and every time we crossed the white line to overtake a vehicle, she would go rigid with fear and close her eyes tightly. Needless to say, she spent most of the journey with her eyes closed. It was later raised in the Transport Committee by one of the members as a cause of serious concern that most of the European money had been spent in the east of Ireland to the detriment of those living in the west.

It was a very gruelling three days for the EU delegation, with meetings and travel from early in the morning till late at night, but it was worth it. There was cross-party unity and public and private sectors stood together, because the upgrading of the roads was so essential for the region. In order to ensure that it stayed above politics I thought it best to set up a steering committee that included a significant number of the main players from the private and public sector. This committee was co-chaired by Michael Farrell of Connacht Gold Dairy Co-Operative and Brendan McKenna of Abbott Ireland, one of the largest healthcare employers in Ireland. I then drew up a letter to the Minister of Transport which everyone signed, ensuring that all could have their say in what upgrade they felt was needed for the sake of the whole region, and the NRA could take note of our findings.

I eventually did meet with the NRA after it was clarified that the Chief Executive hadn't meant to insist on the presence of *all* other elected public representatives. After a meeting with Commissioner Barnier where I shared the findings of the Transport Committee members and gave him a statement from all the main stakeholders in the Border mid-western region, he personally wrote to the Minister for Finance, Charlie McCreevy, presenting 'various arguments in favour of a more ambitious road improvement scheme than that presently proposed by the national authorities'.

Our solidarity within the region contributed to the significant improvements that have taken place on the M4 since that time.

Since the closure of the Fruit of the Loom factory in Donegal I had been brainstorming with individuals, union representatives, state and semi-state bodies, trying to work out a way to bring greater job security to the region. One evening in Brussels I received an information paper announcing the fact that an EU-wide funding programme for pilot schemes, or 'Innovation Strategies', in fifty selected EU regions was coming to a close. Innovation Strategies are simply ways of developing work opportunities and I was immediately aware that this information paper could be a golden opportunity to help not only my constituency, but the rest of the country too.

In the EU great emphasis is laid on co-operation between regions and, to promote this, excellent funding opportunities are made available. Ireland is unique within Europe in that on this one island, we have two distinct European regions—Northern Ireland and the Republic of Ireland. My constituency of Connaught/Ulster spanned almost the entire border between those two severely disadvantaged regions which meant that even more EU funding could be accessed. Donegal and Derry were the two most closely linked cross-border counties and it was clear to me that by cherry-picking and applying the very best of the fifty Innovation Strategies already tried and tested within the EU, the northwest could develop co-operation between the two cross-border regions to grow new companies and to expand and diversify existing companies in every possible field.

It would mean pulling together all local expertise and resources but they wouldn't have to reinvent the wheel. All the hard work had already been done; you could look at the fifty Innovation Strategies and select the most relevant to the region. I believed that if the northwest could establish itself as a European Region of Innovation, that blue print could not only roll out along the rest of the border region, it could also be shared with the ten accession countries that were lining up to join the EU in 2004. This would lead to new opportunities for the northwest and for Ireland, as applicant countries were encouraged to 'co-operate' and link with an existing Member State. So with this blueprint we could foster a working relationship with these countries that would be mutually beneficial to promote investment and trade.

I put together a team of experts to examine and develop the initiative, and together we worked out a Regional Innovation Strategy

for Donegal and Derry, the two counties that already had a long-standing cross-border, inter-regional working relationship.

After many meetings and much discussion the pilot scheme and areas of funding were hammered out and I met with the Taoiseach, Bertie Ahern, to explain the initiative. He liked the proposal and asked me to contact the Minister for Enterprise, Trade and Employment, Mary Harney. From there I contacted various political leaders in the North such as Sir Reg Empey, the Northern Ireland Minister for Enterprise, Trade and Investment in the new if somewhat struggling Northern Assembly at Stormont, and other interested parties like LEDU, an agency representing small business; the LEDU meeting was arranged by Sir Reg Empey. I also contacted funding bodies, county managers and chambers of commerce, and there was a very warm reception to the proposal at every level. I'm glad to say that it did go on to be accepted for funding and development, and I was asked to launch a community project in Cavan that was funded under this scheme.

Chapter 12 ～

CONSTITUTIONS AND CONSTITUTIONS AND CONTROVERSIES

In 2001 the build-up towards the Nice Treaty referendum began in earnest. We were told that the Treaty was essential for EU enlargement, but during a visit to Ireland, Romano Prodi, head of the European Commission, clarified that it was politically rather than legally necessary. This in fact was the essence of the Treaty of Nice: rather than simply widening the EU, it intensified political power in Brussels and away from the nation states, in particular the smaller nations.

The Treaty was regarded as a dismal failure within Europe and even in Ireland John Bruton, then leader of Fine Gael, referred to it as 'one of the weakest negotiating outcomes ever achieved' by an Irish government and a 'very bad day for Europe' because it 'enhanced the position of bigger states (Germany, Britain, France and Italy) in decision-making'. Even the Fine Gael Foreign Affairs Spokesman, Jim O'Keeffe, called the results of Nice 'a permanent shift in the balance of power … away from the smaller member states to the larger member states', and, in the same vein, Labour leader Ruairí Quinn referred to the Nice Treaty as a 'disaster that damaged the interests of Ireland and every other small state'.

One aspect of the Nice Treaty particularly concerned me: it opened the door to an EU Constitution through the European Charter of Fundamental Rights. I had been closely watching the growth of this embryonic EU charter since it had been brought to my attention in the Parliament in autumn 1999. The Prime Minister of Spain, José María Aznar, whose political party was part of my EPP group, addressed us

about the 'pros and cons' of drawing up a new EU Charter of Fundamental Rights, a task bestowed on the Parliament that had to be completed within one year.

But who had asked the Parliament to undertake this task? We did not know and we were not told, but it certainly wasn't the citizens of the Member States! In Prime Minister Aznar's address he told us that we had to choose between 'politically endorsing' this charter, and making it 'legally binding' on the Member States. He warned us that because of the long-term repercussions of a new Charter of Fundamental Rights and its impact on existing rights within the Constitutions of Member States, we needed a much longer time for examination and debate than the one year that had been allotted to the task. He therefore advised that it would be wiser *not* to make it 'legally binding', rather to 'politically endorse' it, thereby agreeing with it in spirit, but not in law.

I thought that what he said made sense; if we did not have adequate time to examine the long-term impact of the document, it would be foolish to make it legally binding on the Member States. I certainly wouldn't want to sign a legal document without thoroughly examining its long-term implications. In Ireland human rights were already enshrined in our own Constitution and as a nation we had signed up to the European Convention on Human Rights; so it wasn't that we really needed another charter of Human Rights. However, the European Union *did* need it because, to establish itself as a 'State', greater than the Member States that made it up, it needed to have its own Constitution, the foundation stone of which was the new EU Charter of Fundamental Rights.

Within a couple of weeks of Mr Aznar's speech, I walked into one of our EPP group meetings, picking up the leaflets and information sheets that were laid out on a table at the back of the room. One of the leaflets was a preparation paper for an upcoming summit and under various headings it laid out the position our group would be taking on the issues for discussion, such as employment, competition in the market place, and so on. One of the headings, entitled 'Charter of Fundamental Rights', caught my eye and, remembering José María Aznar's advice, I naturally expected that the EPP position would be to support the 'political endorsement' of the Charter. However, I was taken aback to

read that my group had 'unanimously' voted to make the proposed Charter 'legally binding' when completed!

I knew that I had attended every group meeting since Mr Aznar's talk and I had no recollection of even having seen this item on an agenda for discussion. I went across to one of the senior Austrian MEPs, Marialiese Flemming, to ask her when the group had voted on the Charter. She was as perplexed as I was and so together we checked with a senior German MEP, Ursula Schleicher, who likewise confirmed that it had not been discussed. There was obviously something very amiss going on and we raised our hands to put a question to the President of the group, Mr Hans-Gert Poettering. We made it quite clear that the group had not discussed this matter and that it should be debated immediately. However, we were politely but firmly told that there wasn't time and that it would be put on the agenda for the Group Working Days that were scheduled to take place in Paris, nearly three months away in March. I was stunned that there was no protection of the democratic right of the elected members even to discuss this vitally important matter, never mind the democratic rights of the people we represented.

I decided to watch developments with the Charter like a hawk. Over the coming months I worked alongside the British Conservatives to prepare a series of questions for the debate in Paris, as they were among the few members of the group who were ready to question what was happening with this unsolicited document. We were denied a proper debate, however. A panel of experts had been assembled in Paris to talk *at* us about the importance of the Charter, and as the afternoon rolled by, we were left with less than forty minutes for questions, out of the three hours dedicated to the debate. It confirmed to me what I had suspected: that a blueprint for the future of Europe must have already been agreed at a higher level and that, like it or not, the EU would enforce that blueprint on us as elected members and on the Member States we represented. From that time, I began sending out information and press statements regarding the Charter and the Treaty of Nice, as well as making statements and raising questions in the European Parliament.

In due course a nominated Convention was established to draw up the Charter. When completed it was politically endorsed by the Heads

of State in the Nice Summit and then offered to the public, cleverly attached to the Nice Treaty. As Carol Coulter, a respected legal affairs correspondent, later wrote in *The Irish Times* (29 May 2001), because the 'Declaration on the Future of the Union' appended to the Treaty of Nice specifically listed that the status of the Charter *had* to be included on the agenda of the next Intergovernmental Conference in 2004 (the year set for the unveiling of the Constitution of Europe), 'the EU Charter of Fundamental Rights could have a future bearing on the Irish Constitution and Irish law.' In effect, then, a vote in favour of the Treaty of Nice was an endorsement of the attached Charter of Fundamental Rights—a charter that had not been properly debated in the European Parliament, or indeed in any national parliament. Most people did not realise the importance of this Charter, but the Taoiseach, Bertie Ahern, knew the danger that it posed to our Constitution and our sovereignty. As Patrick Smyth reported in *The Irish Times* on 16 October 2000 from the EU Summit in France, when Bertie Ahern endorsed the Nice Treaty, 'The Taoiseach warned fellow EU leaders on Saturday that even mentioning the new Charter of Fundamental Rights in the EU (Nice) Treaty could have the same legal effect as incorporation in the Treaty ... Mr Ahern was among the few who strongly opposed giving the Charter binding legal effect', and, in fact he endorsed it only on condition that the Charter of Fundamental Rights would *never* be made legally binding. However, everyone in Europe knew that the stated plan for this Charter was that it would be an integral part of the 2004 Constitutional Treaty that would follow on the heels of the Nice Treaty.

When we voted on the Charter in the EU Parliament, the only copies of it given to us were in French; no other language was made available, and we were not permitted to change even a comma! Once again, the entire *modus operandi* of the Parliament was anything but democratic and transparent.

By the time the Nice referendum campaign began in Ireland in 2001, the leaders of our main political parties appeared to be suffering from identical cases of amnesia. Gone were their previously expressed deep concerns and worries about the Treaty as they obediently promoted their *Yes to Nice* campaigns, though a report in *The Irish Times* stated that, while they supported the Treaty of Nice, Tánaiste Mary Harney,

Ministers Síle de Valera and Charlie McCreevy and Attorney General Michael McDowell had suggested that there was a 'need to limit further political evolution of the EU at the expense of national sovereignty'—a definite case of trying to close the stable door while helping the horse to bolt. There was no rush for the Irish people to vote on this treaty; nonetheless they were fast-tracked into a referendum that did not allow adequate time for much-needed public debate.

Alongside the difficulties contained in the Treaty itself, the Charter of Fundamental Rights conflicted with sensitive articles in our own Constitution dealing with the family, parents' rights, marriage and the right to life. Although there were some positive points in the Charter, as the intended foundation stone of an EU Constitution it provided the means of usurping decision-making power away from the Irish people by making the EU Court of Justice supreme over national Constitutions and courts in the whole vital area of human rights.

I believe that if the Irish people want to change any area of the Irish Constitution by referendum, they have the constitutional right to vote in accordance with their conscience or personal wishes to make those changes; however, it certainly should not be decided for them by unknown bureaucrats in Brussels nor should information be kept from them by their elected representatives. Yet that was exactly what was happening; while the EU Constitution was actually being written I challenged Brian Cowen, then Minister for Foreign Affairs, on radio to tell the people how close we were to an EU Constitution. His response was to accuse me of 'scare-mongering'.

By May 2001, anyone who opposed the Nice Treaty in Ireland was branded as 'anti-enlargement', which, of course, was not the case. I felt that what we needed in Ireland was an alliance of elected Independent public representatives that would include those in the Dáil and in county and city councils; between us we would represent a very significant percentage of the population and would therefore have to be listened to. I telephoned and sent letters and information on Nice to every Independent representative throughout Ireland, inviting them to a meeting in Jury's Hotel, Dublin, on 13 May, reminding them that together we had a 'vital role to play in a full and open debate' on the changes the Nice Treaty would make to our Constitution and to Ireland as a sovereign nation.

Our meeting, held one month before the referendum, was a unique occasion in Ireland and led to the first formal Alliance of Independents in the history of the State. We agreed and signed a joint position paper, which we then released to the media at a press conference in Dublin. A number of high-profile Independents joined the Alliance, like Senators Shane Ross and David Norris, as well as Tony Gregory TD, Harry Blaney TD, Cllr Pádraig Ó Ceallaigh, Cllr Finian McGrath, Commissioner Maureen O'Carroll and many others. In total sixty-six Independent public representatives joined together to inform the public why we felt that the Treaty of Nice was not to their benefit.

On 31 May, one week before the Nice referendum vote, two significant events occurred. The first was that the European Parliament voted in favour of a resolution entitled 'The Treaty of Nice and the future of the European Union'. This resolution, which was supported by Fianna Fáil, Fine Gael and Labour members, 'demanded' the opening of a constitutional process that would 'culminate in the adoption of a European Constitution'. It also renewed the Parliament's call for the Charter to be 'incorporated into the Treaties in a legally binding manner'.

The other event was that the Standing Committee of the Irish Bishops' Conference issued a statement on the Treaty of Nice which was seen in the media and by political leaders as supporting the 'Yes' vote. As far as the bishops' conference was concerned, the Treaty was primarily to facilitate enlargement of the EU. The Charter of Fundamental Rights was highlighted as being 'manifestly incomplete', particularly in its failure to ban all forms of human cloning. However, the statement went on to say that 'in the balance' there seemed to be a 'stronger case for the Treaty than against it'. The Taoiseach welcomed the bishops' statement calling for a 'Yes' vote, stating that there was a moral issue involved in supporting the Treaty and that Pope John Paul II had made strong statements in favour of enlargement. While that may have been so, the Pope had also publicly stated that he was unhappy with the European Charter of Rights because it 'denied God and Family' and failed to defend adequately the dignity of the person against the threats of genetic engineering, euthanasia and abortion.

It was clear that there was immense confusion amongst the electorate about the Treaty of Nice and the EU Charter of Fundamental

Rights, combined with a very powerful official consensus in favour of the 'Yes' vote. As the days rolled on to Referendum Day on 7 June 2001, with all sides battling for media exposure, I was running from pillar to post for public meetings, radio debates and media interviews, while still travelling to Brussels for committee meetings. It was an exhausting time.

Because there had been so little debate on the wording of the Treaty and the Charter in an Irish context, I was gathering as much information as possible on how it might be interpreted. Some articles in the Charter were more or less copied from the European Convention on Human Rights (ECHR), though they were diluted for inclusion. One such instance was the wording of Article 2 of the ECHR which stated, *'Everyone's right to life shall be protected by law.'* In Article 2 of the new EU Charter of Fundamental Rights this translated to, 'Everyone has the right to life.' As the wording did not clarify what was meant by 'everyone', I had asked my assistant, Catherine, to check and see if there had ever been an opinion or ruling given on the meaning of this word in the European Court of Human Rights (ECHR).

I was to fly home from Brussels on Thursday, 1 June, and just as I was about to walk out of my office, Catherine told me that she had been able to locate a transcript of a case taken to the European Court of Human Rights by a young man who had tried to save the life of his unborn child. His case was relying on Article 2 of the ECHR, but in the opinion of the Court the word 'everyone' did *not* specifically include the unborn child. Based on this opinion, therefore, the case was lost and the young man's girlfriend could abort their unborn child.

This was extremely important in the Irish context because it set an EU precedent regarding the interpretation of the term 'everyone'. If the Charter was made legally binding in an EU Constitution, which was the stated intention, the European Court of Justice could rule on any Irish case that conflicted with this interpretation.

The bishops' statement had mentioned the Charter's failure to protect the human embryo from all forms of human cloning and I felt I should inform the bishops of the future implications of the European Court's interpretation. I took a copy of the court ruling with me and, on returning to Dublin that afternoon, I called Cardinal Desmond Connell's residence and asked if I could meet with him to explain the

information I had found. The Cardinal read the papers, listened to what I had to say and then advised me to contact Bishop Joseph Duffy of Clogher Diocese, Chairman of the Bishops' Committee on European Affairs. Bishop Duffy in turn suggested that I speak with Bishop Thomas Finnegan of Killala.

It was extremely difficult to reach anyone that weekend because it was Pentecost and as I did not have any private telephone numbers, and diocesan offices were closed, I just had to leave messages on answering machines. By the time Bishop Finnegan got back to me it was the morning of Pentecost Sunday. I explained the situation and I asked him to examine a copy of the European Court Opinion, which I would fax to him. When he read the papers he was very concerned and when I asked him to recommend any other bishop I could speak to, he explained that he would be meeting Bishop Boyce of Raphoe later that day. He immediately called Bishop Boyce and then asked me to fax him the information. It was now just four days to the referendum. Bishops Boyce and Finnegan quickly understood the implications of the European Court ruling and the danger for Ireland if the Charter were to be made legally binding in an EU Constitution. They were clearly shocked at the potential scenario.

On Monday, 4 June, I issued a press release explaining the European Court's interpretation, and the following day Bishops Boyce and Finnegan decided to break rank with the Conference of Bishops and issue their own statement, in which they said they could not vote 'Yes' to Nice, based on the information I had given them. RTÉ television broadcast their statement that evening on the *Six One News*, just two days before the referendum and immediately before the 24-hour media blackout on referendum coverage. There was consternation at the bishops' statement and claims of a premeditated strike on my part, but the impact was devastating for the 'Yes' campaign!

Two days later, on 7 June, when the Irish electorate went to the polls, 46.13 per cent (453,461) voted 'Yes' and 53.87 per cent (529,478) voted 'No' to Nice. The moral leadership of Bishops Finnegan and Boyce certainly contributed to this result, as did the hard work of our Coalition of Independents and other 'No' activists who took on the Government and the main political parties and defeated their position It was like David beating Goliath again! Not surprisingly, there was

euphoria in the 'No' camp. Ireland was the only Member State with the right to a public referendum and it was widely accepted that if the citizens of other countries had had the right to vote on the Treaty, they too would have voted 'No'.

To the dismay of the EU, the Government had completely misread the mood of the public, and our victory set off political alarm bells throughout Europe. The reaction was one of shock and disbelief, with the BBC reporting that the 'Irish have thrown EU expansion plans into chaos'. It was like a political earthquake. There was also uproar at the statement made by Bishops Boyce and Finnegan, and a number of pro-Nice Treaty supporters lined up to 'assassinate' me verbally!

The *Irish Sun* reported, 'Critics accused the ex-singer of aligning herself with the policies of racism and fundamentalism. Other members of her [EPP] Group including four Fine Gael members, one of them Joe McCartan, called on colleagues to discontinue their meetings with Dana. Her conduct in the recent referendum campaign could not be further removed from the principles of Christian democracy. The grouping with whom Dana aligned herself in the referendum campaign set out to promote division. It had more in common with racism and fundamentalism ... than with the social democratic policies that have established peace and stability throughout the continent of Europe.'

Joe McCartan MEP attacked Bishop Boyce in an open letter printed in the press on 12 June 2001, saying, 'Dr Boyce's intervention to the Nice debate was both racist and dishonest. The No in the Referendum will be seen as opposing a Treaty which will be ratified by every Member State of the Union and is designed to facilitate the entry of poor, formerly oppressed countries of eastern Europe. I felt that your contribution to the debate at the last minute was of major political significance. I was extremely disappointed that you chose a subject which was not part of the decision the Irish people were making and as a consequence I believe you participated in what was a very dishonest and racist No campaign.'

Back in Brussels, to many members I was public enemy number one! I remember walking down the corridor and feeling that people were moving away from me, like the ripples from a pebble dropped in a pond. Not only did my Fine Gael colleagues accuse me of being a 'xenophobic' racist who was obstructing the expansion of Europe, they

also attempted to have me expelled from the EPP group, on the grounds that I had betrayed the principles of the EPP and the Christian Democratic Party. EU treason!

Thankfully I had a lot of support within the EPP, especially within the German and British delegations, and of course as an Independent member, I did not have to vote with the whip of the group or the Christian Democratic Party, so the Fine Gael motion to expel me was defeated. There was also support from members of other political groups and even the Socialist group, who privately thanked me and the Irish people for speaking on behalf of those citizens from other countries who would have voted in the same manner had they had the chance to do so.

Although the Fine Gael attempt to force me out of the EPP group was unsuccessful, I did find myself expelled from the *Irish* delegation within the EPP! Joe McCartan was quoted in *The Irish Times* and *Irish Independent* as saying that after a meeting with Avril Doyle and Mary Banotti they had 'decided to divorce Dana'. Unfortunately what they and other colleagues failed to understand was that I was elected by the Irish people and if I spotted anything coming from Europe that threatened to undermine their rights or our Constitution, I had every right to highlight it; in fact I had a duty to do so, whatever the consequences.

I found out about my so-called 'divorce' while I was travelling on a bus to the Parliament in Strasbourg. My phone rang and it was Conor Sweeney, the Europe Editor of the *Irish Independent*, asking how I felt about my 'divorce'. It was extremely difficult to be dropped so abruptly from my delegation *en route* to vote on some important reports. Luckily the rest of the group rallied round me, and I was very grateful for that support as I waded through the labyrinth of votes that week.

Meanwhile Ireland's 'No' vote was discussed by the various Heads of State in the Gothenburg Summit and, despite the fact that according to European Union law a treaty is 'dead' if rejected by any one of the fifteen Member States, on 11 June, a statement issued by the European Foreign Affairs Ministers announced that they had ruled out any renegotiation of the Treaty following Ireland's rejection and that accordingly ratification would go ahead in all other Member States. The Ministers would be able to do this only because our Government told them that ratification could go ahead and that the vote of the Irish

people could be ignored. At this time only Belgium had ratified the Treaty, so it would not have been so difficult to halt the process if the Taoiseach had told the other Heads of State that Ireland would not ratify the Treaty as it stood. If this had been done, there would have been no choice but to stop ratification and look at renegotiating this very flawed Treaty. Taoiseach Bertie Ahern, however, told the Dáil (21 June 2006) that 'it would have been wrong' for him to try to stop the other EU states from continuing with ratification of the Treaty as they were fully entitled to do so. As former Attorney General John Rogers stated in an RTÉ interview, the Taoiseach and Brian Cowen had 'in a sense rolled over and acquiesced in the decision of the Irish people being ignored [by the EU leaders who] took Ireland for granted'.

The 'expectation' of Brussels and most European capitals, we were told, was that the Irish Government would simply hold a second referendum. And that's exactly what they did, with the total support of the other major Irish political parties.

The Government put the referendum's rejection down to a failure on its own part to communicate properly what the Treaty was all about! Personally I felt that journalist Sam Smyth 'hit the nail on the head' when he wrote (*Irish Independent*, 9 June), 'The electorate in this Republic owes an apology to no-one and certainly not to the local politicians or the emperors of the EU.'

Hans-Gert Poettering, Chairman of the EPP group, was at least more respectful when he commented that 'The Irish vote shows us that we cannot continue as in the past. If we reform the EU it has to be a transparent approach…'

By the time the President of the EU Commission, Romano Prodi, came to Dublin two weeks after the first referendum, the Taoiseach had all but apologised to the rest of Europe for the way the Irish people had voted. Mr Prodi met with a number of 'No' campaigners in a meeting organised by Anthony Coughlan, a senior lecturer in Trinity College Dublin and Ireland's leading critic on the European Union. Prior to this meeting I arranged to meet Mr Prodi with two other MEPs, Patricia McKenna and Nuala Ahern of the Green Party, and we were able to put our individual points to him.

Mr Prodi, his advisors and our Irish Commissioner, Mr David Byrne, attended that meeting in the European Offices in Dublin, during

which we presented Commissioner Prodi with the varied reasons why Independent representatives and the majority of Irish voters had rejected the Nice Treaty, explaining that the spectrum of political and social elements on the 'No' side were as diverse as those on the 'Yes' side and that each had contributed to the rejection of the Treaty. I then asked him why the Commission had not upheld EU law and abandoned the rejected Nice Treaty, as was its duty. It was clear from his answer that the Commission was 'off the hook', because at the Gothenburg Summit the Irish Government had not opposed further ratification of the Treaty and had indicated that it would take care of the Irish problem. I also asked why the EU Charter of Fundamental Rights had been referred to in a number of court cases throughout the EU when it was clearly agreed in the Nice Summit that it was *not* a legally binding document.

I will never forget the response I received to that question; our Commissioner David Byrne immediately spoke up, saying that he was unaware of this having happened, but right away one of the EU advisors informed us that I was correct and that in fact the Charter had been referred to in at least twelve or thirteen court cases to date. This was very serious, as it strengthened and promoted the 'legal' status of the Charter over the heads of national governments and courts, despite the fact that the EU Heads of State, especially Taoiseach Bertie Ahern, had refused to make the Charter legally binding in Nice. Considering that David Byrne, a former Attorney General, had practised law in both Irish Courts and the European Courts of Justice, I was astonished that he would not know this vitally important information.

Just as things began to settle in the Parliament, the *Sunday Independent* printed an inaccurate story on 1 July 2001, saying that the Pope was disappointed with the Irish 'No' vote on the Nice Treaty and in particular was personally disappointed with me. The writer, Sinéad Grennan, quoted a civil servant in the EPP group named Stephen Biller. Even though Mr Biller wrote to the *Sunday Independent* editor, stating that remarks attributed to him had been falsified, the newspaper chose not to publish his letter or to retract the report. The Vatican later rejected the claim that the Pope had given his backing to Polish entry to the European Union, explaining that the Pope had referred to the 'European Community', which was much broader than the 'European Union'.

While all the madness of Europe and Nice was going on throughout 2001, we tried to keep our family life running as smoothly as possible. Ruth, then aged seventeen, sat her Leaving Certificate exams in June and, like other parents, we waited anxiously throughout the summer for the results. On our return to Ireland after my election in 1999, Ruth had only two years to prepare for the Leaving Cert and we felt that she didn't have enough time to take on board a completely new curriculum, including a new language, Spanish. If anything, we felt she would need an additional year in school to get a decent result. We weren't too worried either, because we felt that she was quite young to be heading away from home. However, she secured the points she needed to move on to third level and so, by the end of the summer, we faced into the difficult decision of what college she would go to. After checking out some colleges in England, I was very glad she decided to stay closer to home, in Dublin, where she studied International Business and Languages.

As the weeks rolled by, we eventually found her accommodation with none other than Claire Fitzsimons from Warrenpoint, her best friend since play school. It was an emotional time as Ruth prepared for her departure from home and Grace returned to University in Washington, DC, having spent the summer with us in Galway. I resumed my weekly trips to Brussels and Strasbourg as the new Parliamentary term began in late August. There was much work to do on various issues; the EU Commission had stonewalled protective legislation regarding genetically modified crops and food and there seemed to be an agenda to open up a Europe resistant to GMO products. I felt that this would be very damaging for Irish farming and so I was busy sending out press releases and doing interviews to raise awareness of the problem. I also publicly called for the referendum on abortion that the Irish people had been calling for and that the Taoiseach had promised during the 1997 election campaign.

I was flying to Brussels in the late afternoon of Tuesday, 11 September 2001, after meeting with representatives of the charity organisation St Vincent de Paul who were studying the recurring contributory causes of poverty. I called into my Galway office to pick up my airline tickets and some documents and while I was there we got a phone call to say that apparently a small plane had crashed into the

World Trade Centre in New York, a place we had visited on a few occasions.

It seemed such an unusual occurrence, and as it was lunchtime, Damien suggested we go to the bar/restaurant below our office and see the news report on their television. As we walked in, I could see people gathered around the screen that practically filled the back wall of the room. One of the Twin Towers had smoke billowing from the gashes high up on the building and the news reader was reporting that they were trying to work out the cause of the fatal crash, when all of a sudden, to my disbelief, another plane flew straight into the second tower. I felt myself involuntarily back away from the screen in horror and I realised I was watching a terrorist attack. There was stunned silence in the room and I felt unable to move as an unconfirmed report came through that other planes may have been commandeered by terrorists and one of them could be making its way to Washington.

Our first thoughts were with our daughter Grace who had just returned to college there, and Damien and I immediately rushed back upstairs to the office to try and call her. No matter how many times we tried, we couldn't get through; the telephone lines were obviously jammed and as we listened to the radio reports of an attack on the Pentagon building, our sense of panic increased. When we had almost given up hope of getting through to her, the phone rang; and thank God it was Grace calling to tell us that she was all right. She was obviously traumatised, classes were cancelled at the university and everybody was tuning into the TV for updates on what was happening. The students were fearful because there was a rumour that there could be further attacks on Washington and they were huddled together in their dormitories not knowing what would be hit next.

The horror of the loss of life at the Trade Centre and the Pentagon and on American Airlines Flight 93 continued to unfold over the next few days and fear of future attacks gripped the US. Many of Grace's friends returned to their families, and when flights in and out of the major US airports resumed within a few days, Damien flew to Washington to be with her. She and her friends who had remained in Washington were fearful of leaving the university buildings, so Damien took them out on the metro and into the city and helped them to adjust back to a normal routine. The world was in shock and mourning

after the September 11 attacks and everything seemed different and more uncertain in the wake of those tragic and unforgettable weeks.

In Ireland pressure was mounting for the second Nice referendum. As the Taoiseach had given a commitment to get a positive result this time round, he had to make sure that the Treaty passed at the next attempt. On 14 December 2001, the eve of the Christmas Dáil recess, on one day's notice to the Opposition, the Government pushed through all stages of the Dáil and Seanad an amendment to the Referendum Act that removed from the statutory Referendum Commission its task of setting out for the public the arguments for the Yes and No sides. This was funded by public money and had been of great help to the 'No' side which generally had difficulty raising funds. Instead, the 'Yes' lobby was able to use this money, alone with private financing, to launch a massive campaign the following year, which, according to Senator Shane Ross in the *Sunday Independent*, was supported by donations from several state-owned bodies including An Post, Bord Gáis and Aer Rianta. He stated that these donations, financed with taxpayers' money, were *demanded* by IBEC (The Irish Business and Employers' Confederation) and then passed on to the Government. However, as the donations were from state monopolies, the question arose of this procedure being in breach of the Supreme Court judgment forbidding government funding of referendums. Others were of the opinion that IBEC used the money to finance its own pro-Treaty adverts and that it was perhaps shared with other non-governmental 'Yes' groups. As the change to the referendum legislation happened so swiftly on the last day before the Dáil and Seanad rose for the Christmas break, it basically passed under most people's radar.

After the defeat of the first Nice referendum, Dick Roche, then a Fianna Fáil back-bencher, stated in his Dáil speech of 21 June 2001 regarding the Treaty, 'It failed to meet the democratic test in this nation. It is arrogance for any politician, either here, or any Commissioner in Europe, to ignore the fundamental fact that the Irish people have spoken with some clarity on the matter.' He also confirmed that although the Treaty had been 'sold' to the Irish people as a means of providing for enlargement, on the previous evening Mr Prodi had made it clear that this was not what the Treaty was about. I had felt hopeful on reading this speech that at least someone in the main

Government party was willing to speak out, but in the re-run of Nice I was truly staggered to see that the man who accepted the job of leading the Government campaign for a 'Yes' vote was none other than Dick Roche, now Minister of State! Words fail me on that amazing turn-around, but he was not alone; when John Bruton TD, former leader of Fine Gael, now EU Representative in Washington, was asked whether he had changed his view on the Treaty since his criticism of it in December 2000 on the grounds that it was detrimental to smaller nations, he replied that on reflection the general statement he had made was wrong.

The Bishops' Conference also re-issued its statement which again was presented in the media as supporting the 'Yes' vote.

In the second Treaty of Nice referendum I called for parity of esteem for those who had promoted the 'No' position and respect for the voters' democratic right to say 'No'. As former Attorney General John Rogers had stated after the rejection of the Treaty, it (Nice) would have 'significantly reduced' Irish people's say in decisions that 'intimately' affected them. He also said that he totally rejected threats of the 'dire consequences' that would fall on us if we did not approve the Treaty a second time. He stated quite rightly, 'I think it is important in the Union that small states like Ireland are not pushed around. Now it is time that people understood that when a small state or a big state signs up to a set of rules, it is entitled to have the rules respected. Otherwise we may as well forget about this Union.' This was something that he, John Rogers, did not want to happen, but he concluded, 'If the Union is not going to respect democratic principles ... we, the Irish people, must signify that it cannot have our respect.'

A second referendum on the Treaty of Nice was forced upon the Irish people in October of 2002. This time no money or effort was spared by the 'Yes' side in promoting the Treaty. In fact there was a conservative estimate that they outspent the 'No' camp by a factor of 10 to 1. In Nice 2 there were two questions put to the public but they had to be answered with a single 'Yes' or 'No' answer; so that those people who voted 'Yes' to safeguard neutrality found that they were also compelled to vote 'Yes' to Nice 2. Ironically, many of these same people had rejected Nice 1 precisely because they wanted to protect Irish neutrality. Through no fault of its own, the Referendum Commission spent €3,000,000 of public money publicising what was in effect two

questions in one, and many people considered it a trick amendment. Well, it certainly did the trick and the Treaty of Nice 2 passed. Having finally provided the answer they wanted in Europe, we were not asked to vote on the Treaty for a third time. It was a disappointing period, but the Nice 2 referendum was just one of the things that was to make 2002 among the most challenging and difficult years of my life.

Chapter 13 ~

HARD DECISIONS: HARD KNOCKS

On joining the Parliament in 1999, I was invited to be a member of the EP Bioethics Committee. This was an important committee in light of Ireland's Constitution and the rapid developments taking place in scientific research throughout the world. Since 1991, the European Commission had recognised that biotechnology was the new frontier for EU industry and in order for Europe to be competitive in the global market place, it was vital to be the innovative world leader in this field. To achieve this, the Commission wanted to ensure that Europe was a fertile ground for leading international scientists and biotech companies. Hence, throughout the 1990s, while the 'scientific research' race went on globally, in the European Union there was a 'tug of war' between the Commission and the majority in the Parliament as to what research should be permitted and funded in the European Union, especially regarding the use of human embryos.

In Europe, when one Member State makes a move, others tend to follow suit, so in 1997 when scientists in England successfully cloned 'Dolly', the sheep, an alarmed European Parliament, anticipating future developments, passed a resolution calling on all Member States to ban the cloning of human beings. In 1998, the EU Commission set up a twelve-member European Group on Ethics (EGE), to act as policy advisor to the Commission on ethical questions relating to advances in Science and Technologies.

With the UK 'pushing the envelope', a 'tit for tat' power struggle ensued between the Commission and the Parliament over the coming

years. In September 1998 the Parliament put forward an amendment forbidding the use of EU funds for research that involved the killing of human embryos. In response, the Commission asked for an opinion from the EGE, which announced in November 1998 that 'financial support for destructive embryo research' could be given when it was carried out in countries 'where it was permitted'.

A month later, the UK recommended the cloning of human embryos for use in research and, within a year, the European Patent Office had granted a patent to the University of Edinburgh. The European Parliament immediately objected on the grounds that it could be used to cover the cloning of human beings, and called for the EU 'cloning' patent to be revoked, but within three months the UK Department of Health warranted research on cloned human embryos.

These events caused a major political and ethical problem for those countries within the European Community where research and cloning using human embryos was against the law, namely Germany, Austria and Ireland, with France also prohibiting research that led to the death of the embryo. The question was: could and should the Commission insist on using taxpayers' money to fund research in other Member States, when that research was unethical and illegal in the taxpayers' own country?

This question was raging in the Parliament by the time I was elected in 1999, and with a new research funding programme being drawn up, there was ever-increasing pressure on Member States to support EU funding of the cloning and destruction of embryos for research purposes. The 'European Research Area', proposed by the Commission, was endorsed by the Heads of State at the European Councils of Lisbon, Nice and Stockholm and, as the Nice Treaty stated, the objective was to strengthen the scientific and technological bases of EU industry and its competitiveness at international level, while 'promoting all the research activities deemed necessary ...' (Art. 163).

Our Bioethics Committee examined the latest developments taking place in scientific research throughout the world and how they might impact on the EU Member States. I found it fascinating, as I did the struggle between the Parliament and the institutions of the EU.

Developments in scientific research were moving very rapidly and by the summer of 2000, US President Bill Clinton and UK Prime

Minister Tony Blair presented the world with the Human Genome Map, simultaneously arrived at by their respective research teams. In Brussels, meanwhile, it was clear that the Commission was determined to push ahead with any conditions it felt necessary to promote the EU research industry, whether or not individual Member States agreed. In September of that year, the Commissioner for Research, Philippe Busquin, reiterating the hopes of Commission President Mr Prodi, called for an 'enlightened debate' on 'the value of research into human embryo stem cells'. I was surprised that the Commission would push an issue that was clearly repugnant to many citizens in the European Union and illegal in a number of Member States. The following day, the Parliament rejected a resolution on the cloning of human embryos for research.

By November, the European Ethics Group had issued a statement that the time was 'not yet right' to clone embryos for research, since there was a vast field of research that could still be done using 'surplus embryos', foetal tissue and adult stem cells and, by Christmas 2000, British MPs had voted to allow research on fourteen-day-old embryos left over from IVF treatment. At this point the EU Industry Committee was given the task of writing a report on the needs of industry in light of the new EU funding programme for research.

EU reports are the foundation of the legislation that will be enacted in Member States, so the content of an EU report is vitally important. As a number of controversial issues would be dealt with, the European Parliament voted in favour of setting up an *ad hoc* committee to examine the various ethical and legal questions surrounding the advances taking place in human genetics and, most importantly, to draw up guidelines for EU industry regarding research. I was invited to be one of the members of this new 'gene' committee that would deal with the very senstive question of embryo reseach, as well as examining the use of taxpayers' monies to fund such research in the EU.

The committee was made up of sixty-four members drawn from each political grouping. We were a very diverse group of people whose political and philosophical viewpoints ranged from the far left to the far right and everything in between. I remember thinking that it would be very difficult, if not virtually impossible, for us to reach consensus on such very sensitive issues. Francesco Fiori, an Italian member of my EPP

group, was appointed as *rapporteur* to write the 'guide-line' report at our January 2001 meeting; another EPP member was Avril Doyle of Fine Gael.

Over the course of the coming year the committee held hearings with leading figures from the scientific community, as well as representatives from European institutions and various patient organisations such as the German Cystic Fibrosis Association and the UK Parkinson's Disease Society. We studied and debated the various advances taking place in stem-cell therapies using both 'embryonic' and 'adult' stem cells; the mapping and sequencing of the human genome; post- and pre-natal genetic testing; the use of genetic information and patentability, and so on.

Again and again, scientists told us that they were not law-makers and that it was up to us to lay down the laws within which they could work. However, there was increasing pressure from the Commission, and even from the chairman of our Committee, to permit as liberal research as possible. We were frequently reminded that the EU needed to be able to attract leading scientists from all over the world and that to do so, we needed to provide a fertile ground for those scientists or we would lose them to Asian competitors where there were few or *no* restrictions regarding the use of human embryos in scientific research; in particular to China where they were already experimenting in fusing human DNA with animal eggs (cybrids) and even human and animal embryos (chimeras).

As official EU documents reported, 'the basic argument revolves around the status of the embryo as a living organism with the rights and dignity of a living person'. Therefore the most important question we had to answer was: When did the embryo's life begin; was it at the moment of fertilisation/conception, or when it was implanted in the womb, ten to eleven days later? This particular question had been on the international agenda for some years. The answer was crucial to those who wanted legal access to the pre-implanted embryo for destructive scientific research and this, we were informed, would open the door to using so-called 'surplus embryos' created for in-vitro fertilisation (IVF) but not implanted in the mother's womb. However, biological and genetic evidence showed that from the moment of fertilisation the embryo had its own genetic code and that its

development was continuous and gradual. So it was medical and scientific fact that life began at fertilisation.

Opinions in the committee were sharply divided on the thorny issues with which we were dealing, and with a fund of around €300,000,000 of taxpayers' monies ready and waiting, there was a big incentive for other Member States to follow the UK's liberal position on the cloning and use of human embryos for scientific research. As one of the only countries that protected the human embryo from fertilisation, Ireland's position was crucial.

The closer we got to our November vote, the more the pressure increased and the more apparent it became that the Industry Committee was of the same mind as the EU Commission regarding the use of so-called 'surplus' embryos from IVF in scientific research. The door was also left open for so-called 'therapeutic' cloning. The Parliament was schelduled to vote on the ethical guidelines drawn up by our committee *before* voting on the Industry Committee report, so that they could be applied to the Industry report and used as a reference point for Member State legislation.

As the debate on the guidelines intensified, I travelled to Rome on 24 September 2001 for our EPP/ED group 'Study Days', during which the work of our 'gene committee' was debated and though the majority opposed the destruction of human embryos in research, there were those who supported it within the group and within the Fine Gael Irish Delegation. Again the question came down to the 'status' of the embryo and whether it was given the rights and dignity of a living person at fertilisation/conception or ten to eleven days later, at implantation.

While in Rome, I received a call from Damien telling me that one of my supporters had forwarded a copy of a letter he had received from a member of the National Executive Committee of the Pro-Life Campaign (PLC), a respected pro-life group that I was very familiar with. I had recently addressed the group's Annual Delegate Conference, sharing news of the work I was doing in Europe. In the letter in question, the writer explained that he felt he had to resign from the PLC National Executive Committee because of his conscientious objection to a draft proposal from the Government on a constitutional amend-ment dealing with abortion. It seemed that the Government had decided to deal solely with the PLC on this matter, thereby placing the

organisation in the position of being the main representative of the pro-life people in Ireland. According to the letter, some time earlier at a PLC National Executive Committee meeting, members had discussed the proposed 'non-negotiable' wording, which the PLC obviously intended to endorse and promote.

The vast majority of the Irish people had lobbied for a new pro-life amendment since 1992 when the Supreme Court, in the so-called 'X' Case, interpreted the existing pro-life constitutional article (40.3.3) to include the risk of suicide as grounds for the abortion of an unborn child. It was commonly acknowledged that no psychiatrist could predict suicide and there was no evidence that the refusal of abortion led to suicide. These and other points were made by some of the leading medical and legal experts advising the Oireactas All-Party Committee and were highlighted by the Tánaiste, Mary Harney, in the referendum debate.

Alongside that, research showed that a mother was six times more likely to commit suicide *after* an abortion. The existing article (40.3.3) which had been inserted by the people by public referendum in 1983, stated that 'The State acknowledges the right to life of the unborn and, with due regard to the equal right to life of the mother, guarantees in its laws to respect and as far as practicable, by its laws to defend and to vindicate that right.' Though the term 'unborn' was not defined, it was widely understood to mean from the moment of fertilisation/conception. This interpretation was supported by statute law, Sections 58 and 59 of the Offences against the Person Act (1861). This law, as the PLC explained in a 1998 statement, was seen from its enactment as 'a total ban on direct intentional abortion and as such should remain unchanged'.

In November 1992, in response to intense public lobbying, the Fianna Fáil/Progressive Democrat coalition Government had proposed three constitutional amendments as a response to the Supreme Court's 'X' case interpretation. Two of the amendments, dealing with the right to travel and the right to information, were passed in the referendum, but although the third amendment, referred to as the 'substantive issue', appeared to row back the Supreme Court's interpretation, it was rejected in the referendum, with pro-life supporters stating that it would have permitted direct abortion to be legalised in Ireland.

The first I heard of the *new* constitutional amendment was when I received the phone call in Rome. The ex-PLC member did not have a copy of the proposed amendment wording, as only one copy had been provided to the PLC, but he quoted phrases from memory and outlined why he could not support them. One phrase in particular jumped out at me: abortion would be legally defined for the first time as the destruction of human life 'after implantation in the womb of a woman'. The existing statute law (Sections 58 and 59 of the Offences against the Person Act 1861) was to be repealed, thereby removing the only Irish law that was believed to provide a good deal of protection for the pre-implanted embryo. That would mean that the only remaining protection would be the existing undefined reference to the 'unborn' in the Constitution, Art. 40.3.3, the definition of which could ultimately be left to the Supreme Court in the case of a legal challenge.

I did not know the author of the letter and I had no idea who else had seen the Government's proposed wording, but I felt that whoever might have so far agreed to support the amendment could not be fully aware of how rapidly scientific developments were taking place in Europe and elsewhere. The proposed wording the letter-writer shared seemed to push all the right buttons as far as meeting the needs of the scientific research industry, especially if it could be used to determine not just that 'pregnancy' began at implantation, but also that 'life' began at implantation, a point that had already been mooted at the international level.

The unusual inclusion of the phrase 'in the womb of a woman' also concerned me, since members of our 'gene committee' were aware that scientists in Cornell University Centre for Reproductive Medicine and Infertility and also in the Juntendo University in Tokyo, had already succeeded in growing human embryos in artificial wombs up to the legal limit of six days. They had stated their intention of continuing this research and allowing embryos to grow up to fourteen days, the maximum permitted for IVF. However, both teams believed that artificial wombs, capable of sustaining a child for nine months, would become a reality within a few years. In light of this, the proposed wording might leave a child implanted 'outside the womb of a woman' without any legal protection up to birth.

The first thing I needed to do was to examine the wording for myself, so I dictated a short letter to a key member of staff in my Galway office, requesting a copy of the proposed amendment from the Attorney General, Michael McDowell. I asked that the request be sent off as soon as possible. However, my assistant and friend since the Presidential Campaign of 1997 refused to draft or post a letter on my behalf to the Attorney General. When I asked for an explanation of this incredible reponse, I learned for the first time that my assistant was also a member of the National Executive Committee of the Pro-Life Campaign (PLC); he had therefore been aware of the wording and of the impending referendum, but had felt justified in keeping this information from me. In a nutshell he supported the proposed amendment and I can only presume that being aware of my concerns in the 'gene committee', he and others felt that I might have difficulty with it and so decided it would be better to keep me in the dark in case I said or did anything to jepordise the long-awaited referendum. There was, to put it mildly, a conflict of interest within my office!

His information came as a complete surprise to me. As an Independent, I had always made it clear that while I respected the work of other organisations or individuals and also the freedom of people to support whomever or whatever organisation they wanted to, it was imperative that anyone working with me should also be independent of any other allegiances, and be loyal to me. We didn't have a heated discussion. I think I was more in shock than anything else, but by that evening my assistant and our office secretary, who it transpired was also a member of the PLC, decided to walk out rather than write the letter to the Attorney General, thereby leaving Damien, John and me with no office staff in Galway.

I did not know when the amendment wording was to be made public and I felt I needed to meet with as many pro-life leaders as possible, including those from the Pro-Life Campaign, so that we could discuss the wording at the earliest opportunity and I could share my concerns regarding the impact of the developments in Brussels. Over the next couple of days we were constantly on the telephone trying to contact as many people as possible so as to set up a meeting for the coming weekend, when I would return to Ireland.

I wondered if others were in the same position as I was. It appeared that the Pro-Life Campaign, whose chairman was Fianna Fáil Senator Des Hanafin, was speaking for all the pro-life groups in the country, such as Family and Life, Neart—the National Coalition of Women's Rights, Human Life International, Youth Defence, and so on. That weekend my office was filled with representatives from most of these groups, as well as individuals such as Professor Eamonn O'Dwyer, Nora Bennis and Mary Thornton who had dedicated many years to pro-life work. I learned that the PLC had shown the wording to the leaders of only a few pro-life groups, such as Family and Life and Youth Defence, and those who had seen it were presented with a document that was a *fait accompli*; nothing could be altered. Apparently only one copy of the wording had been issued to the pro-life community and that was in the hands of the PLC leadership, so we could not access a copy for our meeting.

After a lengthy and at times intense discussion, it was clear that there was a great deal of concern as to how the wording might be interpreted and as to whether or not it could be supported with so little clarification and debate. The leaders of the PLC did not attend the gathering and I tried to set up an urgent meeting with them, in order to get some clarity on points of concern. There appeared to be reluctance on the part of the PLC to meet with us but eventually a time was set for Monday, 1 October, at 8.45 a.m. in a hotel in Athlone.

A group of us from the Galway meeting spent two hours talking with Professor William Binchy and Caroline Simmons of PLC. During that time we voiced our concerns and sought clarification. We still did not have a copy of the proposed wording and we were told that the PLC could not make it available to us. There were various concerns expressed, all focusing on the possible vulnerability of the pre-implanted embryo. When I asked if the wording had been discussed in the light of Europe's plans for destructive research on the pre-implanted embryo, William Binchy replied: 'We never thought about that'. It was made clear to me that this aspect was not discussed in the soundings and that the research question would be dealt with *after* the 'X' case interpretation had been clarified. I said that I thought this was a dangerous tactic, considering how rapidly Europe was moving on and the length of time it had taken for the Government to respond to the people's concerns on the 'X' case interpretation.

As the meeting closed, we urged the PLC leadership and William Binchy to inform the Government that at this time there was no consensus among pro-life groups on support for the wording and that, in light of the concerns expressed, there was need for further clarification and debate. The PLC therefore could not undertake to agree the proposed wording on behalf of the pro-life community at this time.

It was my understanding that the Government had also carried out other soundings and would proceed to make the wording public only if there was a prior assurance of support from the legal, medical, religious and pro-life bodies in the country. My last request before leaving the Athlone meeting was that the Government be asked not to make the wording public until there was more time for people to examine and debate it. The response from William Binchy was that he thought it could be difficult to do that.

Our meeting finished just before 11.00 a.m. Damien and I got into the car to drive home and, to our utter dismay, we heard a news report on the radio announcing the Taoiseach's intention to make the proposed amendment wording public that day—it was then clear that our meeting was nothing other than a method of defusing concerns. The timing was quite extraordinary and the proverbial genie was 'out of the bottle'.

Without going into a detailed account of the extraordinarily complicated constitutional amendment and legislative act put to the Irish people, suffice it to say that it caused great confusion and division. As Kieron Wood, journalist and barrister, reported at the time, the language of the Bill was 'complex to the point of obtuseness'. No doubt this, possibly combined with referendum fatigue, contributed to 57 per cent of the electorate failing to vote at all. Of those who did go to the polls, there were pro-life and pro-abortion advocates on the 'Yes' side, just as there were pro-life and pro-abortion supporters on the 'No' side. Many people adhered to a political party position; others abided by the statements of religious leaders.

A number of occurrences made me increasingly worried about the possible interpretation of the wording. In October 2001, the Irish Commission on Assisted Human Reproduction, established by the Government in 2000 to advise on regulation in this area, circulated a leaflet to the public asking for submissions regarding various ethical

issues in IVF. Under the heading 'The Unborn' the Commission's leaflet stated that the definition of this term was crucial in assisted human reproduction, but that if a pre-implanted embryo were to enjoy the protection given to the 'unborn' in our existing constitutional article (40.3.3), it would have very serious implications for current practice.

Then there was the manner in which the EU dealt with the Ethical Guidelines drawn up by our 'gene committee'. By November 2001, after eleven months of deliberation, our committee had completed its task of drawing up guidelines for the European Research Area. Incredibly, despite our very different viewpoints and beliefs, we voted, among other things, that the EU could not fund research involving the destruction of human embryos. Instead, it should prioritise the funding of adult stem-cell research, which had proved to have successful results and was ethically acceptable. We also voted that all forms of cloning should continue to be banned, since there was no difference between the technique used in cloning for the purposes of reproduction and cloning for therapeutic purposes. Also, any relaxation of the present ban would lead to pressure for further embryo production and their use and destruction. Another problem with therapeutic cloning was that it required the availability of a large number of human egg cells, produced by ovarian hyper-stimulation, which could result in major risks to and exploitation of women.

As the Committee neared the completion of its work, there was growing hostility to any opposition to the Commission's research funding programme. Philippe Busquin, Commissioner for Research, had stated at a Life Sciences and Biotechnology meeting in Brussels in September 2001 that there was no limit to research, so 'let's stop these philosophical and ethical debates'! He went on to say that even though a number of Member States had banned some types of research, this would not stop the EU from funding research in countries where it was legal. We also had to contend with our committee chairman Robert Goebbels who stated in one of our September meetings that there were no natural moral principles and that even though some MEPs had religious or moral concerns, 'it would not change anything' (regarding research on embryonic stem-cell lines).

When our committee voted in favour of the restrictive guidelines I was surprised at the outcome but I have no doubt our chairman and

Commissioner must have been really shocked. Suddenly the parliamentary voting schedule was altered and, contrary to the stated intention of the Parliament, we found that the vote on the ethical guidelines was delayed until *after* the vote on the Industry Committee report, which called for funding of research using pre-implanted embryos from IVF (up to fourteen days old).

In the first reading of the Industry Report on 14 November, despite the fact that it was against the Irish constitutional position and illegal in three other Member States, the Parliament voted to use €17.5 billon of taxpayers' money to fund the Commission's research budget line; €300 million of which would be dedicated to destructive embryo research.

I wrote to the Taoiseach and requested a meeting with him. I also wrote press releases and did radio interviews in which I stressed that in light of what was happening in Europe, the wording of the proposed constitutional amendment could not be looked at in isolation. Unfortunately there was little response to this warning. By the time the Parliament voted on the ethical guidelines two weeks later, there had been an attempt to force through the inclusion of amendments from the Liberal and Socialist groups in favour of 'therapeutic' cloning. Many members of the 'gene committee', including the *rapporteur*, Francesco Fiori, decided to reject our own report rather than allow the unethical amendments to be adopted. Most EPP members followed our lead and the report was rejected in the parliamentary vote of 29 November.

During the debate in Parliament that day, the Commissioner, Philippe Busquin, re-stated his support for the use of *supernumerary* embryos for research purposes. I began to feel that fighting against the Commission was like putting a rock in a stream to try and stop the flow of water; invariably the water would find a way around the obstacle. It seemed that the only way to halt a Commission proposal, which of course leads to EU legislation, was to have a certain number of Member State governments, or a significant number of citizens, unite and stand against it, though even then it would be difficult. I remember asking a senior Irish civil servant what percentage of Commission proposals normally went on to be adopted in the Parliament. His response was 'about ninety five per cent of them'! Remembering that more than two-thirds of national law is decided on in the European Parliament, I thought that was a lot of power in the hands of an unelected body like the Commission.

Many members of the 'gene committee' spoke in the parliamentary debate on the day of the vote. Dr Peter Liese (EPP-ED) was very clear. He said 'Yes' to research, but 'No' to anything that did not respect the dignity of human life. Avril Doyle, on the other hand, said that she supported [embryo] research for 'therapeutic reasons' and made the unusual comment that 'even the Vatican [did] not want to ban all forms of research in this area'.

I said that I could not support any research on human embryos and that there were other alternatives available, but I think Mr Fiori summed it up very well when he said, 'From the information we have, the only certainty we can hang on to is the fact that embryos are human, whatever their fate may be ... All human beings must be protected at all stages of their lives, from conception until natural death, particularly if they are vulnerable or disabled. I am in favour of progress in scientific research, not least because it is a source of economic development, but I believe we have to ensure that it does not become a kind of death trap for human beings because due attention was not paid to the ethical principles that should underlie it.'

In early December, I wrote to the Taoiseach, again, not having received a reply to the questions in my previous letter. I expressed my deep concern at the conflict between the EU position on the status of the pre-implanted embryo and the protection afforded by our Constitution and said that in light of this, although I hadn't yet reached a final position on the proposed wording of the new constitutional amendment, I had specific reservations. I asked therefore for an assurance that our constitutional position would continue to be protected in Europe and in Ireland.

The next day I was asked by representatives of Germany, Austria and Italy to contact, on their behalf, the Taoiseach and Minister Noel Treacy, who would be representing Ireland at a meeting of the Council of Ministers for Research on 10 December. As destructive embryo research and use of supernumerary embryos was illegal in their countries, these Member States needed Ireland's support to create a 'blocking minority' that would prevent the Commission from funding these activities in the second reading of the Industry Report. I immediately wrote to the Taoiseach and telephoned and faxed Noel Treacy with the details of the amendments that Ireland was being asked to support. At last there was

a glimmer of hope that, with our Government's help, it might be possible to prevent unethical research and the use of taxpayers' monies to fund it.

I felt I should also inform Cardinal Connell and the bishops on the developments taking place in Europe and urge them to take them into account before reaching a decision on the proposed wording of the constitutional amendment. I wanted to tell them of the request from Germany, Austria and Italy, since any influence they, the bishops, could bring to bear might help to ensure Ireland's support at the Council meeting. I was informed that Cardinal Connell could not meet with me and so I wrote a detailed letter to him and to each bishop in the country. Sadly I was later informed that, at the Research Council meeting, Ireland did not support Germany, Austria and Italy's attempt to block EU funding of destructive embryo research. It was a worrying, though not entirely unexpected, development.

Within a couple of days, the bishops, through the Irish Episcopal Conference, issued a statement in which they opted to support the Government's proposed wording for the 25th Constitutional Amendment. And before Christmas, the PLC also issued a public statement of its support for the wording. It was obvious to me that there had been a prior agreement of support, as I had been advised, and I felt deeply concerned that they didn't seem to see the potential impact of what was happening in Europe, or how the actions of our government representatives there revealed the possible pitfalls in the proposed wording on the constitutional amendment and legislative act. People were now calling my office on a daily basis, asking for clarification on the wording because they were worried and confused as to how they should vote.

With parliamentary and constitutency work back in full swing after the Christmas break, the added pressure of dealing with the abortion referendum made it an extremely stressful time. We were cautious about hiring someone else to work in the Galway office, so various friends helped out, but for the most part, Damien and John had to deal with almost everything on their own. At times it felt as though we were climbing a mountain with our hands tied behind our backs.

The most difficult thing, however, was to find myself on the opposite side from people and friends whom I loved and respected. I was to lose

a lot of friends and supporters over the coming months, but unless the Government gave me the assurance that it intended to protect the pre-implanted embryo, I could not in conscience support the proposed wording, especially knowing that the Government had failed to do so when the opportunity had presented itself in Europe. There were other worrying aspects to the 'Protection of Human Life in Pregnancy Bill' and as time went by and more of its content was revealed, it seemed to me like a Pandora's Box.

In early January 2002 I was sent a copy of a legal opinion on the referendum proposal written by Roderick J. O'Hanlon, now deceased, a highly respected former High Court Judge, President of the Law Reform Commission, and leading Irish pro-life figure. In his opinion, he referred to the proposal as 'intrinsically evil', concluding that it would greatly worsen the legal protection afforded the unborn and would 'definitely liberalise Irish abortion law so as to increase the number of legalised abortions in Ireland'. Other legal opinions such as one written by Charles Rice, Professor Emeritus of Law, Notre Dame Law School, also warned against adopting the proposal, stating that it would undermine and discourage pro-life efforts not only in Ireland but also in other nations and communities.

By early February, with barely a month to go to the referendum, I had still not received the assurances I requested from the Taoiseach, so in light of my concerns with the loopholes in the proposed amendment, I wrote again, asking when he intended to propose protective legislation to the Oireachtas for the pre-implanted embryo. By mid-February the Government had named thirty hospitals throughout the country where 'procedures' could legally take place, but there was no explanation as to the exact meaning of 'procedure'. According to the Taoiseach, the Government would not resolve the question of whether 'procedure' referred to 'legal abortion' or 'termination'. It would, however, require the 'reasonable opinion' of only one medical practitioner, and according to the Minister for Health, Micheál Martin, medical records relating to the 'procedure' would not be subject to scrutiny of any kind. In the UK the signatures of two doctors were required and yet that had not prevented what many regard as a virtual 'abortion on demand' scenario.

In the media, 'Yes' voters were generally portrayed as adopting a pragmatic approach to the proposals and 'No' voters as either pro-abortion or right-wing fundamentalists. Even a leading Irish Catholic newspaper made an unfortunate reference to the 'extreme Catholics' who were voting 'No'. The bishops' pastoral letter, and individual bishops gave the assurance that Catholic voters could in good conscience vote 'No', as did the Papal Nuncio in Ireland, Archbishop Lazzarotto, in answer to a correspondent seeking clarification on this point. Yet there was the impression given that those who did so were disobedient to the bishops and the church, or misguided. It began to sound as though various factions in the pro-life movement were at war with each other, but the truth was that whether they voted 'No' or 'Yes', all pro-life people wanted the same thing: respect and protection for life in all its stages.

I was interviewed on RTÉ radio in mid-February and, when I had clearly stated my position in response to questions, the floodgates opened. Before I knew it I was clashing on the airwaves with Minister Dermot Ahern and a leading gynaecologist, Professor John Bonner. The latter, at an RTÉ *Prime Time* debate, informed me that the 'modern view of conception' was that it began at 'implantation' and that it was impossible to detect pregnancy *before* implantation. He also remarked that only some fundamentalists thought otherwise! I had known Professor Bonner for some years as he had delivered my first child, Grace. Dermot Ahern had stated on the same programme that the Government relied on the opinion of experts like the Professor, so I was glad to be able to forward to Professor Bonner scientific papers and references from the American College of Obstetricians and Gynaecologists (ACOG), confirming that in fact there *are* signals of pregnancy prior to implantation, both in humans and other species, and, as he knows, the ACOG is definitely not a 'fundamentalist' organisation.

Meanwhile letters began arriving at my office from all over the country. Most acknowledged that although the amendment was less than perfect and they did not fully understand the intricacy of the wording, if the Government, legal and medical professions and, in particular, the bishops were in agreement on a 'Yes' vote, then I must be gravely mistaken to vote 'No'. Some were dismayed and saddened, urging me to reconsider my stance. Others, having endlessly lobbied the

Government for a referendum since 1992, were furious with me. They simply could not understand why I was opposing the wording and warned me in no uncertain terms that they would never support me again. Every now and again I'd receive a letter from someone who understood where I was coming from and that was like a ray of light, but for the most part it was a depressing and lonely time.

The Taoiseach finally responded to me in late February, a week-and-a-half before the referendum vote, and regrettably it was as I had anticipated—reiterating the Government's opposition to human 'reproductive' cloning (but not 'therapeutic' cloning) and the creation of embryos for research (but not the use of 'surplus' embryos from IVF). The Taoiseach assured me that the Commission on Assisted Human Reproduction would address the question of legislative control regarding embryo and stem-cell research and that any legislation on these complex issues would be based on the Commission's report, which would not, of course, be available until after the referendum.

In the final run-down to the referendum, there were more examples of how the proposed wording could be interpreted; the Masters of the country's three main maternity hospitals had called for a 'Yes' vote, on the grounds that the proposed constitutional amendment was consistent with the practice of obstetrics in Ireland, which is one of the safest countries in the world for a mother to deliver her baby. However, while maintaining their support for the amendment, they held a joint press conference on 27 February, a little over a week before the referendum vote, to announce that they favoured abortion being made available in Ireland where the foetus could not survive outside the womb.

Three days before the vote, the Sunday Tribune revealed that, according to 'senior figures', the approval of the proposed constitutional amendment would mean that one of Ireland's busiest IVF centres at the Rotunda Hospital in Dublin would be in a legal position to destroy unused frozen human embryos, otherwise referred to as 'surplus' embryos. EU funding could be accessed for research on 'surplus' embryos that would otherwise be destined for destruction.

The day of the referendum, 6 March 2002, I had a very strong feeling that the amendment would be defeated, as did Damien and John. We agreed therefore that we should go to the count centre in Dublin. We felt that it needed to be clarified that there were pro-life people who

voted 'No' because they believed it would help to protect the life of the unborn, from conception.

Mary and Jim Thornton and their family also drove up from Galway, as did a number of other pro-life 'No' voters from different areas of the country. As we travelled along listening to the radio, it was clear that the result would be close. The last constituency to declare was my home ground of Galway West. If the 'Yes' vote were to win, I dreaded the effect it would have, not just on Ireland, but on the many countries that looked to us for leadership on ethical issues. However, I knew that a 'Yes' vote would be easier for me on a personal and political level. If, on the other hand, the amendment were rejected, the *status quo* would remain regarding the protection of the human embryo, both pre-implanted and in the womb, but there would also have been public acknowledgement by members of the Government that the threat of suicide was not considered reasonable grounds for abortion. I had no doubt, however, that in the case of a 'No' vote, my political career would be severely, if not fatally, damaged.

We made our way into the RDS and waited for the last declaration. Just as in the 1992 referendum, pro-life 'No' voters stood alongside those who voted 'No' because they supported the right to abortion. Opposite me stood the gathering of 'Yes' voters, many of them former supporters and friends. The Galway West vote was delayed for some time and the tension was tangible as the result was announced. The 'No' vote had won out in Galway West and in the country. The national turnout was 42.89 per cent of the total electorate, of which the 'No' vote was 50.42 per cent and the 'Yes' vote was 49.58 per cent. The winning margin was just over 10,000 votes and I braced myself for the inevitable backlash.

As we walked down the stairs in the RDS after the votes had been declared, a young woman who had been a supporter of mine approached me. She reached out and shook my hand, congratulating me on the result. Then she said, 'I voted and campaigned for you in the European election but I will *never* vote for you again.' At that she turned away abruptly and disappeared into the crowd, before I could say anything. I will never forget the controlled anger in her voice or the hurt in her eyes. As the weeks and months rolled on, things only got worse and this scenario was to repeat itself many times over. I thought it would never end and eventually I had to learn to live with it. Many

people were hurt or angry, or both. Harry Blaney, leader of the Independent Fianna Fáil Party, was strongly critical of what had happened and was quoted in the *Donegal News* (15 March 2002) as saying that it had taken five years 'to drag the referendum out of the Government' and 'They must have known the wording would split the Pro-Life Movement.'

It is difficult for a loyal Catholic to find themselves apparently on the opposite side from their bishops in a serious public debate, as was perceived to be the case for me and for many others. In dealing with this dilemma I sought advice and spoke with some members of the hierarchy and I was assured that my conscience was properly informed by church teaching. Therefore, as a believing Catholic, I was obliged to act on it.

Despite this, great pressure was exerted on me to change my position to a 'Yes' vote. Among other things, I received a letter from Cardinal Cahal Daly asking that I reconsider my position. He stated that, although the bishops recognised that the proposed referendum wording was imperfect and even in part defective, they believed that a 'Yes' vote would greatly strengthen protection for the unborn and remove the worst of the threats that then existed.

The letter was addressed to me as an MEP and was not marked private or confidential. I was in Brussels when it arrived in my Irish office and, without my prior knowledge or approval, part of it was made public. I was sorry this happened, as it would not have been my choice, and I have no doubt it did nothing to help me to communicate freely with most of the bishops on the issue.

However, my position in conscience made it impossible for me to change my opinion. I firmly believe that, amongst other things, the wording enabled a fundamental shift to occur from the age-old concept that life must be protected from the moment of conception, to a radically new criterion that would protect life only from implantation in the womb of a woman. I believe that this would have led to the pre-implanted human person being left without legal protection and all that that would allow. As more information on the interpretation of the wording was made public and as the debate unfolded, it became even clearer that there was no difference between my position and church teaching, and in reality never had been.

Thankfully since that time there has been a gradual healing of the rift within the pro-life community, and as time went on and the political dust settled, many people came to understand why I voted as I did.

In 2005, after an unaccountable delay of some years, the Government Commission on Assisted Human Reproduction (IVF) finally published its report on the recommendations for regulation in the field of embryonic stem-cell research. The Commission stated that although the legal meaning of the word unborn in Article 40.3.3 in the Irish Constitution was unclear and would have to be clarified by the Supreme Court, or a constitutional amendment, it had profound implications for any research programmes. After quoting a view widely held in Europe that felt there was a case to be made for treating the embryo differently before and after implantation, the Commission recommended that embryo research, including destructive embryonic stem-cell research, should be permitted in Ireland on surplus embryos donated for research up to fourteen days following fertilisation.

These predictable recommendations are against the spirit of the Irish constitutional protection afforded to the unborn child by the Irish people and they confirmed my belief that the abortion referendum of 2002 was an attempt to manipulate and mislead the pro-life people of Ireland in order to facilitate where Europe wanted to go in the area of destructive embryo research. I believe that it was also a political attempt to position a so-called 'progressive' Ireland so as to benefit from EU research funding, whatever the cost in terms of ethics and whether or not it would undermine the protection of human life and dignity enshrined in our Constitution.

Meanwhile in Europe the battle against using taxpayers' monies to fund destructive embryo research continued. After a number of Member States (excluding Ireland) forced a three-year moratorium on this controversial funding in 2001, the Commission pursued its goal again in 2003. The Parliament was sharply divided on the issue; myself, the Irish Greens and six Fianna Fáil MEPs, who stood against their own Government policy on this issue, united in opposing the controversial research funding, while Fine Gael members, Pat Cox, Independent, and Labour's Proinsias De Rossa voted in favour of destructive embryo

research. At the end of the day, the Parliament narrowly voted to lift the moratorium.

In 2006, according to a BBC report, Ministers of the EU Member States agreed to continue funding research using embryonic stem cells that are 'removed from human embryos left over from [IVF] and earmarked for disposal'. Five countries voted against this decision— Austria, Lithuania, Malta, Poland and Slovakia. Germany, Italy and Slovenia reluctantly decided to support the funding, on condition that human embryos from other sources would not be destroyed for research. German Research Minister Annette Schavan told fellow ministers earlier in the day, 'We must conserve human life from its conception. We want no financial incentives to kill embryos.' Portuguese Minister José Mariano Gago was quoted as saying, 'We must avoid a situation where our scientists emigrate to other countries.' And the Irish Minister for Enterprise, Micheál Martin, said, 'Really, nothing has changed.' How true, and yet again Ireland was conspicuous by its silence.

After the 2002 abortion referendum, with hardly any time to catch our breath, the country faced into a General Election and a re-run of the Treaty of Nice referendum before the year was out. The thought of running as a candidate in the General Election did not appeal to me in any way and, as it approached, I still felt physically and emotionally drained. But there was no time to rest.

Chapter 14 ～

LEAVING
POLITICS

The General Election was called for 17 May 2002, with the re-run of the Nice Treaty referendum promised to follow sometime after the summer break. The Nice Treaty was not on the agenda of any of the political parties despite the importance of its implications. I felt that there were two issues the main party candidates would not be planning to discuss on the doorsteps or in the media, yet both these issues needed to be highlighted as election issues. The first related to the difficulties with the Nice Treaty and the proposed EU Constitution that would quickly follow it, and the second related to the fact of only 10 per cent of our European funding reaching the west and the difficulties this was causing for infrastructural and long-term economic development.

The election outlook was not good for me. I had lost members of my election campaign team because of the abortion referendum and we did not know how much support was left on the ground. Neither did we have the finances of the political parties, having just campaigned on two referenda in the previous months. Added to that, we were all still exhausted. However, the General Election was the last major public platform before Nice 2, and as the west would soon lose its EU status as a disadvantaged area, there was little time left to ensure that it got its fair share of funding. After a lot of thought and discussion I felt that I should use whatever time I had left in public office to raise those issues that otherwise might not be addressed. So, with the support of Damien, John and the remainder of my election team, I decided to put my name forward for election.

With less than a three-week campaign planned, it was 'hell for leather' from the beginning. The launch of my campaign on 29 April was almost a disaster. I had slaved over my computer, putting my speech together, till the small hours of the morning, intending to print off copies at the hotel for the journalists present. On the morning of the launch, my brother John went ahead to the Great Southern Hotel in Eyre Square, Galway, about half an hour's drive away, to make sure everything was set up, and Damien was waiting to take me in a little later. All I had to do was put a few finishing touches to my speech and print off a copy of it. And that was when disaster struck! Don't ask me how, but I printed off an earlier, incomplete draft and did not realise it until we were more than halfway to the Great Southern Hotel.

The traffic was difficult as usual but nonetheless we had to go all the way back to the house to get the correct version, only to discover that the final draft of my speech had been accidentally wiped off the computer. It was awful. Already late by this time, I had to rewrite the sections I could remember.

Meanwhile the media were none-too-patiently waiting at the hotel and John was on the phone every few minutes telling us to get in there as quickly as possible. By the time I arrived at the hotel, in a fluster, I was over an hour late, but I slapped on a smile and made my entrance. As Brian McDonald of the *Irish Independent* so delicately put it: '... there's real time and Dana time. Three times members of her campaign team arrived to tell the media she was running late because of traffic. Some cynical hacks dared suggest that the expectation was being built up nicely, but patience ran out for two who left long before she arrived. She finally arrived, a flurry of pale lilac and a beaming smile and had them on their feet in a speech that was a master class in delivery.'

It was wonderful to see so many friends and supporters who had travelled from all over the country to encourage and support me. There were also some new faces who came to offer their help in the campaign. Ironically I hardly bothered to look at my patchwork of a speech, preferring instead to speak off the cuff, from the heart. Pretty soon there were cheers and laughter at some remark or other and, all round, it turned out to be a great launch.

Unlike the Presidential and European campaigns I had fought previously, Galway West saw me covering a much smaller terrain and

with such a short run-up to the election we were able to keep our expenses to a minimum. Before I announced my intention to run I was at 4 per cent in the polls, and as the election campaign began it became obvious that there was still a lot of hurt and confusion over what had happened in the abortion referendum less than eight weeks earlier. Those who were 'waiting in the long grass' took the opportunity to teach me the lesson they had promised, with former supporters in the constituency calling on voters only to 'back candidates and parties that supported a Yes vote in the abortion referendum and are opposed to the introduction of abortion legislation'. So they campaigned for Fianna Fáil candidates and any Independent who voted Yes. The huge media interest following my campaign had plenty to report and any negativity of this kind was, of course, an advantage to my political opponents. Columnist Breda O'Brien wrote in *The Irish Times* a week before election day: 'Dana managed to let down and deeply wound a large part of her natural constituency—the anti-abortion activists— when she destroyed the Referendum they had worked on for ten years.'

Despite the negative reactions, we often campaigned with a group of over thirty people in our team each evening and there was kindness and encouragement from a great many people on the campaign trail. I always enjoyed campaigning, especially in long-established communities like the Claddagh and Shantalla, where they tend to take you as they find you. Often you'd be invited into someone's kitchen for a welcome cup of tea because they could see that you looked tired.

During the campaign there were many memorable moments, like when the media helped to ambush Bertie Ahern on his walk-about in Galway city centre. They really wanted a photo of the Taoiseach and me together, but they knew there was no way the Fianna Fáil team would agree to what would be seen as a 'photo opportunity' for me. I was canvassing that day when my brother received a phone call telling me to be at a certain corner in Galway's Shop Street at an exact time. 'Just wait there,' I was told, 'and you'll get another call.' The Taoiseach was visiting a nearby primary school, surrounded by his party candidates, members and minders, not to mention a posse of press and television people.

As I nonchalantly pretended to window shop, trying not to look too conspicuous, I felt like I was on a secret-service mission. Suddenly my phone rang again and a voice whispered, 'Walk around the corner in

thirty seconds.' As I did so, the jostling crowd of cameramen that filled the narrow laneway parted before me like the Red Sea and closed again behind me, blocking any means of escape. There I was, face to face with Taoiseach Bertie Ahern, who looked only slightly less surprised than his entourage. As we bantered about what needed to be done in Galway and who would do it best, cameras flashed and microphones were eagerly pushed toward us. The deed was done to the satisfaction of all, except perhaps the Fianna Fáil team and candidates!

In the end, the five seats for Galway West went to Éamon Ó Cuív and Frank Fahey of Fianna Fáil, Michael D. Higgins of Labour, Pádraic McCormack of Fine Gael and Noel Grealish of the Progressive Democrats, the latter taking the vacant seat of retiring TD Bobby Molloy. In all honesty, I had not expected to win the seat, and though I'm sure my defeat had some people rubbing their hands with glee, the media coverage I received allowed me to highlight the issues of the neglect of the west and the imminent EU Constitution.

I can truly say that my decision to run in elections was never motivated by a desire to attain the seat or the 'office'. I always did it because I wanted to use the public platform to speak out. No doubt it would have been safer from a political standpoint to have let the dust settle after the abortion referendum and keep my head low for a while. However, I did not pick the election date and I believed that it was vitally important to raise the issues I did.

I feel that losing the Galway West election damaged the political credibility I had garnered in the previous Presidential and European elections, especially with the media, and there was increasing commentary, particularly in *The Irish Times*, that my stand on the abortion issue had wiped out my traditional core support. Although it was true that it had been eroded, it was incorrect to imply that the majority of my support base had been Yes voters; this assertion made me look like a renegade. In fact a great many voted 'No' in conscience, not to follow my example, but because they had carefully considered the question for themselves. Indeed, during the months that followed, every pro-life leader I consulted outside Ireland said that they would also have voted 'No' in light of European and international developments.

From mid-May until the European Parliament closed for the summer break in mid-July, it was a hectic time. In late May I received a

copy of the report, *The Treaty of Nice and the future of the European Union*, which admitted that the Nice Treaty 'marked the opening of a constitutional development culminating in the adoption of a European Union Constitution'. Though I sent out press releases and undertook media interviews, it seemed to be impossible to get this point across in Ireland. The Dáil would soon be closing for the summer recess so there would be little time for formal debate on Nice and its implications. Meanwhile, in Europe, the convention established to draw up the EU Constitution was commencing its work, and our second Nice Treaty referendum was only a matter of months away.

As an MEP, I always had such a variety of issues to deal with, every one of them important, but some were a matter of life or death. An example of the latter was the case of Nigerian woman Amina Lawal Kurami. I had been contacted in early June by an EU official working in Africa, who informed me that Amina had been condemned to death by stoning under Sharia law, for having a child out of wedlock. We needed to highlight her case, for although she had been given a two-year reprieve to wean her child, her ultimate fate would be decided by a judge on 8 July. I immediately informed my fellow MEPs and launched an internet petition on her behalf throughout the EU, as well as internationally, urging people to lobby the Nigerian Embassy in their country to try to save her life and to prevent her child from being left motherless. Many thousands of people responded and in Ireland I met with the Nigerian Ambassador in Dublin to hand in the Irish appeal. We contributed to an international public response that pressurised the Nigerian Government to act on Amina's behalf, and thankfully her life was saved.

On a national level there continued to be serious issues facing the Irish fishing and farming industries and I lobbied hard on their behalf. Through June and early July I was also meeting with the Commission for Regional Policy regarding funding for a much-needed community scheme known as the 'Plaza Project', in Buncrana, Co. Donegal—an area still suffering from the job losses resulting from the closure of the Fruit of the Loom factories—as well as lobbying for a western rail link. There were a number of parliamentary reports and matters of business to be dealt with before the summer break, one of them being the 'Van Lanker' report, in which the EU overstepped its mark yet again, calling

for the legalisation of abortion and sexual and reproductive health centres in schools throughout the EU and candidate countries. This had upset a number of Member States, and in particular candidate countries, because this sensitive topic was not the responsibility of the EU. By the time mid-July arrived, I gratefully collapsed into the summer holidays with a sigh of relief.

During the holidays I travelled to Toronto where I had been invited to sing at World Youth Day. I had written the 1993 WYD theme song, 'We are One Body', and having sung it at the subsequent Paris and Rome gatherings, I was duly invited to perform it again in Toronto, as the song had become a youth anthem.

I brought John James and Robert to Canada with me and it was wonderful to see the hundreds of thousands of young people attending from all over the world. The stage, sound and lighting rigs in Toronto were absolutely massive and I asked John James if he'd like to come on stage with me and play guitar. It was a daunting experience for a young musician, but I wanted him to experience playing in such a fantastic setting. It has to be said, he took it all in his stride, and afterwards he was surrounded by girls looking for photographs and autographs, so he got a little taste of what it would be like to be a rock star!

I really enjoyed being able to share that time with Robert and John James and it made me appreciate all the more how precious it was to have time with my children.

My lovely Great-aunt Mary died that summer, at the age of ninety-nine years, and it was hard to imagine our family without this compassionate woman, with her deep personal faith and wonderful sense of fun. One of the main difficulties for me in my work as an MEP was that I had very little family time. I needed to be in Brussels or Strasbourg during the week and yet also be on call in my constituency in Ireland at the weekend. I loved having my political independence and I felt it was essential in serving the people I represented, but it could also make life more demanding and stressful. Connaught/Ulster was a large constituency, so it meant being on the road a great deal. If, for example, I had been a representative of a political party, living in Galway, and there was a constituency meeting in Donegal, the local TD or councillor there from my political party could have attended the meeting on my behalf. However, as an Independent, you're on your own and you have to be at

meetings regardless of distance or time. If you don't show up, it can give the impression that you don't care about the problems your constituents are facing and it can also be ammunition for your political opponents. This was a dimension of political life that I had not thought too much about and perhaps in general people are not aware of the demands it makes on public representatives and their families, whether they be Independents or party members.

The re-run of the Nice Treaty was set for October 2002 and as I made my way to Canada that July pro-Nice advocates were already making public statements. It was disappointing therefore to read a report in the *Irish Independent* and *Sunday Business Post* that President McAleese during her visit to Greece had told an audience in the Hellenic Centre for European Studies that, after the forthcoming Nice referendum in October, Ireland would have 'another story to tell' and that joining the EU had not diminished Ireland's sovereignty but given it 'added scope and force'.

The Irish Times also reported this last remark and added that the President had said that the low turnout in the previous referendum was because many people thought that they did not adequately understand the arguments. As Damien Kiberd wrote in an article in the *Sunday Business Post*: 'If this report is correct then the President is clearly predicting that the outcome of the October plebiscite will be a Yes vote. She is also gravely deluded if she thinks that membership of the EU has entailed no diminution of sovereignty ... It is shocking to find the President of our country intervening so openly in the debate about Nice three months ahead of a Referendum.'

By 26 August I was back in the European Parliament and the new EU Constitution was looming large on the horizon. I had been told by a respected political journalist that there was a great deal of pressure on Ireland to pass the Nice Treaty and that threats related to this regarding our national funding were being applied from Brussels. I immediately issued a press release stating: 'It is an affront to all democrats that threats are being used to overturn the democratic will of the people of Ireland who have already rejected Nice.' Nonetheless the referendum went ahead and was carried.

Before the year was out, there was another fierce row brewing in the European Parliament, with members yet again locked in a power

struggle with the Commission. It involved a report written by Danish MEP Ulla Sandbæk—someone I regarded as a friend. Ulla's report was on a new EU regulation that would provide a fund of €74 billion over three years for 'reproductive and sexual health services' (previously known as 'population control'). The regulation was legally binding on all Member States. As part of the 'services' provided, EU taxpayers' money would be used to fund abortions and sterilisations in developing countries. I explained to Ulla that abortion was illegal in Ireland by the will of the poeple and that, apart from the fact that the EU had no rights in this area, just as with destructive embryo research funding, it was unethical and against EU law to use taxpayers' money to fund what was illegal in their own country. This regulation was also causing major problems for a number of other Member States and candidate countries as the EU once again pushed the envelope as to who had ultimate control—the Commission, or the citizens of the Member States.

Initially there was a denial that the regulation would fund abortions and sterilisations but in a live radio debate between Ulla and me on Radio Kerry in November 2002, the interviewer, Orla Barry, asked, 'Are you providing money to fund abortions in poorer countries?' and Ulla replied, 'Yes, we are.' It was yet another blatant disregard for EU law and for the laws and Constitutions of EU Member States, particularly Ireland, and a battle ensued with the Commissioner for Research, Poul Nielson that ran into the following year. The Commissioner viewed any opposition as unacceptable, and even when 181 cross-party and pan-European members of the Parliament voted against the regulation, he dismissed their concerns as 'extreme views on religion and sexuality', naming me as a ring leader.

The irony was that although the EU had to ensure non-discrimination and equal opportunity, the Commission website referred organisations seeking development aid to groups that provided and promoted abortion. In order to belong to one of the groups recommended by the Commission, an applicant had to agree with its charter to campaign for 'all methods of fertility regulation including ... safe abortion'. This was not encouraging for groups such as 'Mater Care International', a volunteer association of obstetricians and gynaecologists working with mothers and their children throughout the world, who approched me to lobby the Commission on their behalf. For some years they had

sought EU funding for their work in Africa, and though they were well established, with an excellent track record, it appeared to be impossible to get a penny of funding from the EU, even with the support of the Irish Government. The leaders of the group eventually felt that although the question of abortion provision did not arise in their work, the fact that they did not provide it as a service worked against their receiving EU development aid.

I felt as though I was in a constant battleground during 2002. As the year came to an end, on the family front we found a more spacious unfurnished house to rent and it was a joy to unpack all our furniture and personal belongings that we hadn't seen since we had left America. Christmas 2002 was the first one since 1998 that we actually felt we were in our own 'home', even if it was still a rented one.

By now we were more than ready to put down our roots in our own place, which we hoped would be on the plot of land we had bought in the lovely village of Clarinbridge. Unfortunately the planning process was taking so long that we had almost given up hope of building a home there. When we bought the land, we had one child at college and three at home, but by the time we eventually got planning permission we had three at college and just one child at home. In hindsight it was a blessing, because by the time Robert would have headed off to college in a few years, Damien and I would have been rattling around the big house on our own. We finally decided we should just go ahead and buy a house.

I was in Brussels when Damien, still on the lookout for a suitable house, called me to say that he thought he had found what we'd been looking for. It turned out to be about three or four minutes' walk from where we were renting at that time, yet somehow we had missed seeing it. The thought of finally having our own home was such a relief. It was just a shell when we bought it, but from the outset we knew that it was the place for us, and the fact that it was so close to Galway Airport was a huge plus for me.

Grace came home from Washington for the Christmas holidays, followed by her new boyfriend, Patrick Koucheravy, whom she'd met at university there. We picked Patrick up at Shannon Airport on 29 December for his first visit to Ireland, and we rang in the New Year with our future son-in-law.

As 2003 began, the difficulties facing the Irish fishing industry were increasing daily. Ireland's fishing rights were traded off in negotiating our entry into the EU in the 1970s, so that although Ireland had 11 per cent of EU waters, our fishermen were allocated only 5 per cent of the total EU catch. Now fishing vessels in the northwest were allowed to leave port for only nine days per month, while trawlers from other countries could continue fishing up to six miles from the Irish coast. The industry was in turmoil, and I was lobbying on behalf of families who were dependent on fishing for their livelihood and worried that things were set to get worse as the new round of negotiations began on EU fishing rights.

In the Galway area there were major problems with e-coli contamination in fourteen Group Water Supply Schemes and I had been asked to set up a meeting with EU officials to discuss the problem. I was also lobbying Commissioner of Agriculture Franz Fischler about the plight of the small family farms in the constituency. The Commissioner, a member of my political group, was a burly German farmer and even though EU agricultural policies had swept thousands of small farmers off the land and those remaining were drowning under the ever-increasing red tape that the EU regulations demanded, Franz Fischler was respected by most as a straight-talking, no-nonsense kind of man. He understood the difficulties facing the farming community and when I brought a delegation of farmers from my constituency to meet with the Agriculture Commission, they were able to get answers to questions they had been asking nationally for many years without success.

The vote on the first reading of the Sandbæk Report was passed, to the great disappointment of many people. The Parliament was split on this matter and, as the *Wall Street Journal* reported (3 July 2003), my amendment to bar the EU from funding abortion gained the support of 181 MEPs, 'showing that Mrs Scallon's concerns are not parochial. Nor are Irish taxpayers the only people with reason to worry. The EU might concentrate the power to address difficult moral questions in the hands of a few eurocrats who aren't accountable to the citizens of the member states. There's for sure the potential for abuse and the Commission must be monitored very carefully.' I had done all that I could to highlight and prevent this unethical use of taxpayers' money. Of the

Irish MEPs, only the six Fianna Fáil members voted for my amendment, but unfortunately the Irish Government supported Ulla Sandbæk's report.

Later in the year I travelled to New York to meet with UN representatives of the less developed nations, to find out how they felt about the Sandbæk Report and previous funding for population control. They asked that we meet privately and that they remain anonymous. Those I spoke to told me that they were given very little opportunity to contribute to reports of this kind, which were generally presented to them as a *fait accompli*. In discussing the difficulties their countries faced, including the effects of AIDS, they used the phrase 'our children are our future', and emphasised that there were many pressing needs in which to invest €74 billion, such as clean water supplies and the provision of better education.

Alongside funding abortion through sexual and reproductive health programmes in less developed nations, the European Parliament recently voted, albeit by a narrow majority, to harmonise health service provisions in Member States—which could include abortion, euthanasia and so on—even though the EU has no right to make decisions on these sensitive issues which are outside its remit.

In the UK, it is currently government policy to provide children under sixteen years, and as young as eleven years, with information on obtaining abortion and birth control, without parental knowledge or consent. This is the case in both state and some religious-run secondary schools. The harmonising of such health service provisions throughout the EU could serve virtually to enforce the application of this kind of approach, irrespective of the moral or legal consideration, or indeed the studies confirming the damaging physical and emotional effect on the young person involved. As we stand, Ireland, along with other European countries, has a very high level of sexually transmitted diseases among young people. I know that I am not alone in my concern at the sexualisation of our children at an earlier and earlier age, and as parents struggle to protect their children, there has been, and is, an ongoing undermining of the role of the parent in the formation and teaching of their child. I believe that if a public authority or unaccountable law-maker assumes responsibility of this kind, it can run contrary to the best interests of the child, its parents and, indeed, ultimately society.

Moreover, Kofi Annan, former Secretary General of the UN, informed the European Parliament in 2004 that, because of a dramatic decline in European birth rates, the EU population was set to fall by over 50 million by 2050, with some Member States, like Italy, Austria, Germany and Greece, losing a quarter of their populations, with one in three remaining citizens over the age of 65 years. He told us that unless this demographic crisis was remedied, economies would shrink and societies could stagnate, and added that the same problem was true from Japan to Russia to South Korea.

As we attempt to remedy this critical situation, which is impacting so negatively both socially and economically on Europe and other countries throughout the world, it would be important to consider how abortion and birth control have contributed to this world-wide problem.

It seemed that my days were filled with reading reports, writing amendments, letters or press releases, attending meetings, and of course travelling back and forth to Brussels or Strasbourg and throughout the constituency. We still had just a skeleton staff in Galway and at times I felt I was meeting myself coming back. Some days I just longed to unwind with a few friends, talking about nothing of consequence, just having a laugh and relaxing. Suddenly I got the opportunity to do that, thanks to a phone call from long-time friend Linda Martin—like myself a former Eurovision winner. Linda was presenting a musical quiz show on RTÉ and she wanted to know if I'd appear on it one Sunday night in April. It sounded exactly what I needed. Also taking part were Ronan Collins, Paul Harrington and Colleen Nolan, whom I knew from the days when I'd worked with the Nolan Sisters. I felt relaxed and at ease and I really enjoyed the evening.

It also turned out to be a lucky break for my daughter Ruth, who was in her second year at college in Dublin and had come along to the show to keep me company. While she was waiting for me in rehearsals, she was spotted by Linda's hairstylist, Michael Leon. He had no idea who Ruth was but he immediately asked her to model in a show he was doing. He also gave her the telephone number of a well-known Dublin model agency and suggested that she go there the following day, on his recommendation. This unexpected development was as much of a shock to Ruth as it was to me. Though she was tall and very slim, she

had never thought of modelling. She rarely bothered with make-up and, like most students, she lived in jeans. But she had been desperately looking for a part-time job, so she took Michael's advice and the agency signed her up immediately.

I'll never forget her first attempt to walk in four-inch stiletto high heels; we laughed so much as she tottered along, barely keeping her balance, but within a short space of time Ruth was labelled 'the new face' of Irish modelling. Although she was advised that she could pursue a lucrative career in modelling, she opted to finish her degree in International Business and Languages. Modelling has been a wonderful learning experience for Ruth and she still enjoys working in that field.

April was a busy month for me but compared to May it was a breeze. However, I made sure that I was in Washington on 17 May so that Damien, Robert and I could watch Grace graduate from university with a degree in Communications and Media Studies. It was a special day for us, as Grace was the first of our children to graduate.

While in Washington I took the opportunity to meet with representatives of the US State Department's Transport and Aviation departments regarding the 'Shannon stop-over' and to explain to them how important a thriving Shannon Airport was for the long-term economic security of the west of Ireland, as over 120,000 jobs in various industries were dependent on it. It was a very good meeting, hosted by Republican Congressman Chris Smith of New Jersey. Chris is highly respected by members of both parties in the House for his outstanding work on human rights. As Chairman of the US Commission on Security and Co-operation in Europe (CSCE) and Vice-Chair of the International Relations Committee, he had taken a great personal interest in the Peace Process and in advancing human rights in the North of Ireland, and was working tirelessly to ensure ongoing support, financial and otherwise, from the US congress and administration.

When I brought him to my constituency to meet with business representatives, he immediately saw that, as the US invested millions of dollars to foster employment in the North, it made sense to ensure that jobs were also protected in the closely linked disadvantaged area of the west. He went on to secure support for an amendment that passed in the House of Representatives, which called on the US to examine thoroughly the impact any change to the 'Open Skies' policy might have on Shannon

Airport and business in the west of Ireland, including US investment there.

In the spring of 2002 a convention made up of European and national representatives had been given the task of drawing up a new EU Constitution. By June 2003 a final draft of the document was unveiled by Valéry Giscard d'Estaing, President of the drafting Convention and of the Praesidium. There was much emphasis on how transparent and democratic the work of the 108-strong Convention had been, but most people understood that the text of the draft Constitution was essentially the work of Giscard d'Estaing himself, assisted by Convention Secretary Sir John Kerr of the UK. Not even the twelve selected Praesidium members, who met in private sessions under the forceful leadership of M. d'Estaing, had much of a say. No vote was ever taken on any of the 1,000 plus amendments put to the Convention, just as there was no vote on the final draft which was adopted by 'a consensus' decided on by M. Giscard d'Estaing.

Since 2000, I had written a steady stream of press releases and letters to the Government, calling on our political representatives to defend our Irish sovereignty and to come clean about the proposed Constitution for Europe, a fact denied by our Minister for Foreign Affairs Brian Cowen until the day *after* the nation voted on the second Nice referendum. Now at least the Constitution was out in the open and it contained a number of gems, among them that the EU would be given a legal personality (Art. 6), conferring on it the same rights in relation to legal proceedings as a sovereign nation and whose Constitution and law would override national laws in any case of conflict (Art. 10). As I had warned, the EU Charter of Fundamental Rights would be incorporated into the Constitution and made legally binding, despite the fact that it had not been publicly debated in Ireland and was in conflict with the publicly stated position of our Government and articles of our Irish Constitution. There were many other points in conflict with our Constitution. For example, under the Rights of the Child, parents or the family were never mentioned when referring to the child's right to protection and care; only public authorities and private institutions were given mention.

The Tánaiste, Mary Harney, immediately distanced the coalition Government from the draft Constitution, saying it was 'too Federal in

its scope'. Speaking on the BBC World Service she complained that it went 'much further ... than would have been expected'. Gisela Stuart, representing the UK Labour Government in the Praesidium, went even further when she stated: 'The Convention brought together a self-selected group of the European elite, ... who see national governments and parliaments as an obstacle. Not once in the sixteen months I spent on the convention did representatives question whether deeper integration is what the people of Europe want ...[or] whether it serves their best interests ... none of the existing policies were questioned.'

Former Fine Gael Taoiseach and member of the Praesidium John Bruton, later appointed EU Representative to the USA, claimed that critics of the draft had 'misunderstood it'. On the contrary, I believe they understood it all too well. I again wrote to the Government asking exactly what contribution our representatives had made to the document on behalf of the Irish people.

When the draft Constitution was presented to the European Parliament, MEPs were given just one copy each! I needed to get extra copies before the Parliament closed for the summer, so that I could give them to some journalists in Ireland. They really had no idea how far advanced the EU Constitution was and I wanted them to see for themselves. However, I was told that there were no further copies available and that I would have to put in an order for the number I required. There really wasn't time for that and, as someone had discovered the back entrance into the Parliament's publications room, we crept in there at about one o'clock in the morning to discover plenty of unclaimed copies of the Constitution. So I left for Ireland with an armful of them which I duly distributed to members of the media. I have to say that they were genuinely surprised to hold in their hands the final draft of an EU Constitution. I also shared what I had been told by an MEP and a member of government from one of the accession states, who was a guest at a private luncheon held the day the draft Constitution was presented in the Parliament. Apparently M. Giscard d'Estaing held up a copy of the new EU Constitution and said, 'What we need is a coup d'état and this [Constitution] is it.'

I felt I needed to organise public meetings throughout the constituency so that the people could see for themselves what was going on. The meetings, which were open to the public and to

politicians, were planned for the autumn and were very well attended, sometimes with as many as 400 people present. Again there was shock at how a Constitution could have been written without their knowledge or agreement. Shortly after my series of meetings around the country, the Government's Forum on Europe was set up— unfortunately it was basically a talking shop that leaned towards supporting the EU Constitution.

While all of this was going on, Sue Sheard, who had lived with us since Grace was a toddler, began to feel unwell and unfortunately it turned out to be more serious than any of us had thought. Her illness was a shock for everyone; she was very much a part of our family and also an indispensable support to us. The week we finally moved into our new home, Sue was rushed into hospital for a major operation and John James began his Leaving Certificate exams. Unfortunately I had to be in Strasbourg for some important votes, so Damien had to run the office and the house single-handed as Ruth had exams and couldn't get home. To add to the turmoil, our new home was like a building site and as Damien and I stood in the half-finished kitchen that first day, surrounded by boxes, builders and painters, we didn't know who to turn to for help. Much as they would have been willing to rally round, we just couldn't ask the older family members to cope with the mayhem. Then my phone rang and it was our daughter Grace to the rescue! She flew home from Washington the following day and did a wonderful job of making sense out of the chaos. When Sue came out of hospital, we were still coping with builders and painters on a daily basis and it must have been very difficult for her as she soldiered on without complaint. For Damien and me it was a balancing act between keeping the home running as smoothly as possible so that Sue and John James weren't too disrupted, while keeping everything up to speed on the political front.

The summer was a welcome break. Damien and I had a number of commitments in England and we headed off with Robert. I had been invited by a dear friend, the choreographer Dougie Squires, to attend a garden party at Buckingham Palace. It couldn't have been held on a more beautiful day. The gardens were magnificent in the afternoon sunshine, as we crossed the lawn to take our seats at the long, white linen-covered tables by the lake where we were served afternoon tea. A

brass band played popular selections nearby, as we chatted with old friends like Bruce Forsyth, Petula Clark, Anita Harris, and Vince Hill, as well as some of the cast from *Coronation Street*. One of the lovely things about the world of show business is that although you may not see friends for years at a time, when you do meet up again you can just pick up as though you were never apart. They were very interested in what was going on in the European Parliament, and we spent most of the time either catching up on the latest news, or reminiscing about the various shows we'd worked on together. When we were introduced to the Queen later in the day, she had a word to say to everyone and even wanted to know if I was still singing!

Meanwhile, back in Brussels, Valéry Giscard d'Estaing and German Foreign Minister Joschka Fischer were issuing dire warnings of what would happen if the draft Constitution were to be 'undone' by EU leaders or anyone else. According to Joschka Fischer, the EU would be 'thrown into chaos'. Nevertheless, seventeen candidates and smaller EU Member States planned to meet in Prague in early September because of their difficulties with the 'draft' document. Czech Foreign Minister Cyril Svoboda, host of the Prague meeting, said that there were still points for discussion in the Constitution. The Finnish Prime Minister, Matti Vanhanen, also stated firmly that Finland would not be alone in calling for changes, because 'everyone' he had spoken to had said that there was room for improvement. And how did Mr Fischer respond to this outbreak of democracy? He warned that failure to agree the draft would mean a time of 'deepest crisis for the EU', and with an obvious and shameful threat he reminded the candidate countries that 'enlargement and the constitution [were] two sides of the same European coin'.

In an article in *The Irish Times*, I read that our Minister for European Affairs, Dick Roche, would be representing Ireland at the Prague meeting. The Department of Foreign Affairs was quoted as saying that he would be in 'listening mode'. He would not raise any of Ireland's concerns about the draft, but would 'listen to the concerns of others and warn against unpicking the document'. It was humiliating to read that article and to think of what the other representatives might think of us. If Ireland had concerns about the draft, why couldn't our Government representative state them, instead of trying to discourage

more vulnerable nations from trying to rectify the flaws everyone knew existed? Even Joschka Fischer himself had described the draft as 'a successful compromise that everyone could live with and no one was happy with!'

It seemed to me that either Ireland was under pressure to remain silent, or we were content to be the 'lap dog' of Europe, hoping to be rewarded for good behaviour. A senior political correspondent later told me that, according to his information, every country had concerns with the draft but that Ireland was afraid that if our representatives helped to unpick the draft document, we would come under pressure regarding EU tax harmonisation.

Another major problem was that in the Constitution's preamble in reference to Europe's heritage there was mention of its Roman and Greek roots and the contribution of the 'Enlightenment', but the convention chose to omit its Christian heritage. Catholics, Orthodox, Protestants and members of other religious communities, as well as political representatives of a number of Member States, had asked that there be a reference to God and to the Christian roots of Europe, the latter being recognised as an historical fact, but the request was refused. So as not to mention Christianity, the members of the convention decided to eliminate the reference to Greek and Roman civilisations and the Enlightenment as the inspiration for European values. According to M. Giscard d'Estaing, the proposal to include the reference to Christianity did not get the necessary majority in the convention, but as mentioned earlier there was never a vote taken on *any* of the amendments put to the convention.

Many leading politicians such as French Socialist Jacques Delors and Commission President Romano Prodi criticised the absence of a reference to the Christian roots which, they said, were the foundation for the formulation of human rights. Even atheists like Polish President Aleksander Kwaśniewski, in an interview with the *Daily Telegraph*, denounced the omission, calling it shameful to highlight the pet ideologies of the Left but omit mention of Europe's Christian heritage.

When I was first elected to the European Parliament, I formed a network of MEPs who shared my concern at the way the EU was encroaching on sensitive areas that were the sole responsibility of the Member State, amongst them legislation affecting the family and the

protection of life. We met monthly to examine and discuss upcoming EU reports that touched on these and other issues and to decide how best to respond on behalf of our constituents. In the EU, 90 per cent of over 374 million citizens in the fifteen Member States were Christian, at least nominally, and it was a cause of great concern to many of them that the reference to Europe's Christian roots could be deliberately excluded.

One of the articles in the draft EU Constitution stated that one million citizens could petition the Commission to propose a new law to the Council of Ministers, so we held a press call to launch a European-wide petition that would allow citizens to speak for themselves. We were sure that if a million people signed it, the Commission and Council would certainly have to respond to their request. Each MEP undertook to get out the word about the petition in his/her country. I didn't feel that I should drive the petition in Ireland. It was a very big undertaking and with the public information meetings I was organising on the EU Constitution, on top of my normal workload, I had more than enough to deal with. I decided that the best course of action would be to inform the members of the Oireachtas and Senate of the petition and let *them* inform their constituents and help gather the signatures.

I duly e-mailed each elected member of the Dáil and Seanad before the summer break, but by the autumn of 2003 I still had not received any replies and already petitions in other Member States were gathering hundreds of thousands of signatures. As the Inter-Governmental Conference (IGC) was taking place in Rome in early December, I e-mailed the Senate and Oireachtas members once again in the autumn, but again there was little or no response. The petition did not appear to be going anywhere.

I subsequently met the Taoiseach in New York and spoke to him about the reference to the Christian heritage and to God in the draft text, but I also asked him for an assurance that he would not sign Ireland up to an EU Constitution. His response was that he would support a reference to the Christian heritage and to God in the Constitution if there was consensus on the wording, and I reminded him that it was his duty as Taoiseach to uphold the Irish Constitution and the wishes of the Irish people.

By 18 October, with just eight weeks to go to the IGC deadline, Damien and I, along with family members and some local supporters, took to the streets in the Galway area, to give people an opportunity to sign the petition. We gathered over 700 signatures in less than two hours. The media covered that first day and from there the word spread like wildfire. I called various people and asked them if they would do the same throughout the country, while others acted on their own initiative, working hard on gathering signatures in their local areas and sending them on to the Galway office by the box-full. I also wrote to political and church leaders asking them to sign and support the petition. A number of bishops responded positively and actively supported the gathering of signatures. Pope John Paul II and the future Pope, Cardinal Ratzinger, had both made personal pleas for the inclusion of a reference to Europe's Christian roots and to God. As Cardinal Ratzinger had said, it was important to reiterate the need to 'safeguard human dignity and human rights as values that are above any piece of juridical legislation'.

While there were words of support from political leaders, to my knowledge not one TD or senator signed the petition. It was particularly disappointing to read the replies from the Taoiseach, Brian Cowen and President Mary McAleese, all of whom stated that, in the positions they held, it would be inappropriate for them to sign the petition. The references asked for in the petition were perfectly in line with our Irish Constitution and, in light of the threat of an EU Constitution, I felt that our constitutional position was of primary importance and should be supported by our elected representatives. At the end of the day, to my knowledge, the only public representative to sign the Irish petition was the Italian Foreign Minister, Gianfranco Fini. As I handed him over 100,000 Irish signatures at the Inter-Governmental Conference in Rome in December, he told me that he had already signed the Italian petition and would be proud to accept my invitation to sign the Irish one.

A million signatures were required from across the EU to force the Commission and Council to respond to the citizens' request. Including Ireland's contribution, there were around 700,000 individual signatures, and along with the signed consent of pan-European associations, the total number of signatures came to over 50 million. Nevertheless, EU

leaders decided that the EU Constitution text would remain unchanged, with references to Christian heritage and God excluded. With the Irish Presidency of the EU about to commence, I asked that the Government place the issue at the top of the agenda in light of the phenomenal public response. It was disappointing to realise that our political leaders, regardless of who was in power, would be more likely to respond to the demands of powerful bureaucrats in Europe than to the wishes of their own people.

As 25 December came around, Grace, Ruth and John James travelled home so that we could all spend our first Christmas together in our new home! John James, who had set his sights on Architecture, had been accepted into Oxford Brooks University and, though the course was tough, he had found what he wanted to do in life. Ruth would soon be heading off for a year of study in Spain and there was a lot to be discussed and decided over the holiday period. We all love Christmas time in our house and it was so wonderful to have the family home again. After Boxing Day we drove up to Derry to bring in the New Year with my mother and it was there that sad news arrived.

On 29 December rebels in the state of Burundi shot dead the Vatican Ambassador to the country, fifty-eight-year-old Archbishop Michael Courtney from Nenagh, Co. Tipperary. He had been a great friend to me and to many others in Strasbourg, where he had served as the Representative of the Vatican to the Council of Europe. He had a wonderful gift of hospitality and sense of fun and he used these gifts to bring people together. Often people who were diametrically opposed on certain issues would relax and talk in his presence. A highly intelligent man, he had a gentle, kind nature, and when he took the post of bishop in Burundi he knew that he would be in great danger. He used all of his skills to broker for peace in a very turbulent society, and those who did not want peace ambushed him as he drove to the Capital, Bujumbura. His death brought a sad close to the year but, without doubt, he willingly chose to serve in that troubled land.

The year 2004 had begun on a sad note and on that first day of a new year, I was only too well aware of the many challenges ahead, not least the European election that would take place in my newly named constituency of Ireland North and West.

Chapter 15 ∿

FULL
CIRCLE

I reland took over the Presidency of the EU Council on 1 January 2004. The Italian Presidency had just ended and although there had been much talk of a replay of the historic 1957 signing of the Treaty of Rome, these hopes were dashed when Prime Minister Silvio Berlusconi was unable to get agreement among EU leaders on the new Constitution for Europe.

The main stumbling block was the revision of the crucially important voting system in the Council of Ministers, with Spain and Poland united in wanting to retain the voting arrangements that had been so recently agreed in the Treaty of Nice. However, when the Madrid terrorist bombing led to a shock change of government in Spain and the new administration accepted the voting changes, Poland was left without support and had to give in. With that major obstacle out of the way, the onus was on the Irish Presidency to get agreement on the Constitution before the European elections in June 2004. A statement was released from Ireland promising that our Presidency was 'determined to do all within its power to advance the work of the Inter-Governmental Conference (IGC)'.

Other European issues were looming, among them the up-coming EU elections in June and the review of the US/EU 'Open Skies' policy, with its implications for Shannon Airport and the west of Ireland as a whole. I was the only full-time Irish member on the EU Transport Committee and I had a good working relationship with John Cushnahan who was a substitute member. So, although Shannon Airport was not in my constituency, we co-operated in whatever way

possible to protect the interests of the airport and Aer Lingus, which was based there, as the airport and the airline were so vitally important to businesses and the public throughout the west.

John was already working with representatives of the airport and he made a point of bringing them to meet me in my Brussels office so that we could discuss their concerns. Shannon was in John's constituency and I didn't feel it was appropriate to make any public comments regarding it. However, when the border of my constituency was expanded to include Co. Clare, and John told me that he had opted not to run in 2004, I was able to take a more public stand.

It seemed to me that the general perception of the 'Shannon question' was primarily of airport workers trying to protect their jobs, when in fact a thriving Shannon was crucial for the economic development of the whole western region which was recognised by the EU as being disadvantaged. Throughout the spring of 2004 I held a number of meetings with representatives of various branches of industry in the region, including Irish- and US-owned businesses. I hoped that I could gather their opinions and encourage them to network so that they could make a joint statement on their concerns regarding Shannon. As Kieran MacSweeney, chairman of the Mid-West American Chamber of Commerce, wrote: 'Companies in the mid-west region and all along the west coast of Ireland are totally dependent on Shannon Airport for attracting foreign direct investment … there is concern that changes to the current bilateral arrangement between the US and Ireland will be implemented with adverse implications for the Mid West and West of Ireland.'

I then travelled to Washington where I had a meeting with the chief US aviation negotiators, hosted by Congressman Chris Smith. I explained the importance of Shannon Airport to the economic security of the west of Ireland and stated that, with over 120,000 jobs directly or indirectly dependent on it throughout the region, any downgrading of Shannon could have a disastrous effect on local and US industry there. I was shocked to learn that there had been no consideration given to this point and that it had not been highlighted to them by Irish representatives. Naturally, the US would assume that the only resistance to change in the Shannon stop-over was coming from the workers at Shannon Airport itself. My request was simple: namely that before any

changes were made to the 'Dual Gateway' policy, the US authorities would support the call for an economic impact study to examine the effect those changes would have on the economy of the western region.

I also wrote to and subsequently met with the EU Transport Commissioner, Loyola de Palacio, to discuss the EU position on Shannon. She made it clear and confirmed in writing that any plans to change the stop-over at Shannon were 'first and foremost a responsibility for the Irish Government', and that the Commission 'was ready to include in the EU/US Aviation Agreement any special conditions for Shannon' agreed between Ireland and the US.

I attended a meeting in Shannon soon after my talk with the Commissioner and it was the first time I had spoken publicly there about the situation. The room was crammed with obviously worried and frustrated workers and local business people. I wondered if what I had to say would be of any relevance to them; perhaps they'd heard it all before. But when I took my turn to speak I could hardly believe the reaction. As the *Clare Courier* subsequently reported: '(Dana) stunned the audience with the clarity of her findings,' adding, '... this was stirring stuff but she was not finished yet. She rounded on the proponents of phased change of the bi-lateral agreement. "If you want to talk about phased changes for Shannon ... let's talk about the changes we need to phase in; we need a rail link, we need proper road links that will add to Shannon. Don't think it cannot be fought because it can. This is not a problem for the EU, it is not a problem for the US. Shannon's main problem is here in Ireland. Our main problem here is with Dublin."'

There was prolonged applause and it was clear that what I had told them was a revelation. They had never been given any direct information from Europe before and they had obviously been led to believe that the problem lay with the European Commission.

Subsequently, in late April, Congressman Chris Smith came over from the US, with observers, so that they would get a better understanding of the problems and the urgent need for investment in the west. We drove from the northern tip of Donegal to Shannon, stopping off along the way to talk to members of the public and various business representatives. We ended up with a very big meeting in Shannon where I invited representatives of Irish and US companies, unions,

tourism employees and airport employees to take part. Joe Buckley of Shannon Airport played a key role in helping to organise this. It was a unique and good experience because everyone understood the necessity of rising above any competitiveness or partisanship for the good of the whole region.

Chris Smith subsequently went on to give a rousing speech on the matter in the House of Representatives in Washington, and secured cross-party support to pass an amendment calling on the US to examine thoroughly the impact any changes to the Open Skies policy might have on Shannon Airport and business investment in the west of Ireland.

I knew that we needed support for a similar initiative in the Dáil and so I approached the Independent TD for Clare, James Breen, who said that he would raise the matter in Leinster House. Since that time, representatives of all the main bodies in the region have continued to work together and have drawn up the Mid-West Tourism and Economic Development Plan (2006), in which Shannon Airport is identified as 'a key driver for economic, tourism and industrial development for the Western Region of Ireland'. This plan is of tremendous importance because, unfortunately, the Government agreed to a new Open Skies policy with the US that is to be introduced in 2008, *without* an economic impact study being done and despite the fact that the new agreement, according to the recent Mid-West development plan, could lead to 'serious adverse consequences for industry, tourism and employment in the Mid-West and West regions'.

Another memorable event took place that spring, when I was chosen as the recipient of the San Benedetto Award, presented by the Subiaco Foundation for Life and Family, in recognition of outstanding work in protecting human life and dignity in Europe. I was nominated by the International Federation of Catholic Doctors and the International Catholic Families' Association, and as it had been given to only five other Europeans, including the former Prime Minister of Poland, Tadeusz Mazowiecki, I felt very honoured to be the first woman recipient. The award ceremony took place in St Benedict's Monastery in Subiaco near Rome, in March, and was attended by, amongst others, my family and friends and the Irish Ambassador to the Vatican, Bernard Davenport, and his wife.

The following day I had a private meeting with Cardinal Joseph Ratzinger, who was himself chosen as the 2005 recipient. As I waited for the Cardinal to enter the elegant reception room on that 17 March, a very significant day for me, I was curious to find out what kind of person he would be. He was often referred to in the media as the 'guard dog' of the Catholic Church. I imagined therefore that he would be a very forceful personality, perhaps even intimidating, but he was not at all what I expected. We sat across the coffee table from each other talking on various subjects for almost 45 minutes. He was obviously highly intelligent and informed, but he was also gentle and humble in his manner, anxious to know what the other person thought. We talked at length of developments in Europe and concerns regarding the Charter of Fundamental Rights and the EU Constitution on which he and Pope John Paul II had written extensively. We also touched on developments in Ireland including the abortion referendum, and he affirmed what I had previously been told by others: that my position was in conformity with the teaching of the Church. He warmly congratulated me on receiving the San Benedetto Award, commended me on my pro-life work and encouraged me to continue in the European Parliament. Before leaving, we had our photograph taken together and laughed at the enormous bunch of shamrock pinned to my lapel. As I took my leave, I never dreamt I was saying goodbye to the man who would soon be elected Pope.

Two weeks later Dr Jack Wilke, founder of 'International Right to Life', presented me with the organisation's highest honour in London, in recognition of my work to protect life at all its stages. I found it a moving experience, as it was this organisation's conference in Kansas and my meeting there with members of 'Women Exploited by Abortion' that had had such a deep effect on me back in 1984.

By April the European elections were receiving increasing coverage in the media. This meant that if I wanted to run again I would soon have to present my nomination papers to the returning officer for the constituency. The media were predicting a total collapse in my support because of the after-effects of the 2002 abortion referendum. However, I felt that running as a candidate was the only way to ensure that the imminent EU Constitution would be highlighted as an election issue.

It is extremely difficult for Independents to seek nomination; a member of a political party is effectively nominated automatically to

run for election, but an Independent is required to gather a prescribed number of assenters, possibly on the same day, at the same time, in order to sign nomination papers in a designated county council office. This is not an easy task when most people are working through the day and might need to take time off work and travel from different areas of the constituency.

On 23 April I received a letter from the Sligo office of returning officer Kieran McDermott, regarding the exact dimensions of photographs of candidates needed for the ballot papers. These were to be submitted with the nomination papers. However, there were no instructions or dates regarding the nominating process. This was a crucial point, because, as I had learned in previous elections, a simple mistake or omission in the nomination papers could disqualify a candidate. For further instructions we were to ring Mr McDermott's office, which we did, and thereby ensued a period of incredible confusion and stress.

We were informed that although the nomination deadline was just over three weeks away, the nomination papers had not yet been issued by the Department of the Environment and they were not expected for a week or two! In addition, despite the fact that I was an elected MEP, as an Independent candidate I needed the signatures of sixty assenters (double the number of 1999). We were referred to our local county council for further information, as a designated council official could witness the signatures, after which I would submit my nomination papers to the returning officer in Sligo. It was daunting to have to arrange for sixty individuals to be in Galway on an appointed day and time and we knew that it would have to be well organised in order to suit the assenters and the council official, so we immediately contacted Galway County Council to set up a suitable date.

Unfortunately, although very willing, the people we spoke to were uncertain of who had been delegated to witness the signatures. They also had different dates for the submission of my nomination papers. Four days had now passed, so we called the returning officer again and his representative promised to look into the matter and come back to us with the appropriate information. When we hadn't heard from him two days later, Damien wrote to Mr McDermott, asking for his urgent assistance in getting the correct information for my nominating

process. Also, as we couldn't seem to get the name of the appointed representative in Galway, he asked for the names of responsible officials in other counties, so that we could begin arranging for assenters to assemble at one of the other county council offices.

With just two weeks to go, we entered a bureaucratic nightmare. The council officials recommended to us by Mr McDermott's office informed us that they had no information themselves and asked me not to schedule the assenters until they had instructions on how to handle the matter. Eventually the situation deteriorated to such a farcical level that, with one week to nomination deadline, I had nomination forms in Galway but still no clear information on the procedures to follow.

To cover all possibilities, I had written to supporters in Galway and Sligo, asking them to be ready to go to their respective council offices on 11 and 13 May as that was easier than expecting all sixty individuals to make their way to Galway. My proposer was John Ferry, an ex-garda from Sligo and a very methodical man. Luckily he decided to meet with the designated official in Sligo County Council on 10 May, to sign my nomination papers and double check the procedure, for he discovered another hurdle. Apparently he had to sign all assenters' forms, not just the one in Sligo! The official advised him to go post-haste to the court house where he would have no problem getting extra copies of the nomination form from the returning officer, which he could then sign and send on to me in Galway.

John Ferry had known the returning officer for many years and he didn't anticipate a problem, so he was taken aback when he got a very hostile reception from Mr McDermott, who told him angrily that as forms had already been sent to Galway, no more would be given. John dealt with the situation very calmly and eventually the additional forms were handed over, but only after the returning officer had called my Galway office and shouted at my campaign manager that he would give us no information and that if the forms were not completed properly, he would disqualify me.

We all work under stressful conditions at times, but I felt I should write to Environment Minister Cullen and express my concern at what had happened and what *might* happen if this unprovoked hostility continued. On reflection, I feel that the Minister for the Environment

must bear a lot of the responsibility for the unnecessary delay in sending out forms and clear information and that this contributed to the resulting confusion and tension. I also feel that there is an attempt to make the nomination process as difficult as possible for Independent candidates. Thankfully, my very loyal supporters turned up from every county in the constituency to sign as assenters and there was a communal sigh of relief, followed by a celebration as I handed over my perfectly completed forms to the returning officer in Sligo.

The nomination process proved to be almost as exhausting as the election and, feeling badly in need of a holiday, we started into the campaign trail. Organising a constituency-wide election is a huge undertaking, and once again John and Damien had their hands full managing the campaign, taking turns in travelling with me and keeping the office running smoothly. John also dealt with the PR, and Damien with the campaign literature, while our families again lent all the support they could.

I was the only outgoing MEP running for re-election. Pat 'The Cope' Gallagher had resigned, having been offered a ministerial post in the Government, and Joe McCartan had announced his retirement. There would be an entirely new list of candidates joining me in the race: two Independents including Marian Harkin TD, who had declared her intention to run; Jim Higgins and Madeleine Taylor-Quinn would represent Fine Gael. Labour and Sinn Féin would put forward a candidate each; and Fianna Fáil was hoping for two seats with Minister Jim McDaid running in Donegal and Seán Ó Neachtain, selected after some internal wrangling, targeting my seat in the south of the constituency.

It was a busy and demanding campaign as I canvassed the length and breadth of the newly expanded constituency. Throughout May I attended a great number of public meetings highlighting the neglect of the west, the European Constitution, Shannon Airport, and the need for a western rail corridor.

A Mayo journalist, Christy Loftus, who accompanied me on part of my canvass, recommended that I meet with Dr Jerry Cowley, Independent TD for Mayo, and he offered to take me to the Safe Home project Dr Crowley had founded in Mulranny. I admired the work Dr Crowley was doing there and I decided to ask him if he would be

interested in being my first substitute in Europe, should I be re-elected. The substitute system in the European Parliament works on the basis that if I were to resign, my nominated substitute would automatically take my place, thereby avoiding an expensive by-election.

I said that I would give him time to consider this offer carefully, as obviously it would impact on his work as a TD were he called on to replace me. I also made it clear that I did not expect him to dissociate himself from the work of other Independent candidates. About three weeks passed before I called him again and I was delighted when he told me that he would be 'honoured and privileged' to accept my invitation.

I was planning the formal launch of my campaign when an opinion poll by TNS/MRBI was published in *The Irish Times* on 22 May. As usual I polled low, at just 7 per cent. This of course was nothing new for me and, as trends in the 1997 Presidential election and 1999 European elections had shown, my final tally far surpassed the respective poll figures. Nevertheless it is always disappointing to look at these polls in the middle of an election. Seán Ó Neachtain, Fianna Fáil, was at 20 per cent; Jim Higgins, Fine Gael, 17 per cent; with Marian Harkin, Independent, and Jim McDaid, Fianna Fáil, at 16 per cent each. The others polling above me were Pearse Doherty, Sinn Féin, 9 per cent and Madeleine Taylor-Quinn, Fine Gael, at 8 per cent.

As the sitting MEP, my position on the poll ranking was damaging and certain commentators suggested that I would be eliminated early on. A headline in the *Irish Independent* read, 'Desperate Dana will require a Miracle', and went on: 'There are signs mounting that, with the exception of conservative strongholds, the vote garnered by Dana Rosemary Scallon last time has all but collapsed. Polling a dismal seven per cent in the recent *Irish Times* opinion poll would put the seat out of her reach.'

Within hours of the opinion poll being published, I got a call from Jerry Crowley who told me that he had changed his mind and would not be allowing his name to be put forward as my EU Parliamentary substitute When I asked him why, his response was that the poll figures were bad and that, in light of that, he couldn't support me as he wanted an Independent to be elected. I explained my polling history and asked him please to hold off on his decision, as I hadn't asked for his exclusive

support, but he told me that he would soon be issuing a press statement.

I knew that in the eyes of the media and the public this would signal a lack of faith in me as an electable candidate, and no doubt some voters would look on me as a wasted vote. I had given Jerry three weeks to think about the offer and I've no doubt he had given it considerable thought, but I have to say it was a very big blow to receive his call after the publication of just one poll. As the election results subsequently showed, I lost by a tiny margin of less than half a per cent and my final vote was totally at variance with the poll predictions.

Despite this setback I continued knocking on doors throughout the constituency. All the candidates were hard at work. The bigger parties had well-oiled election machinery, Sinn Féin had an extraordinary network of people on the ground, particularly in the border areas, and Marian Harkin had the most impressive poster campaign. And of course there was the usual rough-and-tumble of the campaign trail. My supporters noticed that large numbers of my posters kept disappearing from telephone poles! We couldn't work out if this was blatant sabotage from supporters of rival candidates or if I had a very big fan base, but whichever it was, by 7 June, four days before the vote, I was forced to issue a press release saying that over 700 of my posters, which had taken an eternity to display, had gone missing in Sligo, Leitrim, parts of Cavan and north Mayo. Six billboards—which didn't come cheap— were either destroyed or stolen!

As the election itself drew near, Grace came home from Washington, John James returned from Oxford and my family rallied around me as they have always done. My position in the opinion polls hardly budged one notch from the outset and I found myself fluctuating around the 7 per cent mark right up to Election Day. We were continually baffled by the figures as the response on the ground completely contradicted the polls.

On 11 June we voted in Claregalway and the count took place two days later in the Mount Errigal Hotel in Letterkenny. I was resigned to being 'hammered'—metaphorically speaking—as all the predictions had been so dire, so I didn't rush over to the count centre but waited until well into the afternoon before going there.

The last thing I wanted was to be humiliated, not only for my own sake but for those who had stood by me. As I walked through the door

of the Mount Errigal Hotel I was resigned to the fact that my seat was gone. However, as I looked around me and soaked up the atmosphere, the Fine Gael candidate, Jim Higgins, came over to me, shook my hand and said 'Congratulations', meaning that I was likely to get the seat. I was very surprised, but as I walked around the room, others congratulated me and then my tally people told me that it was highly likely I *would* take the seat!

As we were breaking for tea at around six o'clock and people were milling around the foyer, it was discovered that water was dripping down from the large chandelier in the entrance hall. Everybody was evacuated to outside the hotel until this drama was attended to and, after some time, we were allowed to return inside for the declarations. When the votes were counted, I received 56,992 first preferences. However, the most extraordinary thing about the figures was that my share of the vote was 13.52 per cent, almost double what the opinion polls had predicted. This confirmed what we had always found to be true, namely that, for me, opinion polls never accurately reflected the response we were getting on the ground, or the sudden turnaround in my vote.

Seán Ó Neachtain of Fianna Fáil, Independent Marian Harkin and Jim Higgins of Fine Gael took the three seats. I was pushed into fifth place by Pearse Doherty of Sinn Féin whose impressive vote probably contributed greatly to my loss.

We had a dinner that night for friends, supporters and activists in my campaign, and while they were all disappointed, they knew that they had done all they could. I was delighted for Seán Ó Neachtain on winning a seat. He's a good man who defied those within the Fianna Fáil establishment who, it seemed, initially wanted Frank Fahey as the candidate.

My time as a Member of the European Parliament was finally over. No more 6.50 a.m. flights out of Dublin on a wet Monday morning to Brussels. No more being away from the children for weeks on end. No more dragging my bags and baggage up to Strasbourg once a month. No more arguing on behalf of fishermen, farmers and employees at Shannon, and so on—although I would still speak on their behalf if I could, no more run-ins with the European Women's Lobby, and of course no more influence where it mattered most, right in the heart of Europe.

Naturally there was disappointment with the outcome of the election, yet I felt a great sense of peace. I knew in my own mind that I had done all I could do and I had fulfilled my 1999 election promises to the best of my ability. No longer an elected representative, I returned to Claregalway to tidy up the loose ends of my European political career, such as closing my offices in Galway, Brussels and Strasbourg. My defeat also meant that I would no longer be working with my excellent assistant, Catherine Vierling, but I had no doubt she would soon find a new door opened to her in the Parliament.

As I pondered about my life ahead, I felt as though I had run into a brick wall and been forced to stop dead! One minute you feel you're working almost 24 hours a day, seven days a week, the next day you're a private citizen with time to spare, and initially it took some adjusting to. My second last official function on the European political stage was a trip to Budapest in the new EU State of Hungary, for a 'study week' to meet the newly elected MEPs and to catch up with and say goodbye to all the good friends I had made since 1999.

On a subsequent trip to Brussels I formally cleared my office. Those of us who weren't re-elected were presented with medals as mementos of our time in the European Parliament. It also represented a formal final parting and goodbye to EU politics.

I returned to Galway, my ties now finally cut with the Parliament, and as I did, I kept asking myself what I could do to highlight the threat of the EU Constitution that would so weaken our Irish Constitution. As this dilemma played around in my mind, irony of ironies, the Taoiseach, in one of his last duties as EU President, secured agreement amongst the heads of the twenty-five Member States of the European Union on the draft Constitution for Europe!

The move was now firmly on to introduce the Constitution by hook or by crook. I had to do something but wasn't sure of exactly what that would be. No longer an elected representative, I could only hope that the high profile I had earned would help me to get the message out on what exactly was coming down the tracks. What I didn't count on at the time was that an off-the-cuff comment I made to one journalist in which I said, 'I'll be back,' was about to be pounced upon by one of the national daily papers.

On Monday, 21 June, the *Irish Independent* carried a story suggesting that I was considering running in the Presidential election that was due the following November. The story had no basis whatever at the time and was clearly written along the lines of 'What next for Dana?' That's how it started out. Running in another election was the very last thing on my mind, but the story put a lot of media focus on me, with numerous articles in other papers over the coming months speculating on whether I was going to run.

I gave the Presidential election little thought, though as I had learned in 1997, such a poll is unique. Unlike a General Election, where the bulk of issues tend to be local, a Presidential election is an opportunity to take stock of where we're going as a society and to examine and debate issues that affect us as a nation. One such issue of course was the European Constitution which was supported by the three main political parties, and, as it happened, would be signed, on behalf of the President, by the Taoiseach and Minister for Foreign Affairs around the date set for the Presidential election. Yet, it had never been properly debated in the country and most people had no idea of the implications for our national independence and the democratic rights of the Irish people.

As the guardian of the Constitution, the President, whoever that person might be, has the moral obligation at least to raise the debate. There is a provision in the Irish Constitution that allows the President to call a meeting of the Oireachtas and address the members. So, as far as I was concerned, it was essential that there be a debate on this vital issue in the run-up to the Presidential election, particularly at a time when national sovereignty and democracy were an issue. This will be the case again when a replacement treaty, based on the now rejected EU Constitution, is put to us once more, probably in 2009.

I felt very tired after the European elections, but I thought I would take the opportunity to go around various radio stations and discuss the constitutional issue so that I could at least raise awareness of the situation. In the meantime, the *News of the World* ran a story on 1 August, saying that I intended to run and that I wouldn't announce my candidacy until President McAleese declared whether or not she would seek election. The *Sunday Business Post* forecast on the same day that President McAleese would not make an announcement until September.

Throughout August and early September I did the media merry-go-round throughout the country. I genuinely still had no intention of putting my hat into the ring even though the question of my running came up in every radio station I visited. As I told Shane Coleman in the *Sunday Tribune* (29 August), 'I would be happy to walk away if there was a proper debate ... all I want is that the Irish people are not walked into a situation where our Irish Constitution is given away.'

After an interview on Castlebar Community Radio on the weekend of 11 September, I got an unexpected call from Johnny Mee (Labour), Deputy Chairman of Mayo County Council, telling me that if I would ask his council for a nomination, they wanted to give it with cross-party support at their meeting on Monday, 13 September. I was very surprised as I had not approached any council member, but it seemed that the closing date for nominations (1 October), announced a few days earlier, was so close, it effectively ruled out the Council's right even to consider nomination requests. The same was true for a number of other county councils. I immediately agreed to his request, as in 1997 when I was nominated through the county council route, it had been a hard struggle for councillors to be able to exercise this constitutional right for the first time in our history. Having achieved that, it would be a terrible shame to let that right be whittled away again at the very next election.

As I faxed off the requested letter, alarm bells were starting to ring very loudly in Dublin and also in the media where there was a growing disquiet at the behaviour of the mainstream political parties. As Alan Ruddock wrote in the *Sunday Times*: 'Something rotten in the state of an unopposed president ... It should not matter that McAleese has been a good or bad President. What matters is that we care enough about the Presidency actually to compete for it rather than mutter about the cost of the campaign and step aside.'

When Mayo County Council met on Monday, 13 September, two crucial things prevented members from giving me the nomination as they wanted to. Firstly, the Minister for the Environment did not sign the Order naming the election date, and until that happened, the council could not vote on my nomination, as it would be deemed null and void. Secondly, Fine Gael members were told by Party Secretary Tom Curran, on behalf of Enda Kenny, that they could not support me,

even though it was their intention to do so. The following day Fine Gael party whip Paddy McGuinness, who wanted to support the request for my nomination, sent me a message saying that he was sorry about the way things had gone, but there was nothing he could do.

The Fine Gael leader, Enda Kenny, having already declared Fine Gael backing for President McAleese, decided that there would be no support allowed for my nomination and subsequently imposed the whip. I felt that this was an abuse of the democratic process and the rights of the county councillors. Clearly Mayo Fine Gael TD Michael Ring did also because he advocated that I should not have a party whip imposed and that I was entitled to seek a democratic nomination. As a result, Enda Kenny removed his political rival to the back bench.

As a point of interest, the Minister for the Environment, Martin Cullen, signed the Order for the date of polling at 7 p.m. on the evening of Monday 13 September, when the Mayo County Council meeting was over. By the next council meeting the following month, the nomination deadline would have passed.

In Clare County Council, the matter actually went to a discussion following a proposal by Councillor Patricia McCarthy, Independent. She was quoted in *The Irish Times* (14 September), 'We are always complaining that councillors do not have enough power and this is an opportunity to use that power. Just because someone has done a good job in office should not mean that an election for that post should not take place.' Patricia was clearly on the same wavelength as me, but in the end, the majority Fianna Fáil group, with the backing of Fine Gael, defeated the motion by a narrow 16–12.

There were similar occurrences in other councils and it was causing a political storm. In Wicklow, Councillor Tommy Cullen, Independent, accused his colleagues of being 'afraid of democracy'. Gwen Halley, writing in the *Sunday Independent*, said, '[President] McAleese needs a presidency poll just as much as we do … Mary McAleese should demand an election.' It was understandable that Fianna Fáil would want to support the person it had chosen as its Presidential candidate, but there were reports that a growing number of Fine Gael councillors were furious at what they saw as a diktat from Fine Gael head office to muzzle them and deny them a legal right to nominate. Some, who had stated their intention of supporting my nomination, were forced to

change their position publicly, even on national television news. It was humiliating and caused great anger throughout the country. It wasn't so much about me and whether I should be nominated; it was about the high-handed manner in which blocks were being put in the way in order to prevent an election from taking place at all. The unfolding scenario also meant that there would be no debate on the EU Constitution, or indeed on any other issue affecting the nation.

Everybody could see what was going on to prevent me and other potential candidates like former UN Assistant Secretary-General Denis Halliday and returned emigrant Kevin Lee of Sligo from entering the contest. In the meantime, President McAleese had not yet declared her intention to run. A glimmer of hope, however, was emerging right in my own back yard. Councillor Jarlath McDonagh, leader of Fine Gael on Galway County Council, told *The Irish Times* on 13 September that if I approached them, they would be facilitating me by putting it on the agenda: 'She's living in Galway. That's the least we could do.' I have to say, that was much appreciated, and with windows of opportunity closing in my face from county to county due to the Fianna Fáil/Fine Gael pact, the one glimmer of hope I had counted on was finally delivered in my own heartland of Galway where city councillors voted across party lines to give me my first formal nomination.

As time moved on and the closing date for the nomination drew ever closer, Damien, John and I didn't give up knocking on the remaining council doors around the country. At this stage, the *right* to run, rather than whether or not I was a no-hoper, was the key principle driving me. But the game was up. One nomination was just not enough. However, I didn't let the matter end there. On nomination day, 1 October, John, Damien and I sat across the table from the returning officer and the lawyer for President McAleese in the Custom House in Dublin, with my one nomination clutched in my hand, and I stated for the record that democracy had been stifled and that county councillors had been muzzled. I then went into the main presentation room where members of the Government stood in line with Opposition TDs, waiting to witness the re-appointment of the President. I remember looking across the room at the line of TDs and the only one who acknowledged my presence was Brian Cowen. But as I left the building that day I was presented with a bouquet of flowers by Paul O'Kelly, a gentleman who

had supported my democratic right to run, even though he had not been a supporter of mine in the past.

Unknown to me, at least two people attempted to take High Court actions that morning in protest at the manner in which the non-election had been dealt with, but their attempts came to nothing.

In the days following the nomination date, the feedback was extraordinary and remarkably positive. The people who corresponded with me fully understood what my motives were and felt just as I did: that our political leaders had abused the rights of the public and the principles of the Constitution.

On 29 October, in Rome, the Taoiseach Bertie Ahern and Minister for Foreign Affairs Dermot Ahern signed the EU Constitution, containing a legally binding EU Charter of Fundamental Rights, on behalf of the Irish people, without any reference to the Irish people themselves and despite the fact that he had stated that he would not do so.

As I gradually recovered from the bruising campaigns, I had other more cheerful events on the horizon. Grace announced that she and Patrick were to be married in the summer of 2005. We were very happy for them both. As a working mother, I had missed out on a lot of key moments in my children's lives, so I was delighted that I could travel over to New York where she was living, to help her to select her wedding dress.

After returning home, I unexpectedly ended up in hospital with severe back pain that thankfully turned out to be muscular. However, it was the best thing that could have happened. Apparently the cure for me was to exercise in order to build up the muscles that helped protect my spine. No doubt sitting behind a desk or on an aeroplane for the past five years had done little to help me, and although I knew I was terribly unfit I didn't seem to be able to dedicate the time needed to remedy the situation! My brother Gerry had a brainwave and, without speaking to me first, he contacted one of his many friends who just happened to be involved in *The Afternoon Show* on RTÉ television. As a result they offered me a slot on the show with a personal trainer and dietician and promised they would get me fit and healthy in no time at all. It sounded too good to refuse even though the downside was that my battle to get fit *and* my weight would be monitored every week on the programme in front of the viewing public! I found the thought of

that very embarrassing, but I knew that I couldn't do it on my own, so I accepted the challenge.

For the next seven weeks I went through tough exercise routines and gave up eating bread! The support of the crew and the public was just fantastic, and by April I felt as fit as fifty fiddles and had managed to lose 15 pounds, just in time for Grace's wedding. A short time after that, Ruth got her degree in International Business and Languages, John James successfully completed the first stage of his studies in Architecture and Robert, nearing his Leaving Cert exams, made an excellent demo with his band Zero Moda. So, after all the challenges of the previous twelve months, we had a lot to celebrate!

Grace and Patrick's marriage ceremony and reception in Connemara were a beautiful experience. The Koucheravy party, which numbered close on 100, travelled from Virgina and fell in love with Ireland, thanks in part to the fine weather and the wonderful scenery of the Connemara coastline. We danced till we dropped, to the Black Magic Big Band and then had our own céilí, with traditional Irish dancers, and all thanks to the Murray family. Thankfully I was able to dance the night away, courtesy of my new fitness regime.

The only sadness was that the following afternoon, Patrick, a member of the US Army, received an urgent phone call from his commander to say that he was to deploy to Afghanistan in a matter of days. Naturally we were all devastated. On the second day of their honeymoon, they had to return home to the United States, and one day later he was deployed. Patrick and Grace said that they would never forget the kindness of the staff in Shannon and Dublin Airports as they did their best to sort out the last-minute travel changes.

As 2006 began, an old friend, Bill Hughes, called me and asked if I would like to take part in a new RTÉ TV series he was filming called *Celebrity Jigs and Reels*. The format was simple: a number of celebrities were asked to learn Irish dancing in the company of an experienced tutor and the public would vote on who made the best progress over a period of weeks. Best of all, each guest contestant could earn money each week for the charity of his or her choice. I selected the Hospice Foundation of Ireland, a truly wonderful organisation that has done outstanding work and brought comfort to many people.

After a brief trip to the US I returned and found myself thrown into the show straightaway. My tutor was Ronan McCormack, a very gifted dancer and choreographer who had toured extensively with *Riverdance*. Other celebrities taking part were Olympic gold medallist boxer Michael Carruth, haute couture dress designer Jen Kelly, well-known tenor Paul Byrom, children's TV presenter Emma O'Driscoll, beautician to the stars Suzanne Walsh and *Fair City* actor Killian O'Sullivan. Marty Whelan compered, with judges Jean Butler, Colin Dunne and the irreplaceable George Hook. We all got on really well together and have kept up our friendships ever since.

When rehearsals began, I thought I'd be floating around the floor in a pair of soft dance shoes. How wrong I was! In fact we had to wear hard dance shoes with a health warning that they could seriously blister your feet. The warning proved accurate as I ended up with blisters on my heels and pains all over my body, much the same as everyone else on the show! I thought I'd be voted off the show after the first programme and I was also convinced I would get a heart attack in the first week, but luckily neither of these events occured. It was hard work, but I loved it. As the programmes went on, my confidence grew and the show turned out to be great fun, providing RTÉ with one of the highest reality-show audiences ever in the Nielsen ratings. I went on to take second place and raise €30,000 for the Hospice Foundation.

With the opening of the newly devolved Northern Ireland Assembly, described by some as 'close to a miracle', 2007 is marked as an historic year, because we have, at last, a real opportunity for enduring peace in the North. It is a happening that I didn't think I would see in my lifetime, and a deep debt of gratitude is owed to all those who have worked, sacrificed and prayed to bring this about. The men and women of the Northern Assembly, whatever their past positions, have taken great personal and political risks for the sake of peace, and I believe that they are determined to ensure a just and fair society for every person in the North. Certainly the First Minister Dr Ian Paisley and Deputy First Minister Martin McGuinness are known to be dedicated constituency workers, whatever the denomination of their constituents. I know that when I needed support in the European Parliament, Dr Paisley was always one of the first to give his backing. I cannot let this opportunity pass without paying a special tribute to An Taoiseach Bertie Ahern and

former Prime Minister Tony Blair for their unfailing commitment to the peace process. When many others would have given up, they kept going. I often wonder if most people in the Republic of Ireland fully understand the pivotal role played by these two men.

It is a wonderful thing to witness this new beginning and though there is still much healing and forgiveness needed, there is a genuine resolve to move forward and not slip back to the old antagonisms of the past. It is truly a new day for all of us on the island of Ireland.

I feel that in my life it's a new day for me too, and I'm ready at this stage to take on any challenges that come my way; I'm back in the studio recording again for DS Music, the company Damien and I have founded. Alongside that, I'm returning to concert work and appearing on television shows in Ireland, the US and the UK where I just met up again with old friends like Paul O'Grady and Sir Terry Wogan. I also continue to share my political experiences in various parts of the world when invited to do so, and carry on with the work I have always done on behalf of youth, family and life.

Looking back at all the things that have happened to me—the unexpected twists and turns that took me where I least expected to go—I have to say, it's been a great journey thus far. Through the highs and lows of life, my faith has brought me peace and given me strength. My marriage, my children and my family have been my greatest gifts and I thank God for them. I can't help wondering sometimes how my life would have turned out if I hadn't met the inimitable Tom McGrath, the man who set me on the road to All Kinds of Everything.

INDEX